Codes, Regulations, and Standards in Interior Design

Samuel L. Hurt, R.I.D., P.E., R.A.

Prentice Hall

Boston Columbus Indianapolis New York San Francisco Upper Saddle River
Amsterdam Cape Town Dubai London Madrid Milan Munich Paris Montreal Toronto
Delhi Mexico City Sao Paulo Sydney Hong Kong Seoul Singapore Taipei Tokyo

Editorial Director: Vern Anthony
Acquisitions Editor: Sara Eilert
Editorial Assistant: Doug Greive
Director of Marketing: David Gesell
Senior Marketing Coordinator: Alicia Wozniak
Marketing Manager: Harper Coles
Senior Marketing Assistant: Les Roberts
Production Editor: Holly Shufeldt
Senior Art Director: Jayne Conte
Cover Designer: Suzanne Duda
Manager, Rights and Permissions: Karen Sanatar
Cover Art: Corbis
Full-Service Project Management and Composition: Integra Software Services Pvt. Ltd.
Printer/Binder: Courier Company
Cover Printer: Lehigh-Phoenix Color
Text Font: 9/13, Frutiger 45 Light

Credits and acknowledgments borrowed from other sources and reproduced, with permission, in this textbook appear on the appropriate page within the text.

"Portions of this publication reproduce excerpts from the 2009 International Building Code, 2009 International Residential Building Code for One and Two Family Dwellings, 2009 International Mechanical Code, 2006 International Fire Code, and ICC/ANSI A117.1 - 2003 (Accessible and Usable Buildings and Facilities), International Code Council, Inc., Washington, D.C. Reproduced with permission. All rights reserved." www.iccsafe.org

Many of the designations by manufacturers and seller to distinguish their products are claimed as trademarks. Where those designations appear in this book, and the publisher was aware of a trademark claim, the designations have been printed in initial caps or all caps.

Library of Congress Cataloging-in-Publication Data
Hurt, Samuel L.
 Codes, regulations, and standards in interior design / Samuel L. Hurt.
 p. cm.
 Includes index.
 ISBN-13: 978-0-13-703303-4
 ISBN-10: 0-13-703303-6
 1. Interior decorators—Legal status, laws, etc.—United States. 2. Building laws—United States.
 3. Interior decoration firms—United States. 4. Interior decoration—Practice. I. Title.
 KF2930.I58H87 2011
 343.73'078729—dc22

 2010047713

10 9 8 7 6 5 4 3 2 1

Prentice Hall
is an imprint of

ISBN 10: 0-13-703303-6
ISBN 13: 978-0-13-703303-4

CONTENTS

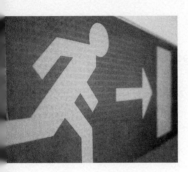

Design is the subject of this book. Codes, regulations, and standards are merely the topics that will be used to assist readers with developing more technical skill as designers. But it is design that matters first and foremost because all is for naught—this book and everything else—if the end result is not a high-quality code-compliant design. The thousands of pages of codes, regulations, and standards—a true avalanche of information—that might be applicable to a given project are daunting in and of themselves, so it is vital to develop a clear understanding of the reasons for, the history of, the meaning and application of, and the enforcement of applicable codes, regulations, and standards to real problems in interior design.

It may seem strange to talk about design first in a context like this, but I believe completely that an emphasis on design will make the subject matter more interesting and more understandable, mostly by focusing on real work and the true day-to-day application of these oftentimes difficult-to-read documents. Having been educated in design (both a B.S. and an M.Arch. in architectural design), practiced for nearly 10 years as a registered architect, about 7 years in commercial (mostly) interior design (and a registered interior designer in Indiana since October 2009), more than 12 years as a professional engineer (in mechanical, electrical, and plumbing systems), and as an adjunct or part-time instructor in interior design for more than 10 years, I have seen the full gamut of code applications, across a vast swath of project types and sizes: from single-room renovations through new high-rise buildings, from restaurants to small airports, condominiums to large offices, health care to corrections, and just about every other project type there is.

Over the years since my career began in 1981, I have observed that many designers (architects, interior designers, and engineers alike) consider code documents to be a necessary evil. But this really is not correct. At the most fundamental level, design is complex problem solving of the highest order: the synthesis of a multitude of diverse factors into a cohesive whole that meets a complicated (and not always consistent) set of objectives. To design a project that is beautiful but fails to meet code requirements is to have failed. To design a project that is completely code-compliant but ill suited to the owner's desires is also to have failed. Design success, at least in my view, is defined by the completeness of the solution, across the full spectrum of design issues: meaning, beauty, functionality, cost, and, yes, code compliance.

So this book will take a somewhat unusual point of view. Codes, regulations, and standards are not necessary evils; in fact, they are there to assist you as an interior designer, to assist you in understanding and applying the principles of life safety and property protection, both of which are integral and important goals in any design project. Will some of this subject matter be a little dull? Probably, but don't give up early. We will begin with the most general aspects, moving gradually through deepening levels of detail, until a complete picture has been developed. The overall image may be a little vague at the beginning, but bear with me. All should be clear—at least reasonably clear—once we get to the end.

If you see something that bothers you, look it up. If you still disagree, send me a note. I'm learning too, and I certainly want to avoid confusion to the greatest degree possible.

Samuel L. Hurt, R.I.D., P.E., R.A.

ACKNOWLEDGMENTS

Thank you to the reviewers for their input on this book: Nancy Bredemeyer, Indian River State College; Carol Caughey, Oregon State University; Pamela K. Evans, Kent State University; and Cynthia M. Landis, Indiana University–Purdue University, Indianapolis. And to my professional colleagues Ralph Gerdes, Ralph Gerdes Consultants; Michael Halstead, Halstead Architects; and Drew White, Axis Architecture + Interiors. To numerous students at The Art Institute of Indianapolis, but especially to Janet Miller and Jeri Norris, who suffered through the first draft of this book. To my patient and understanding family—my wife Carmen, and sons Kyle, Ian, and Austen. And especially to Fabiola Fiuza, former academic director for interior design at The Art Institute of Indianapolis, who made this possible.

INTRODUCTION

The most basic purpose of *Codes, Regulations, and Standards in Interior Design* is to assist students and practitioners of interior design with understanding and applying applicable codes, regulations, and standards in their design work. As noted in the preface, integration of technical code requirements is a critical element of success in any design, so it is indeed necessary for all designers (architects, engineers, and—yes—interior designers) to have a solid working knowledge of the subject. These goals will be accomplished by covering the following broad topics, each in its own Chapter:

Chapter 1	Why is code language so difficult? How do codes affect the day-to-day practice of interior design? What is code research? Why are team dynamics and professional courtesy important?
Chapter 2	What are codes? What is a law? What is a standard? Also included are the more specific subtopics of code history, model codes, and codes adoption. This Chapter will establish the basic need for, and the structure of, the building-construction regulatory environment in the United States.
Chapter 3	What is code enforcement? Also included are the more specific topics of federal, state, and local enforcement, enforcement conflicts, appeals, and compliance liability.
Chapter 4	What is building type? Even though building types are determined by architects and have usually been established before interior designers are involved in a project, a basic knowledge of the subject is important in order to understand the many issues that flow from construction type, such as the need for fire-rated corridors, the number of exits, and so on. The limitations of building type are also critical to understanding how, and why, to renovate an existing building.
Chapter 5	What is occupancy? This is the key issue in interior design, and it is one of the two most important topics to be covered. The determination of occupancy type (i.e., assembly, business, educational, hazardous, institutional, mercantile, residential, or storage) and subtype (A-1, A-2, A-3, A-4, or A-5), coupled with the determination of building type (see Chapter 3), sets nearly all important code parameters. The other key topic is egress; see next Chapter.
Chapter 6	What is egress? This is another key issue, of equal importance to occupancy and building type, because egress requirements set the number of exits, limit the pathways to those exits, and ensure that buildings can be safely evacuated in a reasonable time period under emergency conditions. More than any other single factor, egress protection is the primary reason for having building rules in the first place.
Chapter 7	Accessibility. Accessibility requirements have existed, to one degree or another, for decades, but this subject has become an integral part of all design work in the United States since the enactment of the Americans with Disabilities Act in 1992.
Chapter 8	Interior materials. There are products that can and cannot be used in various circumstances, and this Chapter will review how and why.

Chapter 9	Mechanical, electrical, and plumbing systems. Even though most of this work is done by engineers (and sometimes architects), it is necessary to understand certain aspects of these systems, especially how they can affect space planning and ceiling heights.
Chapter 10	One- and two-family dwelling (residential) requirements. Requirements are different in this arena, and some of them are crucial to interior design.
Chapter 11	Building renovation requirements. Special requirements apply to the renovation of all buildings—especially historic buildings—and some of them are crucial to interior design.

The general progression will be from broad scope to narrow scope, with inevitable circling back and forth here and there to relate disparate topics to one another in a coherent manner. This subject is vast and complex, but understandable when taken one step at a time. Much emphasis will be placed on tracing the "threads," which are explained in Chapter 1. This subject is also of unequaled importance to working designers due to the legal liability issues involved, not just for code enforcement but also for long-term building safety.

To maintain the focus on design, numerous "Design Tips" are located throughout the text. These brief comments are simply practical suggestions from a deeply experienced practitioner, developed over many years and across a broad swath of project types and sizes.

This book is based on the most current model codes, regulations, and standards that are available, most of which are 2009 documents that were published late in 2008 or early in 2009. These include the International Code Council's 2009 documents (the mostly widely used model codes in the United States); key documents published by the National Fire Protection Association (NFPA), including NFPA 13-2007 Installation of Sprinkler Systems; NFPA 70-2008 National Electrical Code; NFPA 72-2007 National Fire Alarm Code; NFPA 99-2005 Healthcare Facilities; NFPA 101-2009 Life Safety Code; and NFPA 5000-2009 Building Construction and Safety Code; the Americans with Disabilities Act (especially the Americans with Disabilities Act Accessibility Guidelines); and ICC/ANSI A117.1-2003 Accessible and Usable Buildings and Facilities.

The reader must understand, however, that it is absolutely necessary for each designer to verify all applicable codes, regulations, and standards at the outset of each and every individual project, especially if that project is in a jurisdiction that is new to the designer or in a familiar jurisdiction where substantial time has passed since the rules were last checked.

The author bears no liability of any kind for the applicability of any particular code, regulation, or standard, or for compliance with any of those documents. This book is strictly advisory, and nothing in it should be construed as a "final ruling" by an "authority having jurisdiction."

Why Is Code Language so Difficult?

1.1 Code Language

Code, regulation, and standard documents tend to be difficult to read. They are sparsely illustrated, if they are illustrated at all, and language is used to convey complex geometric and relational requirements. It should come as no surprise that it's difficult to convey complex geometric and relational requirements using only language. But that is how it is, and it is vital that interior designers understand the basic approach to the language and structure of the various codes, regulations, and standards. Graphics will be used wherever appropriate in this book to help in understanding specific requirements, but it is important for the reader to understand and appreciate the necessity of understanding the language itself.

The first thing to note is that all of these documents are legalistic, meaning that they are intended to be either (1) laws or (2) backup documents to laws. This is of critical importance because this means that the document must be clear. This is also largely why there are few illustrations in these documents. Lawyers have been known to argue that only text is legally enforceable and that illustrations, when used, can be only supplemental information.

objectives

1.1. To understand the challenges of typical code language.

1.2. To understand the practical effects of codes on interior design practice.

1.3. To understand team dynamics and professional courtesy in interior design practice

The second thing to note is that all of these documents are complex, because they apply to vastly different circumstances—tiny single-room freestanding buildings and giant complexes of high-rise buildings alike.

So how can complex legalistic documents be written clearly? Not easily. Although the language may appear to be clear at a glance, it is vital to learn to look for exceptions, footnotes, and references that can change the meaning in drastic ways. It is also necessary to be very careful about the language itself. If one of these documents has a listing of six items, but it doesn't say that "all" of the following are required, that means that the list is a list of options and not a list of requirements. This subtle difference has led to many misunderstandings about the meaning of code documents.

When reading through these documents, it is necessary to follow the "threads." In other words, when a paragraph refers to another paragraph in another chapter, the reader must go to that paragraph, and then to the next reference and to the next and to the next until there are no more next references. This is key because any of the references could easily alter the meaning of the original paragraph, and that would be missed if all of the references were not carefully read too.

This is also true with exceptions, of which there are many in these documents. One would expect that the basic provision would be the most common, but such is not always the case. Here is a simple example to illustrate this issue.

For many years, the basic building codes have required one-hour fire-rated corridors in all buildings. Back in the late 1980s, some of these basic building codes were changed to provide for an exception whereby corridors could be nonrated in office buildings having complete fire protection sprinkler systems. That exception applied to more projects than did the basic requirement. In the 2009 International Building Code, these requirements have been put into Table 1018.1 without exceptions. The latter is much clearer, but it took a number of years and code revisions to get there.

When tables are used, it is very important to read all footnotes, because many of the footnotes include significant exceptions to the requirements listed in the table.

So are the documents as clear as they are intended to be? Not really, mostly because it is so easy to lose track of the threads, to miss exceptions, and to gloss over footnotes. Reading these documents requires concentration and careful tracking to make sure that all provisions have been found and understood; there simply is no shortcut. Throughout this book, the reader will be guided through the twists and turns so as to make all of this as clear as possible.

Even though all of these documents are related to life safety and property damage reduction, which are laudable goals, the organizations that publish the documents are not governmental entities or public service organizations. They are publishers like the publisher of this book. As publishers, selling books is their main source of revenue (supplemented for many of them by selling training courses to help in understanding their difficult-to-read documents) so they have incentives to sell more books. This is largely why many of the books are updated on a regular cycle; in other words, they are updated according to a schedule whether they really need to be or not. This is also why the organizations lobby the authorities to adopt new versions. More on all of this in Chapter 2.

How can an unusual situation that is not covered in the codes get resolved? If there is a need to do something on a project that simply isn't covered in the documents, the International Codes Council (ICC—the primary "model code" publisher in the United States) offers an evaluation service, called ICC-ES. This service can evaluate virtually anything—for a price, so it should be considered only for very large projects with long schedules.

Last, both the ICC and the National Fire Protection Association (NFPA)—see Chapter 2 for more detail about these organizations—publish extensive commentary books that help in understanding the meaning of the actual documents themselves. (They run extensive classes too.) But it is vital to keep in mind that commentary about a code is not a code itself, and commentary language is not enforceable.

1.2 Day-to-Day Practice

Everyone is resistant to redoing work for what are perceived to be unimportant reasons: someone changed her mind, something didn't fit, the rules changed suddenly, and so on. So how can an individual designer minimize code-related changes? By understanding the code requirements in the first place to the greatest extent possible.

Whether the project is proceeding along the typical interior design phases of Programming, Space Planning, Interior Design, Construction Documents, Construction Administration, and Post-Construction (Fixtures, Furnishings, and Equipment [FF&E]) installation, move coordination, etc.) or along the typical architectural phases of Pre-design/Programming, Schematic Design, Design Development, Construction Documents, and Construction Administration, code requirements must be identified as early as possible. Although there is probably no harm done in proceeding with programming without having done code research, it is a big mistake to proceed further.

As the design industry moves more and more into building information modeling (BIM—intelligent 3-D modeling using software similar to Autodesk's Revit) and integrated project delivery (IPD—a very close contractual relationship between the owner, designers, and contractors), this will become all the more important because decision making will be pushed up to earlier stages of the project under this approach.

1.2.1 WHAT IS CODE RESEARCH?

Code research is a two-step process—

Step 1: Determine which codes are applicable to the specific project. This will include—at a minimum—administrative rules (plan review, permitting, and enforcement), a building code, a fire code, a mechanical code, a plumbing code, an electrical code, and accessibility requirements. But a number of other documents could come into play too: fire protection sprinkler rules, residential fire protection sprinkler rules, fire alarm rules, elevator and escalator rules, health care rules, day care rules, food service rules, school rules, specialized life safety rules, specialized accessibility requirements, or possibly more. And it is vital to determine which version of each document is in force; this issue will be covered in Chapter 2.

Step 2: Read through all of the applicable documents to determine which provisions apply to the project, and write a summary report.

For interior designers working with mechanical, electrical, and plumbing consulting engineers, it should be reasonable to leave the mechanical, electrical, and plumbing portions of the code research to the engineers. For interior designers working with

> **Starting Code Research**
> When first using code documents, it is helpful to write down the references as they come along, noting which ones are dead ends, which ones continue to others, and which ones really matter. This is a good way to begin the code research report.

design/build mechanical, electrical, and plumbing contractors, it might also be reasonable to leave the mechanical, electrical, and plumbing portions of the code research to the contractors (who should be working with the engineers behind the scenes). For interior designers working with architects, even though the architect may bear primary responsibility, the interior designer should do as much of the work as possible.

It is common to use specialist code consultants for this work on medium to large or unusually complex projects. But the mere presence of a code consultant does not alleviate other team members of their professional and legal responsibilities, so it is important to understand the code consultant's work and verify that it is correct. Ultimately, no one (licensed or not) should agree to do anything on a project that is believed to be less than 100% code compliant. The risks are simply too great to take such actions. (See Chapter 3 for more discussion of liability issues.)

Once the applicable provisions have been identified, it is vital to build them into the design from the very beginning—the beginning of space planning or design before

anything has been put "on paper" or "in the computer," as the case may be. This is especially critical for provisions that affect the space plan: widths of aisles, corridors, stairs, and doors; sizes of accessible restrooms and bathrooms, and so on.

As projects proceed through greater and greater development, there should be additional periodic checks to

- Re-verify requirements before a final space plan is published
- Re-verify requirements at an early point in the construction documents phase
- Re-verify requirements again before construction documents are published

During plan review (whether done by local or state officials), it is common to have disagreements about code provisions (which is covered in Chapter 3), so interior designers should be prepared to respond to challenges from the reviewing officials, which could require significant plan changes. Occasionally, changes in mechanical, electrical, or plumbing systems are needed.

The lesson that should be taken from the plan review is that plans should not be worked out so carefully that it's impossible to make changes to accommodate varying interpretations. Having said that, it is also impossible to know what an interpretation could be that might lead to such a problem, but it is still necessary to recognize that unexpected things happen all the time.

1.2.2 PROJECT SCHEDULES

Ultimately, someone has to file most projects (every jurisdiction has a few exempt projects) for official plan review and for construction permitting. The procedures involved vary widely from one jurisdiction to another, but it is usually true that contractors file for construction permits and that either designers or contractors file for plan review. Figure 1.1 shows an "Application for Construction Design Release" document for the state of Indiana. This form is filed by a designer (interior designer, architect, or engineer) in person at the agency's office or electronically and the fee is paid at the time of filing. The review process usually takes a few weeks or so and that time must be built into the project schedule. In Indiana, the contractors may not file for local construction permits until after the state issues the "Construction Design Release" document; see Figure 1.2.

In some jurisdictions, especially those having local plan review, this is often a combined process (plan review and permitting together) and the filing is done by the contractor(s). The length of time required to obtain a construction permit varies widely as well, from a few hours to days, weeks, and even months. Again, this time must be planned into the project schedule to the greatest extent feasible.

1.3 Team Dynamics and Professional Courtesy

For many small and/or simple projects, interior designers work alone, completing the entire project themselves (in conjunction with a licensed interior designer or a registered architect who will certify the construction documents). This would include simple mechanical (e.g., relocating diffusers), electrical (lighting and power devices), and plumbing (fixture replacement and occasional new fixtures) work as well, but that depends on the specific requirements in each jurisdiction. Some jurisdictions require the involvement of engineers for the smallest projects.

APPLICATION FOR CONSTRUCTION DESIGN RELEASE

☐ **STANDARD** / ☐ **PARTIAL**

☐ **FOUNDATION REQUEST**

State Form 37318 (R13 / 8-99)
Approved by State Board Of Accounts 1999

PLEASE PRINT CLEARLY

PROJECT LOCATION (Must Be Complete and Accurate)

Name of Project		Closest intersecting street or road	
Address *(site location, number and street)*		Suite or Floor	Direction FROM intersection TO project ☐ North ☐ South ☐ East ☐ West
City	County	Is project within city limits? ☐ Yes ☐ No	Is building State owned ☐ Yes ☐ No

OWNER'S CERTIFICATE (Must Be Executed)

As owner of the project for which this application is being filed, I hereby certify:
1. The description of use and information contained on this application are correct:
2. The project will be constructed in accordance with the released documents and applicable rules of the Fire Prevention and Building Safety Commission:
3. Any changes to the released documents will be filed with the Indiana Department of Homeland Security, Division of Fire and Building Safety, Plan Review Branch.

Authorized signature	Name of owner or business		
Name *(typed or printed)*	Address *(number, street, PO Box if applicable)*		
Title	City, State, Zip Code		
Telephone Number:	Fax Number:	E-Mail:	Facility use:

Foundation Requested — I agree to take full responsibility for removing and replacing any construction found by plan examination or by inspection, to be in violation of the building codes. I further agree not to proceed with above grade construction until the complete building plans and specifications have been reviewed and released by the Indiana Department of Homeland Security, Division of Fire and Building Safety, Plan Review Branch.

DESIGN PROFESSIONAL CERTIFICATE
(Must Be Executed for all new buildings or additions exceeding 30,000 Gross Cubic feet or any alteration affecting Structural Safety)

As the design professional for the project for which this application and plans are being filed, I hereby certify:
1. I am qualified and competent to design such buildings, structures, and systems;
2. the plans filed in conjunction with this application were created by me and / or by persons under my immediate personal supervision and will comply with all applicable building laws and rules of the Commission.
3. the project data contained on this application is correct and corresponds with the plans that are being filed in conjunction with this application:
4. the design professional identified below or a designee will inspect the construction covered by this application at appropriate intervals to determine general compliance with the released documents and applicable rules of the Commission and will cause all noted deviations from released documents and code violations to be corrected or notify the owner and authorities having jurisdiction of all specific deviations and code violations: and
5. I affirm under penalty of perjury that the representations contained herein are true and I further understand that providing false information constitutes an act of perjury, which is a Class D felony punishable by a prison term and a fine of up to $10,000.

Responsibility is for the following systems: ☐ Site ☐ Foundation ☐ Structural ☐ Architectural ☐ Mechanical
☐ Plumbing ☐ Electrical ☐ Fire Suppression ☐ All Above ☐ Other *(specify)* _____

Signature	Name of firm *(if applicable)*	
Name *(typed or printed)*	Address *(number, street, PO Box if applicable)*	
Indiana Registration Number: ☐ Architect ☐ Engineer	City, State, Zip Code	
Telephone Number:	E-Mail:	Fax Number:
Designated Inspecting Design Professional:	Indiana Registration Number:	Telephone Number:

STANDARD FILING FEE	PROCESSING	PARTIAL	FOUNDATION	INSPECTION	LATE FILING	TOTAL

IF MULTIPLE DESIGN PROFESSIONALS ARE INVOLVED IN THE CERTIFICATION PROCESS, SUBMIT AN ADDITIONAL PAGE 1 WITH THE APPROPRIATE INFORMATION.

FIGURE 1.1A Indiana ACDR, page 1

Why Is Code Language so Difficult? 5

PROJECT DATA
(to be completed by submitter) *Please answer all pertinent questions*

FOR OFFICE USE ONLY	
SBC project number	Filing date

DOCUMENTS REQUIRED FOR FILING

1. One Application for Construction Design Release, together with correct filing fees. *(See Fee Schedule)*
2. One complete filing (paper or e-mail). This filing will not be returned to the applicant. A set of drawings identical to those released by the Indiana Department of Homeland Security, Division of Fire and Building Safety, Plan Review Branch, shall be maintained on the project site. Weight limit of each submitted package is 30 pounds.
 A. Site plan showing dimensioned location of building to all property lines and to all existing buildings on the property, as well as width of any streets, access roadways or easements bordering the property.
 B. Foundation and basement plans and details.
 C. Dimensioned floor plans for all floors.
 D. Fire and life safety plan showing graphically or by legend the location and rating of building elements such as area separation walls, smoke barriers, fire-resistive corridor walls, stair enclosures, shaft enclosures and horizontal exists.
 E. Wall elevations of all exterior walls including adjacent ground elevation.
 F. Sections and details of walls, floors and roof, showing dimensions, materials.
 G. Structural plans and elevations showing size and location of all members, truss designs showing all connection details, and stress calculations.
 H. Room finish schedule showing finishes for walls, ceilings and floors in all rooms, stairways, hallways and corridors.
 I. Door schedule showing material, size, thickness and fire-resistive rating for all doors.
 J. Electrical plans, diagrams, details and grounding of service entrance and power or lighting information required for energy conservation.
 K. Plumbing plans showing location of fixtures, risers, drains, and piping isometrics.
 L. Mechanical plans showing location and size of ductwork, equipment, fire dampers, smoke dampers and equipment schedules showing capacity.
 M. Fire protection plans showing type of system, location of sprinkler heads, standpipes, hose connections, fire pumps, riser and hanger details.

PROJECT DESCRIPTION *(Must Be Complete)*	FLOOR AREAS	ESTIMATED COSTS
Scope of work: ❒ New building ❒ Addition ❒ Remodeling	Total existing *(if applicable)* Sq. ft.	
Is this construction the result of fire or Natural disaster? ❒ Yes ❒ No \| Sewer : ❒ Existing ❒ Proposed ❒ Public ❒ Private ❒ None	Addition *(if applicable)* Sq. ft.	Addition *(if applicable)* $
Fire suppression system in building ❒ Full ❒ Partial ❒ None \| Detailed suppression system plans/specs ❒ Provided ❒ To follow	Remodeled *(if applicable)* Sq. ft.	Remodeling *(if applicable)* $
If partial, specify where* \| Located in flood plain (check county plan commission) ❒ Yes ❒ No	Total building area square feet	Total project cost $
Building construction type and occupancy classification \| Building height *(stories)**	Number of buildings this submittal *(Describe if necessary)**	Volume cubic feet (Fee category E only)
Indiana rehabilitation standard *(Rule 8)* used? ❒ Yes ❒ No \| Evaluation documents provided? ❒ Yes ❒ No	Use of conversion rule *(Rule 13)* proposed? ❒ Yes ❒ No	
Does project include: *(Check if yes)* ❒ Elevator or lift ❒ Combustible fibers storage ❒ Fireworks storage ❒ Explosives storage ❒ High-piled storage ❒ Boiler or pressure vessel ❒ Hazardous or flammable materials storage		
Describe proposed use of facility IN DETAIL including types of flammable or combustible materials stored or handled *		
Describe IN DETAIL previous or current use of facility *(if existing facility)**		
		Number of persons employed (max/shift)
General comments*		Number of persons *(public)*

GENERAL INFORMATION

Has work at this location ever been filed? ❒ Yes ❒ No ❒ Unknown	Does project include use of a master plan design release or a factory built modular or mobile structure? ❒ Yes ❒ No		
What year and month?	Previous SBC Project Number	Name of Manufacturer	Master Plan / Modular Number
Has construction started? ❒ Yes ❒ No	If yes, has notice of violation or investigation been issued? ❒ Yes ❒ No		If no, probable construction starting date?

NOTE: USE SEPARATE SHEET IF ADDITIONAL SPACE IS REQUIRED.

FIGURE 1.1B Indiana ACDR, page 2

CONSTRUCTION DESIGN RELEASE
State Form 41191 (R9/5-98)

Report Printed on:

Indiana Department of Homeland Security
DIVISION OF FIRE & BUILDING SAFETY
PLAN REVIEW DIVISION
402 W. Washington St., Room E245
Indianapolis, IN 46204

To: Owner / Architect / Engineer

INDIANA 02
F
S 0000
HOOSIER SAFETY
Available At Your Local Licence Branch
SUPPORT HOOSIER SAFETY

Fax & e-mail:

Project number		Release date
Construction type		Occupancy classification
Scope of release		
Type of release		
Project name		
Street address		
City		County

The plans, specifications and application submitted for the above referenced project have been reviewed for compliance with the applicable rules of the Fire Prevention and Building Safety Commission. The project is released for construction subject to, but not necessarily limited to, the conditions listed below. THIS IS NOT A BUILDING PERMIT. All required local permits and licenses must be obtained prior to beginning construction work. All construction work must be in full compliance with all applicable State rules. Any changes in the released plans and/or specifications must be filed with and released by this Office before any work is altered. This release may be suspended or revoked if it is determined to be issued in error, in violation of any rules of the Commission or if it is based on incorrect or insufficient information. This release shall expire by limitation, and become null and void, if the work authorized is not commenced within one (1) year from the above date.

CONDITIONS:

Note :(A1A & A1B): In accordance with the affidavit sworn under penalties of perjury in the application for construction design release the plans and specifications filed in conjunction with this project shall comply with all of the applicable rules and laws of Fire Prevention and Building Safety Commission. Providing false information constitutes an act of perjury, which is a Class D felony punishable by a prison term and a fine up to $10,000.

In accordance with Section 19 of the General Administrative Rules (675 IAC 12-6-19) a complete set of plans and specifications that conform exactly to the design that was released by the office of the state building commissioner shall be maintained on the construction jobsite as well as a copy of the design release.

4G0412AC	No addition or alteration shall cause an existing building, structure, or any part of the permanent heating, ventilating, air conditioning, electrical, plumbing, sanitary, emergency detection, emergency communication, or fire or explosion suppression systems to become unsafe or overloaded under the provisions of the rules of the Commission for new construction in accordance with 675 IAC 12-4-12(c).
4G0412AF	No addition, alteration, or repair shall reduce existing exit capacities to less than that required under the provisions of the rules of the Indiana Fire and Building Safety Commission for new construction in accordance with 675 IAC 12-4-12(d).
4G0603AE	Detailed plans and specifications of the fire suppression system shall be filed with the required application and appropriate fees in accordance with 675 IAC 12-6-3(a) and 675 IAC 13-1-8. (N.F.P.A. 13)
4G0615A	This is a partially submitted and released project. Subsequent submittals shall be accompanied by a completed standard / partial form (ACDR) and proper fees in accordance with 675 IAC 12-6-15(c).
4G0603AG	This release does not include electrical, mechanical, and plumbing work. Plans and specifications for adding or remodeling these systems shall be filed as a new project or as one or more partials before commencing work on those systems in accordance with 675 IAC 12-6-3.
3B0306A	Buildings classified as F-2 Occupancies shall be in accordance with Section 306.3 (675 IAC 13-2.4).
3B0306C	This project has not been designed to accommodate high-piled combustible storage as defined in Section 2302.1, IFPC (675 IAC 22-2.3).
3B0705C	One or more fire walls are being provided for the purposes of allowable area and minimum construction type in accordance with Section 705.1, IBC (675 IAC 13-2.4)
3B0714A	Openings in fire walls shall be protected with fire-rated assemblies in accordance with Section 714, IBC (675 IAC 13-2.4).

FIGURE 1.2A Indiana CDR, page 1

Why Is Code Language so Difficult? 7

ELECTRONICALLY FILE YOUR PROJECT WITH STATE OF INDIANA at http://www.in.gov/dhs/fire/branches/plan_review/index.html.
This on-line filing is through a secure site, you can use it to submit your project information, pay the fees and upload your project plans.

Please be advised that if an administrative review of this action is desired, a written petition for review must be filed at the above address with the Fire Prevention and Building Safety Commission identifying the matter for which a review is sought no later than eighteen (18) days from the above-stated date, unless the eighteenth day falls on a Saturday, a Sunday, a legal holiday under State statute, or a day in which the Department of Fire and Building Services is closed during normal business hours. In the latter case, the filing deadline will be the first working day thereafter. If you choose to petition, and the before-mentioned procedures are followed, your petition for review will be granted, and an administrative proceeding will be conducted by an administrative law judge of the Fire Prevention and Building Safety Commission. If a petition for review is not filed, this Order will be final, and you must comply with its requirements.

Filed By	Code review official	Code Enforcement & Plan Review Branch Director
Address (name,title of local official,street,city,state and ZIP code		
		State Fire Marshal
Fax & e-mail:		

FIGURE 1.2B Indiana CDR, page 2

8 Chapter 1

For larger and/or more complex projects, interior designers usually work in teams with other professionals: code consultants, engineers (civil, structural, mechanical, electrical, and plumbing), architects, acoustics consultants, lighting designers, elevator consultants, audio/video consultants, liturgical consultants, owner's representatives, program managers, construction managers, and others. The most important word here is *team*, and team should be defined as a group of professionals working together on the owner's behalf. Even if the interior designer is leading the project (which is very common), the other professionals are not mere supporting players. Instead, they are equal partners, and the approach should be to foster strong communication and collaboration to achieve the best possible result given the specific circumstances of the project. It is important to recognize the professional expertise of all team members and to act accordingly. Conversely, it is inappropriate for other team members to try to push around interior designers just because they think that they can. Interior designers should be as professional as they can be, and code knowledge is a large part of professionalism in the practice of architecture, engineering, and interior design these days.

Should a situation arise where there is a disagreement, the party having the highest degree of liability should make the ultimate decision. For example, the interior designer and the architect bear primary responsibility for building code compliance, and a mechanical, electrical, or plumbing engineer should defer to the interior designer or architect regarding interpretations of the building code; similarly, the interior designer and architect should defer to the electrical engineer regarding interpretations of requirements for the fire alarm system, which is within the electrical engineer's realm of primary responsibility.

summary

The simplest way to do any design project is for a single individual to complete all aspects of the work: meet with the owner and do the programming, space planning, interior design, construction documents, and construction administration—by himself or herself. This does still happen more often than one might think, mostly by architects who work alone or in small practices. But for most projects, it is simply impractical for all of the work to be done by one person (even if a single individual is qualified to do all of the work, which is rare), so teams are put together. These teams can consist of two individuals or dozens of individuals, depending on the size and complexity of the project.

It is vital for interior designers to be effective team players, taking on appropriate responsibilities and responding to valid input from other team members as the project progresses. This includes code knowledge and the incorporation of code requirements into the progressing design. This also includes basic professional courtesy.

But first, and foremost, it is critical to get into the habit of doing thorough code research at the outset of each project. If a code consultant is brought in, it is necessary to work directly with that consultant to develop an approach that is acceptable to all parties involved, including other team members where applicable.

And, finally, as the project proceeds, it is critical for the interior designer to incorporate all code requirements into the project from the beginning to the end.

results

Having completed this chapter, the following objectives should have been met:

1.1. To understand the challenges of typical code language by grasping the importance of language and the necessity of careful reading.

1.2. To understand the practical effects of codes on interior design practice by knowing code provisions in general, knowing why and how to do code research, and by knowing the potential effects of plan review and permitting on project schedules.

1.3. To understand team dynamics and professional courtesy in interior design practice by knowing that teams function best when all team members have professional respect for all other team members.

What Are Codes?

objectives

2.1. To define *law* and understand its application in the practice of interior design.

2.2. To define *regulation* and understand its application to the practice of interior design.

2.3. To define *standard* and to understand its application to the practice of interior design.

2.4. To define *code* and understand its application to the practice of interior design.

2.5. To understand that codes are minimum requirements.

2.6. To understand the basic history of codes, regulations, and standards in the United States, and how that history affects the practice of interior design.

2.7. To understand the development of model codes and their use in the practice of interior design.

2.8. To understand the code adoption process, in general terms, and how that affects the practice of interior design.

2.1 What Is a law?

In the United States, legal issues pervade the construction industry in general and interior design practice in particular. Everything that is done is governed by law, code, standard, and/or contract, so it is vital to begin with a basic introduction to the non-design aspects of the subject, beginning with the governmental structure of the United States.

The government of the United States is a federal system that has national (federal), state, and local (county, parish, township, city, town, village, etc.) components. Although these three levels of government are intertwined in certain ways, they are actually highly independent. Because the U.S. Constitution provides no enumerated powers for Congress or the president to regulate building construction, the federal government has no authority to make building rules and does not do so. Yet numerous federal laws affect how many different facilities are designed and built, from accessibility regulations under the Americans with Disabilities Act to workplace safety regulations enacted and enforced by the Occupational Safety and Health Administration (OSHA). That these regulations affect building construction does not make them "codes," even though they are applicable to certain projects due to different legal mechanisms. Building rules are entirely within the province of each and every state, and each state has determined, individually, how to regulate building design and construction in that state. These regulations vary widely from state to state. Here are three examples—

Centralized State: In a centralized state, all authority rests in the central state government, and localities are limited in their authority. In most centralized states, enforcement (on-site inspection) is usually done by local authorities, and all other activities (code adoption, plan review, variance approval, etc.) are done at the state level.

The state of Indiana provides a good example of a centralized state. In Indiana, building rules are enacted and enforced by the Indiana Department of Homeland Security, via the Division of Building Services. Plan review is done by the Plan Review Section of the Division of Building Services at the state capitol in Indianapolis, and on-site inspection is done primarily by local authorities. (The state has on-site inspectors, but they are usually called in only for special situations and in the few instances when there is no local inspector.) In recent years, Indiana has allowed local rules to be enacted by counties, cities, and towns if, and only if, those rules are reviewed and approved by the State Building Commission (within the Division of Building Services). Few such rules have been approved by the commission to date; when they have been approved, they are usually essentially the same as the state's rules. This is true mostly because the commission looks negatively upon rules that vary substantially from the state rules. Given that the state and local rules are nearly the same in most cases, the primary reason for having local rules appears to be enhanced local enforcement, mostly through local plan review. (That localities consider this appropriate or necessary is a negative statement about the effectiveness of the Division of Building Services, particularly the plan review process—or lack thereof some would say. There is much that can be said about this state versus local turf war of sorts, but none of that is essential to the broader subject of this book.)

Local (Decentralized) State: In a local state, all authority rests with local officials and there is little or no state involvement. The requirements for individual localities vary widely, and such entities often use combined plan review and construction permitting processes. On-site inspection will be done locally. (In 1992 the federal government complicated this when the Energy Policy Act was enacted into law. The 2002 EPAct update required each state to adopt a statewide energy code at least as restrictive as the requirements of ASHRAE 90.1-1999 no later than July 2004, at the risk of losing federal funding. That's difficult to do for a state that has no central building rules.)

Illinois provides a good example of a local (decentralized) State. Illinois has no statewide building rules at all, except for a recently adopted statewide energy code. In Illinois, all other building rules are local and they vary from county to county, city to city, and village to village. It has been observed that the statewide energy code is also widely ignored by local authorities.

Mixed State: In a mixed state, authority may rest with the state, locality, or both as the case may be. In mixed states, the local building department may be authorized (by the state) to handle the building code and the plumbing code but not the mechanical code or the electrical code—or any other possible combination. Obviously, this makes for the most confusing situation because projects may have to be filed for plan review with multiple agencies. Construction permitting would still be done locally in most cases.

Ohio is a good example of mixed state because it has a complex system of both state and local building rules. This means that plan review and enforcement for projects is done at the state level, at the local level, or some combination of both, even for a single project. Again, in Ohio, the state authorizes local enforcement (plan review and inspection). As an example, some county health departments are authorized to do plan review for the plumbing code and some are not; if the local

Plan Review

—The process whereby governmental authorities review construction drawings for compliance with applicable rules and regulations.

Inspection

—The process whereby governmental officials visit construction sites to verify compliance with applicable rules and regulations.

health department is not authorized to do plumbing code plan review (even if the local building department is authorized to do plan review for the building, electrical, and mechanical codes), that plan review is done by the state.

All jurisdictions in the United States will fall into one of these three categories: centralized state, local (decentralized) state, or mixed state. Although it may be somewhat more common for states to have more centralized than decentralized building rules, the uncertainties are such that the designer simply must verify the applicable building rules at the outset of every project. Verification should be done by contacting the local—yes, local—authorities (by phone, website, e-mail, etc.) and asking what the local rules are. If the locality is subject to state rules only, someone should simply say so. Once it is known what the rules are, it is then necessary to research them to make sure that all applicable provisions are identified and understood.

Verifying Codes

When contacting local officials to verify their current codes, simply explain that you are working on a project in their jurisdiction and that you want to be sure to respond to the correct codes. They will probably be happy to help.

It is also necessary to point out that the processes discussed here relate only to codes, narrowly defined. Numerous other regulations, especially for food service, health care, and schools could have completely different enforcement mechanisms.

So back to the original question: what is a law? Here is one basic definition:

LAW: an act written and adopted by a legislative body (federal, state, or local) and enacted by executive signature. Laws fall into broad categories of criminal and civil, and they are enforced by a number of different means, from the local police and prosecuting attorney to the FBI and the U.S. attorney general. All citizens are equally bound by the provisions of a law. (Laws are also called "statutes," "ordinances," "acts," and, unfortunately, "codes.")

2.2 What Is a Regulation?

Regulation: a document written or edited by a regulatory body (federal, state, or local), which is then adopted by a legislative body (federal, state, or local) and enacted by executive signature. Obviously, this definition is very similar to the definition of *law* given earlier, mostly because regulations *are* laws once they have been adopted and enacted. The difference between a law and a regulation is that a law is usually written directly by a legislative body (or the executive branch with or without outside assistance), whereas a regulation is usually written or edited by a technical administrative staff or some other group of "qualified experts." The regulation itself (or its enabling law) defines who and what are being regulated and how, so a regulation does not automatically apply to all citizens or activities equally. So regulations are a subset of laws that are adopted for specific purposes in specific situations. The rules of the federal Internal Revenue Service are regulations because they apply only to federal taxpayers; the food service rules of your local county health department are regulations because they apply only to individuals engaged in commercial food service in your county. Numerous other examples could be provided. Suffice it to say that there are extensive federal, state, and local regulations affecting many different activities virtually everywhere in the United States.

2.3 What Is a Standard?

Standard: a document written, edited, and adopted by a body of experts. The body of experts may exist within an industry (e.g., NEMA—National Electrical Manufacturers Association or AWA—the American Woodworkers Association) or it may be completely independent (e.g., UL—Underwriter's Laboratory or NFPA—National Fire Protection

Association). Clearly, Standards are *not* laws, unless they are adopted, usually by reference, by a legislative body and then enacted by executive signature. So even though NFPA calls their document 70 the "National Electrical Code," it is not in fact a code at all. It only becomes a code when a jurisdiction adopts it directly or by reference within another law or regulation. A standard could well be binding upon the membership of the organization that wrote and adopted it, but, in general, it would not be binding on anyone else.

2.4 What Is a Code?

Code: a building rules document written or edited by a regulatory body (state or local) that is then adopted by a legislative body (state or local) and enacted by executive signature. Obviously, this definition is nearly the same as the definition of *regulation* given earlier. This is true because codes *are* regulations; they are simply a subset of all regulations that refer only to building construction. Note that only state and local codes are possible; again, the federal government in the United States has no authority to enact direct building rules of any kind. Some entities—federal, state or local—may choose to call some or even all of their laws and/or regulations "codes." Even though this broad usage of the term "is somewhat different from the specific usage in this text, the distinctions made here among "law," "regulation," "code," and "standard" remain valid in the context of professional practice in interior design, architecture, and engineering. The basic point is that building rules (i.e., codes) are a special subset of regulations.

Why is it necessary to dwell on these similar definitions of these seemingly similar terms? Because these terms are widely confused in the industry, even to the point of being used interchangeably from time to time. The first lesson about codes is that enforcement officials (whoever and wherever they may be) can enforce the law, or regulation, or code only as it has been adopted and enacted. Enforcement officials never have the authority simply to make up new rules as they wish, although it is not all uncommon for officials to make such attempts. (Especially in locally controlled areas, this can be a real challenge. Local officials seldom have meaningful oversight, which can limit a designer's ability to have a valid discussion with such officials about reasonable interpretations. The lesson here is to contact such officials early in an attempt to identify unexpected rules at the outset of the project, to avoid later complications.) This can be made even more difficult when various codes and regulations conflict, which is most often seen between state or local codes and federal regulations. There is no simple answer to "what to do" when encountering such a conflict, but one can never ignore enforcement of building rules, which are directly tied to professional licensure, title registration, and ethics.

Verifying Appeal Procedures

If a conflict should arise, make sure to verify appeal procedures before jumping into a discussion with the AHJ. It may be difficult to find out exactly what the appeals processes are, but it is important to know before taking on an argument with an official. After all, there is no point in arguing at all if there is no practical appeal mechanism.

2.5 Codes Are Minimum Requirements

By definition, all building rules represent the minimum that is allowed. In other words, it may be desirable to do more than what the code requires, and it often is in many different situations and for many different reasons. But doing more than the code requires is merely desirable. It is not required, and anything above and beyond code requirements is therefore

legally unenforceable, no matter what it might be and no matter who wants it. Again, this doesn't mean that officials won't try to get more than what is required by the enforceable codes; it just means that one doesn't have to agree automatically (see Chapter 3, What Is Code Enforcement?). Here are two simple examples—(1) A local official told a contractor that a visual fire alarm device is required in a medical office's administrative office (at the check-in/check-out counters), despite the fact that "Bulletin #2: Visual Alarms," published by the U.S. Architectural and Transportation Barriers Compliance Board in July 1994 says that common-use areas (the areas where such devices are required) do not include areas used "solely as employee work areas." Bulletin #2 is considered the authoritative document in this area. (2) A local official required emergency egress lighting in all electrical rooms (even small closets) in a medical office building, despite the fact that such lighting is required only in spaces that are required to have two exits—a requirement that sometimes applies to large electrical rooms but virtually never to small electrical rooms.

2.6 Code History

From the earliest days of building design and construction thousands of years ago, inherent risks (e.g., fire, flood, earthquake, hurricane, tornado, structural collapse) have been recognized, if not fully understood. These risks fall into the two broad categories of *life safety* and *property protection*. The first category recognizes that there are risks to the occupants of building under emergency conditions (especially fire), and the second category recognizes the necessity of protecting the large financial investments that are required to build structures.

As a result of these risks, attempts have been made to require minimum standards in building construction since the Code of Hamurabi in the eighteenth century BCE. Early in the 1600s in New Amsterdam (now New York), laws were enacted to restrict roof coverings to minimize the risk of fires. What we would recognize today as a "building code" first appeared in the United States in the early years of the twentieth century.

These risks have also been affected by changing building technology. From prehistoric times until only 150 years ago or so, all buildings were constructed using masonry (stone, adobe, brick, and even unreinforced concrete in Roman times), mud, and wood because they were the only available materials. Stone, adobe, brick, mud, and concrete are highly fire resistant, but wood is highly combustible; numerous large-scale fires have occurred over time, especially in London, England, in 1666 and in Chicago, Illinois, in 1871. Some improvements were made after the London fire, especially widening of major streets to provide greater separation between buildings, but much remained the same. Even after the Chicago fire, little changed right away in terms of how buildings were constructed, largely because the available building technology limited improvements.

Iron was first used as a structural material in buildings in the early nineteenth century. Iron is noncombustible, meaning that it will not burn, but it is not fire resistant, meaning that it can soften, or even melt, under high temperatures, losing its strength and causing structural failure. Steel (iron plus carbon and other additives) was developed a few decades later, increasing structural flexibility and capacity, but not increasing fire resistance. Steel also can soften, and even melt, and fail under high temperatures (most recently demonstrated on a large scale in the September 11, 2001, attacks on the World Trade Center in New York City).

As cities and individual buildings grew, concerns about life safety and property protection grew in parallel. Multistory buildings have been built for thousands of years, but buildings higher than six stories (true high-rises) only appeared in the mid-1880s. The response to these concerns has been in two tracks: *building codes* and *professional qualifications*. Building code development started first, but professional qualifications will be covered first.

Life Safety

—The protection of life in buildings by preventing rapid escalation of emergencies and by providing adequate means of emergency evacuation.

Property Protection

—The protection of the physical fabric of buildings against structural collapse and damage from natural disasters, including fires and explosions.

Fire Resistance

—The ability of a material to resist fire spread and fire damage.

Until the early twentieth century in the United States, architects learned their profession mostly through professional apprenticeship but sometimes also through education. L'Ecole des Beaux-Arts in France was the earliest formal architectural school in the world, having started in the mid-seventeenth century as the Academies de Beaux-Arts. The first formal program in architectural education in the United States started at the Massachusetts Institute of Technology (then the Boston Institute of Technology) in Boston, Massachusetts, in 1865. But there were no requirements for architects to earn degrees from formal educational programs. One of the most famous architects of all time—Frank Lloyd Wright—attended a college for only one year, apprenticed with another great architect Louis Sullivan, and practiced in the United States and in other countries until 1959.

Nevertheless, more than 100 years ago, efforts began to "regulate" important professions, including medicine, law, architecture, and somewhat later engineering. Today, every state in the United States has professional licensing laws for registered architects and professional engineers, and the primary reason for such regulation is the "protection of the public's health and safety." (Indiana's Architectural Licensing Law, IC 24-4-1-17 says "The practice of architecture is the performance of professional services embracing the safe, healthful, scientific, aesthetic or orderly coordination of the planning, designing, erection, alteration or enlargement of any public or private building or buildings, structure or structures, project or projects, or any part thereof, or the equipment or utilities thereof.")

In recent years, interior designers have attempted to extend professional regulation to the practice of interior design, with somewhat mixed results. According to the ASID (American Society of Interior Designers) website, Alabama was the first state to regulate interior design in 1982 with a title act; in 2001, Alabama added a practice act. Florida was the first state to enact a practice act in 1994 (the title act was enacted in 1988); Nevada enacted a practice act in 1995, and Louisiana enacted a practice act in 1999. (Washington, D.C., enacted both title and practice acts in 1986.) As of mid-2009, four states (and Washington, D.C.) have practice acts, and 23 states (and Washington, D.C.) have title acts, but this is constantly changing and must be verified for each case. Title acts have no direct effect on practice, in the sense that such acts do not require, or allow, signing and sealing ("certifying") documents. The purpose of title acts is to identify and enforce minimum standards of practice alone, including controlling the use of the title. The primary difference between title acts and practice acts is document certification, which can be done only by licensed professionals (registered Architects, professional engineers, or sometimes licensed interior designers).

Typical licensing statutes use language that says, in effect, that licensed design professionals are required for all (well, most anyway) projects to ensure code compliance, among other things. Licensed professionals are required to "certify" that construction documents are code compliant. This is done by affixing a "seal" (a rubber stamp, which is often used electronically today) and a signature (also done electronically most of the time these days—but not everywhere and not all the time) to each sheet of the original drawings, before reproduction. In some localities, it is required to stamp and sign each sheet of individual copies of the drawings.

Meanwhile, building codes began to be better developed, usually spurred on by building disasters. An incident in Boston, Massachusetts, in 1942 at the Coconut Grove nightclub galvanized the movement to enact more effective building codes. In this disaster, 492 people died in a fire because there were inadequate exits from the large basement-level club, inadequate emergency illumination (as in none), and inadequate fire control systems (also as in none). It was understood before this disaster that risks rise rapidly as the number of occupants in any given space or building rises, and that the risks rise faster than the basic numbers may indicate. But there was little research available, so the standards of the time were estimates made from a nonscientific point of view. Little thought had been given to how many exits there should be, or where those exits should be located, or how someone would get out of the building once an exit was reached—what about upper floors? Floors below ground? What if an exit led out through a lobby or into a courtyard? Or fire protection of the structure? How long could a fire burn in a given situation before a structural collapse might occur? Or could a spreading fire block exits?

Title Act

—A law that regulates the use of a professional title; in the building design world, the most commonly regulated titles are "registered landscape architect" and "registered interior designer."

Practice Act

—A law that regulates the use of a professional title and which regulates the practice of that profession; in the building world, the professions most commonly regulated in this manner are "registered architect," "professional engineer," and, less commonly, "interior designer."

Given the fragmented nature of building regulation in the United States (remember: no federal building rules), over the next few decades, a number of different systems developed. Some of the largest cities—meaning New York and Chicago—had the resources and the desire to develop their own rules, and they did so. Some states wrote their own rules, but the technical expertise that is required to write good building rules is daunting and unavailable to most government agencies, even at the state level. And then some enterprising people found a way to begin the standardization process. For practitioners, one of the greatest challenges is inconsistent rules from one location to another, even within a state sometimes, and standardization has long been the goal of the building code development industry. So the model code was born.

2.7 Model Codes

The idea of a model code is to write a standardized document that can be adopted and enacted by multiple jurisdictions, such as states, counties, parishes, cities, towns, and villages, and model codes have done much to simplify and standardize code requirements in the United States. But it was a slow process, primarily because there wasn't just one group of people writing model codes. Over a period of decades, three dominant organizations emerged:

- ***Building Officials and Code Administrators International, Inc. (BOCA)*** BOCA documents were most widely used in the middle part of the country (except in Indiana, which was mostly an ICBO state).
- ***International Conference of Building Officials (ICBO)*** ICBO documents were most widely used on both coasts (and in Indiana).
- ***Southern Building Code Congress International (SBCCI)*** SBCCI documents were most widely used in the southeastern part of the country.

2.7.1 THE INTERNATIONAL CODE COUNCIL (ICC)

All three of these organizations published multiple model codes, including a building code, a plumbing code, and a mechanical code. NFPA's standard 70, *National Electrical Code,* actually dates back to 1897,[1] predating the model code organizations and most other building rules, and it is in use almost universally throughout the United States; hence, BOCA, ICBO, and SBCCI never published model electrical codes. Several decades ago, there was little interest in energy conservation in the United States, so these organizations either didn't publish energy codes at all, or they came along much later. As early as the late 1980s, all three organizations recognized that it was a problem to have three purported national (really international) standards; in the 1990s, they started talking about a merger. That merger took place in 1997[2] when the International Code Council was formed by a merger of BOCA, ICBO, and SBCCI. Since 2000,[3] only one family of model codes—the International Code series—has been published by the ICC.

So far, so good. Unfortunately, this doesn't mean that there really is only one typical set of rules.

First, the ICC revises its rules every three years, so there are 2000, 2003, 2006, and 2009 versions of the International Building Code (IBC).[4]

Second, when jurisdictions adopt the International Building Code, they tend to do so "with changes," meaning that they strike some provisions and add others; this means that the basic building code could be, and probably is, different in each and every individual jurisdiction, even if in only minor details.

Using the Right Codes and Amendments

A project cannot be designed without knowing the version of the basic model code and having the appropriate amendments for the jurisdiction of the project. It does no good to try to correlate the 2008 amendments to a 2003 model code, if the amendments are based on the 2006 version of the same model code.

Third, in the late 1990s (before the ICC issued the first version of the International Building Code), NFPA decided to offer its own model code. In 2002,[5] NFPA published the first version of NFPA 5000 *Building Construction and Safety Code 2003*, which is intended to be direct competition for the International Building Code. NFPA promotes its model code by noting that they use the only "open consensus-based procedures accredited by the American National Standards Institute."[6] Although it is true that ICC's procedures are not accredited by the American National Standards Institute (ANSI), those procedures are well developed and widely accepted. And the IBC is used virtually everywhere in the United States today. NFPA has since published 2006 and 2009 updates to NFPA 5000.

In addition to all of this, for many years, NFPA has published standard 101 *Life Safety Code*, which is widely misunderstood to be a competitor to the International Building Code and to NFPA 5000. As it says in its title, this standard is a life safety–only document, which omits many important building construction–related issues. The U.S. government has determined that NFPA 101 is applicable to all federal facilities, which they have every authority to do, as the projects' owner. That doesn't make it a "code" in any sense at all. It simply makes it part of the owner's requirements. In the past, especially before the ICC was created, there could be substantial conflicts between NFPA 101 and the old Uniform Building Code or the old Basic Building Code or the old Southern Building Code, but such conflicts have been greatly reduced in recent years.

NFPA 101 is also applicable to licensed health care facilities practically everywhere in the country, again largely due to federal policies regarding Medicare and Medicaid; again, this is an owner's requirements issue, and not a codes issue at all.

> **Is NFPA 101 Life Safety Code Applicable?**
> The Life Safety Code can cause significant complications (in emergency egress lighting, if nothing else—see Section 9.2.1 in this text) so it is important to confirm if it does, or does not, apply to the project in question. It could be required by the AHJ, by another government agency (especially for health care projects), or simply by the owner.

It is also necessary to keep in mind that adoptions of model codes happen after the model codes are published, and code adoptions by states and localities may or may not follow the "standard" three-year revision schedule for the model codes.

For example, as of May 2010, Indiana is using the following codes—

- 2008 Indiana Building Code, based on the 2006 International Building Code with 2008 Indiana Amendments.

- 2008 Indiana Mechanical Code, based on the 2006 International Mechanical Code with 2008 Indiana Amendments.

- 1999 Indiana Plumbing Code, based on the 1997 Uniform Plumbing Code (UPC) with 1999 Indiana Amendments. (The 1997 UPC was published by the now defunct ICBO.)

- 2009 Indiana Electrical Code, based on NFPA 70-2008 National Electrical Code with 2009 Indiana Amendments.

- 2009 Indiana Energy Conservation Code, based on ASHRAE 90.1-2007.

- 2008 Indiana Fire Code, based on the 2006 International Fire Code with 2008 Indiana Amendments.

- 2005 Indiana Residential Code, based on the 2003 International Residential Code with 2005 Indiana Amendments.

- 2006 Safety Code for Elevators, Escalators, Manlifts, and Hoists, based on ANSI/ASME (American Society of Mechanical Engineers) A17.1-2004 Elevator Safety Code, ANSI A10.4-2004 Personnel Hoists, ANSI/ASME A90.1-2003 Manlifts, ASME A18.1-2003 Platform and Stairway Chair Lifts and others with 2006 Indiana Amendments and several others. All of these vary from jurisdiction to jurisdiction and from time to time.

Generally speaking, agencies do not provide direct notice when codes change; it is usually necessary to contact the appropriate state or local officials to determine current codes, or that information is sometimes available on government websites (although not necessarily completely up-to-date).

The model codes include suggested adoption language, again in the interest of standardization, but such language is widely ignored (i.e., stricken by amendment) by adopting entities. The model codes also include suggested administrative (code official qualifications, plan review, site inspection, appeal, etc.) provisions, which are also widely ignored.

2.7.1.1 ICC Model Codes

As of February 2009, the ICC published the following model codes:

- ***The International Building Code (IBC)*** This is the all-purpose basic building code for everything except most one- and two-family dwellings, and it, or an earlier version, is used nearly everywhere in the United States. The most critical issues for interior design include building type, occupancy classification, occupant load calculations, egress (exiting) paths and methods, materials standards, and accessibility for the disabled.

- ***The International Electrical Code (IEC)*** This code provides only adoption and enforcement provisions, coupled with adoption, by reference, of NFPA 70-2008 National Electrical Code.

- ***The International Energy Conservation Code (IECC)*** This code is widely used, most commonly in the 2006 or the 2003 editions. Energy codes show the most extensive changes over the past 20 years or so, as larger-scale concerns have grown about energy efficiency and global warming. The IECC has a "dual-path" methodology, in which compliance can be achieved by using either one of two tracks. The first track is a prescriptive system spelled out in the IECC itself, and the second track is compliance with a document called ASHRAE 90.1-2007. ASHRAE is the American Society of Heating, Refrigeration, and Air-conditioning Engineers, and document 90.1-2007 represents ASHRAE's recommendations for energy conservation in commercial buildings. ASHRAE plays a major role in the International Mechanical Code as well and a similar role in the energy conservation and mechanical engineering worlds to the role that NFPA plays in the fire safety world, which means that it likes to present itself as the be-all-and-end-all of energy and heating, ventilation, and air-conditioning (HVAC) practices (as does the Illuminating Engineering Society [IES] for lighting issues), whereas, in fact, it is simply a well-established trade organization that publishes extensively. That said, most people in the design world believe in the general policies of NFPA, ASHRAE, and the IES.

- ***The International Existing Buildings Code (IEBC)***

- ***The International Fire Code (IFC)*** This code is widely used (the 2006 edition is the most common), mostly in parallel with the IBC.

- ***The International Fuel Gas Code (IFGC)*** This code is widely used, most commonly in the 2006 edition. This code governs the use of natural gas and propane in buildings.

- ***The International Mechanical Code (IMC)*** This code is widely used, most commonly in the 2006 edition, and it governs all aspects of heating, ventilating and air-conditioning (jointly with the International Building Code).

- ***The International Performance Code***

- ***The International Plumbing Code (IPC)*** This code is widely used, most commonly in the 2006 edition, and it governs domestic water, storm water drainage, and sanitary drainage and venting.

- ***The International Private Sewage Code***

- ***The International Property Maintenance Code***

- ***The International Residential Code*** This code is widely used, most commonly in the 2006 edition, for one- and two-family dwellings.

- ***The International Wildland-Urban Interface Code***

- ***The International Zoning Code***

Obviously, this is a tremendous amount of information; the IBC alone runs to 676 pages. But there is more, much more.

2.7.2 THE NATIONAL FIRE PROTECTION ASSOCIATION

The National Fire Protection Association was formed to promote fire safety in buildings early in the twentieth century. NFPA first published a pamphlet titled *Exit Drills in Factories, Schools, Department Stores, and Theaters* in 1912,[7] which was the precursor to the current NFPA 101 *Life Safety Code* and NFPA 5000 *Building Construction and Safety Code.* Today, NFPA publishes hundreds of standards, encompassing virtually all aspects of fire safety in buildings. Many of these documents are standards of the industry, and many have been adopted either directly or by reference by many state and local entities.

NFPA documents (and ICC documents to a somewhat lesser extent) are written in a unique style that many people find dense and sometimes nearly indecipherable. The basic numbering structure of this book—chapters (1), articles (1.1), sub-articles (1.1.1), and sub-sub-articles (1.1.1.1)—has been "borrowed" from the NFPA, at least in part to familiarize the reader with this structure. The ICC uses a similar structure in all of its model codes too. For the NFPA and ICC, this numbering scheme is taken to much greater lengths than it is here, where virtually every paragraph and item are numbered.

As noted in Chapter 1, the key to understanding the language is simply to realize that it means what it says, as precisely as possible. For example, if a list is preceded by "any of" or "some of" or "all of," the difference between these terms is critical, both for NFPA and ICC. Similarly, the difference between "must" and "may" is also key; *must* means that it, whatever it is, must be done with no exceptions, whereas *may* means that it, whatever it is, is optional.

In general, if one of these books doesn't say "all of the following," the list that follows is a list of options and not a list of requirements. After all, only "all" means "all," but it can still be challenging to ferret out the meaning of the language. This is made all the more difficult by backward or even circular citations within the documents. A paragraph in Chapter 10 of the IBC may reference a different paragraph in Chapter 7, which in turns references something in Chapter 5 and something else in Chapter 10. These paths, or threads, must be fully traced out to ensure that the meaning is fully understood. Specific examples will be provided in later chapters.

The International Building Code 2009 says the following about language:

"Selected terms set forth in Chapter 2, Definitions, are italicized where they appear in code text (except those in Sections 1903 through 1908 where italics indicate provisions that differ from ACI 318). Such terms are not italicized where the definition set forth in Chapter 2 does not impart the intended meaning in the use of the term. The terms selected have definitions which the user should read carefully to facilitate better understanding of the code."[8]

This paragraph numbering practice will be followed throughout this book in a simplified form, and the official definitions found in 2009 IBC Chapter 2 (or elsewhere) will be provided in the margins.

2.7.2.1 Key NFPA Publications

The following NFPA publications are critical to understanding requirements for typical interior design projects:

- ***NFPA 13-2007 Installation of Sprinkler Systems*** This document, or an earlier version, governs the installation of wet-pipe and dry-pipe fire protection sprinkler systems in most jurisdictions. Generally speaking, interior designers are not directly involved in the design of sprinkler systems. That said, it is useful to know where one can use certain types of sprinklers and what typical sprinkler spacing is under various circumstances.

- ***NFPA 13R-2010 Standard for the Installation of Sprinkler Systems in Residential Occupancies Up to and Including Four Stories in Height*** This document, or an earlier version, is used for the installation of wet-pipe and dry-pipe fire protection sprinkler systems in residential occupancies in most jurisdictions. This document allows for a lesser degree of sprinkler fire protection and is an alternative to NFPA 13-2007.

- **NFPA 13D-2010 Standard for the Installation of Sprinkler Systems in One- and Two-Family Dwellings and Manufactured Homes** This document, or an earlier version, is used for the installation of wet-pipe fire protection sprinkler systems in one- and two-family dwellings in many jurisdictions.

- **NFPA 70-2008 National Electrical Code** The National Electric Code (NEC) is one of the most dominant model codes in the United States, and it is used virtually everywhere (except New York and Chicago and possibly a few other places). Again, interior designers will rarely, if ever, be involved in engineering power systems, but it is useful to know about space and fire protection requirements in particular.

- **NFPA 72-2007 National Fire Alarm Code** This document, or an earlier version, governs the installation of manual and automatic fire alarm systems, including voice evacuation systems for high-rise buildings and other large facilities. Interior designers could potentially lay out locations for fire alarm devices, so it is necessary to understand the basic rules.

- **NFPA 99-2005 Healthcare Facilities** This document, or an earlier version, provides specific health care requirements in special situations. In states where the American Institute of Architects' (AIA) *Guidelines for Design and Construction of Hospital and Health Care Facilities* has been adopted, NFPA 99 will also be in effect because it is adopted by reference within the AIA document.

- **NFPA 101-2009 Life Safety Code** As previously discussed, this document, or an earlier version, governs life safety in projects funded by the federal government directly and in most licensed health care facilities. It may or may not be applicable to other projects in any given jurisdiction. Many people misunderstand that NFPA 101 is applicable everywhere, all the time, and that misunderstanding causes significant confusion. In particular, sales people are fond of saying that emergency egress lighting is governed by NFPA 101, but that is true if and only if, NFPA 101—as a whole—is applicable to the project under some specific criteria, as already noted.

- **NFPA 5000 Building Construction and Safety Code** Even though NFPA would like this document to become the standard model building code everywhere, there is little evidence that such an event will ever occur. The ICC is well established and the IBC in particular is extremely well established, and the IBC does represent the "future" of all three past model codes: the UBC, BOCA, and SBC. As such, it is familiar to nearly everyone, from architects to fire chiefs and from inspectors to contractors, and it has proven to be successful over the long term. The IBC alone is now onto its fourth major update, and that doesn't include several decades' worth of UBC, BOCA, and SBC updates before that. Nevertheless, comparisons will be drawn between the IBC and NFPA 500 throughout this book.

2.7.3 AMERICAN NATIONAL STANDARDS INSTITUTE (ANSI)

The American National Standards Institute (ANSI) is an independent body that sets standards in innumerable areas. The most critical area of concern for interior designers is accessible design. Starting decades ago, ANSI developed some of the earliest standards for "accessible" or "universal" design—in other words, what clearances and dimensions are required for disabled people—whether or not in wheelchairs—to use typical facilities, including building entrances, doors, stairs, ramps, corridors, and toilet and bathing facilities. When the Americans with Disabilities Act (ADA) was passed by Congress and signed into law by President George H. W. Bush in 1990 (enforceable beginning in 1992), ANSI had the most developed standards at that time. ADA is a civil rights law, which means that its scope is far broader than determining if a ramp or toilet room is "accessible," but it was necessary to define "accessible" for purposes of both new construction and for renovation of existing facilities. So it was decided to put together the ADA Accessibility Guidelines (ADAAG), which are essentially the ANSI standards of the time pulled into the ADA law. After ADA was enacted, most other jurisdictions (states and localities) eventually

adopted accessibility rules that closely resemble ADA's, with or without certain special provisions (such as the exclusion of religious facilities and the "dis-proportionality rule" for renovation of existing facilities). The dis-proportionality rule is a provision within ADA that limits the extent of required accessibility modifications in a renovation project (usually to 20% of the overall cost) so as to avoid being dis-proportionate; this was included to avoid having owners cancel projects to avoid making accessibility improvements. State codes rarely include such language.

Meanwhile, ANSI has moved on, and the latest version of its accessibility guidelines (now co-published with the ICC) is ICC/ANSI A117.1-2003 *Accessible and Usable Buildings and Facilities.* As an example, the 2006 IBC (and 2009 IBC) includes this document by reference as the basis of accessibility guidelines. ADA itself was updated in July 2010, and its requirements have been updated accordingly.

For federal or federally funded housing projects, the provisions of the Fair Housing Act Guidelines (FHAG, 1991) and/or Code Requirements for Housing Accessibility (CRHA, 2001) apply as well.

Finally, prior to the enactment of ADA in 1990, the federal government had already enacted the Architectural Barriers Act, which was accompanied by the Uniform Federal Accessibility Standards (UFAS). These requirements were updated in the 2006 Architectural Barriers Act (ABA) Accessibility Standards for Federal Facilities, replacing the old UFAS standards.

2.7.4 LICENSED HEALTH CARE, FOOD SERVICE, SCHOOLS, AND DAY CARE

In many, if not most, jurisdictions, additional regulations apply to some or all health care, food service, school, and day care facilities.

In health care in most jurisdictions, in-patient hospitals and outpatient surgery centers are licensed by some governing body. Licensing procedures are usually completely separate from code-compliance procedures, and differing rules usually apply. This is an area in which there is still far more inconsistency than in the basic building rules. There is no national equivalent to ICC or to NFPA in this area. The most widely used set of standards is the *Guidelines for Design and Construction of Hospital and Health Care Facilities*, as published jointly by the American Institute of Architects Academy of Architecture for Health, the Facilities Guidelines Institute, and the U.S. Department of Health and Human Services. The most recent version was published in 2006, but the 2001 version is more commonly used. This document in turn adopts various standards from ASHRAE related to heating, ventilating, and air-conditioning— critical systems in such facilities—and from NFPA (especially NFPA 99). Typical health care regulations, whether or not among the documents noted earlier, have numerous requirements that affect space planning (8′- 0″-wide corridors are usually required as are special rooms, such as soiled utility, clean utility, processing, and sterilizing, and room sizes are often controlled) and interior design (finish materials may be more restricted than in other project types).

Special Health Care Requirement

When working on a health care project, it is vital to determine state and/or local requirements prior to starting design, which may or may not include the common AIA Guidelines for Healthcare Facilities. It is also important to understand the reviewing agency's typical schedule because a long plan review time or a long field inspection time could extend a schedule by many weeks.

Special Food Service Requirements

When working on a food service project, it is vital to determine state and/or local requirements prior to starting design. It is also important to understand the reviewing agency's typical schedule because a long plan review time (plan review would be unusual in this area but it can't be ruled out) or a long field inspection time could extend a schedule by many weeks.

Special School Requirements

When working on a school (kindergarten through 12th grade) project, it is vital to determine state and/or local requirements prior to starting design. It is also important to understand the reviewing agency's typical schedule because a long plan review time or a long field inspection time could extend a schedule by many weeks.

Special Day Care Requirements

When working on a day care project, it is vital to determine state and/or local requirements prior to starting design. It is also important to understand the reviewing agency's typical schedule because a long plan review time or a long field inspection time could extend a schedule by many weeks.

Regulations for food service facilities are even less consistent, often relying on no recognized standards at all. Food service requirements are most commonly enforced on a local basis, but school and day care requirements are more often enforced on a state basis. In all cases, it is the designer's responsibility to determine what the applicable regulations are and to verify enforcement procedures.

2.8 Code Adoption

The typical code adoption process includes the following steps—

1. Identify the need for new regulations.
2. Write proposed regulations.
3. Conduct public hearings about the proposed regulations.
4. Modify the proposed regulations based on public comment (or not).
5. Adopt the proposed regulations via whatever process is required.
6. Set up regulatory administration (usually required for new regulations but not usually required for code adoption due to existing administrative practices).
7. Begin enforcement of new regulations.

Verifying Code Adoption Procedures

Each interior designer should become familiar with the code adoption and enforcement practices in his or her home area at the outset of his or her career. This should be updated periodically, and new research should be done in new jurisdictions whenever needed.

There is often little public awareness of much of this process, so it is important for individuals who are interested in new regulations to seek out information about proposed upcoming changes. This applies to all regulations, not just codes.

The reasons for adopting new codes vary widely; here are some examples—

1. Adopt a new energy code to prevent the loss of federal funding due to EPAct 2002.
2. Adopt a new plumbing code because it is no longer feasible to get interpretations for the old ICBO Uniform Plumbing Code.
3. Adopt a new building code just to stay current.

Many adopting entities have requirements for cost impact analysis for new regulations, which tend to slow down adoption of new rules, including codes.

Overall, regulatory adoption processes are open and public and any interested party can participate in the review and approval process at some level.

summary

Clearly, building rules are necessary to promote the public health, safety, and welfare, and someone has to take responsibility for complying with such rules. Those most directly responsible for compliance are the licensed professionals—registered architects and/or professional engineers (and licensed interior designers in Alabama, Florida, Louisiana, Nevada, and Washington, D.C.)—who certify documents, but everyone shares in the responsibility too. (Much more on that in Chapter 3.) Interior designers must have a solid basic understanding of these codes, regulations, and standards for at least two important reasons:

1. Basic professional knowledge—one can't do the job of designing residential and commercial interiors without a working knowledge of the applicable rules.
2. Basic professional ethics—one should not do the job of designing residential and commercial interior without a working knowledge of the applicable rules.

Fortunately, over the past few decades, the codes' picture has become much clearer, thanks in large part to the establishment of the ICC and the widespread adoption (with limited amendments) of several of the ICC model codes. Even if there are amendments from one jurisdiction to another, those amendments are unlikely to be so extensive as to invalidate the basic provisions of the model code. This is all to the good.

Before the year 2000, it was necessary to know, and to remember, that BOCA allowed for 50'-0"–long dead-end corridors, whereas the UBC allowed for 20'-0"-long dead-end corridors. Could one simply have done everything with 20'-0" dead-end corridors? Yes, but surely someone trying to save money might have pointed out the 50'-0" rule in the local area, potentially causing a minor, but embarrassing, problem. Conversely, if one worked primarily in a BOCA jurisdiction but took on a project in a UBC jurisdiction, and planned to use 50'-0" dead-end corridors, such a violation could have created a much larger problem.

Once the applicable rules are known, it is entirely up to the designer to make the project compliant—with all of them. That is a big part of what design professionals do, like it or not. So the sooner that one can develop a good understanding of the scope and meaning of the applicable rules, and the basic structure of those rules, the sooner one can spend more time designing beautiful, sophisticated, and successful projects.

Some of the most basic rules, such as exit separations, dead-end corridor length, corridor width, and so on, will become almost second nature, but it remains necessary to be vigilant for changes. Some rules haven't changed much in 30 years; others have disappeared completely, and yet others have appeared seemingly from nowhere. Codes, regulations, and standards all evolve over time, and it is most important to keep track of the changes, as they affect ongoing work. But it is not correct to assume that one should simply design to the most current version of each document. Just because the ICC published the 2009 IBC doesn't mean that every jurisdiction will immediately adopt the new version. Some jurisdictions may never adopt the newest version of some of these documents. And, on occasion, a new version removes requirements from a previous version.

Even though the general trend in building rules for a period of several decades has been for them to be tightened when they are revised, that is not always the case. Particularly, when the first IBC was issued, it represented a loosening of some of the previous model code requirements while tightening others. This was mostly due to combining the varying requirements of the previous three model codes.

Even though designers often focus more on how to get occupants into buildings and spaces—arrival, entrance, and path of movement—it is equally important (even more important really) to consider how to get those occupants out of the space or building under emergency conditions. Occupants tend to enter buildings one at a time or in small groups, but they tend to leave all at once in emergencies; this is why egress should take precedence. So, when designing ingress (entering) don't forget about egress (leaving). Also, it is necessary to remember that both ingress and egress get more complicated as the number of occupants increases, especially for egress. Then it is necessary to make sure that there is a safe means to leave the building, even after leaving a particular space; this relates to corridors, stairs, and other exit ways.

After basic life safety has been covered, it is appropriate to consider property protection. Larger and more heavily populated buildings require both more egress paths *and* more property protection. The increased property protection is required to provide for more time for egress, and for direct property protection. But, in a circular effect, a building having greater property protection (e.g., more or better sprinklers or generally higher fire resistance) may have somewhat less restrictive egress requirements. So these issues are all worked together to find the most appropriate, and affordable, balance of factors. Sometimes these issues will determine if a given building is five stories or six stories, or they may limit the size of the building footprint.

Uniquely to interior design (whether done by interior designers or architects), it is necessary to be very careful to understand and maintain these building-wide provisions when renovating interiors. It is easy to miss an existing exit way enclosure, or fire separation, especially if a facility has already been renovated without regard for such issues. First and foremost, it is unacceptable to decrease existing life safety and property protection under any modifications, codes or no codes. And the better goal is to increase both to the greatest degree possible.

One of the greatest challenges to code compliance is thoroughness. There are thousands of pages of rules and innumerable ways to create minor, even meaningless, violations, so many, in fact, that there are almost certainly existing problems in virtually every building everywhere, no matter what the rules may be. And the more times a given facility has been renovated, the more likely it is to see such problems.

In most, but not all, jurisdictions, requiring the correction of all existing problems is considered to be excessive and unreasonable, but this is a dangerous and tricky area to negotiate. Again, the first goal is not to decrease life safety or property protection provisions, and the second goal is to make improvements where that is feasible.

When a designer observes a problem in the field in an existing situation, it is necessary to bring that issue to the attention of the rest of the team: the architects, engineers, owners, and even the contractors in some instances. Ultimately, correction of existing problems may be the owner's decision, but the designer must be sure to make it clear that the he or she can accept no responsibility for an existing problem.

Finally, sometimes the authorities having jurisdiction don't see it the way that the designers do. Despite the great care that is taken, and has been taken, in the writing of these documents, interpretations can still vary (although misinterpretations are probably more common than truly different interpretations), so it is necessary to learn to deal with code enforcement. That is subject of Chapter 3.

results

Having completed this chapter, the following objectives should have been met:

2.1. To define *law* and to understand its application in the practice of interior design, by knowing that codes are a subset of regulations, which are a subset of laws.

2.2. To define *regulation* and to understand its application to the practice of interior design, by knowing that regulations are a subset of laws.

2.3. To define *standard* and to understand its application to the practice of interior design, by knowing that standards are law (or regulation or code) only when adopted by a legislative body as such and when enacted by executive signature.

2.4. To define *code* and to understand its application to the practice of interior design, by knowing that codes are regulations that are specific to the design and construction of buildings and that they are adopted only by state and local authorities.

2.5. To understand that codes are minimum requirements by recognizing that the regulations define the least that is acceptable in any situation.

2.6. To understand the basic history of codes, regulations, and standards in the United States, by knowing that codes are relatively new, although now very widespread yet still highly variable from one location to another.

2.7. To understand the development of model codes and their use in the practice of interior design, by knowing that model codes (particularly the ICC series) have greatly improved code consistency from one location to another.

2.8. To understand the code adoption process, in general terms, by knowing that codes are adopted by state or local legislative bodies and enacted by executive signature, thereby making them regulations, which are in turn laws.

notes

1. NFPA-70-2005 National Electrical Code, pages 70–1.
2. International Building Code 2009, page iii.
3. Ibid.
4. Ibid.
5. NFPA 5000 Building Construction and Safety Code 2009, pages 5000–1.
6. Ibid.
7. NFPA 101 Life Safety Code 2009, pages 101–1.
8. International Building Code 2009, page iv.

What Is Code Enforcement?

3.1 Federal, State, and Local

Code enforcement varies according to the code in question and the circumstances of its adoption. Since there are no federal building rules, there is no federal building code enforcement. But there is federal enforcement of the Americans with Disabilities Act (ADA; which is enforced only by the U.S. attorney general's office—but as a civil rights law, not as code per se), the Fair Housing Act (similar to ADA), and all other federal regulations. Because building rules are adopted and enacted by the states and/or localities, code enforcement is done by the states and/or localities through various mechanisms.

objectives

3.1. To understand the differing roles of federal, state, and local governmental units in code enforcement.

3.2. To understand who the "authority having jurisdiction" may be in a given situation.

3.3. To understand the code-review approval process and how conflicts can occur between multiple or overlapping jurisdictions.

3.4. To understand how the appeals process operates.

3.5. To understand code-compliance liability.

3.6. To understand typical code enforcement.

3.2 The Authority Having Jurisdiction

"Authority having jurisdiction" (AHJ) is the most important term in code enforcement, because it indicates who has the authority to determine what the code means and how it is to be enforced. The difficulty is that it is not always clear who the AHJ is any given situation.

Here's why—

In a state having centralized building rules, the ultimate AHJ is the state-level body that is designated, by law, as the AHJ. In such a state, all other officials must defer to this body when it comes to code interpretation and enforcement, or at least they are supposed to. The first complication is that there is a parallel structure in some but not all states, which is the Office of the State Fire Marshal. Typically, the State Fire Marshal is responsible for enforcing the fire code. The fire code is similar to, but not the same as, the building code in most jurisdictions. Here's one example to demonstrate the difference:

> The 2009 International Building Code (IBC) includes requirements for portable fire extinguishers in buildings in section 906, but all that this section says is to refer to the International Fire Code (IFC). The 2009 IFC requires portable fire extinguishers in all facilities, except those that are fully sprinklered and do not have special hazards. Special hazards include many different things, including commercial cooking equipment and use, storage, or dispensing of flammable or combustible liquids.

This parallel structure exists at the local level too, and that's where things get really confusing. Fire departments are usually based on county (or parish), city, or subcounty (town, village, or township) local government structure, and each jurisdiction has its own local fire marshal. Many of these local fire marshals consider themselves the AHJ, which is correct for the fire code but usually not correct for all of the other codes.

For all other codes, this is not correct because most counties, cities, and towns also have building departments of one sort or another that are authorized to perform field inspections to confirm code compliance. The local building department is the AHJ for all codes except the fire code in most jurisdictions. This does mean that there are at least two local AHJs virtually everywhere plus multiple state officials.

Finding the AHJ

As noted under Design Tip 13, it is very important to have a reasonably clear understanding of who the AHJ is in each jurisdiction, keeping in mind that it may be difficult to come to that clear conclusion. Over time, typical practices will become familiar, but young designers should look to their more experienced peers for this information early on.

3.3 The Approval Process

Nearly every jurisdiction everywhere requires some form of plan review prior to construction (usually) and field inspections during construction, so, on a real project, how is this done?

The procedures involved can vary from elaborate plan review–only applications to state authorities to simple combined plan-review-and-construction-permit applications at the local level. Multiple fees are likely to be involved too—fees for plan review at the state level (if applicable), fees for local plan review (if applicable), and several construction permitting fees.

Here's how it works in the state of Indiana—

The state of Indiana has made it illegal for localities to issue building permits without a "Construction Design Release" document from the State Plan Review agency, except for one-and two-family dwellings, some exempt agricultural structures, and some exempt very

How Are Codes Adopted?

Again, it is important to understand how the rules come about in a jurisdiction, especially one's home jurisdiction.

small projects. In order to obtain the Construction Design Release, someone (usually the certifying design professional—registered architect or professional engineer) files the project with the Plan Review Division and pays the required fee (see Figure 1.1). This fee is usually then reimbursed to the designer by the owner, if not paid directly by the owner. After some period of time (usually a few weeks), the State Plan Review agency issues the Construction Design Release usually with conditions (see Figure 1.2). If the State Plan Review agency sees too many problems to issue the release, it usually contacts the design professional directly to work out the issues, whatever they may be. (The Construction Design Release includes language something like this: "released for construction pending compliance with all rules and regulations." The agency takes no responsibility for code compliance whatsoever.)

The design professional then turns over the approved Construction Design Release document to the contractors, who then pursue local permits. During construction, the locality may, or may not, send out inspectors on a regular basis.

In some locations, at the end of construction the local AHJ (building inspector, fire marshal, or sometimes both) will issue a "Certificate of Occupancy," or another similar document, if the project is code compliant. This certificate allows the owner to occupy and use the facility. In other locations, such certificates are not issued at all.

In recent years, the state of Indiana has approved local codes at a few locations around the state. Starting in November of 2009, the City of Indianapolis/Marion County was the first local entity to require pre-permit local plan review and to collect associated fees. This local plan review is done in parallel to the state's plan review. Prior to November 2009, the City of Indianapolis/Marion County completed local plan review after permits had been issued for projects. This was problematic because it is always more difficult, and usually more costly, to make changes after construction has started.

And there's more. In at least one township within the City of Indianapolis/Marion County, a local building code was written, adopted, and enacted by the township government in the 1980s. This code was never submitted to the state commission for approval, and it is therefore technically illegal and unenforceable. (This had never been addressed by the state of Indiana.) But the township fire department routinely reviews plans for all projects in the township, issuing its own violation letters totally separate from the state's Release of Design Construction or the city/county review process. So, for at least some projects, there can be multiple plan review processes and disputes with multiple officials. Although it is perfectly valid to resist the illegal township plan review letters, to do so risks irritating the officials who are attempting to enforce their local code (illegal though it may be). Fire officials (as separate from building officials) have the authority, in most cases, to close buildings and force evacuation (although they rarely use that authority), so arguing with them can raise serious concerns too.

This example points out the one and only advantage of all-local codes and code enforcement, which is that there is only one clear authority (unless there are issues among the local reviewer, inspector, fire marshal, and/or fire chief). The major disadvantage of all-local systems is that such local officials usually have little to no oversight, which allows them to do whatever they want. This can mean that the written rules can be incomplete or inaccurate, because the official can, and will, change them at will. This exposes the design professional to much uncertainty, and it can expose the project to extensive unknown costs—both of which can be big problems.

There can be more officials too. In addition to fire marshals, there are fire chiefs in every fire department, no matter how small (even for volunteer fire departments), and some of those fire chiefs have been known to consider themselves the AHJ. Larger fire departments sometimes have fire inspectors in addition to the fire marshal, and they might consider themselves the AHJ. Fire inspectors should answer to either a fire chief or a fire marshal, however. And the local building department could have a building commissioner (most common in cities and towns) as well as building inspectors. Usually, if there is a building commissioner, the local building inspectors would answer to the building commissioner, which means that the building commissioner could delegate AHJ authority to the building inspector(s) but might not.

What does all of this mean for a practicing interior designer? It means that it is vital to design the project in full compliance (to the greatest degree possible) with all applicable

codes, so as to minimize any potential conflicts with enforcement authorities. It also means that it is necessary to learn how to deal with conflicts with enforcement authorities, which are nearly inevitable, given the scope and complexity of the rules involved.

3.4 The Appeal Process

So what should a designer do when faced with an AHJ who claims that there is a violation on a project? Here is one suggestion for a step-by-step process—

1. Verify the code language in question. In other words, make sure that the official's accusation is clear. Make no mistake—this is a legal accusation, so it should be taken very seriously. If the accusation is in writing, it should be clear right away what the problem is. If it is verbal, which happens often on job sites, it is necessary to get the language from the official. This should be done by asking for it, and insisting (nicely and politely) that it is necessary for the official to provide the specific code citation. (In the case of verbal citations, this will often mean that there will be no further citation. Many such citations are mere bluffs with which the official is trying to get something that is not required, and a simple request to verify the citation will often result in no further comment from the official.)

2. Understand the language in question. Read the citation carefully, and compare the cited language to the code (whichever one it is) as it is understood and as it applies to the project. It may seem to be unnecessary to compare the language to the code in question, but officials have been known to "cite" non-code language. Obviously, if the language is not in the code in question, it cannot be enforceable on the project.

3. Determine if the local official is correct. It is not necessary to agree with everything officials say. They are often wrong, and it is the designer's professional responsibility to meet code requirements, not to exceed them "just because" someone wants that. At this point, the dispute should be discussed with everyone who cares about the issue, including the owner. If the designer is not confident to make a ruling, get another opinion—from the project's architect, a professional engineer, or an independent code consultant. If the design team's opinion is that the official is wrong, the official should be contacted—by telephone is acceptable—to discuss the issue. If the official is adamant about the interpretation, it may be necessary to pursue an appeal. If the design team decides that the official is right, then the designer is obligated to correct the problem, no matter what it is and no matter what it takes.

Appeals processes vary from location to location and could be simple or complex depending on the circumstances.

Understanding Appeals

Again, it is vital to understand the appeal procedures if a conflict should arise. It does no one any good to get in a losing argument with the AHJ.

4. Here is an example.

 In the state of Indiana, the first appeal is to get a written binding code interpretation (technically called a "non-rule policy") from the State Building Commissioner at the state Department of Homeland Security. If such an interpretation is obtained, and it disagrees with that of the local official, it should be presented to the local official, who should simply accept the higher authority of the state. If the local official resists (which is technically illegal but not all that uncommon), then further appeals may be necessary. If the opinion supports the local official, the designer is obligated to correct the problem, no matter what it is and no matter what it takes.

5. If the official resists the written opinion, two options may be available. First, it may be possible to obtain a "modification" from the AHJ, if the circumstances are such that a deviation from full code compliance could be considered reasonable and appropriate. This process usually takes at least six weeks in Indiana, so timing could be a problem. a modification is not an option (unnecessary or unobtainable for some reason), the only remaining option is to take the local official to an administrative law court, which

usually takes several months or longer. Because few owners can afford such a long delay, administrative law appeals are rarely used in Indiana.

What happens if an official refuses to accept good reasoning or even rulings from higher authorities? Unfortunately, it can become necessary to placate that misguided official by doing work on the project that is unnecessary. In situations like that, it is vital for the designer to track the process carefully, keeping the owner fully informed at all stages, so that the owner understands that he or she is being forced to do something that is out of the designer's control. This is important because the owner could well ask the designer to pay for changes in the project that are necessary for code compliance. Owners often think that way because their perspective is that they hired design professionals largely to ensure that they would not have such problems.

A note about modifications: code modification are usually used to avoid awkward situations or challenging circumstances that could prevent a project from being built.

Here are a few examples from the author's practice:

An Informed Owner

Keeping the Owner fully informed cannot be over-stated. Few designers have the equivalent resources (financial and/or legal) to many of their clients, so it is worth the effort to avoid major arguments with Owners—especially legal arguments.

Code Modifications

Modifications should be pursued when appropriate, but it must be kept in mind that they don't happen by themselves. They often require the involvement of a Code Consultant (who could charge hundreds or thousands of dollars in fees) and there is always going to be a fee to be paid to the agency in question. Owner's are not fond of paying for losing modification applications.

1. Reduce ventilation in the retail section of a new high-rise building. In order to reduce operating costs, construction costs, and physical problems with routing ventilating ducts in a new seven-story building, it was proposed to reduce the ventilation rate by approximately 2/3. To offset this obvious weakening of the ventilation system, it was proposed to use special high-performance filtration to reduce contamination in the air. The Indiana State Building Commission accepted this reasoning and approved the modification.

2. Reduce ventilation to interior rooms in apartments and condominiums. In order to reduce construction costs, it was proposed (by the design/build mechanical contractor) to eliminate direct ventilation of interior bedrooms (rooms having no exterior windows) in a large high-rise apartment/condominium building. The proposed offsetting factor, if any, is unknown, but the modification was not approved by the Indiana State Building Commission.

3. Install Ansul fire protection systems in kitchen hoods in a supermarket at +8′-4″above the finish floor. At the time (this is no longer the case), the Indiana Mechanical Code had a state amendment that required installation of hood fire protection equipment at or below 8′-0″above the finish floor. After some contentious debate, the modification was approved by a vote of 7 to 5. In this case, the original amendment was an arbitrary rule, and logic won out.

Many, many other examples could be provided, and modifications are granted (and denied) on a regular basis all around the country. Modification applications should be held to a minimum, but requests can be made when sensible and when there is reason to believe that the request will be granted. A modification application usually includes at least two parts: (1) a hardship (or why it is difficult or impossible to comply with the rule(s) as written) and (2) off-setting factors to minimize the impact of noncompliance with the rule(s) in question. A modification application without an off-setting factor is unlikely to succeed.

Back to the example—

In Indiana, the technical staff places modification applications into three categories prior to each hearing:

A. recommended for automatic approval
B. recommended for approval with discussion, and
C. not recommended for approval

It is a rare category C modification application that is approved. The difference between categories A and B is that the commission doesn't discuss category A modifications during the

hearing, and they are voted on as a group. At the beginning of the hearing, any one of the commissioners can move a modification request from category A to category B. The third example above (the Ansul kitchen hood example) was a category A modification that was moved by a commissioner to category B, due to the opposition of the local official (inspector). Modifications in category B are presented to the commission by an interested party (most commonly a code consultant) and a discussion follows among the commission, the presenter, and other interested parties present at the hearing. Following the discussion, the commission votes on the modification, which then either succeeds or fails (occasionally, a modification will be delayed until a future and hearing and no vote occurs).

3.5 Code-Compliance Liability

This process is especially critical for licensed design professionals (registered architects, professional engineers, and licensed or registered interior designers, depending on the jurisdiction) because they certify that their designs are code compliant. But what are code liabilities for everyone else? What about owners, contractors, non-licensed design professionals (including non-licensed interior designers), and even individual working men or women?

Primary code compliance actually falls, first and foremost, on the property's owner. But, as noted earlier, it is presumed that the owner has hired a professional design team to ensure code compliance, so the owner will routinely transfer all such issues directly to that design team. This does mean that the owner cannot resist a local official's demands for changes or additional work, even if incorrect according to the design team and other authorities, but it also does not prevent the owner from pursuing the design team for financial compensation.

Contractors are protected from code liability if, and only if, they build the project exactly as designed. If there is any deviation (a very dangerous term itself that is highly subject to dispute) from the design, the contractor could be fully liable for problems resulting from that deviation.

Non-licensed professionals—non-licensed interior designers, space planners, drafters, even administrative staff involved in projects—have no direct liability in most situations. But if there is a problem that results in litigation, the non-licensed professional's firm would almost certainly get tied into the case, which could greatly compromise the individual's employment security, if nothing else.

Code consultants are an interesting class of professionals. Many code consultants are not licensed professionals; in central Indiana, of the 10 or so working code consultants only three are licensed professionals: two registered architects and one professional engineer. As is the case for non-licensed professionals, there is no direct liability here, but these individuals would also almost certainly get tied into any litigation that might occur. That could lead to financial liability, damage to reputation, or both, any of which could be harmful to future business.

For working men and women in many trades, there is little to no direct liability, but some trades are regulated and require licensed workers, usually electricians and plumbers. In such cases, those licensed workers would bear significant liability for code compliance, as a product of their having a license.

General Code Knowledge

The need for Interior Designers to be knowledge about Code requirements cannot be overstated. Each individual simply must make the effort to learn the basic rules, to stay up-to-date with changes, and apply those rules on a day-to-day basis.

3.6 How Much Enforcement Is Out There?

This is a terrific question, and the answer is: it all depends. It all depends upon how motivated and how resourceful the AHJ is in any particular situation. In some jurisdictions, it is actually rather rare to see inspectors on commercial projects, although the recent trend seems to be

toward more, rather than less, enforcement. This is mostly due to the limited resources of the local building department, but it is also a matter of policy and budgeting for the local government. Largely due to the complexity of the rules, most building inspectors tend to be specialists, in that they may know the electrical code, or the plumbing code, or portions of the building code, but rarely more than one. So sometimes there is stringent enforcement of one code, weak enforcement of another one, and no enforcement of the rest.

Generally speaking, there is little detailed enforcement of the structural provisions of the building code anywhere except California, Florida, and New York City (maybe Chicago too). Detailed enforcement of the mechanical code is also rare, largely due to the highly technical issues involved. Certain provisions of the electrical code are strictly enforced in some locations, and there is virtually no enforcement in other locations. Plumbing codes seem to be some of the most often enforced, much of which grows out of the health issues involved. A few building code provisions for occupant load, egress (and sometimes emergency egress lighting), assembly occupancies, and air-plenum requirements are often enforced. Energy code provisions are frequently enforced, at least at the plan review level. Accessibility requirements tend to be widely enforced, largely due to the high profile of the issues since the enactment of ADA.

Air Plenum

—usually a space above a ceiling that is used for return air in the heating, ventilation, and air-conditioning (HVAC) system.

This only reinforces how important it is for design professionals to know the rules and to design accordingly because professional liability remains with or without government enforcement. Even if the inspectors attempted to enforce all of the rules, there really is no practical way to do so. Many systems are concealed during construction, and many issues are, or can be, concealed after construction. Sometimes, owners make unauthorized changes with no design professionals and with no permits. At the same time, it is also impossible for designers to verify full code compliance in the field, so they rely on the construction documents to communicate the requirements and to offer some protection if something is done differently in the field (see comments about contractor liability discussed earlier).

Whatever else is true, if a design professional sees a code violation in the field, it is absolutely necessary to raise the issue with the contractor(s) and the owner. The only option that is not available is to ignore the problem and blame someone else later.

It is vital to remember, at all times, that the primary purpose of the codes (and most regulations and standards) in the first place is the improvement of public health, safety, and welfare, so it is necessary to maximize compliance to the greatest degree feasible all the time, for every project in every location at every point in history.

Typically, code violations are considered civil crimes, but deliberate violations of codes can be construed as criminal offenses in some circumstances. Even without criminal penalties, civil penalties can be severe—fines, loss of business, loss of reputation, and loss of license for licensed professionals—and should be avoided if at all possible.

None of this means that all code provisions are created equally or that all provisions are equally important. Clearly, some rules matter more than others. But it is extremely difficult to know which ones are important and which ones aren't important without having extensive experience and deep and broad knowledge. And, even then, a local official could decide that a relatively unimportant provision is critical in his or her jurisdiction.

Here's one relatively simple example—

The building code dictates maximum rise for stair risers and minimum run for stair treads, minimum width of stairs, maximum variation between maximum and minimum rise, and the diameter and height of the handrail (among many other items). Clearly, all of those singular provisions are not equally critical. Handrail diameter is regulated because odd shapes and sizes can be difficult to grip, making it slightly more hazardous to climb or descend the stairs. But having two risers in the same stairs that are 3/8″ different in height is actually dangerous because it could cause people to fall, especially in emergency situations. Does this mean that one can ignore the handrail size provisions? No, but it means that the consistency of the risers is more important.

It is always necessary in design to address critical issues first—whether code related or not—and to move on to less significant issues. The worst thing that a designer can do is to get the color right and the life safety wrong. No one gets killed over bad colors and rarely does anyone get sued. But many lawsuits (and even some criminal prosecutions) have occurred in projects with poor life safety provisions, especially if a tragedy has occurred and lives have been lost.

summary

In many ways, enforcement is the most important aspect of codes. After all, are rules that are not enforced really rules at all? When it becomes known that a particular rule is not going to be enforced (either through experience or because someone actually said that it won't be enforced), that rule tends to get ignored. But such lack of enforcement doesn't mean that the rule doesn't exist or that it can't be enforced. Design professionals who work under the assumption that a rule won't be enforced are taking a serious risk.

Code enforcement is a good thing, but inaccurate code enforcement is a bad thing. Everyone on the team (the Owner, the design professionals, the code officials, the contractors, etc.) should be working toward the same goal: a facility that is built to required standards. If the Owner is willing to go beyond the required standards, that's perfectly OK, but the officials have no right to require compliance with anything beyond the adopted and enforceable language. This frustrates many enforcement officials, but that is the simple truth.

Designer professionals can, and should, make every effort to incorporate all applicable code requirements into their designs, and there is little to fear from officials under such circumstances. When an official does head off into the unknown, the design professional simply has to deal with the issues as calmly and professionally as possible. This does not mean that the design professional should automatically agree with everything an enforcement official ask for; far from it, in fact. Just as the design professional is legally obligated to follow the adopted and enforceable language, so is the code official. Both parties should be able to agree upon exactly what that means in a given situation. When that does not occur because the official is exceeding the adopted and enforceable language, unnecessary work is sometimes required. That's unfortunate but sometimes true.

results

Having completed this chapter, the following objectives should have been met:

3.1. To understand the differing roles of federal, state, and local governmental units in code enforcement, by knowing that the federal government is involved only in enforcing federal regulations (e.g., the Americans with Disabilities Act, the Energy Policy Act) and that all code enforcement is done by state and/or local authorities, depending upon the particular governmental structure at a given location.

3.2. To understand who the authority having jurisdiction (AHJ) may be in a given situation, by knowing that it could be a state or local official; a building commissioner, a fire marshal, or a fire chief; or a building inspector or a fire inspector. And by knowing that the AHJ could vary from one code to another, even at a single location.

3.3. To understand how conflicts can occur between multiple or overlapping jurisdictions, by knowing that boundaries of authority are not always clear-cut and that conflicts exist between various governmental units (such as between a fire marshal and a building commissioner).

3.4. To understand how the appeals process operates, by knowing that appeals are possible and that there is a "typical" process to follow. The specific process will depend upon the specific practices in place at a particular location.

3.5. To understand code compliance liability, by knowing that virtually everyone involved in a construction project bears at least some liability for code compliance, beginning with owners and licensed professionals (registered architects and professional engineers in most states and licensed interior designers in some states) and working down through the team to those least directly involved.

3.6. To understand typical code enforcement, by knowing that enforcement is inconsistent and selective, but that responsibility remains for the designer with or without governmental enforcement.

What Is Building Type?

4.1 Construction Type

Many years ago, certainly by the middle of the nineteenth century, it was understood that larger and more heavily populated buildings represented greater risks of both life and property loss. Since that time, a more nuanced understanding has developed, which is expressed directly in the construction type sections in the International Building Code (IBC) and National Fire Protection Association (NFPA) 5000. This more nuanced understanding links the type of construction—masonry, concrete, steel, or wood (protected or unprotected)—to the size of the structure and to the occupancy type (assembly, business, educational, hazardous, institutional, mercantile, residential, or storage, with various subcategories—to be covered in detail in Chapter 5).

Ricks factors include items far beyond the number of occupants (covered in Chapter 5) and type of the structure (covered here). Here are some other risk factors that come into play—

- Sleeping occupants
- Less-than-alert occupants (e.g., medicated patients in hospitals)
- Immobile occupants (e.g., some patients in hospitals or nursing homes);
- Extensive flammable materials (e.g., storage rooms, product displays), and even
- Noisy environments.

objectives

4.1. To understand "construction type."

4.2. To understand "fire resistance ratings."

4.3. To understand the effects of construction type and fire resistance ratings on the practice of interior design.

Fire-retardant-treated wood

—Even though this term is in italics in the IBC, the IBC offers no definition for it.

Exterior wall

—A wall, bearing or nonbearing, that is used as an enclosing wall for a building, other than a fire wall, and that has a slope of 60 degrees (1.05 rad) or greater with the horizontal plane.

There are five basic construction types in each code. The details are covered in Chapter 6, Types of Construction, in the 2009 IBC. The differences among the types are based on materials allowed and degree of fire protection that's required. The 2009 IBC says:

"602.2 Types I and II. Types I and II construction are those types of construction in which the building elements listed in Table 601 are of noncombustible materials, except as permitted in Section 603 and elsewhere in this code."[1]

"602.3 Type III. Type III construction is that type of construction in which the exterior walls are of noncombustible materials and the interior building elements are of any material permitted by this code. *Fire-retardant-treated wood* framing complying with Section 2303.2 shall be permitted within *exterior wall* assemblies of a 2-hour rating or less."[2]

"602.4 Type IV. Type IV construction (Heavy Timber, HT) is that type of construction in which the exterior walls are of noncombustible materials and the interior building elements are of solid or laminated wood without concealed spaces. The details of Type IV construction shall comply with the provisions of this section. *Fire-retardant-treated wood* framing complying with Section 2303.2 shall be permitted within exterior wall assemblies with a 2-hour rating or less. Minimum solid sawn nominal dimensions are required for structures built using Type IV construction (HT). For glue-laminated members the equivalent net finished width and depths corresponding to the minimum nominal width and depths of solid sawn lumber are required as specified in Table 602.4."[3]

There are seven subparagraphs under Type IV to provide details for columns, floor framing, roof framing, floors, roofs, partitions, and exterior structural members. There is no need to go into those requirements in any greater detail.

"602.5 Type V. Type V construction is that type of construction in which the structural elements, *exterior walls* and interior walls are of any materials permitted by this code."[4]

As noted under 602.2 Types I and II, Table 601 contains the detailed information to distinguish one type from another. Here is Table 601 from the 2009 IBC.[5]

The primary differences between the types are in the degree of fire protection that is required for various building elements.

What is fire protection for building elements? Fireproofing, to use an inexact word. Protecting steel means that the steel is completely enveloped in sprayed-on fireproofing (non-asbestos), intumescent paint (paint that expands under high heat to develop a protective foam covering), gypsum board, plaster, concrete, concrete masonry, or some more exotic system or material. This includes steel reinforcement inside structural concrete. Protecting wood means that the wood is completely covered by gypsum board or plaster.

As is shown on Table 601, in a Type I-A building, all structural elements are required to be protected to a minimum of 3-hours fire resistance (more on fire resistance in the next section); floor construction and secondary members are required to be protected to 2 hours, and roof construction and secondary members are required to be protected to 1-1/2 hours; only interior nonbearing walls and partitions are allowed to be unprotected in Type I-A. As may already be obvious, this type is used only for large high-rise buildings, large hospitals, and a few other very large buildings. The reason is simple: this is the most costly type of construction, due to the high degree of fire protection and the requirement for all noncombustible materials. Basically, the requirements drop off with each step moving across the table from left to right, ending up with Type V-B, where no fire resistance is required at all. This type is used only for small structures with low occupancy and non-demanding occupancy type. Non-demanding occupancy type refers to an occupancy in which there is relatively low

BUILDING ELEMENT	TYPE I		TYPE II		TYPE III		TYPE IV	TYPE V	
	A	B	A[d]	B	A[d]	B	HT	A[d]	B
Primary structural frame[g] (see Section 202)	3[a]	2[a]	1	0	1	0	HT	1	0
Bearing walls Exterior[f, g]	3	2	1	0	2	2	2	1	0
Interior	3a	2a	1	0	1	0	1/HT	1	0
Nonbearing walls and partitions Exterior	See Table 602								
Nonbearing walls and partitions Interior[e]	0	0	0	0	0	0	See Section 602.4.6	0	0
Floor construction and secondary members (see Section 202)	2	2	1	0	1	0	HT	1	0
Roof construction and secondary members (see Section 202)	$1\frac{1}{2}$[b]	1[b, c]	1[b, c]	0[c]	1[b, c]	0	HT	1[b, c]	0

Table 4.1 — Table 601 Fire-Resistance Rating Requirements for Building Elements (hours), 2009 International Building Code

For SI: 1 foot = 304.8 mm.

a. Roof supports: Fire-resistance ratings of primary structural frame and bearing walls are permitted to be reduced by 1 hour where supporting a roof only.

b. Except in Group F-1, H, M and S-1 occupancies, fire protection of structural members shall not be required, including protection of roof framing and decking where every part of the roof construction is 20 feet or more above any floor immediately below. Fire-retardant-treated wood members shall be allowed to be used for such unprotected members.

c. In all occupancies, heavy timber shall be allowed where a 1-hour or less fire-resistance rating is required.

d. An approved automatic sprinkler system in accordance with Section 903.3.1.1 shall be allowed to be substituted for 1-hour fire-resistance-rated construction, provided such system is not otherwise required by other provisions of the code or used for an allowable area increase in accordance with Section 506.3 or an allowable height increase in accordance with Section 504.2. The 1-hour substitution for the fire resistance of exterior walls shall not be permitted.

e. Not less than the fire-resistance rating required by other sections of this code.

f. Not less than the fire-resistance rating based on fire separation distance (see Table 602).

g. Not less than the fire-resistance rating as referenced in Section 704.10

risk of fire: offices, residences, small stores, churches, and so on. This most definitely does NOT include occupancies such as storage places for hazardous materials, welding, vehicle service, and large concentrations of occupants.

Most medium-to-large buildings will be Type II noncombustible (A or B) or Type III mixed combustible (A or B). Type III is a relatively recent code development, so Type II is more common in buildings built before 1990 or so. For a long time, the vast majority of medium-to-large commercial buildings were Type II-B—unprotected noncombustible (steel) construction. Type III has become more popular recently, largely due to the desire to use wood-framed interior walls. It is not entirely clear that wood-framed interior walls are actually less costly than steel-framed interior walls, but there are segments of the market (especially multifamily residential) where there is a strong desire to use the wood framing. Obviously, the use of Type III will be somewhat more restricted, due to the presence of large amounts of combustible wood.

Anything that will burn is fuel for a fire, so the presence of large amounts of combustible materials—wood, paper, plastic, and others—clearly increases the risk of fire in a building. It is important to note that there can be large amounts of fuel for a fire even in a Type I-A building, in the form of furnishings, equipment, and supplies (paper in particular). This is why it is necessary to have more fire protection in taller and larger buildings. The World Trade Center towers in New York City failed after the attack on September 11, 2001, not because there was inadequate fire protection (although questions have been raised about the state of the structural steel framing's fire protection) but because the jet fuel in the planes represented a fuel load for the resulting fire that was far beyond anything that anyone had considered prior to that attack. The buildings were actually designed to survive planes crashing into

them, but the designers used much smaller planes (the buildings were designed in the late 1960s) with much smaller fuel loads.

So what does all of this mean to interior designers? Not very much, in the direct sense, but quite a lot in the indirect sense. Given that interior designers work only in "existing" buildings (even a new building that has not yet been constructed should be considered "existing" by the interior designers), it is necessary to understand the limitations imposed by the classification of that existing building. If the building is a Type I or Type II structure, then the interior designer cannot use wood-framed interior walls, ceilings, or bulkheads. If the building is a Type III-A structure, then the interior designer can use protected wood-framed interior walls, and so on.

So how does the interior designer find out the classification of the building? That is not always easy or obvious, and it tends to become murkier and murkier over time and multiple renovations.

Existing Building Limitations

Understanding the limitations of an existing building is a key challenge to an interior designer, and young interior designers may need assistance from more senior interior designers, or even architects, to develop a good understanding of these issues. Each project will provide more and more examples to draw from for future work.

The author has seen unprotected wood framing in older Type II buildings (probably in some Type I buildings too), so seeing unprotected wood framing in an existing situation is not cause to assume that the structure is a Type V or even a Type III. Ideally, one should find out how the building was classified when it was built, which should be possible, in theory, for most buildings that were built since the early 1970s. In Indiana, the building classification is listed on the Construction Design Release form, but such documentation is not always available. For older buildings, one can only make an educated guess, in most cases.

Understanding and Documenting Existing Conditions

For each project, the existing conditions must be documented and shared with the owner. If the building is believed to be a Type II-A building, it is vital to put that into writing as part of the project assumptions to the entire project team, including the owner. If it should later be found that the building is really a Type II-B building, at least everyone will understand that the design was based on incorrect information—wherever it came from.

Clearly, one can never go wrong by assuming a higher classification, and it is recommended to use non-combustible interior wall framing (i.e., steel studs and not wood studs) everywhere. Steel-framed walls are straighter and flatter; the steel is a high embodied-energy material (for those who are concerned about energy conservation), but it is also almost indefinitely recyclable. Wood studs are renewable, if forest growth is planned and managed, but they are not rapidly renewable; it is widely agreed that only the best-managed logging operations are not environmentally harmful. This gives the edge to steel studs from a sustainability point of view. Of course, if the existing building is clearly all wood, protected or otherwise, there could be no harm done by using new wood framing.

In one- and two-family dwellings (which will be covered in detail in Chapter 10), wood framing is most common system, with some light-gauge steel framing and some masonry.

How can an interior designer recognize these different types in the field?

FIGURE 4.1A Cast-in-Place Concrete Beams and Slabs *(photo by the author)*

FIGURE 4.1B Cast-in-Place Concrete 1-Way Joists *(photo by the author)*

A. If bare concrete columns, beams, and girders (large beams that support smaller beams), are visible, the structure is almost certainly a Type I. Concrete construction is inherently fire-resistive. See Figures 4.1a, 4.1b, and 4.1c for photographs of typical concrete structures.

B. If there is an extensive amount of "fuzzy" material on the structure, it is probably a protected steel structure, probably Type I-B or possibly Type II-A. If the fuzzy

FIGURE 4.1C Cast-in-Place Concrete 2-Way Joists ("Waffle Slab") *(photo by the author)*

FIGURE 4.2A Protected Open-Web Steel Joists ("Bar Joists") *(photo by the author)*

material covers the decking (underside of the floor above), it's almost certainly a Type I-B structure. See Figures 4.2a and 4.2b.

 C. If there is visible unprotected steel framing, it is probably a Type II-B (one of the most common types) or Type III. If there are wood-framed interior partitions, it is a Type III

FIGURE 4.2B Protected Steel Beams *(photo by the author)*

FIGURE 4.3A Unprotected Open-Web Steel Joists *(photo by the author)*

building and not a Type II-B building (because the latter requires noncombustible elements throughout). See Figures 4.3a, 4.3b, and 4.3c.

D. If there is visible heavy wood framing where all framing components and mthe decking are at least 3"thick, it is probably a Type IV-HT building. See Figure 4.4

If there is visible light wood framing (2 x 4, 2 x 6, 2 x 8, 2 x 10, 2 x 12, etc.), it must be a Type V-B building. If there is light wood framing, but it is all completely covered by

FIGURE 4.3B Unprotected Steel Beam and Girder *(photo by the author)*

FIGURE 4.3C Unprotected Prefabricated Wood Trusses *(photo by the author)*

gypsum board, it is probably a Type V-A protected building. Both wood- and metal-framed stud walls are generally open inside. Walls that provide improved acoustics often have internal insulation or additional gypsum board layers or other special construction. See Figure 4.5.

Table 601[6] provides the degree of fire protection that's required. But what do 3-hour, 2-hour, 1-1/2 hour, and 1-hour really mean? Those details are provided in the 2009 IBC in Section 703.2[7] of Chapter 7. Here is a brief summary.

FIGURE 4.4 Heavy Timber Buildings *(photo by the author)*

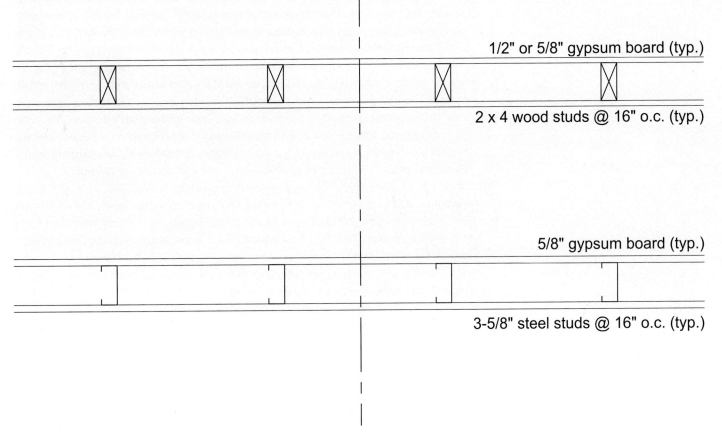

1/2" or 5/8" gypsum board (typ.)

2 x 4 wood studs @ 16" o.c. (typ.)

5/8" gypsum board (typ.)

3-5/8" steel studs @ 16" o.c. (typ.)

FIGURE 4.5 Light Wood (and Steel) Framed Buildings *(drawing by the author)*

4.2 Fire-Resistance Ratings

The 2009 IBC says—

"702.3 Fire-resistance ratings. The *fire-resistance rating* of building elements, components, or assemblies shall be determined in accordance with the test procedures set forth in ASTM E 119 or UL 263 or in accordance with Section 703.3. Where materials, systems or devices that have not been tested as part of a fire-resistance-rated assembly are incorporated into the building element, component or assembly, sufficient data shall be made available to the *building official* to show that the required *fire-resistance rating* is not reduced. Materials and methods of construction used to protect joints and penetrations in fire-resistance-rated building elements, components or assemblies shall not reduce the required *fire-resistance-rating*."[8]

"703.2.1 Nonsymmetrical wall construction. Interior walls and partitions of non-symmetrical construction shall be tested with both faces exposed to the furnace, and the assigned *fire-resistance rating* shall be the shortest duration obtained from the two tests conducted in compliance with ASTM E 119 or UL 263. When evidence is furnished to show that the wall was tested with the least fire-resistant side exposed to the furnace, subject to acceptance of the *building official*, the wall need not be subjected to tests from the opposite side (see Section 705.5 for *exterior walls*)."[9]

So what does this mean? What are ASTM E 119 and UL 263?

ASTM E 119 is a testing procedure developed and promoted by the American National Standards Institute (ANSI) and UL 263 is a similar procedure developed and promoted by Underwriters' Laboratories (UL). Both ANSI and UL are independent laboratories that

Fire-resistance rating

—The period of time a building element, component, or assembly maintains the ability to confine a fire, continues to perform a given structural function, or both, as determined by the tests, or the methods based on tests, prescribed in Section 703.

Building official

—The officer or other designated authority charged with the administration and enforcement of this code, or a duly authorized representative.

perform innumerable tests for a vast array of products and systems. Manufacturers pay ANSI or UL for these tests, so that manufacturers can "list" their products or systems with ASTM or UL numbers. The most common testing procedures for fire-rated assemblies are those done by UL, but both are equally acceptable, as noted in the citations given earlier. Both ASTM E 119 and UL 263 are somewhat controversial, in that they are not as specific as they should be, specially related to the construction of the furnace that is used for the testing. Specifically, some of the gypsum gypsum-board manufacturers criticize ASTM E 119 in particular for failing to produce repeatable results, which means that a successful 2-hour test for one product could be different from that for another product. In other words, all 2-hour tests are not necessarily the same, which means that some 2-hour rated assemblies might actually last for 2 hours under fire whereas others might not. However, it is acknowledged that these tests provide good relative results, meaning that 2-hours is better than 1-hour, as if that wouldn't be obvious.

There are more ratings above and below those listed in 2009 IBC Table 601. Those additional ratings are 4-hour (more restrictive than anything on the table), and 45 minutes (3/4 hour), 30 minutes (1/2 hour), and 20 minutes (1/3 hour), all of which are less restrictive than anything on Table 601. Four-hour walls are used in special circumstances, like an exterior wall that is too close to a property line or for a fire separation between sections of very large buildings; 45-minute, 30-minute, and 20-minute ratings are generally used for openings in 1-hour rated construction (walls or ceilings).

Why are these ratings needed? And why do they matter to interior designers? The answer is that some walls and other assemblies that are placed by interior designers during the normal course of a project fall under these requirements, or other requirements. In most non-sprinklered buildings, corridors are required to be 1-hour rated.

In licensed and some large non-licensed health care projects, corridors are required to be 1-hour rated. Two-hour rated and smoke-proof "smoke walls" are commonly required in licensed health care projects. All of these could conceivably fall under the realm of the interior designer. Also, as noted on Table 601, interior bearing walls in Type II-A, Type III-A, and Type V-A are required to be 1-hour rated. Bearing walls will not usually be located or designed by interior designers, but existing walls of this type could readily be encountered in renovation projects, and it is important to recognize them so as to avoid decreasing the life safety or fire protection during a renovation project.

What is a typical 1-hour rated wall? There are two basic approaches.

In noncombustible construction, a standard wall using steel studs (virtually any steel studs, from 2-1/2"wide and up, and of nearly any gauge) at either 16" on center (o.c.) or 24" o.c. spacing with standard 5/8"-thick gypsum board on both sides will earn a 1-hour label. The same 1-hour label can also be achieved with the same studs with special 1/2"-thick "Type X" gypsum board on both sides, although this is rarely done in commercial construction (because the 1/2" Type X gypsum board is more costly than standard 5/8"-thick gypsum board).

In wood construction, the same systems can be used: standard 5/8" gypsum board on both sides of typical wood studs or 1/2" Type X gypsum board on both sides of the same studs. The ASTM and UL tests do have specific requirements for fastener (screws or nails) spacing and gaps around the edges, but those requirements are easily met.

Conventional gypsum board has two major weaknesses as a building material: (1) it is highly subject to water damage and (2) it is physically weak (i.e., it is easily damaged). To address these problems, special composite boards have been developed. These boards (sold under various trade names including "Fiberrock") are made by compressing (under very high pressure) a combination of finely chopped recycled newspaper and gypsum into a board that is both more water resistant and stronger than conventional gypsum board. There is no paper facing and the boards are installed in the same manner as conventional gypsum board. These composite boards

Existing Violations

It is common to find violations of code in existing corridors. One often sees nonrated doors and frames, or rated frames and unrated doors, or unrated frames and rated doors, or nonrated walls, or all kinds of other problems. If such discoveries are made, an analysis must be done to determine if it is necessary to correct the problems—which will be based on the scope of work and requirements of the project jurisdiction. If it is found that the problems must be corrected, the owner must be fully informed of the extent of the problems and the potential impact on the budget and the schedule.

are also offered in "extra-strong" versions that have fiberglass reinforcing scrims glued to the back side. Boards such as these (especially the reinforced versions) are tough enough for most institutional environments, including schools and hospitals, but not including prisons.

Concrete masonry unit (CMU) walls can be 1-hour rated as well, depending on the thickness of the wall and the specific type of concrete used in manufacturing the units. Solid concrete walls can also be 1-hour rated, depending on their thickness.

What is a typical 2-hour rated wall? Basically the same as the 1-hour rated walls, plus another layer of 5/8"-thick standard gypsum board or 1/2" Type X gypsum board on both sides, using staggered joints between the layers.

CMU walls can be 2-hour rated as well, depending on the thickness of the wall and the specific type of concrete used in manufacturing the units. Solid concrete walls can also be 2-hour rated, depending on their thickness.

All of the major gypsum-board manufacturers publish long lists of rated assemblies of many different types for many different applications. The designer simply needs to find such a list and use the system that works best in a given situation, noting the "UL number" on the construction drawings.[10] See Figure 4.6.

Sometimes the thickness of the wall really matters (which is a reason to use thinner Type X gypsum board) to maximize usable space, and sometimes it's necessary to use asymmetrical walls, where most, or even all, of the rating is achieved from one side of the wall. Special systems are available for shaft construction, which is most commonly used for elevator hoist ways, although they could be used for typical shafts for piping, ductwork, and wiring too. Fire-rated ceilings are sometimes also used, although their use should be avoided due to the obvious complications. These complications include having to use radiation dampers for duct penetrations and having to have fire-rated enclosures for recessed light fixtures. Whenever a rated assembly (a wall, floor, or ceiling) is penetrated, some protection is also required for the penetration, per 2009 IBC.

> **Rated Ceiling Complications**
>
> The complications of rated ceilings in general, and rated lay-in (grid) ceilings in particular, really cannot be overstated. Even if everything is built correctly during the initial construction, over time some of the provisions tend to change—hold-down clips on the ceiling panels are left out, light fixture enclosures are disturbed, and so on. It is best to avoid rated ceilings whenever possible.

"709.6 Openings. Openings in a *fire partition* shall be protected in accordance with Section 715."[11]

Fire partition

—A vertical assembly of materials designed to restrict the spread of fire in which openings are protected.

"715.4 Fire door and shutter assemblies. Approved *fire door* and fire shutter assemblies shall be constructed of any material or assembly or component materials that conforms to the test requirements of Sections 715.4.1, 715.4.2, or 715.4.3 and the *fire protection rating* indicated on Table 715.4. *Fire door* frames with transom lights, sidelights or both shall be permitted in accordance with Section 715.4.5. *Fire door* assemblies and shutters shall be installed in accordance with the provisions of this section and NFPA 80."[12]

Fire door

—The door component of a fire door assembly.

Here is 2009 IBC Table 715.4[13]

As you can see from this table, the most typical requirement is for an opening in a rated assembly to be rated one level lower than the rating of the assembly itself—hence 3-hour rated openings in 4-hour and 3-hour rated walls; 1-1/2 hour rated openings in 2-hour and 1-1/2 hour rated walls; 1 hour, 3/4 hour, and 1/3 hour rated openings in 1-hour rated walls; and 1/3-hour rated openings in 1/2 hour rated walls. The inconsistencies, such as 3-hour rated openings for both 4-hour and 3-hour rated walls, exist because of the reasons for using a 3-hour wall instead of a 4-hour wall and to having the rating in the first place. In other words, some rated walls are more critical than others. For example, take the 3-hour protection that's required for an opening in a 3-hour rated fire wall. The fire wall is intended to separate two buildings (literally) and it has to remain standing if the building on either side were to fall down in a fire, so this is a highly critical application. Having a 1.5-hour protection for an opening (as would be allow for a 3-hour rated exterior wall) could seriously compromise the protective capability of the fire wall.

Fire door assembly

—Any combination of a fire door, frame, hardware, and other accessories that together provide a specific degree of fire protection to the opening.

A Partitions

Steel Framed

◉

1 Hour Fire-rated Construction	Non-loadbearing			Acoustical Performance		Reference	
Construction Detail	Description	Test Number	STC	Test Number		ARL	Index
wt. 6 4⅞"	• 5/8" Sheetrock® Brand Firecode® Core Gypsum Panels or Imperial® Brand Firecode Core Abuse-Resistant Gypsum Base, or Fiberock® Brand Panels – 3-5/8" 25 gauge steel studs 24" o.c. – joints finished • optional veneer plaster	UL Des U419 or U465	40	USG-860808		SA700 SA920	A-1
			49	SA-870717 Based on 3" SAFB in cavity			
			51	RAL-TL-90-166 Based on 5/8" Firecode C Core panels and 3" SAFB, and veneer finish surface SAFB 25" wide, creased to fit cavity			
wt. 6 2⅞"	• 5/8" Sheetrock Brand Firecode Core Gypsum Panels or Fiberock Brand Panels – 1-5/8" 25 gauge steel studs 24" o.c. – joints finished – perimeter caulked	U of C 7-31-62	38	USG-860809			A-2
wt. 6 3⅝"	• veneer plaster only (not drywall) 1/2" Imperial Brand Firecode C Core Gypsum Base and veneer finish or 5/8" Fiberock Brand Panels – 2-1/2" 25 gauge steel studs, 16" o.c. – joints staggered and taped – 1/16" veneer finish.	GA-WP-1240	45	CK-664-1 Based on 3-5/8" studs 24" o.c. with 1" mineral wool batt in cavity		SA920	A-3
wt. 5 3½"	• 1/2" Sheetrock Brand Firecode C Core Gypsum Panels – 2-1/2" 25 gauge studs 24" o.c. – 1-1/2" Thermafiber SAFB – joints finished	UL Des U419 or U448	47	SA-831001			A-4
wt. 6 3¾"	• 5/8" Sheetrock Brand Firecode Core Gypsum Panels – 2-1/2" 25 gauge steel studs 24" o.c. – 1-1/2" mineral wool batt – horiz joints directly opposite and finished – CEG 8-11-83 rating also applies to assembly with 1/2" Sheetrock Brand Firecode C Core Gypsum Panels, panels and joints finished – CEG 5-9-84 rating also applies with Imperial Brand Firecode Core Gypsum Base and veneer finish surface	CEG 8-11-83 CEG 5-9-84	45	RAL-TL-69-42			A-5
			48	SA-800422 Based on 3-5/8" studs and 2" mineral wool batt			
wt. 7 3½"	• 1/2" Sheetrock Brand Firecode C Core Gypsum Panels – 2-1/2" 25 gauge steel studs 24" o.c. – 1-1/2" Thermafiber SAFB – joints finished	UL Des U419 or U448	41	RAL-TL-69-148 Based on same construction without Thermafiber SAFB		SA920	A-6
			50	SA-800504			
wt. 7 3⅛"	• Face layer 1/2" Sheetrock Brand Firecode C Core Gypsum Panels – 1-5/8" 25 gauge steel studs 24" o.c. • base layer 1/4" Sheetrock Brand Gypsum Panels – joints finished	GA-WP-1090	53	CK-684-13 Based on 1-1/2" mineral wool batt and 2-1/2" studs			A-7

9 USG Fire-Resistant Assemblies

FIGURE 4.6 Page 9 from USG SA100 Fire-Resistant Assemblies *(used by permission of United States Gypsum)*

44 Chapter 4

| | | | |

Table 4.2 | Table 715.4 Fire Door and Fire Shutter Fire Protection Ratings, 2009 *International Building Code*

TYPE OF ASSEMBLY	REQUIRED ASSEMBLY RATING (hours)	MINIMUM FIRE DOOR AND FIRE SHUTTER ASSEMBLY RATING (hours)
Fire walls and fire barriers having a required fire-resistance rating greater than 1 hour	4 3 2 1^1/2	3 3[a] 1^1/2 1^1/2
Fire barriers having a required fire-resistance rating of 1 hour: Shaft, exit enclosure and exit passageway walls Other fire barriers	 1 1	 1 3/4
Fire partitions: Corridor walls Other fire partitions	 1 0.5 1 0.5	 1/3[b] 1/3[b] 3/4 1/3
Exterior walls	3 2 1	11/2 11/2 3/4
Smoke barriers	1	1/3[b]

a. Two doors, each with a fire protection rating of 1^1/2 hours, installed on opposite sides of the same opening in a fire wall, shall be deemed equivalent in fire protection rating to one 3-hour fire door.
b. For testing requirements, see Section 715.4.3

"709.7 Penetrations. Penetrations of *fire partitions* shall comply with Section 713."[14]

"713.3.1.1 Fire-resistance-rated assemblies. Penetrations shall be installed as tested in an *approved* fire-resistance-rated assembly."[15]

"713.3.1.2 Through-penetration firestop system. *Through penetrations* shall be protected by an *approved* penetration firestop system installed as tested in accordance with ASTM E 814 or UL 1479, with a minimum positive pressure differential of 0.01 inch (2.49 Pa) of water and shall have an F rating of not less than the required *fire-resistance rating* of the wall penetrated."[16] These units are pressure units; inches of water column in the English unit system (where 27.7 inches equals one pound per square inch (psi) and Pascals (Pa) in the metric unit system.

Essentially, this simply requires fire caulking at penetrations. Naturally, many different products are available for such fire stopping, but it doesn't matter which one is used as long as it complies with ASTM E 814 or UL 1479.

"709.9 Ducts and air transfer openings. Penetrations in a *fire partition* by ducts and air transfer openings shall comply with Section 716."[17]

"716.2 Installation. *Fire dampers, smoke dampers, combination fire/smoke dampers* and *ceiling radiation dampers* located within air distribution and smoke control systems shall be installed in accordance with the requirements of this section, the manufacturer's installation instructions and the *dampers'* listing."[18]

"716.3.2.1 Fire damper ratings. *Fire dampers* shall have the minimum *fire protection rating* specified in Table 716.3.2.1 for the type of penetration."[19]

Approved

—Acceptable to the code official or the authority having jurisdiction.

Fire damper

—A listed device installed in ducts and air transfer openings designed to close automatically upon detection of heat and resist the passage of flame. Fire dampers are classified for use in either static systems that will automatically shut down in the event of a fire, or in dynamic systems that continue to operate during a fire. A dynamic fire damper is tested and rated for closure under elevated temperature airflow.

Listed

—Equipment, materials, products, or services included in a list published by an organization acceptable to the code official and concerned with evaluation of products or services that maintain periodic inspection of production of listed equipment or materials or periodic evaluation of services and whose listing states either that the equipment, material, product, or service meet identified standards or has been tested and found suitable for a specified purpose.

Smoke damper

—A listed device installed in ducts and air transfer openings designed to resist the passage of smoke. The device is installed to operate automatically, controlled by a smoke detection system, and where required, is capable of being positioned from a fire command center.

Combination fire/smoke damper

—A listed device installed in ducts and air transfer openings designed to close automatically upon the detection of heat and resist the passage of flame and smoke. The device is installed to operate automatically, controlled by a smoke detection system, and where required, is capable of being positioned from a fire command center.

Horizontal assembly

—A fire-resistance-rated floor or roof assembly of materials designed to restrict the spread of fire in which continuity is maintained.

Fire and Smoke Dampers

The importance of fire dampers and smoke dampers to mechanical engineers cannot be overstated. It is vital for the interior designer to notify all other team members whenever any rated assembly is used in a project.

Fire barrier

—A fire-resistance-rated wall assembly of materials designed to restrict the spread of fire in which continuity is maintained.

Fire wall

—A fire-resistance-rated wall having protected openings, which restricts the spread of fire and extends continuously from the foundation to or through the roof, with sufficient structural stability under fire conditions to allow collapse of construction on either side without collapse of the wall.

Table 716.3.2.1 is quite simple, requiring 3-hour damper ratings for 3-hour or greater assemblies, and 1-1/2-hour damper ratings for assemblies having ratings less than 3 hours.

"713.4 Horizontal assemblies. Penetrations of a floor, floor/ceiling assembly or the ceiling membrane of a roof/ceiling assembly not required to be enclosed by a shaft by Section 708.2 shall be protected in accordance with Sections 713.4.1 through 713.4.2.2."[20]

"713.4.1.2 Membrane penetrations. Penetrations of membranes that are part of a *horizontal assembly* shall comply with Section 713.4.1.1.1 or 713.4.1.1.2. Where floor/ceiling assemblies are required to have a *fire-resistance rating*, recessed fixtures shall be installed such that the required *fire-resistance* will not be reduced."[21]

"713.4.1.3 Ducts and air transfer openings. Penetrations of *horizontal assemblies* by ducts and air transfer openings shall comply with Section 716."[22]

For small penetrations for noncombustible pipes and conduits for wiring, all that is required is simple fire stopping around the outside of the penetrating pipe or conduit, as noted earlier. But for ductwork, rated fire dampers are required; fire dampers are costly to install, they can be a maintenance headache for the owner, and they should be avoided whenever possible. For a smoke-wall, the ductwork penetrations have to be protected by combination fire- and smoke-dampers, which are very, very costly. This is especially important for ceilings because it is very common to have extensive penetrations for ductwork, wiring, and light fixtures, all of which add significant complexity to maintaining the fire-protection rating for the ceiling.

For standard 1-hour rated walls, typical openings are required to be rated for 20-minutes, and that's the same for doors and windows (which are both considered "openings"). As noted earlier, penetrations are different from openings, and penetrations also break out into "ducts" and "other," with the first requiring dampering and the second requiring only fire stopping. The good thing about all of this is that it is universal, meaning that these fire-stopping and dampering requirements are the same (more or less) for all applications for a given fire rating. In other words, all 1-hour rated corridor walls are treated the same, no matter how large the building is or what is it used for. This is one of the few areas in the codes where that is true.

4.3 Effects of Construction Type and Fire Resistance Ratings in Interior Design

Of course, there are additional requirements that have not yet been discussed. Of particular interest are the limitations on opening sizes in rated assemblies, which require the introduction of additional terms. So far, this discussion has been limited (by design) to *fire partitions*, the least restrictive category. The other two categories are *fire barrier* and *fire wall*.

Fire partitions (the least restrictive category) are used for

1. Walls separating dwelling units in the same building (e.g., apartments and condominiums)
2. Walls separating sleeping units in the same building (e.g., hotels and hostels)
3. Walls separating tenant spaces in covered mall buildings (note that many mall buildings are not technically *covered mall buildings*.

4. Corridor walls
5. Elevator lobby separation

Fire barriers (moderately restrictive) are used for

1. Shaft enclosures
2. Exit enclosures (usually stairs)
3. Exit passageways
4. Horizontal exits (usually between a stair discharge and the exterior)
5. Atriums
6. Incidental accessory occupancies (an important issue that will be covered in detail in Chapter 5).
7. Control areas
8. Separated occupancies (another issue that will be covered in detail in Chapter 5
9. Fire areas

Fire walls (most restrictive) are used for

1. Party walls to separate buildings (when a fire wall is used, the structures on opposite sides of the wall are actually considered to be completely separate buildings; this concept is not crucial to interior design, but it is very important in architecture).

 There are restrictions on the size of openings in fire barriers and in fire walls.

"707.6 Openings. Openings in a *fire barrier* shall be protected in accordance with Section 715. Openings shall be limited to a maximum aggregate width of 25 percent of the length of the wall, and the maximum area of any single opening shall not exceed 156 square feet (15 m^2). Openings in *exit* enclosures and *exit* passageways shall also comply with Sections 1022.3 and 1023.5, respectively.

Exceptions:

1. Openings shall not be limited to 156 square feet (15 m^2) where adjoining floor areas are equipped throughout with an *automatic sprinkler system* in accordance with Section 903.3.1.1.
2. Openings shall not be limited to 156 square feet (15m^2) or an aggregate width of 25 percent of the length of the wall where the opening protective is a *fire door* serving an *exit* enclosure.
3. Openings shall not be limited to 156 square feet (15m^2) or an aggregate width of 25 percent of the length of the wall where the opening protective has been tested in accordance with ASTM E 119 or UL 263 and has a minimum *fire-resistance rating* not less than the *fire-resistance rating* of the wall.
4. Fire window assemblies permitted in atrium separation walls shall not be limited to a maximum aggregate width of 25 percent of the length of the wall.
5. Openings shall not be limited to 156 square feet (15m^2) or an aggregate width of 25 percent of the length of the wall where the opening protective is a *fire door* assembly in a *fire barrier* separating an *exit* enclosure from an *exit* passageway in accordance with Section 1022.2.1."[23]

"706.8 Openings. Each opening through a *fire wall* shall be protected in accordance with Section 715.4 and shall not exceed 156 square feet (15 m^2). The aggregate width of openings at any floor level shall not exceed 25 percent of the length of the wall.

Exceptions:

1. Openings are not permitted in party walls, constructed in accordance with Section 706.1.1.

Covered mall building

—A single building enclosing a number of tenants and occupants, such as retail stores, drinking and dining establishments, entertainment and amusement facilities, passenger transportation terminals, offices, and other similar uses wherein two or more tenants have a main entrance into one or more malls. For the purpose of this chapter, anchor buildings shall not be considered as a part of the covered mall building.

Ceiling radiation damper

—A listed device installed in a ceiling membrane of a fire-resistance-rated floor/ceiling or roof/ceiling assembly to limit automatically the radiative heat transfer through an air inlet/outlet opening.

2. Openings shall not be limited to 156 square feet (15 m^2) where both buildings are equipped throughout with an *automatic sprinkler system* installed in accordance with Section 903.3.1.1."[24]

So what does all of this mean? Essentially, the basic rule is that the width of openings in both fire barriers and fire walls cannot exceed 25% of the length of the wall and 156 square feet unless one of these several exceptions applies. In fact, the exceptions do apply quite frequently, so it is quite practical to have large openings in these walls.

One of the most common methods to do so is to use a special door called a "WonDoor" (www.wondoor.com). This is a folding, travelling accordion-type door that is tested in accordance with ASTM and UL and that can do almost anything. The doors can be very tall, very wide, and even curving—the only limitations are imagination and money because these doors are costly. A single 10'-0" wide by 8'-0" high WonDoor could easily cost in excess of $10,000, so they need to be used judiciously. But when a design simply won't work (or the owner's operational needs simply can't be met) without a large opening in a fire barrier or a fire wall, these doors can offer a good solution. A common application is at the ends of elevator lobbies in large high-rise buildings. The use of the doors allows for what appear to be completely open elevator lobbies under normal conditions, which close off automatically during emergencies. WonDoors also incorporate standard exiting features so that they will open just far enough for someone to leave the area and then close again automatically after a preset time delay.

Is it feasible to use fire-rated glass in windows, doors, and sidelights? Certainly it is, but, again, the products are costly. Over the past 15 years or so, a number of fire-rated glass products have been made available, which can be rated up to 1-1/2 hours. As a result, they can be used in 1-1/2-hour rated doors and for windows in most 2-hour rated walls. These materials are not actually glass at all; instead, they are usually transparent ceramic materials that have better resistance to heat than does glass. Obviously, glass is heat resistant in the sense that it doesn't melt until very high temperatures are reached, but it can become brittle under much lower heat, thereby losing strength and structural integrity.

Glass, or something that appears to be glass, in an opening in a rated assembly must be able to maintain itself in place and intact throughout the required rating period, and typical glass simply can't do that. More than 20 years ago, it was common to use what is called "wired glass" for applications like this. Wired glass is a sandwich product that consists of a thin layer of glass on both sides of wire mesh (usually 1" square on a 45-degree diagonal to the floor), and the wire is quite visible. Modern fire-resistive glass products are so close to completely transparent that most people would never guess that is they are anything other than plain glass. But remember that they are costly and should be used sparingly as a result.

Fire-Rated Glass

Even though fire-rated glass is readily available on the market, its use should be carefully considered due to its high cost. It's easy to get in trouble over just a few thousand dollars if it causes the project to go over budget or if the owner simply didn't know about the high-cost item.

summary

The key issues in Chapter 4 include understanding the basics of risk, the effects of construction type, and the effects of fire-resistance ratings. Risk is relatively straightforward, increasing as there are more occupants, occupants who are not capable of self-preservation, or large amounts of flammable material.

When there are many occupants (in large buildings such as shopping malls, large high-rise buildings, arenas, and stadia), getting those occupants out of the building under emergency situations can be challenging—and it can take a significant amount of time—so it is necessary to build the building in such a way as to provide for that time. This means that more fire resistance is required, both to minimize the likelihood of fire from the outset but also to slow down the spread of a fire should one get started.

When there are incapacitated occupants (especially in hospitals but also in nursing and convalescent homes and in jails/prisons), it is sometimes nearly impossible to get those occupants out of the building at all, so a much higher degree of fire protection is usually required.

If there are large amounts of flammable material (especially in high pile storage in warehouses), it is vital to control the spread of a fire.

Construction type is used to match the risk to the protection. There is no reason to build a 5,000 square foot free-standing dentist office with 10 occupants to the same standard as a 50-story building with 5,000 occupants, and the code allows for that variation.

Also, given that interior designers routinely do renovation work in existing buildings, it is critical for such designers to under-stand the limitations of the existing context. If a client comes forward with a plan to convert a former big-box retail store into a large-scale church, there could be some problems because the church represents a greater risk than the store, simply because of the greater number of occupants. Conversely, if one were to con-vert an old school into an office building, the risk would be lower due to the fewer number of occupants. Recognizing the construction type of an existing structure can be difficult, but it is very important.

results

Having completed this chapter, the following objectives should have been met:

4.1. To understand construction type, by knowing that there are five general types, I through V, with some subtypes and more, or less, fire resistance. The types relate to noncombustible verses combustible elements.

4.2. To understand fire-resistance ratings, by knowing that elements and assemblies can be designed for varying degrees of fire resistance, and that performance is verified by ASTM or UL testing.

4.3. To understand the effects of construction type and fire-resistance ratings on the practice of interior design, by knowing that some corridors are required to be 1-hour rated (in some high-rise buildings, some health care facilities, and some other large-scale buildings), that existing fire resistance is never to be reduced by renovation, that fire resistance should be increased during renovation where feasible, and that it is feasible (though costly) to use fire-resistive glazing and large-scale fire doors.

notes

1. International Building Code 2009, page 89.
2. Ibid.
3. Ibid., pages 89–90.
4. Ibid., page 91.
5. Ibid., page 89.
6. Ibid.
7. Ibid., page 94.
8. Ibid.
9. Ibid.
10. United States Gypsum, SA100 Fire-Resistant Assemblies, page 9.
11. International Building Code 2009, page 108.
12. Ibid., page 114.
13. Ibid.
14. Ibid., page 108.
15. Ibid., page 111.
16. Ibid.
17. Ibid., page 108.
18. Ibid., page 118.
19. Ibid.
20. Ibid., page 111.
21. Ibid., page 112.
22. Ibid.
23. Ibid., page 104.
24. Ibid., page 103.

What Is Occupancy Type?

objectives

5.1. To understand the meaning of Assembly (A), Business (B), Educational (E), Factory (F), Hazardous (H), Institutional (I), Mercantile (M), Residential (R), Storage (S), and Utility and Miscellaneous (U) occupancies and the meaning of subgroups A-1, A-2, A-3, A-4, A-5, F-1, F-2, I-1, I-2, I-3, I-4, R-1, R-2, R-3, R-4, S-1, and S-2.

5.2. To understand special detailed occupancy-based requirements.

5.3. To understand the general meaning of building height and area.

5.4. To understand incidental and accessory uses.

5.5. To understand multiple occupancies, including mixed occupancies.

5.6. To understand "occupant load" and the determination thereof.

5.1 Occupancy Type

Occupancy type defines the purpose for which a given building, or space within a building, is used, which in turns determines the degree of risk that must be anticipated. There are 10 basic occupancy types in Chapter 3 of the 2009 International Building Code, as follows—

Assembly Group A

"303.1 Assembly Group A. Assembly Group A occupancy includes, among others, the use of a building or structure, or a portion thereof, for the gathering of persons for purposes such as civic, social or religious functions; recreation, food or drink consumption or awaiting transportation."[1]

There are several exceptions to 303.1, which include—

* Buildings or tenant spaces having *occupant loads* less than 50 (which are classified as Group B occupancies)
* Assembly rooms having occupant loads less than 50 where accessory to another occupancy (also Group B occupancies)

- An assembly space that is less than 750 square feet (70 m²) and accessory to another occupancy (also Group B occupancies)
- Assembly areas that are accessory to Group E (except for the accessibility requirements of Chapter 11)
- Accessory religious educational rooms and religious auditoriums with occupancy loads less than 100 (which are not considered separate)

The last exception is confusing because most religious facilities, overall, are classified as Group A-3. Also, it must be pointed out that occupant load has nothing to do with the structural capacity of the building. Structural loads are governed by Chapter 16 in the 2009 IBC and they include dead loads (the permanent weight of the structure), live loads (occupants, furniture, equipment, walls, etc.), wind loads, snow loads, and seismic loads. Occupant load is simply another term for occupant count.

Within Group A, there are five subgroups, as follows—

"**A-1** Assembly uses, usually with fixed seating, intended for the production and viewing of the performing arts or motion pictures including, but not limited to:

Motion picture theaters

Symphony and concert halls

Television and radio studios admitting an audience

Theaters

A-2 Assembly uses intended for food and/or drink consumption including, but not limited to:

Banquet halls

Night clubs

Restaurants

Taverns and bars

A-3 Assembly uses intended for worship, recreation or amusement and other assembly uses not classified elsewhere in Group A including, but not limited to:

Amusement arcades

Art galleries

Bowling alleys

Community halls

Courtrooms

Dance halls (not including food or drink consumption)

Exhibition halls

Funeral parlors

Gymnasiums (without spectator seating)

Indoor swimming pools (without spectator seating)

Indoor tennis courts (without spectator seating)

Lecture halls

Libraries

Museums

Places of religious worship

Pool and billiard parlors

Waiting areas in transportation terminals

Accessory occupancies

—"Those occupancies that are ancillary to the main occupancy of the building or portion thereof."

Incidental occupancies

—Identified specifically in 2009 IBC Table 508.2.5.

Occupant load

—"The number of persons for which the means of egress of a building or portion thereof is designed."

Means of egress

—"A continuous and unobstructed path of vertical and horizontal egress travel from any occupied portion of a building or structure to a public way. A means of egress consists of three separate and distinct parts: the exit access, the exit and the exit discharge."

Public way

—"A street, alley or other parcel of land open to the outside air leading to a street, that has been deeded, dedicated or otherwise permanently appropriated to the public for public use and which has a clear width and height of not less than 10 feet (3048 mm)."

Exit access

—"That portion of a means of egress system that leads from any occupied portion of a building or structure to an exit."

Exit

—"That portion of a means of egress system which is separated from other interior spaces of a building or structure by fire-resistance-rated construction and opening protectives as required to provide a protected path of egress travel between the exit access and the exit discharge. Exits include exterior exit doors at the level of exit discharge, vertical exit enclosures, exit passageways, exterior exit stairways, exterior exit ramps and horizontal exits."

Exit discharge

—"That portion of a means of egress system between the termination of an exit and a public way."

Level of exit discharge

—No definition is provided for this term in the 2009 International Building Code.

Exit enclosure

—"An exit component that is separated from other interior spaces of a building or structure by fire-resistance-rated construction and opening protectives, and provides for a protected path of egress travel in a vertical or horizontal direction to the exit discharge or the public way."

Exit passageways

—"An exit component that is separated from other interior spaces of a building or structure by fire-resistance-rated construction and opening protectives, and provides for a protected path of egress travel in a horizontal direction to the exit discharge or the public way."

Exterior exit stairway

—No definition is provided for this term in the 2009 International Building Code.

Assembly Occupancies

It is important for interior designers to be careful about assembly occupancies, largely due to the tendency of many officials to look toward concentrated occupant load factors (more on that in Section 5.4.2) in too many cases. This is an area that is probably worth discussing with the officials, if that's practical, early in the design process.

Exit ramps

—No definition is provided for this term in the 2009 International Building Code.

Horizontal exit

—No definition is provided for this term in the 2009 International Building Code.

Bleachers

—Tiered seating supported on a dedicated structural system and two or more rows high and is not a building element (see "Grandstands").

Grandstand

—Tiered seating supported on a dedicated structural system and two or more rows high and is not a building element (see "Bleachers").

Clinic, outpatient

—"Buildings or portions thereof used to provide medical care on less than a 24-hour basis to individuals who are not rendered incapable of self-preservation by the services provided."

A-4 Assembly uses intended for viewing of indoor sporting events and activities with spectator seating including, but not limited to:

Arenas

Skating rinks

Swimming pools

Tennis courts

A-5 Assembly uses intended for participation in or viewing outdoor activities including, but not limited to:

Amusement park structures

Bleachers

Grandstands

Stadiums"[2]

This avalanche of new terms—occupant load, means of egress, public way, exit access, exit, exit discharge, level of exit discharge, exit enclosures, exit passageways, exterior exit stairways, exit ramps, and horizontal exits—will be covered in detail in Chapter 6. For now, suffice it to say that this provides a clear demonstration of the interconnectedness of the International Building Code and the spiral nature of code analysis.

For the five subgroups within Group A, A-3, and A-2 are used the most extensively, mostly for churches, certain types of meeting or conference facilities, and restaurants and bars.

Business Group B

"304.1 Business Group B. Business Group B occupancy includes, among others, the use of a building or structure, or a portion thereof, for office, professional or service-type transactions, including storage of records and accounts. Business occupancies shall include, but not be limited to, the following:

Airport traffic control towers

Ambulatory health care facilities

Animal hospitals, kennels and pounds

Banks

Barber and beauty shops

Car wash

Civic administration

Clinic, outpatient

Dry cleaning and laundries: pick-up and delivery stations and self-service

Educational occupancies for students above the 12th grade

Electronic data processing

Laboratories: testing and research

Motor vehicle showrooms

Post offices

Print shops

Professional services (architects, attorneys, dentists, physicians, engineers, etc.)

Radio and television stations

Telephone exchanges

Training and skill development not within a school or academic program."[3]

Clearly, this list covers a vast swath of territory, and it should come as no surprise that Group B is the most widely used occupancy classification on a broad basis.

Educational Group E

"**305.1 Educational Group E.** Educational Group E occupancy includes, among others, the use of a building or structure, or a portion thereof, by six or more persons at any one time for educational purposes through the 12th grade. Religious educational rooms and religious auditoriums, which are accessory to *places of religious worship* in accordance with Section 303.1 and have *occupant loads* of less than 100, shall be classified as A-3 occupancies.

305.2 Day care. The use of a building or structure, or a portion thereof, for educational, supervision or *personal care services* for more than five children older than 2 1/2 years of age, shall be classified as a Group E occupancy."[4]

One of the most interesting aspects of Group E is that it does not include higher education, which is clearly spelled out as a Group B occupancy. (See Group B above.)

Factory Group F

"**306.1 Factory Industrial Group F.** Factory Industrial Group F occupancy includes, among others, the use of a building or structure, or a portion thereof, for assembling, disassembling, fabricating, finishing, manufacturing, packaging, repair or processing operations that are not classified as a Group H hazardous or Group S storage occupancy.

306.2 Factory Industrial F-1 Moderate-hazard Occupancy. Factory industrial uses which are not classified as Factory Industrial F-2 Low Hazard shall be classified as F-1 Moderate Hazard and shall include, but not be limited to, the following:

Aircraft (manufacturing, not to include repair)

Appliances

Athletic equipment

Automobiles and other motor vehicles

Bakeries

Beverages: over 16-percent alcohol content

Bicycles

Boats

Brooms or brushes

Business machines

Cameras and photo equipment

Canvas or similar fabric

Carpets and rugs (includes cleaning)

Clothing

Construction and agricultural machinery

Disinfectants

Dry cleaning and dyeing

Electric generation plants

Electronics

Engines (including rebuilding)

Food processing

Furniture

Hemp products

Jute products

Laundries

Leather products

Machinery

Metals

Millwork (sash and door)

Motion pictures and television filming (without spectators)

Musical instruments

Optical goods

Paper mills or products

Photographic film

Plastic products

Printing or publishing

Recreational vehicles

Refuse incineration

Shoes

Shops and detergents

Textiles

Tobacco

Trailers

Upholstering

Wood: distillation

Woodworking (cabinet)

306.2 Factory Industrial F-2 Low-hazard Occupancy. Factory industrial uses that involve the fabrication or manufacturing of noncombustible materials which during finishing, packing or processing do not involve a significant fire hazard shall be classified as F-2 occupancies and shall include, but not be limited to, the following:

Beverages: up to and including 16-percent alcohol content

Brick and masonry

Ceramic products

Foundries

Glass products

Gypsum

Ice

Metal products (fabrication and assembly)"[5]

Even though these lists encompass many, many different potential projects, the number of such new facilities is small when compared to offices, stores, clinics, churches, and others, so the F group is used relatively infrequently.

High-Hazard Group H

"307.1 High-hazard Group H. High-hazard Group H occupancy includes, among others, the use of a building or structure, or a portion thereof, that involves the manufacturing, processing generation or storage of materials that constitute a physical or health hazard

in quantities in excess of those allowed in control areas complying with Section 414, based on the maximum allowable quantity limits for *control areas* set forth in Tables 307.1(1) and 307.1(2). Hazardous occupancies area classified in Groups H-1, H-2, H-3, H-4 and H-5 and shall be in accordance with this section, the requirements of Section 415 and the *International Fire Code.* Hazardous materials stored, or used on top of roofs or canopies shall be classified as outdoor storage or use and shall comply with the *International Fire Code.*"[6]

There are numerous exceptions to these basic requirements, but, in general, hazardous occupancy requirements are some of the most complex elements in the International Building code and a full exploration of them is beyond the scope of this book. For now, suffice it to say that most hazardous use projects will probably require outside expertise to address these requirements. That said, there are a few circumstances where partial hazardous occupancies occur in more common projects. These include—

Paint storage (virtually all kinds of paint, if stored in quantities exceeding several gallons)

Acid storage (as in wet batteries—significant in large uninterrupted power supply (UPS) installations for computer facilities and in storage rooms for vehicle servicing)

Millwork production (usually custom case goods and standing and running trim but sometimes windows and doors)

In these latter cases, it is necessary to provide fire separation of the affected areas, and specialized treatment within the areas (up to and including explosion-proof lighting fixtures and light switches and "blow-out" panels for explosions), and such provisions can be made without special expertise.

Institutional Group I

"**308.1 Institutional Group I.** Institutional Group I occupancy includes, among others, the use of a building or structure, or a portion thereof, in which people are cared for or live in a supervised environment, having physical limitations because of the health or age are harbored for medical treatment or other care or treatment, or in which people are detained for penal or correctional purposes or in which the liberty of the occupants is restricted. Institutional occupancies shall be classified as Group I-1, I-2, I-3 or I-4.

308.2 Group I-1. This occupancy shall include buildings, structures or parts thereof housing more than 16 persons, on a 24-hour basis, who because of age, mental disability or other reasons, live in a supervised residential environment that provides personal care services. The occupants are capable of responding to an emergency situation without physical assistance from staff. This group shall include, but not be limited to, the following:

Alcohol and drug centers

Assisted living facilities

Congregate care facilities

Convalescent facilities

Group homes

Halfway houses

Residential board and care facilities

Social rehabilitation facilities

A facility such as the above with five or fewer persons shall be classified as a Group R-3 or shall comply with the International Residential Code in accordance with Section 101.2. A facility such as above, housing at least six and not more than 16 persons, shall be classified as Group R-4.

What Is Occupancy Type?

308.3 Group I-2. This occupancy shall include buildings and structures used for medical, surgical, psychiatric, nursing or custodial care for persons who are not capable of self-preservation. This group shall include, but not be limited to, the following:

> Child care facilities
>
> Detoxification facilities
>
> Hospitals
>
> Mental hospitals
>
> Nursing homes . . ."[7]

308.3 Group I-3. This occupancy shall include buildings and structures that are inhabited by more than five persons who are under restraint or security. An I-3 facility is occupied by persons who are generally incapable of self-preservation due to security measures not under the occupants' control. This group shall include, but not be limited to, the following:

> Correctional facilities
>
> Detention centers
>
> Jails
>
> Prerelease centers
>
> Prisons
>
> Reformatories"[8]

Five "conditions" apply to I-3 occupancies, which are related to the degree of confinement. Condition 1 is the least restrictive and it actually allows the facility to be classified as Group R. Condition 5 is the most restrictive because occupants are allowed out of occupied spaces, including sleeping rooms, only by manual action by the staff. Given that it is highly unlikely that an interior designer would do the planning for a facility subject to these requirements (it is usually done by specialist architects and code consultants), there is no need to go into these requirements in any greater detail.

"308.5 Group I-4, day care facilities. This group shall include buildings and structures occupied by persons of any age who receive custodial care for less than 24 hours by individuals other than parents or guardians, relatives by blood, marriage or adoption, and in a place other than the home of the person cared for. A facility such as the above with five or fewer persons shall be classified as a Group R-3 or shall comply with the International Residential Code in accordance with Section 101.2. Places of worship during religious functions are not included.

308.5.1 Adult care facility. A facility that provides accommodations for less than 24 hours for more than five unrelated adults and provides supervision and personal care services shall be classified as Group I-4.

> **Exception:** A facility where occupants are capable of responding to an emergency situation without physical assistance from the staff shall be classified as Group R-3.

308.5.2 Child care facility. A facility that provides supervision and personal care on less than a 24-hour basis for more than five children 2 1/2 years of age or less shall be classified as Group I-4.

> **Exception:** A child day care facility that provides care for more than five but no more than 100 children 2 1/2 years or less of age, where the rooms in which the children are cared for are located on a level of exit discharge serving such rooms and each of these child care rooms has an exit door directly to the exterior, shall be classified as Group E."[9]

It is quite clear that the requirements for I occupancies are the most restrictive occupancy-related requirements in the International Building Code, NFPA 5000, and NFPA 101 Life Safety Code. This is why there are exceptions for "small" facilities, especially in Group I-4.

Child care facilities

—"Facilities that provide care on a 24-hour basis to more than five children, 2 1/2 years of age or less."

Detoxification facilities

—"Facilities that serve patients who are provided treatment for substance abuse on a 24-hour care basis and who are incapable of self-preservation or who are harmful to themselves or others."

Hospitals and mental hospitals

—"Buildings or portions thereof used on a 24-hour basis for the medical, psychiatric, obstetrical or surgical treatment of inpatients who are incapable of self-preservation."

Nursing homes

—"Nursing homes are long-term care facilities on a 24-hour basis, including both intermediate care facilities and skilled nursing facilities, serving more than five persons and any of the persons are incapable of self-preservation."

The requirements are so restrictive that it would be only a small exaggeration to say that the day care industry has planned its facilities around the exception to 308.5.2 note above.

Mercantile Group M

"**309.1 Mercantile Group M.** Mercantile Group M occupancy includes, among others, the use of a building or structure or a portion thereof, for the display and sale of merchandise and involves stocks of goods, wares or merchandise incidental to such purpose and accessible to the public. Mercantile occupancies shall include, but not be limited to, the following:

Department stores

Drug stores

Markets

Motor fuel-dispensing facilities

Retail or wholesale stores

Sales rooms

309.2 Quantity of hazardous materials. The aggregate quantity of nonflammable solid and nonflammable or noncombustible liquid hazardous materials stored or displayed in a single control area of a Group M occupancy shall not exceed the quantities in Table 414.2.5(1)."[10]

As noted under Group H above, it is very important not to exceed the limits imposed under 309.2. No one can or will build a store that is subject to the hazardous use requirements.

Residential Group R

"**310.1 Residential Group R.** Residential Group R includes, among others, the use of a building or structure, or a portion thereof, for sleeping purposes when not classified as an Institutional Group I or when not regulated by the *International Residential Code* in accordance with Section 101.2. Residential occupancies shall include the following:

R-1 Residential occupancies containing *sleeping units* where the occupants are primarily transient in nature, including:

Boarding houses (transient)

Hotels (transient)

Motels (transient)

Congregate living facilities (transient) with 10 or fewer occupants are permitted to comply with the construction requirements for Group R-3.

R-2 Residential occupancies containing *sleeping units* or more than two *dwelling units* where the occupants are primarily permanent in nature, including:

Apartment houses

Boardinghouses (nontransient)

Convents

Dormitories

Fraternities and sororities

Hotels (nontransient)

Live/work units

Monasteries

Motels (nontransient)

Vacation timeshare properties

Sleeping unit

—"A room or space in which people sleep, which can also include permanent provisions for living, eating, and either sanitation or kitchen facilities but not both. Such rooms and spaces that are also part of a dwelling unit are not sleeping units."

Dwelling unit

—"A single unit providing complete, independent living facilities for one or more persons, including permanent provisions for living, sleeping, eating, cooking and sanitation."

Boarding house

—"A building arranged or used for lodging for compensation, with or without meals, and not occupied as a single-family home."

Transient

—"Occupancy of a dwelling unit or sleeping unit for not more than 30 days."

Congregate living facilities

—"A building or part thereof that contains sleeping units where residents share bathroom and/or kitchen facilities."

Dormitory

—"A space in a building where group sleeping accommodations are provided in one room, or in a series of closely associated rooms, for persons not members of the same family group, under joint occupancy and single management, as in college dormitories or fraternity house."

Congregate living facilities with 16 or fewer occupants are permitted to comply with the construction requirements for Group R-3.

R-3 Residential occupancies where the occupants are primarily permanent in nature and not classified as Group R-1, R-2, R-4 or I, including:

Buildings that do not contain more than two *dwelling units.*

Adult care facilities that provide accommodations for five or fewer persons of any age for less than 24 hours.

Child care facilities that provide accommodations for five or fewer persons of any age for less than 24 hours.

Congregate living facilities with 16 or fewer persons.

Adult care and child care facilities that are within a single-family home are permitted to comply with the *International Residential Code.*

R-4 Residential occupancies shall include buildings arranged for occupancy as residential care/assisted living facilities including more than five but not more than 16 occupants, excluding staff."[11]

The most important distinction in Group R is between the International Building Code and the International Residential Code. The latter will be covered separately in Chapter 9, but the key issue is to understand which code applies to which project. In general, the International Residential Code applies only to one- and two-family dwellings, although the IBC does provide for a small "out" for adult care and child care facilities located in single-family homes; however, this must be carefully checked against state and local rules because it is quite feasible that such rules could eliminate this out (which is the case in the state of Indiana). In a state or locality without this out, an adult care or child care facility located in a "single-family" house would still be subject to the full requirements of the IBC.

Storage Group S

"**311.1 Storage Group S.** Storage Group S occupancy includes, among others, the use of a building or structure, or a portion thereof, for storage that is not classified as a hazardous occupancy.

311.2 Moderate-hazard storage, Group S-1. Buildings occupied for storage uses that are not classified as Group S-2, including, but not limited to, storage of the following:

Aerosols, Levels 2 and 3

Aircraft hangar (storage and repair)

Bags: cloth, burlap and paper

Bamboos and rattan

Baskets

Belting: canvas and leather

Books and paper in rolls or packs

Boots and shoes

Buttons, including cloth covered, pearl or bone

Cardboard and cardboard boxes

Clothing, woolen wearing apparel

Cordage

Dry boat storage (indoor)

Furniture

Furs

Glues, mucilage, pastes and size

Grains

Horns and combs, other than celluloid

Leather

Linoleum

Lumber

Motor vehicle repair garages complying with the maximum allowable quantities of hazardous materials listed in Table 307.1(1) (see Section 406.6)

Photo engravings

Resilient flooring

Silks

Soaps

Sugar

Tires, bulk storage of

Tobacco, cigars, cigarettes and snuff

Upholstery and mattresses

311.3 Low-hazard storage, Group S-2. Includes, among others, buildings used for the storage of noncombustible materials such as products on wood pallets or in paper cartons with or without single thickness divisions; or in paper wrappings. Such products are permitted to have a negligible amount of plastic *trim*, such a knobs, handles or film wrapping. Group S-2 storage uses shall include, but not be limited to, storage of the following:

Asbestos

Beverages up to and including 16-percent alcohol in metal, glass or ceramic containers

Cement in bags

Chalk and crayons

Dairy products in nonwaxed coated paper containers

Dry cell batteries

Electrical coils

Electrical motors

Empty cans

Food products

Foods in noncombustible containers

Fresh fruits and vegetables in nonplastic trays or containers

Frozen foods

Glass

Glass bottles, empty or filled with noncombustible liquids

Gypsum board

Inert pigments

Ivory

Meats

Metal cabinets

Metal desks with plastic tops and *trim*

Metal parts

Metals

Trim

—"Picture molds, chair rails, baseboards, handrails, door and window frames and similar decorative or protective materials used in fixed applications."

Mirrors

Oil-filled and other types of distribution transformers

Parking garages, open or enclosed

Porcelain and pottery

Stoves

Talc and soapstones

Washers and dryers"[12]

This seems to be clear enough, but what about the overlap with retail stores, especially warehouse and big box stores? Generally speaking, Group B would be considered more demanding than Group S (except for high-pile storage—that is, dense storage more than 25'-0" high—which introduces new and special requirements) because Group B assumes a higher occupant load due to the presence of customers and staff as compared to staff only in most storage occupancies. One cannot go wrong by using a more demanding classification, but there must be some justification for doing so. Otherwise, a knowledge-able owner, or even a contractor, can point out that the project could be done using the "lower" classification.

Utility and Miscellaneous Group U

"312.1 General. Buildings and structures of an accessory character and miscellaneous structures not classified in any specific occupancy shall be constructed, equipped and maintained to conform to the requirements of this code commensurate with the fire and life hazard incidental to their occupancy. Group U shall include, but not be limited to, the following:

Agricultural buildings

Aircraft hangars, accessory to a one- or two-family residence (see Section 412.5)

Barns

Carports

Fences more than 6 feet (1829 mm) high

Grain silos, accessory to a residential occupancy

Greenhouses

Livestock shelters

Private garages

Retaining walls

Sheds

Stables

Tanks

Towers"[13]

Even though this appears to cover a number of building types, in reality this group is rarely used.

So now that Assembly, Business, Educational, Factory, Hazardous, Institutional, Mercantile, Residential, Storage, and Utility Groups have been defined, how are they actually used? In any given project, each space (room or area) must be assigned an occupancy classification according to the definitions given. Then two additional steps must be taken:

1. Determine if there are any special detailed requirements based on the occupancy classification(s). This is covered in Section 5.2.
2. Determine if fire separation is required between multiple- or mixed-occupancy classifications. This is covered in Section 5.4.

5.2 Special Detailed Occupancy-Based Requirements

Special detailed requirements are covered in Chapter 4 of the 2009 International Building Code, and they include the following (in general terms):

5.2.1 COVERED MALL

The special provisions for covered mall buildings include—

- lease plans for local building and fire departments (for locating tenants);
- means of egress for each tenant;
- special occupant load calculations;
- arrangement of exits;
- distance to exits (200'-0" maximum);
- access to exits;
- minimum mall width (20'-0");
- types of construction (Type I, II, III, and IV allowed);
- fire-resistance rated separation (not required between tenants and the mall but fire partitions required between tenants);
- fire wall separation of anchor tenants;
- automatic fire protection sprinkler system;
- fire protection standpipe system;
- smoke control system for atria;
- special requirements for kiosks;
- special requirements for children's playground structures;
- special requirements for security grilles and doors that are part of the egress system;
- voice evacuation fire alarm system with standby power;
- special requirements for plastic signs, and
- marking for fire department access.

Fire alarm systems are available in several different types, which are covered in detail in Chapter 9.

> **Covered Mall or Not?**
>
> Many existing covered mall buildings are not covered mall buildings per these IBC requirements. Instead, they are unlimited area type B or type M buildings. The differences are significant because the latter has no smoke control and no voice-evacuation fire alarm system, both of which are significant cost factors. If an interior designer is working on a tenant space in one of these "non-malls", there should be no need to worry about the voice-evacuation fire alarm system.

5.2.2 HIGH-RISE BUILDINGS

The special provisions for high-rise buildings include—

- types of construction (IB up to 420 feet [128 m] high and Type IA if higher);
- 1-hour shaft enclosures for up to 420 feet (128 m) high and 2-hours for higher;
- seismic (earthquake) provisions as required by seismic zone;
- special requirements for exit enclosures and elevator hoistway enclosures;
- automatic fire protection sprinkler system;
- fire protection fire pumps;
- voice evacuation fire alarm system;
- fire command center;
- standby (minor emergency) power for the fire command center, ventilation and fire detection equipment for smoke-proof enclosures (usually stair towers), and elevators;

> **High-rise building**
>
> —A building with an occupied floor located more than 75 feet (22 860 mm) above the lowest level of fire department vehicle access. The 75 feet (22 860 mm) limitation is very important because it is derived from the maximum height that a fire department can reach from the ground with a ladder. Spaces beyond the reach of such equipment simply must be better protected.

- emergency power for exit signs and means of egress lighting, elevator car lighting, voice evacuation fire alarm system, and fire pumps;
- special means of egress requirements;
- remoteness of exit stairway enclosures;
- smoke-proof exit enclosures;
- fire service elevators; and
- occupant evacuation elevators.

Many of these special requirements for high-rise buildings are related to smoke control. When fires start, smoke development is based on the building's contents and the characteristics of the fire. But once smoke has developed, pressures change in the building—with higher pressures in the fire area as compared to adjacent areas—and smoke tends to move rapidly into adjacent areas, especially areas above the fire. Most smoke is lighter than air (it is buoyant), it is expansive, and it is hotter than air; these three factors combine to move smoke upwards during fires. This upward smoke movement is exacerbated by the "stack effect," which develops in any tall space—temperatures inherently are higher at the top of high spaces than at the bottom, which encourages upward smoke movement.

For this reason alone, stair enclosures in high-rise buildings are now required to be smoke-proof or equipped with pressurization systems. Making stairways smoke-proof requires providing a vestibule at every entrance to the stair to discourage smoke movement into the area; but these vestibules can take up lots of precious space and they are rarely used. Instead, most stairways in high-rise buildings are being designed with pressurization systems, which are fan systems that bring in large quantities of outside air to pressurize the enclosure so as to minimize smoke entrance. This applies to elevator hoistways too, but they are usually constructed as smoke-proof and not with pressurization systems.

Fire command centers, which apply to high-rise buildings and some very large projects (which might consist of multiple buildings in a common grouping), have specific requirements (Section 911 in the 2009 International Building Code), including—

- location to be approved by the local fire chief;
- 1-hour fire barrier separation from surrounding spaces;
- minimum size of 200 sf (19 m^2);
- prior approval of layout;
- voice evacuation fire alarm control;
- fire department communications (radio) control;
- fire alarm annunciator (a device that shows where a fire alarm signal originated);
- elevator car position annunciator;
- status indicators for air distribution systems;
- smoke-control firefighters control panel;
- controls for unlocking stairway doors simultaneously;
- sprinkler water flow indication;
- emergency power status;
- telephone line to the public system;
- fire pump status indicators;
- schematic building plans locating means of egress and the various systems noted above;
- a work table;
- generator supervision devices;
- public address system;

- elevator recall switch; and
- elevator emergency power selector switch(es).

Clearly, high-rise buildings require extensive and coordinated systems.

5.2.3 ATRIUMS

The special provisions for atrium include—

- low hazard uses only;
- automatic fire protection sprinkler system;
- fire alarm system;
- smoke control system with standby power (required only for 3-stories and higher);
- enclosure (1-hour fire barrier required between atrium and adjacent spaces, with some exceptions); and
- travel distance to exits (200'-0" maximum).

The atrium has become a very popular, though widely misunderstood, design feature over the past few decades. In the 1970s, an architect and developer named John Portman began to build dramatic high-rise Hyatt Regency Hotels around the country (beginning in Atlanta). These buildings are dramatic largely due to their very large atria—sometimes more than 20 stories. At the time, the codes had no provisions for such large-scale openings in high-rise buildings, and most of the projects were completed using a negotiation process with the authority having jurisdiction (AHJ). (In the case of the Indianapolis Hyatt Regency, which was combined with two high-rise office buildings around a 17-story atrium—a special building code was written just for that project. That code expired long ago and it is now mostly forgotten.)

Occasionally, an atrium is added to some of the upper floors of a large high-rise building to connect the floors occupied by a large tenant. Cases like that usually require special sprinkler system modifications to provide "deluge curtains" around the opening as well as code modification.

If an interior designer wants to build an atrium, or add an atrium to an existing building, the requirements of 2009 IBC Section 404 should be used, but it may also be necessary to bring in a code consultant, a structural engineer, an architect, a mechanical engineer, and an electrical engineer to make sure that all requirements are covered.

> **Atriums**
>
> Although it is highly desirable to design atriums in buildings, the owner must be directly involved in the decision to do so, mostly due to the high cost of smoke control with emergency power back-up and some other requirements.

5.2.4 UNDERGROUND BUILDINGS

For underground buildings, defined as building spaces having a floor level used for human occupancy more than 30 feet (9144 mm) below the finished floor of the lowest level of exit discharge, special requirements include—

- Type I construction only;
- fire protection sprinkler system;
- compartmentation;
- smoke barriers between compartments;
- elevator access from each compartment;
- smoke control system;
- voice evacuation fire alarm system;
- special means of egress requirements;

Atrium

—"An opening connecting two or more stories other than enclosed stairways, elevators, hoistways, escalators, plumbing, electrical, air-conditioning or other equipment, which is closed at the top and not defined as a mall. Stories, as used in this definition, do not include balconies within assembly groups or mezzanines that comply with Section 505."

Story

—"That portion of a building included between the upper surface of a floor and the upper surface of the floor or roof next above (also see 'Basement,' 'Mezzanine' and Section 502.1). It is measured as the vertical distance from top to top of two successive tiers of beams or finished floor surfaces and, for the topmost story, from the top of the floor finish to the top of the ceilings joists or, where there is not a ceiling, to the top of the roof rafters."

Stairway

—"One or more flights of stairs, either exterior or interior, with the necessary landings and platforms connecting them, to form a continuous and uninterrupted passage from one level to another."

Mezzanine

—"An intermediate level or levels between the floor and ceiling of any story and in accordance with Section 505."

Basement

—"A story that is not a story above grade plane (see 'Story above grade plane' in Section 202)."

Story above grade plane

—"Any story having its finished floor surface entirely above grade plane, or in which the finished surface of the floor next above is: 1. More than 6 feet (1829 mm) above grade plane, or 2. More than 12 feet (3658 mm) above the finished ground level at any point."

- smoke-proof enclosures for exit stairways;
- standby power for smoke control system, ventilation for smoke-proof enclosures, and fire pumps;
- emergency power for fire alarm system, elevator car lighting, and exit signs; and
- fire protection standpipes.

5.2.5 MOTOR VEHICLE–RELATED OCCUPANCIES

For motor vehicle–related occupancies (private garages and carports, enclosed parking garages, open parking garages, and repair garages), special requirements include—

- special separation requirements;
- openness requirements (for garages, carports, and open parking garages);
- minimum clear height of 7 feet (2134 mm);
- vehicle barrier system requirements;
- ramp requirements;
- floor surface requirements;
- special area and height increases;
- fire protection standpipes;
- fire protection sprinkler systems (not always);
- mechanical ventilation (for enclosed garages and repair garages); and
- special canopy requirements for fuel-dispensing facilities (gas stations).

5.2.6 GROUP I-2

The special requirement for Group I-2 include—

- continuous and separated corridors to exits;
- open nurses stations;
- special exceptions to corridor rules for mental health treatment areas;
- smoke barrier requirements (22,500 sf [2092 m^2] maximum smoke compartments) with refuge areas;
- fire protection sprinkler system;
- fire alarm system;
- secured yard provisions, and
- special requirements for hyperbaric facilities.

5.2.7 GROUP I-3

The special requirements for Group I-3 include—

- special definitions (cell, cell tier, housing unit, and sallyport);
- special means of egress requirements;
- special locking requirements;
- special protection of vertical openings;
- smoke barriers (200 residents maximum in a compartment) with refuge areas;
- special security glazing (windows) requirements;
- separation of housing areas;
- special windowless (nonoperable) building requirements; and
- fire alarm.

5.2.8 MOTION PICTURE PROJECTION ROOMS

For motion picture projection rooms (where cellulose acetate or other safety film is used in combination with electric arc, xenon, or other light sources), the special requirements include—

- separation of projection room;
- special room requirements including size and height;
- special room requirements for ventilation including direct machine exhaust;
- special lighting control provisions; and
- requirements for rewind and film storage facilities.

5.2.9 STAGES AND PLATFORMS

The special requirements for stages and platforms include—

- special requirements for stage construction;
- special requirements for galleries, gridirons, catwalks and pinrails (specialized stage equipment);
- special proscenium wall requirements including 2-hour rating and a fire or water curtain for the opening;
- special scenery requirements;
- emergency stage ventilation (primarily for smoke removal);
- separation requirements for dressing and appurtenant rooms;
- fire protection sprinkler system; and
- fire protection standpipe system.

These stage rules are of great significance, and it is important to understand the distinction between "stage" and "platform." Most projects—churches, schools, meeting rooms, and so on—should use platforms and not stages, mostly to avoid compliance with the challenging requirements for full stages. Stages are dangerous places, both for performers and crews. As a result of both movement and fire risk, a true stage should be built only when necessary and when the owner understands the attendant risks and costs. In some instances, a platform may look very much like a stage, having a raised surface; a proscenium opening; and front, side, and back curtains; however, if there is no provision to move the curtains vertically or to raise scenery vertically (to "fly" in stage parlance), this facility would constitute a platform and not a true stage. See Figure 5.1. Even without the special code requirements, full stages are costly simply because of the extensive architectural and

Stage

—"A space within a building utilized for entertainment or presentations, which includes overhead hanging curtains, drops, scenery or stage effects other than lighting and sound."

Platform

—"A raised area with a building used for worship, the presentation of music, plays or other entertainments; the head table for special guests; the raised area for lecturers and speakers; boxing and wrestling rings; theater-in-the-round stage; and similar purposes wherein there are no overhead hanging curtains, drops, scenery or stage effects other than lighting and sound. A temporary platform is one installed for not more than 30 days."

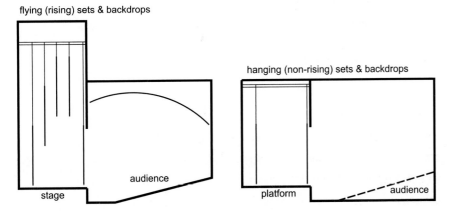

flying (rising) sets & backdrops

hanging (non-rising) sets & backdrops

audience

stage

platform

audience

FIGURE 5.1 Stage or Platform? *(drawing by the author)*

structural work that's required to accommodate flying curtains, drops, and scenery. If the curtains, drops, and scenery are 25'-0" tall (not uncommonly tall), the "fly tower" (as it's called) would have to be at least 75'-0" tall—a very tall single-story building indeed.

5.2.10 SPECIAL AMUSEMENT BUILDINGS

The special requirements for special amusement buildings include—

* automatic fire detection and voice evacuation fire alarm;
* fire protection sprinkler system; and
* special exit marking requirements.

5.2.11 AIRCRAFT-RELATED OCCUPANCIES

For aircraft-related occupancies (airport traffic control towers, heliports, residential aircraft hangar, transient hangar, and aircraft hangar), the special requirements include—

* construction type restrictions (towers can be Type IA, IB, IIA, IIB, or IIIA, depending upon their height);
* special egress requirements;
* fire alarm system;
* fire protection sprinkler system;
* standby power for pressurization equipment, mechanical equipment, lighting, elevators, and fire alarm in towers;
* 2-hour minimum fire rating for hangar walls located less than 30 feet (9144 mm) from lot lines; special basement requirements;
* floor surface requirements;
* special heating equipment restrictions (to avoid the risk of igniting fuel) in hangars; and
* fire area separation in hangars (depending upon types of planes and building construction type).

5.2.12 COMBUSTIBLE STORAGE

For combustible storage (high-pile stock or rack storage), the special requirements include—

* *International Fire Code* requirements and
* 1-hour fire separation for attic, underfloor, and concealed storage spaces.

5.2.13 HAZARDOUS MATERIALS

The special requirements for hazardous materials include—

* *International Fire Code* requirements;
* compliance with Section 415 of the *International Building Code;*
* special finish requirements;
* inventory report to the building official;
* control areas;
* special ventilation requirements;
* explosion control;

- fire alarm system;
- standby or emergency power for mechanical ventilation, treatment systems, temperature control alarm, and detection systems; and
- spill control, drainage and containment.

5.2.14 GROUP H

Groups H-1, H-2, H-3, H-4, and H-5 have numerous special requirements under Section 415 in addition to the extensive basic requirements under Section 307. And, again, detailed discussion of these requirements is beyond the scope of this book.

5.2.15 APPLICATION OF FLAMMABLE FINISHES

For the application of flammable finishes (Section 415), which applies to the use of products in finishing, usually in spray booths, the special requirements include—

- minimum 1-hour fire barrier separation for spray rooms;
- special ventilation for spraying spaces; and
- fire protection sprinkler system.

5.2.16 DRYING ROOMS

The special requirements for drying rooms include—

- noncombustible construction;
- minimum 2" clearance for overhead piping to combustible contents;
- special insulation requirements; and
- fire protection sprinkler system.

5.2.17 ORGANIC COATINGS MANUFACTURING

The special requirements for organic coatings manufacturing include—

- not located in buildings with other occupancies;
- minimum 2-hour fire barrier separation to tank storage;
- minimum 2-hour fire barrier separation to nitrocellulose storage; and
- minimum 2-hour fire barrier separation to finished products storage.

5.2.18 LIVE/WORK UNITS

The special requirements for live/work units include—

- maximum area of 3,000 sf (279 m^2);
- maximum 50% of total area as nonresidential;
- nonresidential on first floor only;
- maximum of five nonresidential workers;
- classified as R-2;
- horizontal sliding doors and spiral stairs permitted in the means of egress;
- monitored fire protection sprinkler system and fire alarm system; and
- ventilation in compliance with the *International Mechanical Code.*

Although this category of building has extensive historical precedent (as in typical smaller downtown buildings with apartments over retail or restaurant spaces), this

category is relatively new to the codes. In many localities, such combinations were effectively outlawed by zoning ordinances and such buildings were not constructed for a period of several decades in those communities. But the "new urbanism" that has grasped both cities and "edge cities" has brought back this type of structure, so the requirements have been updated accordingly. This is not to say that all such multiple-occupancy structures would be classified as "live/work" because that it not the case; this is a specific class of occupancy for limited circumstances. Other projects—usually larger projects—are done using the conventional multiple-occupancy requirements that will be covered at the end of this chapter.

5.2.19 AMBULATORY HEALTH CARE FACILITIES

The special requirements for ambulatory health care facilities include—

- smoke barriers (to form compartments not to exceed 10,000 sf (929 m^2);
- maximum travel distance to an exit of 200'-0";
- refuge areas in each smoke compartment;
- independent egress from each smoke compartment;
- fire protection sprinkler system; and
- fire alarm system.

In early versions of the International Building Code, outpatient (or ambulatory) health care facilities were classified as Group I occupancies, which greatly increased the costs for code compliance in such facilities. Recently, this has been changed and such facilities are now classified as Group B occupancies, but with these added requirements. This represents a compromise between full institutional construction, which is really not necessary for outpatient facilities (even surgery centers) due to the transient nature of the patients and short duration of most procedures, and typical commercial construction, which is somewhat inadequate for health care occupancies. This is why these additional requirements have been put in place.

Smoke Compartmentation

One of the most critical issues to mechanical engineers in an ambulatory surgery center, a hospital, or some other facilities is the requirement for smoke compartmentation, so it is vital for the interior designer to make sure that the entire team is well aware of such requirements.

5.2.20 STORM SHELTERS

Storm shelter

—"A building, structure or portion(s) thereof, constructed in accordance with ICC 500 [ICC 500-08 ICC/NSSA Standard on the Design and Construction of Storm Shelters] and designated for use during a severe wind storm event, such as a hurricane or tornado."

The special requirements for storm shelters include compliance with all requirements of ICC 500, which is beyond the scope of this book.

Suffice it to say that some entities, mostly 911 call centers and some utility operations centers, are beginning to build storm shelters in order to assure continuity of services under severe weather conditions. The standards for such construction are actually somewhat unclear, and the owner usually decides how far to go. Such facilities can be constructed as, or within, new buildings, or within existing buildings. One of the greatest challenges in designing and constructing such facilities is to assure continuity of heating, ventilating, and air-conditioning; domestic water; and emergency power.

5.3 General Building Heights and Areas

As is the case with basic construction types (as discussed in Chapter 4), there are also restrictions for overall height and area. These restrictions are based on the combination of occupancy type and construction type, as shown on Table 503 from the 2009 *International Building Code.*

Building height limitations shown in feet above grade plane. Story limitations shown as stories above grade plane.
Building area limitations shown in square feet, as determined by the definition of "Area, building," per story

GROUP		TYPE I A	TYPE I B	TYPE II A	TYPE II B	TYPE III A	TYPE III B	TYPE IV HT	TYPE V A	TYPE V B
HEIGHT(feet)		UL	160	65	55	65	55	65	50	40
		STORIES(S) AREA (A)								
A-1	S	UL	5	3	2	3	2	3	2	1
	A	UL	UL	15,500	8,500	14,000	8,500	15,000	11,500	5,500
A-2	S	UL	11	3	2	3	2	3	2	1
	A	UL	UL	15,500	9,500	14,000	9,500	15,000	11,500	6,000
A-3	S	UL	11	3	2	3	2	3	2	1
	A	UL	UL	15,500	9,500	14,000	9,500	15,000	11,500	6,000
A-4	S	UL	11	3	2	3	2	3	2	1
	A	UL	UL	15,500	9,500	14,000	9,500	15,000	11,500	6,000
A-5	S	UL	UL	UL	UL	UL	UL	UL	UL	UL
	A	UL	UL	UL	UL	UL	UL	UL	UL	UL
B	S	UL	11	5	3	5	3	5	3	2
	A	UL	UL	37,500	23,000	28,500	19,000	36,000	18,000	9,000
E	S	UL	5	3	2	3	2	3	1	1
	A	UL	UL	26,500	14,500	23,500	14,500	25,500	18,500	9,500
F-1	S	UL	11	4	2	3	2	4	2	1
	A	UL	UL	25,000	15,500	19,000	12,000	33,500	14,000	8,500
F-2	S	UL	11	5	3	4	3	5	3	2
	A	UL	UL	37,500	23,000	28,500	18,000	50,500	21,000	13,000
H-1	S	1	1	1	1	1	1	1	1	NP
	A	21,000	16,500	11,000	7,000	9,500	7,000	10,500	7,500	NP
H-2d	S	UL	3	2	1	2	1	2	1	1
	A	21,000	16,500	11,000	7,000	9,500	7,000	10,500	7,500	3,000
H-3d	S	UL	6	4	2	4	2	4	2	1
	A	UL	60,000	26,500	14,000	17,500	13,000	25,500	10,000	5,000
H-4	S	UL	7	5	3	5	3	5	3	2
	A	UL	UL	37,500	17,500	28,500	17,500	36,000	18,000	6,500
H-5	S	4	4	3	3	3	3	3	3	2
	A	UL	UL	37,500	23,000	28,500	19,000	36,000	18,000	9,000
I-1	S	UL	9	4	3	4	3	4	3	2
	A	UL	55,000	19,000	10,000	16,500	10,000	18,000	10,500	4,500
I-2	S	UL	4	2	1	1	NP	1	1	NP
	A	UL	UL	15,000	11,000	12,000	NP	12,000	9,500	NP
I-3	S	UL	4	2	1	2	1	2	2	1
	A	UL	UL	15,000	10,000	10,500	7,500	12,000	7,500	5,000
I-4	S	UL	5	3	2	3	2	3	1	1
	A	UL	60,500	26,500	13,000	23,500	13,000	25,500	18,500	9,000
M	S	UL	11	4	2	4	2	4	3	1
	A	UL	UL	21,500	12,500	18,500	12,500	20,500	14,000	9,000
R-1	S	UL	11	4	4	4	4	4	3	2
	A	UL	UL	24,000	16,000	24,000	16,000	20,500	12,000	7,000
R-2	S	UL	11	4	4	4	4	4	3	2
	A	UL	UL	24,000	16,000	24,000	16,000	20,500	12,000	7,000
R-3	S	UL	11	4	4	4	4	4	3	3
	A	UL	UL	UL	UL	UL	UL	UL	UL	UL
R-4	S	UL	11	4	4	4	4	4	3	2
	A	UL	UL	24,000	16,000	24,000	16,000	20,500	12,000	7,000
S-1	S	UL	11	4	2	3	2	4	3	1
	A	UL	48,000	26,000	17,500	26,000	17,500	25,500	14,000	9,000
S-2b, c	S	UL	11	5	3	4	3	5	4	2
	A	UL	79,000	39,000	26,000	39,000	26,000	38,500	21,000	13,500
Uc	S	UL	5	4	2	3	2	4	2	1
	A	UL	35,500	19,000	8,500	14,000	8,500	18,000	9,000	5,500

For SI: 1 foot = 304.8 mm, 1 square foot = 0.0929 m².
A = building area per story, S = stories above grade plane, UL = Unlimited, NP = Not permitted.
a. See the following sections for general exceptions to Table 503:
 1. Section 504.2, Allowable building height and story increase due to automatic sprinkler system installation.
 2. Section 506.2, Allowable building area increase due to street frontage.
 3. Section 506.3, Allowable building area increase due to automatic sprinkler system installation.
 4. Section 507, Unlimited area buildings.
b. For open parking structures, see Section 406.3.
c. For private garages, see Section 406.1.
d. See Section 415.5 for limitations.

FIGURE 5.2 Table 503 Allowable Building Heights and Areas, 2009 *International Building Code*

Here are some specific examples—

Example 5.3.1 Retail strip center (Type M) using Type II-B construction
Maximum height is 2 stories or 55 feet
Maximum area is 12,500 sf

Example 5.3.2 High-rise multi-tenant office building (Type B) using Type I-A construction
Maximum height is unlimited in stories and in feet
Maximum area is unlimited

Example 5.3.3 Mid-rise office headquarters building (Type B) using Type II-A construction
Maximum height is 5 stories or 65 feet
Maximum area is 37,500 sf

Example 5.3.4 Large multiunit apartment building (R-2) using Type III-B construction
Maximum height is 4 stories or 55 feet
Maximum area is 16,000 sf

From these examples, the relationship between risk and limitations is clear. Only Example 5.3.2 has unlimited area and height and that is due to the Type I-A construction. Lower construction types (III-B) allow for smaller buildings, in general. But it might be noticed that these seem to be relatively small areas. After all, a five-story building that totals only 37,500 sf would allow for only 7,500 sf per floor, whereas the industry standard for such office buildings is roughly 20,000 sf per floor. So how are larger buildings done?

First, these area figures really only apply to the first floor (the ground floor) of the building, and various "area increases" are permitted, as follows:

"504.2 Automatic sprinkler system increase. Where a building is equipped throughout with an *approved automatic sprinkler system* in accordance with Section 903.3.1.1, the value specified in Table 503 for maximum *building height* is increased by 20 feet (6096 mm) and the maximum number of *stories* is increased by one. These increases are permitted in addition to the *building area* increase in accordance with Section 506.2 and 506.3. For Group R buildings equipped throughout with an *approved automatic sprinkler system* in accordance with Section 903.3.1.2, the value specified in Table 503 for maximum *building height* is increased by 20 feet (6096 mm) and the maximum number of *stories* is increased by one, but shall not exceed 60 feet (18 288 mm) or four *stories*, respectively."[14]

So, for the four examples above, the automatic sprinkler system increases mean the following—

Example 5.3.1 Retail strip center (Type M) using Type II-B construction, with sprinklers
Maximum height is 3 stories or 75 feet
Maximum area is 12,500 sf

Example 5.3.2 High-rise multi-tenant office building (Type B) using Type I-A construction (sprinklers automatically required)
Maximum height is unlimited in stories and in feet
Maximum area is unlimited

Example 5.3.3 Mid-rise office headquarters building (Type B) using Type II-A construction with sprinklers
Maximum height is 6 stories or 85 feet
Maximum area is 37,500 sf

Example 5.3.4 Large multiunit apartment building (R-2) using Type III-B construction with sprinklers
Maximum height is 5 stories or 60 feet
Maximum area is 16,000 sf

As noted above, general area increases are also allowed, as follows—

"506.1 General. The *building areas* limited by Table 503 shall be permitted to be increased due to frontage (I_f) and *automatic sprinkler system* protection (I_s) in accordance with the following: $A_a = \{A_I + [A_t \times I_f] + [A_t \times I_s]\}$ where: A_a = Allowable building area per story (square feet). A_t = Tabular building area per story in accordance with Table 503 (square feet). I_f = Area increase factor due to frontage as calculated in accordance with Section 506.2. I_s = Area increase factor due to sprinkler protection as calculated in accordance with Section 506.3. . . . $I_f = [F/P - 0.25]W/30$ where: I_f = Area increase due to frontage. F = Building perimeter that fronts on a public way or open space having 20 feet (6096 mm) open minimum width (feet). P = Perimeter of entire building (feet). W = Width of public way or open space (feet) in accordance with Section 506.2.1.

Let's take example 5.3.1 again. Assume for the moment that the building is going to be 360'-0" long and 80'-0" deep (or 28,000 sf—well beyond the 12,500 sf allowed by Table 503) and that only the front of the building adjoins a public way. That makes for 360'-0" of frontage or building perimeter that fronts on a public way, or F, and for a total perimeter of 880'-0"(= 360'-0" + 360'-0" + 80'-0" + 80'-0") or P. Assume that the width of the public way is 30'-0" or W. See Figure 5.3. The frontage equation looks like this—

$$I_f = [360'\text{-}0''/880'\text{-}0'' - 0.25]30'\text{-}0''/30'\text{-}0''$$

$$I_f = [0.41 - 0.25]1$$

$$I_f = 0.16$$

Section 506.3 allows for a sprinkler system increase of 200% ($I_s = 2$) for buildings with more than one story above grade and 300% ($I_s = 3$) for single-story buildings. Because we have a single-story building, we'll use $I_s = 3$.

So now the overall area increase equation looks like this—

$$A_a = \{12,500\ sf + [12,500\ sf \times 0.16] + [12,500\ sf \times 3]\}$$

Total area = basic area + [basic area times the frontage factor]
+ [basic area times the sprinkler factor].

$$A_a = \{12,500\ sf + 2,000\ sf + 37,500\ sf\}$$

$$A_a = 52,000\ sf$$

Obviously, 52,000 sf is far greater than 28,000sf, so the proposed design is acceptable.

For multistory buildings, this works a little differently. Take Example 5.3.3 again and assume that the desired outcome is 20,000 sf per floor for six floors for a total of 120,000 sf. According to Section 506.4, for a single-occupancy building with more than one story, the total allowable building area is 3 times the basic area from Table 503 for buildings having more than 3 stories. So, in this case, the maximum allowable area is 37,500 sf \times 3 = 112,500 sf, or a little less than the 120,000 sf goal. This can be accommodated by making each floor 18,750 sf or by making some of the upper floors smaller to reduce the overall area by 7,500 sf. See Figure 5.4.

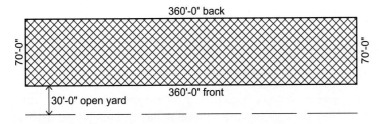

FIGURE 5.3 Strip Center Example *(drawing by the author)*

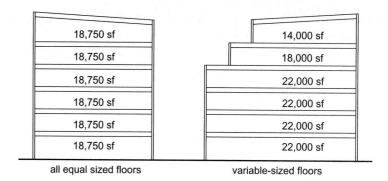

18,750 sf		14,000 sf
18,750 sf		18,000 sf
18,750 sf		22,000 sf
18,750 sf		22,000 sf
18,750 sf		22,000 sf
18,750 sf		22,000 sf

all equal sized floors variable-sized floors

FIGURE 5.4 Multistory Buildings *(drawing by the author)*

5.3.1 MEZZANINES

What is a mezzanine? The official definition is found in Section 5.2.3, but what does it mean? Historically, common uses of mezzanines have been in gymnasiums (usually for spectator seating during games and other purposes at other times), in churches (a balcony would be considered a mezzanine, technically), and sometimes in high-ceilinged restaurants and other spaces. When a space qualifies as a mezzanine, its area is not counted in the floor area of the building, mostly because the area under the mezzanine is counted. But there are significant obstacles to having a space qualify as a mezzanine.

First, there must be at least 7 feet (2134 mm) of clear vertical space above and below the mezzanine. (This would usually mean that the minimum total clear height of a space would have to be 15'-0' or so to accommodate a mezzanine.)

Second, the area of the mezzanine may not exceed 1/3 of the area of the larger room below (including the area of the mezzanine). In other words, if a room is 120' × 120' = 14,400 sf, a mezzanine could be 40' deep on one side or 20' deep on both sides. There is an exception to allow this to be increased to 2/3 in Type I and Type II structures for special industrial occupancies. In other occupancies in Type I and Type II buildings, this can be increased to 1/2.

Third, each mezzanine must have at least two independent means of egress.

Fourth, the mezzanine must be open to the larger room, except that—

- mezzanines having occupant load of 10 or less may be enclosed;
- if one of the two means of egress leads directly out of the building, at mezzanine level, the mezzanine can be enclosed;
- if the mezzanine is less than 10% of the floor area of the larger room, the mezzanine can be enclosed;
- if the mezzanine is used in an industrial facility for control equipment, it can be glazed on four sides; and
- if the mezzanine is located in a maximum two-story fully sprinklered building that is not a Group H or Group I occupancy, and it has two means of egress, it can be enclosed.

The main purpose of these requirements is to prevent substantial additional floor space to be added without having adequate exiting and fire protection. It is quite feasible to add mezzanines if these restrictions are followed.

> **Mezzanines**
>
> Mezzanines are great devices for tall spaces, but the rules must be considered carefully. Many of these rules have been implemented over the past 25 years or so because the old, less restrictive rules, were abused by enterprising designers, who were looking for ways to add "free space." As long as the rules are followed, there should be no problems.

5.3.2 AREA CALCULATIONS

How often will interior designers go through these area calculations? Virtually never because such work is done by architects. However, having a reasonable basic understanding can help interior designers recognize limitations and building types somewhat more

readily. If in working in an existing retail strip center, a solid masonry wall is encountered that extends through the roof, the interior designer should verify if that wall is a fire wall. If so, it may not be possible to remove more than 25% of that wall, even if the owner is willing to pay for it. Fire walls have often been used in such situations (and in large warehouse buildings) to avoid having to install a fire protection sprinkler system. The combination of the lack of sprinklers and the presence of a fire wall should alert the interior designer that the fire wall must be maintained intact, including protecting any openings; it could also indicate that adding a sprinkler system to the entire building could eliminate the need for the fire wall.

5.4 Multiple Occupancies and Mixed Uses

As noted previously, each room or area is to be individually classified by occupancy. Section 508.1 says

"Each portion of a building shall be individually classified in accordance with Section 302.1. Where a building contains more than one occupancy group, the building or portion thereof shall comply with the applicable provisions of Section 508.2, 508.3 or 508.4, or a combination of these sections:"[15]

5.4.1 ACCESSORY OCCUPANCIES

"508.2 Accessory occupancies. Accessory occupancies are those occupancies that are ancillary to the main occupancy of the building or portion thereof. Accessory occupancies shall comply with the provisions of Section 508.2.1 through 508.2.5.3."[16]

The requirements of 508.2.1 and others are, in brief, as follows—

- area limitation: not more than 10% of the building area of the story;
- occupancy classification: individual;
- allowable area and height: per Section 503.1 and Table 503 without increases;
- separation: none (with some exceptions for some Group H and some Group I occupancies); and
- Separation of incidental accessory occupancies: per Table 508.2.5.[17]

The incidental accessory occupancies are of great concern in most projects. As can be seen in Figure 5.5, this list includes very commonly used spaces: laundry rooms more than 100 sf, fire pump rooms, and waste and linen collection rooms more than 100 sf, although older versions of the IBC also included storage rooms more than 100sf. This last requirement was particularly troublesome, especially in retail stores. Basically, the requirements are simple: 1-hour or 2-hour fire barriers (or horizontal assembly) in unsprinklered buildings and nonrated but smoke-controlling in sprinklered buildings. Nonrated smoke-controlling simply means that the walls between one of these incidental uses and an adjacent space (any adjacent space) must be sealed to prevent smoke movement—not easily done but achievable.

It is vital to stress how these accessory occupancies are calculated. Here's an example: assume for the moment that there is a building that has a 3,000-sf conference center, 15,000 sf of general office space, three 500-sf conference rooms within the office space, one 800-sf conference room within the office space, and a 600-sf break room within the office space. Which of these smaller occupancies is accessory to the general office space?

The 3,000-sf conference center? No, because it would exceed the 10% threshold (10% of 15,000 sf is only 1,500 sf; 15,000 sf is used because that it the main occupancy).

ROOM OR AREA	SEPARATION AND/OR PROTECTION
Furnace room where any piece of equipment is over 400,000 Btu per hour input	1 hour or provide automatic fire-extinguishing system
Rooms with boilers where the largest piece of equipment is over 15 psi and 10 horsepower	1 hour or provide automatic fire-extinguishing system
Refrigerant machinery room	1 hour or provide automatic sprinkler system
Hydrogen cutoff rooms, not classified as Group H	1 hour in Group B, F, M, S, and U occupancies; 2 hours in Group A, E, I, and R occupancies.
Incinerator rooms	2 hours and automatic sprinkler system
Paint shops, not classified as Group H, located in occupancies other than Group F	2 hours; or 1 hour and provide automatic fire-extinguishing system
Laboratories and vocational shops, not classified as Group H, located in a Group E or I-2 occupancy	1 hour or provide automatic fire-extinguishing system
Laundry rooms over 100 square feet	1 hour or provide automatic fire-extinguishing system
Group I-3 cells equipped with padded surfaces	1 hour
Group I-2 waste and linen collection rooms	1 hour
Waste and linen collection rooms over 100 square feet	1 hour or provide automatic fire-extinguishing system
Stationary storage battery systems having a liquid electrolyte capacity of more than 50 gallons, or a lithium-ion capacity of 1,000 pounds used for facility standby power, emergency power, or uninterrupted power supplies	1 hour in Group B, F, M, S, and U occupancies; 2 hours in Group A, E, I, and R occupancies.
Rooms containing fire pumps in nonhigh-rise buildings	2 hours; or 1 hour and provide automatic sprinkler system throughout the building
Rooms containing fire pumps in high-rise buildings	2 hours

For SI: 1 square foot = 0.0929 m², 1 pound per square inch (psi) = 6.9 kPa, 1 British thermal unit (Btu) per hour = 0.293 watts, 1 horsepower = 746 watts, 1 gallon = 3.785 L.

FIGURE 5.5 Table 508.2.5 Incidental Accessory Occupancies, 2009 *International Building Code*

The three 500-sf conference rooms? Yes, because each room is less than 1,500 sf (the 10% threshold) and all three rooms together still do not exceed 1,500 sf.

The 800-sf conference room? It would be accessory occupancy because it is under the 10% threshold, but it must be counted as an A-3 occupancy because it exceeds 750 sf; therefore, it is NOT an accessory occupancy.

The 600-sf breakroom? Yes, because it is less than the 10% threshold and less than 750 sf.

Why does this matter? Because anything that counts as an accessory occupancy has an occupant count that is calculated the same as for the main occupancy. So, in this example, the three 500-sf conference rooms and the 600-sf break room are counted as general office space at 100 sf/occupant; so the total office occupant count is (15,000 sf − 800 sf[the larger conference room]) ÷ 100 sf/occupant = 142 occupants). The 800-sf conference room is counted at 15 sf/occupant (as unconcentrated assembly, tables, and chairs) for a count of 54 occupants (always round up with occupant counts), for a total of 196 occupants, not including the conference center. If the three conference rooms and the break room were counted individually, the count would be (15,000 sf − 800 sf − 1,500 sf − 600 sf) ÷ 100 sf/occupant = 121 plus (800 sf + 1,500 sf + 600 sf) ÷ 15 sf/occupant = 194, or a total of 315 occupants. The difference between 196 total occupants and 315 total occupants is significant in terms of exit width and stair width.

NFPA 70-2008, the National Electrical Code, requires 1-hour fire separation for rooms that contain dry-type transformers larger than 112.5 kva, which will be discussed in more detail in Chapter 9.

Required Separation of Occupancies (Hours)

OCCUPANCY	A^d, E S	A^d, E NS	I-1, I-3, I-4 S	I-1, I-3, I-4 NS	I-2 S	I-2 NS	R S	R NS	F-2, S-2^b, U S	F-2, S-2^b, U NS	B, F-1, M, S-1 S	B, F-1, M, S-1 NS	H-1 S	H-1 NS	H-2 S	H-2 NS	H-3, H-4, H-5 S	H-3, H-4, H-5 NS
A^d, E	N	N	1	2	2	NP	1	2	N	1	1	2	NP	NP	3	4	2	3^a
I-1, I-3, I-4	—	—	N	N	2	NP	1	NP	1	2	1	2	NP	NP	3	NP	2	NP
I-2	—	—	—	—	N	N	2	NP	2	NP	2	NP	NP	NP	3	NP	2	NP
R	—	—	—	—	—	—	N	N	1^c	2^c	1	2	NP	NP	3	NP	2	NP
F-2, S-2^b, U	—	—	—	—	—	—	—	—	N	N	1	2	NP	NP	3	4	2	3^a
B, F-1, M, S-1	—	—	—	—	—	—	—	—	—	—	N	N	NP	NP	2	3	1	2^a
H-1	—	—	—	—	—	—	—	—	—	—	—	—	N	NP	NP	NP	NP	NP
H-2	—	—	—	—	—	—	—	—	—	—	—	—	—	—	N	NP	1	NP
H-3, H-4, H-5	—	—	—	—	—	—	—	—	—	—	—	—	—	—	—	—	1^e, f	NP

For SI: 1 square foot = 0.0929 m².
S = Buildings equipped throughout with an automatic sprinkler system installed in accordance with Section 903.3.1.1.
NS = Buildings not equipped throughout with an automatic sprinkler system installed in accordance with Section 903.3.1.1.
N = No separation requirement.
NP = Not permitted.
a. For Group H-5 occupancies, see Section 903.2.5.2.
b. The required separation from areas used only for private or pleasure vehicles shall be reduced by 1 hour but to not less than 1 hour.
c. See Section 406.1.4.
d. Commercial kitchens need not be separated from the restaurant seating areas that they serve.
e. Separation is not required between occupancies of the same classification.
f. For H-5 occupancies, see Section 415.8.2.2.

FIGURE 5.6 Table 508.4 Required Separation of Occupancies (hours), 2009 *International Building Code*

5.5 Mixed Occupancies

Figure 5.6 shows separation requirements for all possible occupancy adjacencies.[18] This is a key concept because there are so many instances where it may appear as though fire-rated separation is required, but it really isn't. The most obvious case is a conference room, even a large conference room, within a larger office space, which is seen in nearly all office projects. If the conference room were classified as "A-3" and the office were classified as "B," a 1-hour fire barrier would be required if the building is sprinklered and a 2-hour fire barrier would be required if the building is unsprinklered. In practice, this is awkward, costly, and unnecessary. But the exceptions to Section 303.1 (as noted at the beginning of this chapter) specifically say that such spaces with occupant loads less than 50 are classified as "B" occupancies. If a conference room were larger than 750 sf, the fire separation rules would apply.

5.6 Occupant Load

So how does one determine occupant load? As in the case of occupancy classification, it's done room (or area or space) by room by assigning a classification to each room and then applying the factor provided in Figure 5.7 (Chapter 10).[19]

For the example of the office space with internal conference rooms, here are two methods to calculate the occupant load, given 18,000 gross sf overall, 1,500 sf of conference in three equal-sized rooms, 600 sf of storage, 500 sf of breakroom, and 400 sf of restrooms with two 44"-wide stairway exits accessed by two 36"-wide exit doors—

FUNCTION OF SPACE	FLOOR AREA IN SQ.FT. PER OCCUPANT
Accessory storage areas, mechanical equipment room	300 gross
Agricultural building	300 gross
Aircraft hangars	500 gross
Airport terminal Baggage claim Baggage handling Concourse Waiting areas	 20 gross 300 gross 100 gross 15 gross
Assembly Gaming floors (keno, slots, etc.)	 11 gross
Assembly with fixed seats	See Section 1004.7
Assembly without fixed seats Concentrated (chairs only—not fixed) Standing space Unconcentrated (tables and chairs)	 7 net 5 net 15 net
Bowling centers, allow 5 persons for each lane including 15 feet of runway, and for additional areas	 7 net
Business areas	100 gross
Courtrooms—other than fixed seating areas	40 net
Day care	35 net
Dormitories	50 gross
Educational Classroom area Shops and other vocational room areas	 20 net 50 net
Exercise rooms	50 gross
H-5 Fabrication and manufacturing areas	200 gross
Industrial areas	100 gross
Institutional areas Inpatient treatment areas Outpatient areas Sleeping areas	 240 gross 100 gross 120 gross
Kitchens, commercial	200 gross
Library Reading rooms Stack area	 50 net 100 gross
Locker rooms	50 gross
Mercantile Areas on other floors Basement and grade floor areas Storage, stock, shipping areas	 60 gross 30 gross 300 gross
Parking garages	200 gross
Residential	200 gross
Skating rinks, swimming pools Rink and pool Decks	 50 gross 15 gross
Stages and platforms	15 net
Warehouses	500 gross

For SI: 1 square foot = 0.0929 m^2.

FIGURE 5.7 Table 1004.1.1 Maximum Floor Area Allowances per Occupant, 2009 *International Building Code*

Method A:

Business areas, 18,000 gross sf / 100 gross	= 180 occupants

Method B:

Business areas, 15,000 gross sf / 100 gross	= 150 occupants
Conference rooms, 500 net sf / 15 net \times 3 rooms	= 100 occupants
Storage rooms, 600 gross sf / 300 gross	= 2 occupants
Breakroom, 500 sf	= ??
Restrooms, 400 sf with 4 fixtures in each room	= ??

Clearly, there's a problem with Method B because "breakroom" and "restroom" aren't found on Table 1004.1.1. When such events occur, it is reasonable to use the closest category on Table 1004.1.1, so we'll use "Assembly without fixed seats, unconcentrated" for breakroom and the number of stalls for the restrooms, which will give us

Breakroom, 500 sf / 15 net	= 33 occupants
Restrooms, 4 \times 2	= 8 occupants
Total occupant load for Method B	= 293 occupants

Which method is right? Strictly speaking, only Method B is correct due to the requirements of 508.2 noted above (unless accessory occupancies come into play; see Section 5.4.1), but the most important thing to know is that it doesn't really matter—in this particular case. The only things that are affected by the difference between 180 and 293 occupants are total egress (exit path) width, corridor and stair widths, and the number of exits required. Exiting will be covered in Chapter 6, but, for now, it should be noted that the total egress width requirements are 36" for 180 occupants and 59" for 293 occupants; that stair width is required to be 54" for 180 occupants and 88" for 293 occupants; that corridor width is required to be at least 44" for both 180 and 293 occupants; and that 2 exits are required for 50 to 500 occupants. What's different between the requirements for 180 and 293 occupants? Nothing. Because minimum exit door width is 36" and two doors are provided for a total of 72", surpassing the total egress width requirement in both cases; stair width will be at least 88" (due to a 44" minimum width), meeting the requirements in both cases; corridor width is the same, and the two exits provided meet the requirements in both cases. If the 293 occupant load increased by only one occupant, the stairs would not be wide enough though. Each case will be different and needs to be studied carefully to make sure that all provisions are covered. The example noted in Section 5.4.1 should be noted here as well. In this case, the conference rooms, restrooms, and break room are all accessory occupancies, which makes it possible to use Method A. Confused? In the example above, the difference between 180 and 293 occupants doesn't really matter; in the previous example from Section 5.4.1, the difference between 196 and 315 occupants does matter. What is important is that occupant count is calculated so as to result in reasonably safe conditions for egress and having a plausible explanation should enforcement officials disagree.

It should be noted that the occupant load of 180 (Method A above) would accommodate 150 permanent workers and 30 guests, or 120 permanent workers and 60 guests, or 100 permanent workers and 80 guests—all highly plausible scenarios.

It must also be pointed out that Method B highly exaggerates the actual number of occupants because it assumes that different occupants are in the restrooms, storage areas, conference rooms, and the breakroom than those who are in the "business areas." Although guests are certainly possible in such a facility, they are highly unlikely to exceed 100 additional occupants. It would be entirely reasonable to throw out the storage, restrooms, and breakroom figures altogether (because the office occupants would be using those spaces and they shouldn't be counted twice), which would reduce total occupant load under Method B to 250, which could still accommodate more than 70 guests. And, last, the occupant load factors themselves are non-precise in the sense that few offices can actually accommodate one occupant for each 100 gross sf; in fact, more typical offices accommodate something

It is always important for the interior designer to follow the occupant load requirements as rigorously as possible in each given situation. There is nothing to be gained from trying to argue that the occupant load of a space is 150 when the official thinks that it's 300 and there is no practical difference.

closer to one occupant for each 200 gross sf. Reaching 100 sf per occupant requires a very dense office arrangement, using small workstations or cubicles and highly efficient space plans. The one lone exception to this would be call centers, where large numbers of very small cubicles are placed in open areas, sometimes far exceeding 100 sf/occupant. In a case like that, the actual occupant count should be used instead of these load factors to make egress provisions more appropriate for the actual number of occupants in the space.

The Assembly occupancies on Table 1004.1.1 cause much confusion. Clearly, there are three Assembly classifications on the table—

- gaming
- fixed seats
- without fixed seats

The latter causes most of the problem because the other two are reasonably clear. Assemblies without fixed seats includes three subclassifications:

- concentrated (chairs only—not fixed)
- standing space
- unconcentrated (tables and chairs)

Standing space applies only to spaces where dense concentrations of occupants can be expected on a regular basis, including primarily lobbies and breakout spaces; such occupancies are usually of short duration as occupants move in and out of the larger adjoining meeting rooms, theaters, arenas, and so on.

Concentrated spaces are used primarily in "lecture" format, with individual chairs placed in rows (or some other pattern) and where tables, desks, and so on are not used. Spaces like that are really quite limited because the majority of these spaces are also used with tables, and desks. They are usually called conference or meeting rooms. If the table, or tables, in a conference room are fixed, then it would be clear that "concentrated (chairs only—not fixed)" would not apply. To be safe, one would use "concentrated" when unsure, but the ramifications of doing so are significant.

First, using "concentrated" when combined with the requirement for two exits at or above occupant load 49 (Table 1015.1 Spaces with One Exit or Exit Access Doorway, 2009 IBC, to be covered in Chapter 6) would mean that a room that is only 343 sf (49 occupants × 7 sf/occupant) would have to have two exits. Although that can be done, it could be burdensome in many circumstances—and entirely unnecessary.

Second, if the room is larger than 350 sf (50 occupants × 7 sf/occupant), the occupant load would exceed 50, which could cause the room to be fire separated from surrounding spaces.

Third, if the occupant load of the room is 49, only one means of egress (e.g., door) is required and that door can swing into the room (these details will be covered in Chapter 6), but if the occupant load is 50, two means of egress will be required and the doors will have to swing outward (in the direction of travel).

Also, how many owners would try to put 49 people into a 343 sf room? It's actually quite difficult to do, if reasonable (and code compliant) aisles are provided to get to and from the seating. For example, in a 343 sf room that is 22'-6" long by 15'-8 1/4" wide, providing a 36'-wide aisle at all four sides would use up 183 sf, or more than half of the space! Which would leave space for only 23 seats, if using 7 sf/occupant. If the "nonconcentrated" 15 sf/occupant rule is applied, the occupant count for this room would be 23 (343 sf ÷ 15 sf/occupant). In most cases, it only makes sense to use the nonconcentrated rule, unless there is solid reason to believe that the space will really be used at very high density.

This can be a problem with local officials because many of them seem to believe that the concentrated rule applies to many, if not most, potential assembly spaces. This has been observed in the field on numerous occasions. Attempts have been made to apply the

concentrated rule to a "basic" basketball gymnasium—a room with a full-sized court and only 5′ or so around all four sides, leaving no space for spectators, or anyone else really. The actual number of occupants in this space on a regular basis is highly unlikely to exceed 20, although the room could be used for community dinners for up to 400, but the local official tried to argue that the occupant load for the room exceeded 900! Exiting had been designed for the unlikely dinner scenario occupant load of more than 400, on the basis of the unconcentrated rule, and the official eventually accepted that reasoning.

> **Concentrated or Unconcentrated?**
> This is critical issue. There is nothing to be gained from arguing with an official if the official can be accommodated with little damage to the project or the owner's budget.

More recently, local officials have attempted to apply the concentrated rule to a multipurpose gathering space at a summer camp. This is a room with a platform and it is intended primarily for religious services, musical and dramatic presentations, and general recreation. Again, when considering the use of aisles, it is quite impossible to fill the space with occupants up to 7 sf/occupant net and it makes no sense to attempt to argue that the room is a concentrated assembly use. The local officials lost their argument with the state of Indiana and before an administrative law judge, but they appealed. They eventually dropped their objection.

In general, this mixed-use calculation methodology is used for nearly all projects, using appropriate and sensible adjustments where necessary. Separations must be provided where they are required, and such separations can be horizontal as well as vertical. The most critical factor is to determine a valid occupant count and to provide egress as necessary for that count. Egress requirements will be covered in detail in Chapter 6.

summary

First and foremost, it is necessary to understand how to assign an occupancy type, or types, to a facility. This is done by evaluating the design space by space, identifying accessory occupancies (where reasonable and appropriate), mixed occupancies, and separation requirements along the way.

Second, the occupancy type must be cross-checked against the building type to make sure that it is feasible to have that occupancy in the particular structure under consideration. In many jurisdictions, change of occupancy can cause a building to be brought up to all current rules, which can be so burdensome as to kill the project. This must be taken into consideration, preferably before an owner with unrealistic expectations has purchased a building.

Third, it is necessary to incorporate all special detailed requirements for the occupancy (or occupancies) at hand.

And, fourth, it is necessary to calculate occupant load in each space and for the facility as a whole in order to proceed with designing corridors, doors, stairs, and other features. The latter is the topic of Chapter 6.

results

Having completed this chapter, the following objectives should have been met:

5.1. To understand the meaning of Assembly (A), Business (B), Educational (E), Factory (F), Hazardous (H), Institutional (I), Mercantile (M), Residential (R), Storage (S), and Utility and Miscellaneous (U) occupancies and the meaning of subgroups A-1, A-2, A-3, A-4, A-5, F-1, F-2, I-1, I-2, I-3, I-4, R-1, R-2, R-3, R-4, S-1, and S-2, by having read and understood the definitions and the differences between groups and subgroups.

5.2. To understand special detailed occupancy-based requirements, by having read the requirements and by understanding the application of those requirements to real-world situations.

5.3. To understand the general meaning of building height and area, by having read and understood the basic explanation and by demonstrating basic calculations.

5.4. To understand incidental and accessory uses, by having read and understood the requirements and the explanation and by applying the requirements to real-world projects.

5.5. To understand multiple occupancies, including mixed occupancies, by having read and understood the requirements and the explanation and by applying the concepts to real-world projects.

5.6. To understand "occupant load" and the determination thereof, by having read and understood the methodology and explanation and by applying the methodology to real-world projects.

notes

1. International Building Code 2009, page 23.
2. Ibid., pages 23–24.
3. Ibid., page 24.
4. Ibid.
5. Ibid., pages 24–25.
6. Ibid., page 25.
7. Ibid., page 33.
8. Ibid., page 34.
9. Ibid.
10. Ibid.
11. Ibid., page 35.
12. Ibid., pages 35–36.
13. Ibid., page 36.
14. Ibid., page 81.
15. Ibid., page 84.
16. Ibid.
17. Ibid., page 85.
18. Ibid., page 86.
19. Ibid., page 220.

What Is Egress?

6 CHAPTER

6.1 What Is Egress?

Broadly speaking, getting occupants out of a building, especially under emergency conditions, is called "egress." (Similarly, getting those same occupants into a building could be called "ingress," but that term is rarely used.) Given that one of the most critical priorities of codes, in general, is life safety, egress requirements are—arguably—the most important requirements of all. Most of the terms involved—means of egress, public way, exit access, exit, exit discharge, level of exit discharge, exit enclosures, exit passageways, exterior exit stairway, exit ramps, and horizontal exit—were defined in Chapter 5, as related to occupancy requirements, but they will be discussed in detail in this chapter. Despite its importance, there is no technical definition of "egress" in the 2009 *International Building Code*.

These issues are covered in the all-important Chapter 10 Means of Egress in the 2009 International Building Code, beginning with some more definitions—

> **"Accessible Means of Egress.** A continuous and unobstructed way of egress travel from any *accessible* point in a building or facility to a *public way*.
>
> **Aisle.** An unenclosed *exit access* component that defines and provides a path of egress travel.
>
> **Aisle Accessway.** That portion of an *exit access* that leads to an *aisle*. . . .
>
> **Area of Refuge.** An area where persons unable to use *stairways* can remain temporarily to await instructions or assistance during emergency evacuation. . . .

objectives

6.1. To understand the meaning of "egress."

6.2. To understand when multiple exits are required.

6.3. To understand where to put multiple exits.

6.4. To understand travel distance and egress paths.

6.5. To understand exiting through intervening spaces.

6.6. To understand egress width and height.

6.7. To understand dead-end corridors.

6.8. To understand doors in egress.

6.9. To understand stairways in egress.

6.10. To understand elevators in egress.

6.11. To understand exit marking.

6.12. To understand special assembly requirements.

6.13. To understand egress and emergency egress illumination.

Common Path of Egress Travel. That portion of *exit access* which the occupants are required to traverse before two separate and distinct paths of egress travel to two *exits* are available. Paths that merge are common paths of travel. Common paths of egress travel shall be included within the permitted travel distance.

Corridor. An enclosed *exit access* component that defines and provides a path of egress travel to an *exit*. . . .

Exit. That portion of a *means of egress* system which is separated from other interior spaces of a building or structure by fire-resistance-rated construction and opening protectives as required to provide a protected path of egress travel between the *exit access* and the *exit discharge*. Exits include exterior exit doors at the *level of exit discharge*, vertical *exit enclosures*, *exit passageways*, *exterior exit stairways*, exterior *exit ramps* and *horizontal exits*. . . .

Exit Access Doorway. A door or access point along the path of egress travel from an occupied room, area or space where the path of egress enters an intervening room, corridor, unenclosed *exit access stair* or unenclosed *exit access ramp*. . . .

Floor Area, Gross. The floor area within the inside perimeter of the *exterior walls* of the building under consideration, exclusive of vent shafts and court, without deduction for corridors, stairways, closets, the thickness of interior walls, columns or other features. The floor area of a building, or portion thereof, not provided with surrounding *exterior walls* shall be the usable area under the horizontal projection of the roof or floor above. The gross floor area shall not include shafts with no openings or interior courts.

Floor Area, Net. The actual occupied area not including unoccupied accessory areas such as corridors, stairways, toilet rooms, mechanical rooms and closets."[1]

Most of these definitions are self-explanatory, except for "common path of egress travel." This term refers to shared exit paths before multiple exit options are encountered, like the typical arrangement in a small suite of offices. In such a case, the occupant of each office would exit into the corridor within the suite, in common with other occupants. Upon leaving the suite, two exit options must be available and it would no longer be a common path of egress travel.

In Figure 6.1, the egress path for the small room at the upper right corner runs through the room to its left, which is why the second room is noted as the "Intervening Room." That egress path continues through the common hallway to the corridor at the bottom. The two rooms along the hallway also have egress paths that pass through the hallway. Because the hallway has only one means of egress (i.e., the corridor), that's the "common path" of egress travel. Once the corridor is reached, an exit is available in both directions, so the common path ends.

6.2 When Are Multiple Exits Required?

All facilities, or areas, do not require two or more exits. This is determined by the table in Figure 6.2.

Evidently, under no circumstances can an occupant load of 49 be exceeded without having two exits, but even more stringent rules apply for Storage, Hazardous, and Institutional occupancies.

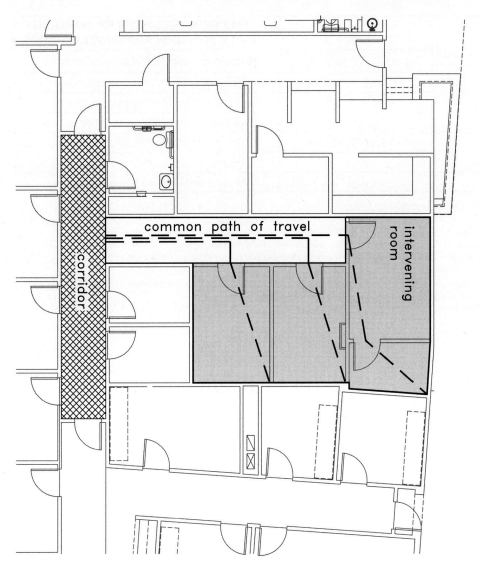

common path of travel

intervening room

corridor

FIGURE 6.1 Common Path of Egress Travel *(drawing by the author, base plan used by permission of Axis Architecture + Interiors)*

NFPA 70-2008, the National Electrical Code, requires two means of egress from a room containing electrical equipment rated 1,200 amps or larger unless double working space is provided (these requirements will be discussed in more detail in Chapter 9).

For the second story, or higher, two exits are required for Group B, F, M, and S occupant loads higher than 29 (2009 International Building Code, Table 1021.2 Stories with One Exit). See Figure 6.3.

For large facilities, three exits are required for occupant loads from 501 to 1,000, and four exits are required for occupant loads greater than 1,000 (2009 IBC, 1015.1.1, page 239). For very large facilities, a scheme would have to be worked out in conjunction with the authority having jurisdiction.

SPACES WITH ONE EXIT OR EXIT ACCESS DOORWAY

OCCUPANCY	MAXIMUM OCCUPANT LOAD
A, B, E[a], F, M, U	49
H-1, H-2, H-3	3
H-4, H-5, I-1, I-3, I-4, R	10
S	29

a. Day care maximum occupant load is 10.

FIGURE 6.2 Table 1015.1 Spaces with one Exit or Exit Access Doorway, 2009 *International Building Code*

STORY	OCCUPANCY	MAXIMUM OCCUPANTS (OR DWELLING UNITS) PER FLOOR AND TRAVEL DISTANCE
First story or basement	A, B[d], E[e], F[d], M, U, S[d]	49 occupants and 75 feet travel distance
	H-2, H-3	3 occupants and 25 feet travel distance
	H-4, H-5, I, R	10 occupants and 75 feet travel distance
	S[a]	29 occupants and 100 feet travel distance
Second story	B[b], F, M, S[a]	29 occupants and 75 feet travel distance
	R-2	4 dwelling units and 50 feet travel distance
Third story	R-2[c]	4 dwelling units and 50 feet travel distance

For SI: 1 foot = 304.8 mm.

a. For the required number of exits for parking structures, see Section 1021.1.2.

b. For the required number of exits for air traffic control towers, see Section 412.3.

c. Buildings classified as Group R-2 equipped throughout with an automatic sprinkler system in accordance with Section 903.3.1.1 or 903.3.1.2 and provided with emergency escape and rescue openings in accordance with Section 1029.

d. Group B, F, and S occupancies in buildings equipped throughout with an automatic sprinkler system in accordance with Section 903.3.1.1 shall have a maximum travel distance of 100 feet.

e. Day care occupancies shall have a maximum occupant load of 10.

FIGURE 6.3 Table 1021.2 Stories with One Exit, 2009 *International Building Code*

6.3 Where to Put Multiple Exits?

When multiple exits are required, the locations of those exits are limited—

"1015.2.1 Two exits or exit access doorways. Where two *exits* or *exit access doorways* are required from any portion of the *exit access,* the *exit* doors or *exit access doorways* shall be placed a distance apart equal to or not less than one-half of the length of the maximum overall diagonal dimension of the building or area to be served measured in a straight line between *exit* doors or *exit access doorways*. . . .

Exceptions:

1. Where *exit enclosures* are provided as a portion of the required *exit* and are interconnected by a 1-hour fire-resistance-rated *corridor* conforming to the requirements of Section 1018, the required *exit* separation shall be measured along the shortest direct line of travel within the *corridor*.

2. Where a building is equipped throughout with an *automatic sprinkler system* in accordance with Section 903.3.1.1 or 903.3.1.2, the separation distance of the *exit* doors or *exit access doorways* shall not be less than one-third of the length of the maximum overall diagonal dimension of the area served."[2]

FIGURE 6.4 Diagonal Distances *(drawing by the author)*

FIGURE 6.5 Multiple Exits *(drawing by the author)*

In the case of Figure 6.4, the diagonal measurement of the room is $\sqrt{(22'\text{-}6'' \times 22'\text{-}6''+ 15'\text{-}8 \, 1/4'' \times 15'\text{-}8 \, 1/4'')}$ = 27'-5 1/8". If the building is non-sprinklered and two exits are required, the minimum spacing would be 0.5 (one-half) × 27'-5 1/8" = 13'-8 9/16". (If two 36" doors were placed 6" from the ends of this 26'-6" room, the distance between their centers would be 18'-6", which would be more than adequate.) If the building is sprinklered and two exits are required, the minimum spacing would be 0.33 (one-third) × 27'-5 1/8" = 9'-1 11/16". For this reason alone, it is sometimes worthwhile to put in a fire-protection sprinkler system. See Figure 6.5. Note that the doors swing out and away from one another; having them open toward one another (not prohibited by the IBC) would defeat the purpose, to some degree, in having two means of egress.

When dealing with irregularly shaped spaces or buildings, the IBC is of little help. The only reference to how to measure is noted above in 1015.2.1, and all it says is "maximum overall diagonal." How would one measure the diagonal of an oval building? Or a triangular building? Or, even worse, an L-shaped building? In the first two cases, one would simply

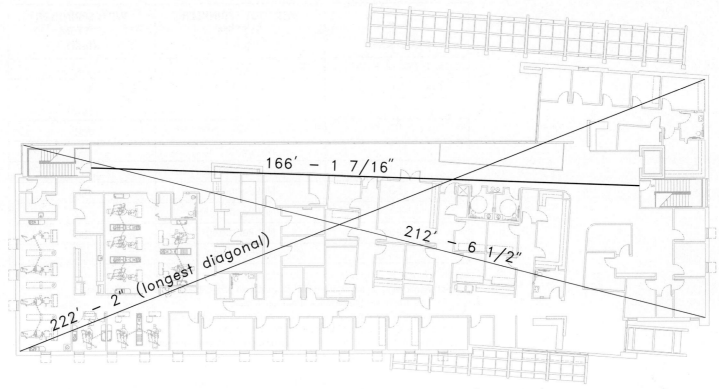

Minimum exit separation = > 0.5 x 222' – 2" = 111' – 1" (non-sprinklered)
Minimum exit separation = > 0.33 x 222' – 2" = 74' – 0 9/16" (sprinklered)
Actual exit separation = 166' – 1 7/16" (OK for sprinklered or non-sprinklered)

FIGURE 6.6 Diagonal Measurements *(drawing by the author, base plan used by permission of Axis Architecture + Interiors)*

measure the longest diagonal that would fit into the plan. For the L-shaped building, one could measure a diagonal that passes through the "void" in the crook of the L, which seems to be more than a little odd. But it would result in a longer diagonal than any diagonal that would fit within a portion of the overall shape. Using a longer diagonal is more conservative and therefore inherently safer. See Figure 6.6.

Exit Separations

There is nothing to be gained from tying to stretch the required distances for exit separations. In fact, it is best to separate exits more than the requirement to make sure that there is no problem with the officials or with egress in an emergency.

6.4 What Is Travel Distance?

The 2009 International Building Code says—

"1016.1 Travel distance limitations. *Exits* shall be so located on each *story* such that the maximum length of *exit access* travel, measured from the most remote point within a *story* along the natural and unobstructed path of egress travel to an *exterior exit* door at the *level of exit discharge*, an entrance to a vertical *exit enclosure*, an *exit passageway*, a *horizontal exit*, an *exterior exit stairway* or an exterior *exit ramp*, shall not exceed the distances given in Table 1016.1."[3] See Figure 6.7.

As can be seen in this table, increasing the level of safety in a building by adding a fire protection sprinkler system allows for increasing the allowable travel distances—which in turn allows for larger buildings. This is just one of the many trade-offs that can be made to substitute one alternative for another to maintain a reasonable degree of life safety while providing for a reasonable degree of design flexibility.

OCCUPANCY	WITHOUT SPRINKLER SYSTEM (feet)	WITH SPRINKLER SYSTEM (feet)
A, E, F-1, M, R, S-1	200	250[b]
I-1	Not Permitted	250[c]
B	200	300[c]
F-2, S-2, U	300	400[c]
H-1	Not Permitted	75[c]
H-2	Not Permitted	100[c]
H-3	Not Permitted	150[c]
H-4	Not Permitted	175[c]
H-5	Not Permitted	200[c]
I-2, I-3, I-4	Not Permitted	200[c]

For SI: 1 foot = 304.8 mm.

a. See the following sections for modifications to exit access travel distance requirements:
 Section 402.4: For the distance limitation in malls.
 Section 404.9: For the distance limitation through an atrium space.
 Section 407.4: For the distance limitation in Group I-2.
 Sections 408.6.1 and 408.8.1: For the distance limitations in Group I-3.
 Section 411.4: For the distance limitation in special amusement buildings.
 Section 1014.2.2: For the distance limitation in Group I-2 hospital suites.
 Section 1015.4: For the distance limitation in refrigeration machinery rooms.
 Section 1015.5: For the distance limitation in refrigerated rooms and spaces.
 Section 1021.2: For buildings with one exit.
 Section 1028.7: For increased limitation in assembly seating.
 Section 1028.7: For increased limitation for assembly open-air seating.
 Section 3103.4: For temporary structures.
 Section 3104.9: For pedestrian walkways.
b. Buildings equipped throughout with an automatic sprinkler system in accordance with Section 903.3.1.1 or 903.3.1.2. See Section 903 for occupancies where automatic sprinkler systems are permitted in accordance with Section 903.3.1.2.
c. Buildings equipped throughout with an automatic sprinkler system in accordance with Section 903.3.1.1.

FIGURE 6.7 Table 1016.1 Exit Access Travel Distance, 2009 *International Building Code*

One might think that this means that the travel distance is measured from the most remote point to the stair enclosure door on the upper floors of most multistory buildings, but that is the case only if the corridors are not fire-resistance-rated. If the corridor is fire-resistance-rated, the travel distance ends at the corridor itself, and any further travel along the corridor does not count against the limit. However, it is very common these days for the corridors in multistory office buildings to be non-fire-resistance-rated, so the travel distance would extend to the stair doors in most cases.

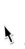

Travel Distances

Just as in exit separation, there is nothing to be gained from playing games with travel distances. Again, it is best to provide shorter than required travel distance so as to avoid arguments and future problems.

6.5 Is It Permissible to Exit Through Intervening Spaces?

Yes, with some significant exceptions, as follows—

"1014.2 Egress through intervening spaces. Egress through intervening spaces shall comply with this section.

1. Egress from a room or space shall not pass through adjoining or intervening rooms or areas, except where such adjoining rooms or areas and the area served are accessory to

one or the other, are not a Group H occupancy and provide a discernable path of egress travel to an *exit*.

Exception: *Means of egress* are not prohibited through adjoining or intervening rooms or spaces in a Group H, S, or F occupancy when the adjoining or intervening rooms or spaces are the same or a lesser hazard occupancy group.

2. An *exit access* shall not pass through a room that can be locked to prevent egress.
3. *Means of egress* from dwelling units or sleeping areas shall not lead through other sleeping areas, toilet rooms or bathrooms.
4. Egress shall not pass through kitchens, storage rooms, closets or spaces used for similar purposes. . . ."[4]

So a room can exit through another room, as long as that room is not a kitchen, storage room, or closet. Also, a room can exit through two intervening rooms if that room is within a "suite" and if the travel distance to the exit access door is 50 feet (15 240 mm) or less (IBC 2009 1014.2.4.4).[5] And, last, once an occupant has entered the exit way, it is not acceptable to pass through any intervening rooms from that point until reaching the exit discharge.

6.6 How High and Wide Does an Egress Path Need to Be?

In general, the minimum height in a means of egress is 7'-6" (with some very specific exceptions for sloping ceilings, and within dwelling units and sleeping units).[6] The minimum width (in inches) for stairways is 0.3 times the occupant load and the minimum width (in inches) for other egress components is 0.2 times the occupant load (2009 IBC, 1005.1).[7]

Here is the example from Chapter 4 again—

Occupant Load	180 occupants	293 occupants
Stairway width (total)	$180 \times 0.3 = 54"$	$293 \times 0.3 = 88"$
Other components width (total)	$180 \times 0.2 = 36"$	$293 \times 0.2 = 59"$

These totals should be equally divided among the number of exits required. In this example, there are two stairway doors, so each door could be $36" \div 2 = 18"$, according to this formula. But the minimum opening for a stairway door is 32" (see Section 6.8). The larger dimension rules, so the minimum exit width becomes 64" instead of 36" as given by the formula. For swinging doors, the fully open door (against the wall) cannot reduce the required width by more than 7", and it cannot reduce the required width by more than half in any position. Non-structural decorative trim and other features are allowed to encroach up to 1 1/2" on each side (IBC 2009, 1005.2).[8]

Corridors are to be fire-resistance-rated according to Table 1018.1 Corridor Fire-Resistance Rating (see Figure 6.8). This table makes it clear that fire protection sprinkler systems are required for Groups H, R, and I occupancies and that they are optional for Groups A (not usually), B, E, F, M, S, and U occupancies. Corridor width is required to be 24 inches (610 mm) for access to and utilization of electrical, mechanical, and plumbing equipment; 36 inches (914 mm) for occupant loads below 50; 36 inches (914 mm) within a dwelling unit; 72 inches (1829 mm) in Group E at occupant load of 100 or more; 72 inches (1829 mm) in medical occupancies having gurney traffic; 96 inches (2438 mm) in Group I-2 occupancies where required for bed movement, and 44" everywhere else (2009 IBC, 1018.2).[9] The last rule is by far the most commonly used, and nearly all corridors are at least 44" wide.

Corridor Width

Even though most corridors are built to a net dimension of 44", it is best to enlarge this slightly to make sure that an inadvertent construction error doesn't create an illegal corridor. After all, 43.875" is illegal.

OCCUPANCY	OCCUPANT LOAD SERVED BY CORRIDOR	REQUIRED FIRE-RESISTANCE RATING (hours)	
		Without sprinkler system	With sprinkler system[c]
H-1, H-2, H-3	All	Not Permitted	1
H-4, H-5	Greater than 30	Not Permitted	1
A, B, E, F, M, S, U	Greater than 30	1	0
R	Greater than 10	Not Permitted	0.5
I-2[a], I-4	All	Not Permitted	0
I-1, I-3	All	Not Permitted	1[b]

a. For requirements for occupancies in Group I-2, see Sections 407.2 and 407.3.
b. For a reduction in the fire-resistance rating for occupancies in Group I-3, see Section 408.8.
c. Buildings equipped throughout with an automatic sprinkler system in accordance with Section 903.3.1.1 or 903.3.1.2 where allowed.

FIGURE 6.8 Table 1018.1 Corridor Fire-Resistance Rating, 2009 *International Building Code*

6.7 Is It Acceptable to Have Dead-End (i.e., One Way Out) Corridors?

Yes, if they are 20'-0" long, or less (except in I-3 Condition 2, 3, or 4 occupancies and in sprinklered B, E, F, I-1, M, R-1, R-2, R-4, S, and U occupancies where the maximum length is 50'-0"). Also, there is no limit to the length if the dead-end is less than 2.5 times the width of the corridor.[10] In the latter case, if there were a 25'-0" wide corridor in a convention center, it would be acceptable for a dead-end to be 2.5 × 25'-0" = 62'-6" long. See Figure 6.9.

What this shows is that the maximum length of a dead-end corridor is either (a) 20'-0" (for non-sprinklered buildings and some occupancies), (b) 50'-0" (for most sprinklered buildings), or (c) 2.5 times the width of the corridor, whichever is GREATER. For a typical 44" wide corridor, 2.5 times the width is only 9'-2", so the 20'-0" or 50'-0" conditions prevail depending on the circumstances. For wide corridors in malls, convention centers, schools, airports, and so on, dead ends could be longer than 50'-0".

6.8 How Do Doors Affect Egress?

Doors are critical exit components because they both provide access to and limit access to exit ways. They provide access simply by allowing entry into protected exit ways: vertical stair enclosures, corridors, exit passageways, and horizontal exits. They limit access because they are physically smaller (usually) than the exit ways themselves, mostly for practical reasons.

So how large does an exit door have to be? And what other special requirements are there?

Door widths are required to be sufficient for the occupant load served or no smaller than 32 inches (813 mm) clear opening, whichever is larger. The clear opening is measured with the door open 90 degrees, as the distance from the door face to the strike-side (opposite) stop. The maximum width for a single egress door leaf is 48 inches (1219 mm). Egress doors in I-2 occupancies must provide clear openings at least 41 1/2 inches (1054 mm) for the movement of

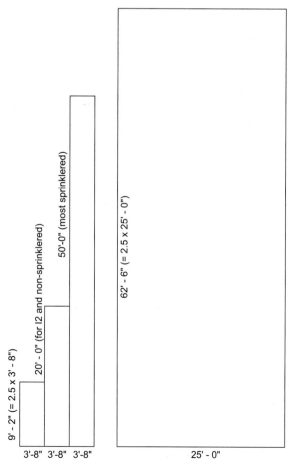

FIGURE 6.9 Maximum Dead-End Corridor *(drawing by the author)*

9'-2" (= 2.5 x 3'-8")
20'-0" (for I2 and non-sprinklered)
50'-0" (most sprinklered)
62'-6" (= 2.5 x 25'-0")

3'-8" 3'-8" 3'-8" 25'-0"

beds. Clear height must be at least 80 inches (2032 mm), or 6'-8", and projections (i.e., hardware, including knobs, handles, push plates) may not encroach below 34 inches (864 mm) above the floor (2009 IBC, Section 1008.1).[11]

Egress doors must be "of the pivoted or side-hinged swinging type,"[12]

except for—

- private garages, office areas, factory and storage areas having occupant load of 10 or less;

- Group I-3 occupancies;

- critical or intensive care patient rooms in health care;

- doors within dwelling units in Groups R-3 and R-4;

- revolving doors (except in Group H) [*note the exception to the exception here*];

- power-operated sliding doors;

- bathroom doors within individual sleeping units in Group R-1; and

- manual sliding doors where the occupant load is 10 or less (except in Group H).

Egress doors must swing in the direction of travel when serving an occupant load of 50 or more or any Group H occupancy.[13]

The force to push or pull interior swinging doors may not exceed 5 pounds (22 Newtons [N]) except for fire doors. Collapsible revolving doors may be used as egress doors as long as a minimum clear path of 36 inches (914 mm) is provided and the revolutions per minute do not exceed the requirements of Table 1008.1.4.1 Revolving Door Speeds.[14]

Power-operated swinging and horizontal sliding doors may be used for egress as long as the doors have features for manual opening and closing in the event of a power failure. In most occupancies, access-controlled (automatically locked) doors may be used for egress as long as they are fail-safe, meaning that the doors must unlock if the power fails.[15]

There must be a landing on each side of every egress door, with slope of 0.25 unit vertical to 12 units horizontal (2%) or less. The landing must be at least as wide as the door or stairway, whichever is larger, and at least 44 inches (1118 mm) long in the direction of travel.[16] This landing requirement is quite important because it can have a major effect on spacing planning. Just remember, ALL egress doors must have full landings on both sides.

Having reviewed multiple exiting requirements and door requirements, a few examples might help to clarify the issues. The following five figures will illustrate the principles involved by using a single 4,900 sf "business" space. Each figure will be followed with a specific explanation.

In Figure 6.10a, the occupant load is 4,900 sf ÷ 100 sf/occupant = 49 occupants, so just one exit is required, which could be located anywhere along the perimeter. The door can also swing inward because the occupant load is below 50.

In Figure 6.10b, interior walls have been added to define offices and storage spaces. The occupant load doesn't change because all of the space is still "business." So the number of exits is still one and the door can still swing inward. The exit door can be located anywhere in the "corridor/lobby" space. This could create a problem with a dead-end corridor that's longer than 50'-0" (if this is a sprinklered building; 20'-0" if it's non-sprinklered). If so, a door can be placed across the corridor at the 50'-0" (or slightly less) point to eliminate that problem.

Sliding Doors

These days, sliding egress doors are very popular in interior design, but it is necessary for the interior designer to make sure that sliding doors are allowed for the application in question and that all provisions are met.

Door Landings

Door landings also cannot be overemphasized. Interior designers simply must design every door with a full landing on both sides to avoid problems.

4,900 gsf

office

occupant load = 4,900 sf / 100 sf/occupant = 49
number of exits required = 1
exit doors can swing in

FIGURE 6.10a Exiting for 4,900 sf of business space *(drawing by the author)*

4,900 gsf

occupant load = 4,900 sf / 100 sf/occupant = 49
number of exits required = 1
exit doors can swing in

FIGURE 6.10b Exiting for 4,900 sf of business space
(drawing by the author)

4,900 gsf

occ. load = 4,135 sf / 100 sf/occ = 41 + 51 = 92
number of exits required = 2
exit doors must swing in the direction of travel
min. exit separation @ conf = $\frac{1}{2}$ of room diagonal
min. overall exit separation = $\frac{1}{2}$ of overall diagonal

FIGURE 6.10c Exiting for 4,900 sf of business space *(drawing by the author)*

In Figure 6.10c, this is now a multiple occupancy that combines Business and Non-Concentrated Assembly. The occupant load is now 4,135 sf ÷ 100 sf/occupant = 41 occupants plus 765 sf ÷ 15 sf/occupant = 51 for a total of 92 occupants, so two exits are now required—both from the conference room itself and from the overall space. Assuming that this facility is located in a non-sprinklered building (such information is not given so one must assume the worst case—non-sprinklered), the exits must be separated by at least 1/2 of the greatest diagonal measurement of the space served (applying both to the conference room and the overall space—and as shown by the two diagonal lines). The doors shown in the conference room are located at the minimum separation; the separation of the two overall exits exceeds the requirement. Also, the exit doors must swing out from the conference room and from the overall space. The corridor outside the conference room is shown at 5'-0" wide to allow for the conference room doors to swing into the corridor, where the minimum width would be 36" (the width of the door) plus 1/2 of the required exit width (which is 44" ÷ 2 = 22") for a total minimum width of 58" (4'-10"). Exit signs are also required when two or more exits are required.

In Figure 6.10d, this is also a multiple occupancy, as in Figure 6.10c. Nothing has changed except that the dead-end corridor on the right side could be a problem as it was in Figure 6.10b.

In Figure 6.10e, things change again, due to the two separate corridors. The corridor on the right requires two exits as in Figure 6.10c, but now the corridor on the left requires its own exit; the dead-end corridor rule would apply to the left side corridor in this case too.

These examples show that some things matter and that some things don't—it is hoped in a clearer way than in the general review. All of these overlapping requirements must be considered simultaneously to make sure that all issues are addressed.

6.8.1 DOOR HARDWARE

There are numerous special requirements for hardware for egress doors, as follows—

Accessibility requirements apply to ALL egress doors (see Chapter 7 for more details).

Handles, pulls, latches, locks, and so on are to be installed between 34 inches (864 mm) and 48 inches (1219 mm) above the finished floor (2009 IBC 1008.1.9.2).[17]

In general, egress doors may not have key-operated locking devices from the egress side, except in Groups A (occupant load less than 300), B, F, M, and S, where the locking device is readily distinguishable and where a sign is placed reading "THIS DOOR TO REMAIN UNLOCKED WHEN BUILDING IS OCCUPIED." A local official can revoke this exception if there is a specific reason (2009 IBC 1008.1.9.3).[18]

Manually operated flush bolts or surface bolts (i.e., devices that require manual movement of sliding components for locking and unlocking) are not permitted for egress doors (2009 IBC 1008.1.9.4).[19]

The unlatching of any egress door must be done in a single operation (i.e., turn of the key, or turn of a handle, but not both) (2009 IBC 1008.1.9.5).[20]

Electromagnetic locks may be used for egress doors if the hardware is listed, there is a built-in switch (to turn off the lock), and a power failure automatically unlocks the door. The latter is called "fail-safe" and it applies to all situations except some very limited circumstances in jails, prisons, and high-security psychiatric facilities. This includes stairway doors too, where there is an additional requirement to unlock all stairway doors simultaneously in the event of a power failure or an emergency (2009 IBC 1008.1.9.8).[21]

Where the occupant load exceeds 50 in a Group A or E occupancy, all egress doors must have panic hardware, often called "panic bars." These are the devices that automatically unlock and unlatch a door when pressure is applied to the device, which prevents crowds of people from getting trapped by latched (or locked) exit doors under panic circumstances. This also applies to electrical rooms housing equipment rated 1,200 amperes or more and more than 6 feet (1829 mm) wide (2009 IBC 1008.1.10).[22]

6.9 How Do Stairways Affect Egress?

Stairways are an unavoidable and critical part of the egress system for upper and lower levels of buildings. Egress stairways must be at least 44 inches (1118 mm) wide (except for stairways serving occupant loads of less than 50 which can be 36 inches (914 mm) wide) and have at least 80 inches (1981 mm) of headroom. Headroom is measured from a line connecting together the nosings to whatever is overhead and must extend at least one tread depth beyond the bottom riser (2009 IBC 1009).[23]

Landings are required at the top and bottom of each run of stairs. Landings must be as wide as the stairs and at least 48 inches (1219 mm) or the width of the stairs in the direction of travel, whichever is smaller for a straight-run stair. Corner landings where stairs turn must be as wide as the stairs in both directions. Doors opening onto a landing may not reduce the required dimensions by more than half (2009 IBC 1009.5).[24] See Figure 6.11.

Space under stairways may be enclosed using 1-hour fire-resistance-rated construction if the access is not directly through the stair enclosure (2009 IBC 1009.6.3).[25] This means that a storage space under a stair must be accessed from outside the stair. See Figure 6.12

The maximum vertical rise of a stair between floors, landings, or floors and landings is 12 feet (3658 mm) (2009 IBC 1009.7).[26] This means that stairs that run more than 12 feet (3658 mm) vertically must have an intermediate landing or landings. There is no restriction on where to put such landings, as long as the 12 feet (3658 mm) requirement is observed. In other words, a stairway running 15 feet (4573 mm) vertically could have a landing at +3 feet (915 mm), at +12 feet (3658 mm), or anywhere in between.

Handrails are required on both sides of stairs, with the following exceptions—

1. Aisle stairs
2. Stairways within dwelling units, spiral stairs and aisle stairs for seating on one side
3. Decks, patios, and walkways with oversized landings
4. In Group R-3 for single riser stairs
5. In Groups R-2 and R-3 for three or fewer riser within dwelling units and sleeping units

Egress ramps have very similar rules to stairs for stairs—

- maximum vertical rise between landings is 30 inches (762 mm);
- minimum width between rails is 36 inches (914 mm);
- minimum headroom is 80 inches (2032 mm); and
- landing have to be 60 inches (1525 mm) long.

Maximum slope is one unit vertical to 12 units horizontal, or 8%, and maximum cross slope is one unit vertical to 48 units horizontal, or 2% (2009 IBC 1010).[27] See Figure 6.13.

4,900 gsf

occ. load = 4,135 sf / 100 sf/occ = 41 + 51 = 92
number of exits required = 2
exit doors must swing in the direction of travel
min. exit separation @ conf = $\frac{1}{2}$ of room diagonal
min. overall exit separation = $\frac{1}{2}$ of overall diagonal

FIGURE 6.10d Exiting for 4,900 sf of business space
(drawing by the author)

4,900 gsf

occ. load = 4,135 sf / 100 sf/occ = 41 + 51 = 92
number of exits required = 3
exit doors must swing in the dir. of travel @ right side
min. exit separation @ conf = $\frac{1}{2}$ of room diagonal
min. overall exit separation = $\frac{1}{2}$ of overall diagonal

FIGURE 6.10e Exiting for 4,900 sf of business space
(drawing by the author)

Handrails for stairs and ramps must be—

- mounted between 34 inches (864 mm) and 38 inches (965 mm) above the stair or ramp;
- Type I circular handrails must be at least 1 1/4 inches (32 mm) and no more than 2 inches (102 mm) outside diameter; and
- Type II noncircular handrails must have a perimeter of at least 4 inches (102 mm) and no more than 6 inches (160 mm) with a maximum cross-sectional dimension of 2 1/4 inches (57 mm) and with edges having a minimum radius of 0.01 inches (0.25 mm) (2009 IBC 1010.8).[28]

Type II handrails are large rails with graspable finger recesses on both sides near the top, and they are infrequently used.

Handrails must be continuous, without interruption by newel posts or other obstructions, and must extend at least 12 inches (305 mm) beyond the top riser and at least one tread depth beyond the bottom riser, and there must be at least 1 1/2 inches (38 mm) between the handrail and the wall or other surface (2009 IBC 1012).[29] See Figure 6.14.

Guards are required wherever there is an open-sided walking surface that is more than 30 inches (762 mm) above the lower surface (2009 IBC 1013).[30] This nearly always applies to stairs and stair landings. Guards are required to be at least 42 inches (1067 mm) high with no openings large enough for a 4 inch (102 mm) sphere to pass through (2009 IBC 1013.3).[31] See Figure 6.15.

Numerous other accessibility requirements apply as well, which will be covered in detail in Chapter 7.

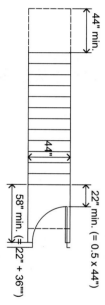

FIGURE 6.11 Stairway Requirements *(drawing by the author)*

6.10 How Do Elevators Affect Egress?

In general, elevators, escalators, and moving walks are not to be used as part of the egress system. However, elevators having emergency power backup that are accessible from areas of refuge or horizontal exits in non-sprinklered buildings and from any part of the egress system in sprinklered buildings and that comply with the signaling requirements of Section 2.27 of ASME A17.1 may be used for egress (2009 IBC 1007.5).[32] Nonetheless, it is best to avoid attempting to use an elevator for egress because only elevators in relatively new high-rise buildings have emergency power backup and elevator hoistways are prone to moving smoke during fires.

6.11 What Is Exit Marking?

Under the 2009 IBC, exits and exit doors must be clearly marked where two or more exits are required, using approved exit signs. Every point in the corridor or passageway must be within 100 feet (30 480 mm) of an exit sign, but exit signs can be omitted from main exterior exit doors that are obviously and clearly identifiable when approved by the building official and from individual sleeping and dwelling units in Groups R-1, R-2, and R-3. Exit signs are to be internally (nearly universal) or externally illuminated, and illuminated at all times (2009 IBC 1011).[33] Most internally illuminated exit signs use LED lamps these days, but cold cathode, fluorescent, and even incandescent lamp options are also available. (Up-to-date energy codes limit the wattage that can be used in exit signs.)

Internally illuminated exit signs come in two basic types: back-lit and edge-lit. Back-lit signs consist of lamps in a housing with a stenciled faceplate with either red or green "exit" letters, with or without directional arrows. Edge-lit signs consist of lamps in a small

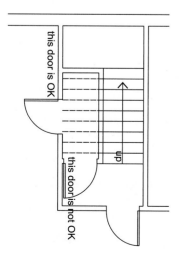

FIGURE 6.12 Space Under Stairs *(drawing by the author)*

housing along an edge with red or green "exit" letters and/or directional arrows applied to the edge-lit faceplate. Edge-lit signs are considered more attractive, but they are considerably more costly. Back-lit signs are available with thermoplastic (the least costly and most common), steel, and aluminum housings, and even in outdoor, weather-proof versions.

Exit signs are required to operate for at least 90 minutes in case of primary power failure, so they require either internal batteries or an external emergency power source (2009 IBC 1011.5.3).[34] Internal batteries are simpler to install, but they require careful, and costly, maintenance, especially if the owner wants to be in full compliance with NFPA (not necessarily code) requirements for testing.

Exit signs should be located to identify the exit path and to direct occupants through the exit path. This means that both ends of all corridors serving occupant loads of 50 or more must have exit signs; all stairway doors must have exit signs; most corners in corridors should have exit signs, and additional signs could be required at visual obstacles, offsets, and other special features that block direct view to an exit door. See Figure 6.16.

New requirements for luminous path markings have been added for high-rise buildings housing Groups A, B, E, I, M, and R-1 occupancies in the 2009 IBC. This includes both self-luminous and photo-luminescent materials, but the key issue is that these are not electrical devices. Instead, these materials are tapes or paints that have to be continuously (more or less) applied to the top of handrails, along the bottoms of walls, along the floors, and across landing and stair nosings (2009 IBC 1024).[35]

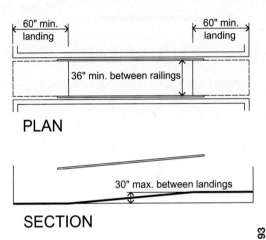

FIGURE 6.13 Ramp Requirements *(drawing by the author)*

6.12 What Are Special Assembly Requirements?

In environments with fixed seating (e.g., large lecture rooms, theaters, arenas, stadia), special requirements come into play. These include minimum aisle widths, maximum travel distances to aisles, and minimum row-to-row spacing. There are two sets of such requirements, for "smoke-protected" and "non-smoke-protected" facilities. Given that only the largest facilities are likely to be smoke-protected (arenas and stadia), discussion of those requirements is beyond the scope of this book. The following discussion summarizes the requirements for non-smoke-protected facilities.

"1028.9.1 Minimum aisle width. The minimum clear width of *aisles* shall be as shown:

1. Forty-eight inches (1219 mm) for *aisle stairs* having seating on each side.

 Exception: Thirty-six inches (914 mm) where the *aisle* serves less than 50 seats.

2. Thirty-six inches (914 mm) for *aisle stairs* having seating on only one side.
3. Twenty-three inches (584 mm) between an *aisle stair handrail* or *guard* and seating where the *aisle* is sub-divided by a *handrail*.
4. Forty-two inches (1067 mm) for level or ramped *aisles* having seating on both sides.

 Exceptions:
 1. Thirty-six inches (914 mm) where the *aisle* serves less than 50 seats.
 2. Thirty inches (762 mm) where the *aisle* does not serve more than 14 seats.
5. Thirty-six inches (914 mm) for level or ramped *aisles* having seating on only one side.

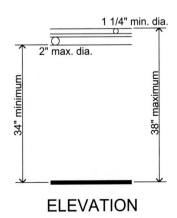

ELEVATION

FIGURE 6.14 Hand Rails *(drawing by the author)*

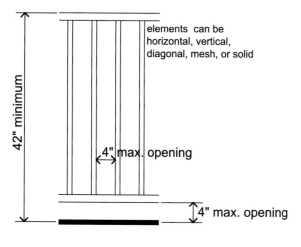

elements can be horizontal, vertical, diagonal, mesh, or solid

42" minimum

4" max. opening

4" max. opening

ELEVATION

FIGURE 6.15 Guards *(drawing by the author)*

Exceptions:

1. Thirty inches (762 mm) where the *aisle* does not serve more than 14 seats.
2. Twenty-three inches (584 mm) between an *aisle stair* handrail and seating where an *aisle* does not serve more than five rows on one side."[36]

The only thing that's very clear here is that aisles have to be either 30 inches (762 mm), 36 inches (914 mm), or 42 inches (1067 mm) wide, where the aisles serve seats on both sides at 14 or fewer seats, 50 or fewer seats, or more than 50 seats respectively. Also, aisle stairs have to be wider than the aisles, in most cases. In such circumstances, that really means that the aisles have to be as wide as the stairs.

Generally speaking, aisle widths have to accommodate whatever number of persons is being served, including converging aisles. Where two smaller aisles converge into a larger aisle (as in the front or back of most such arrangements), the combined aisle must accommodate the combined capacity of the two smaller converging aisles.

According to 1028.9.4, where egress is possible in both directions, aisle width should be uniform (2009 IBC 1028.9.4).[37]

According to 1028.9.5, aisles are required to terminate at cross aisles, foyers, doorways, vomitories (i.e., a tunnel from the "house" to the "lobby"), or concourses having access to exits. Dead-end aisles may not exceed 20 feet (6096 mm) (2009 IBC 1028.9.5).[38]

The spacing between rows is critical too. The general rule (1028.10) is to provide a minimum of 12 inches (305 mm) between the back of a row and the nearest projection of the row behind (i.e., in other words, between the farthest point back on the back of the seat and the nearest forward on the front of the seat in the next row). If the seats can be raised, the measurement can be taken with the seats in the up position, which explains why many theaters and other similar facilities can get so congested. If tablet arms are used, the measurement is taken with the tablets in the in-use position (2009 IBC 1028.10).[39]

For rows having aisles at both ends, the maximum number of seats in the row is 100, and the 12 inches (305 mm) minimum is to be increased by 0.3 inch (7.6 mm) for each additional seat beyond 14, up to and including a maximum width of 22 inches (559 mm). For example, if a theater had continental (i.e., no center aisle) seating with 50 seats in each row, the minimum width would be 12 inches (305 mm) plus $0.3 \times 36 = 12$ inches (305 mm) + 10.8 inches (275 mm) = 22.8 inches (580 mm), which exceeds the maximum. So the spacing would be 22 inches (559 mm) in this case, or if there were more than 50 seats in each row (2009 IBC 1028.10.1).[40]

For rows having access at one end, there is no maximum number of seats, but the minimum width is 12 inches (305 mm) plus 0.3 inch (7.6 mm) for each additional seat beyond seven, not to exceed 22 inches (559 mm). For example, if an aisle served 20 seats on one side only, the minimum spacing between rows would be 12 inches (305 mm) plus $0.3 \times 13 = 12$ inches (305 mm) plus 3.9 inches (99 mm) = 15.9 inches (404 mm) (2009 IBC 1028.10.2).[41]

There are additional requirements for aisle walking surfaces (1028.11), seat stability (1028.12), handrails (1028.13), assembly guards including sight-line constrained guard heights (1028.14), and bench seating (1028.15). The latter requirement applies primarily to churches that use pews, and the occupant load requirement is one person for each 18 inches (457 mm) of length. As a result of increases in average body size in the United States in recent years, this very old bench seating rule tends to exaggerate actual occupancy (2009 IBC 1028.11–1028.15).[42]

6.13 What Is Egress Lighting?

Egress illumination is required during all occupied hours for the entire means of egress in all buildings, from exit access to exit discharge, except for Group U; dwelling units and sleeping units in Groups R-1, R-2, and R-3; sleeping units of Group I; and aisle access ways in Group A.

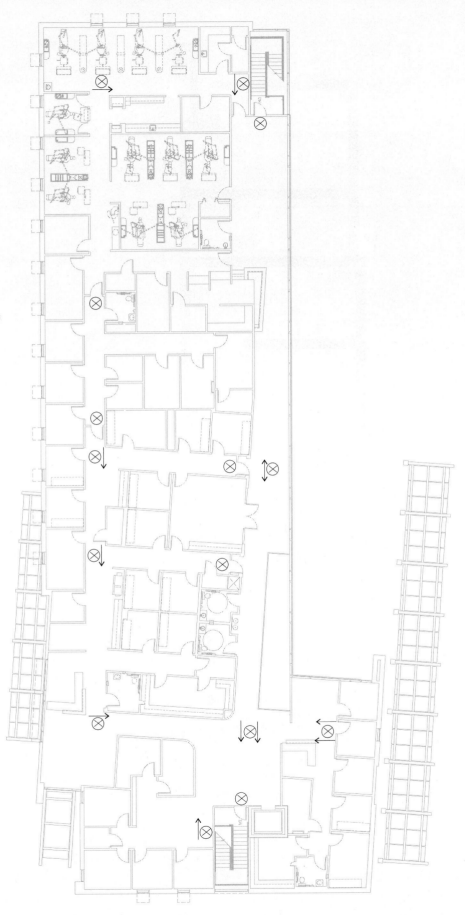

FIGURE 6.16 Exit Sign Locations *(drawing by the author, base plan used by permission of Axis Architecture + Interiors)*

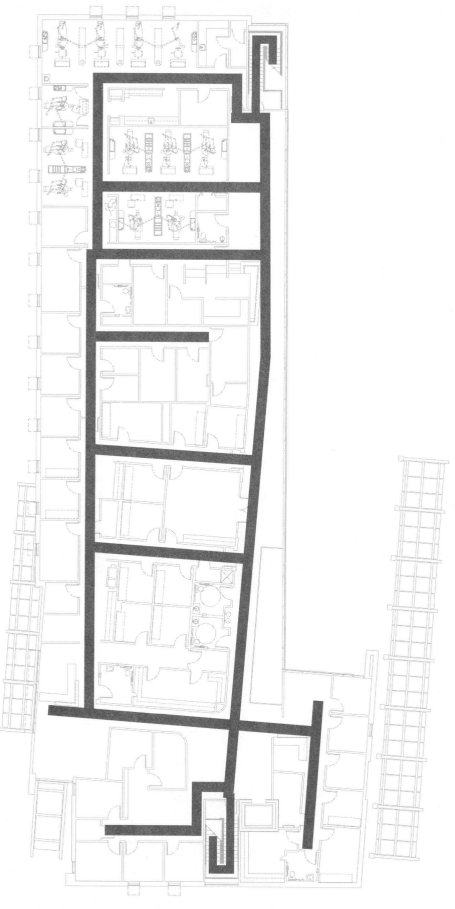

FIGURE 6.17 Egress and Emergency Egress Illumination *(drawing by the author, base plan used by permission of Axis Architecture + Interiors)*

The minimum level is 1 foot-candle (11 lux) at the walking surface, which can be reduced to 0.2 foot-candle (2.15 lux) during performances in auditoriums, theaters, concert or opera halls, and similar assembly occupancies (2009 IBC 1006).[43]

If the main power supply fails, an emergency electrical system (batteries or a generator) is required to operate the egress lighting for at least 90 minutes. Emergency egress illumination is required for the following specific areas (not the full path, as noted above for egress illumination):

1. "*Aisles* and unenclosed egress *stairways* in rooms and spaces that require two or more *means of egress*.

2. *Corridors*, *exit enclosures* and *exit passageways* in buildings required to have two or more *exits*.

3. Exterior egress components at other than their *levels of exit discharge* until *exit discharge* is accomplished for buildings required to have two or more *exits*.

4. Interior *exit discharge* elements, as permitted in Section 1027.1, in buildings required to have two or more *exits*.

5. Exterior landings as required by Section 1008.1.6 for *exit discharge* doorways in buildings required to have two or more *exits*" (2009 IBC 1006.3).[44]

Emergency egress illumination is also functionally different because it is required to provide an initial average of 1 foot-candle (11 lux)—not the 1 foot-candle (11 lux) minimum for egress lighting—and a minimum of 0.1 foot-candle (1 lux) with a maximum-to-minimum ratio not to exceed 40:1. Also, these levels are allowed to decline to 0.6 foot-candle (6 lux) and 0.06 foot-candle (0.6 lux) at the end of the 90-minute period (2009 IBC 1006.4).[45]

> **Emergency Egress Lighting**
>
> It is actually difficult to meet the emergency lighting requirements when using dedicated emergency-only fixtures (such as the wall-mounted two-headed fixtures that are all over the place). Calculations should be done for emergency egress lighting to confirm that all requirements are met.

There is one key distinction here that is easily missed, which relates to the official definition of exit discharge – "That portion of a *means of egress* system between the termination of an *exit* and a *public way*."[46] Because the egress lighting requirement specifically mentions the exit discharge, this means that egress lighting is required to be provided to the public way whenever the building is occupied, which is done easily enough under normal power. But item 5 on the list above, for emergency egress illumination, specifically says that such illumination is required at "exterior landings" for exit discharge doorways. This is an entirely different, and less stringent, requirement because it requires battery or generator backup only for the light at the door landing, and not all the way to the public way. This is a major issue because providing emergency backup power for site lighting is not a trivial undertaking. NFPA 101 Life Safety Code complicates this because it says that emergency egress illumination is required to the public way.[47] But, again, this only applies to the project at hand if NFPA 101 applies to that project under some statutory authority or under an owner's specific requirements. See Figure 6.17.

summary

Egress requirements are detailed and specific, covering everything from how many exits, to how big, to how to locate them, to sizes of stair landings, and even dimensions of handrails. But all of this is intended to make buildings safer to occupy, and even more important, safer to evacuate under emergency conditions. Corridor ratings can be lowered by having sprinkler systems because such systems minimize the chances of a rapidly spreading fire, or even the wide-scale spread of fire at all. Door, corridor, and stair dimensions are intended to provide enough space for all occupants to exit within a reasonable time frame. The dead-end rules are intended to minimize loss of life under catastrophic failure circumstances. Emergency egress illumination is required so that there is a chance of finding one's way out even if the power has failed.

And all of these requirements are integrated with the basic occupancy classification and building construction type requirements. Overall, one can put more occupants into better protected facilities,

and vice versa. If an owner wants to save money by using an inexpensive construction type, there will be limits on the size of the building and the number of occupants in that building. This is all reasonable in the sense that trade-offs are reasonable. If someone wants to build a high-rise on a small site alongside two existing high-rise buildings, there is substantially greater risk to life and adjoining property if there is a problem. So the rules should require more fire-resistant construction and more extensive life safety requirements such as voice evacuation fire alarm systems, enlarged stairs, and standpipe systems for fighting fires.

These first six chapters have covered the most critical issues in codes in interior design. The remaining chapters will cover more specific, though still critical, associated topics, beginning with accessible design in Chapter 7.

results

Having completed this chapter, the following objectives should have been met:

6.1. To understand the meaning of "egress" by having read the definition and by seeing how occupants move out of buildings, especially in emergency circumstances.

6.2. To understand when multiple exits are required by understanding the 49, 501, and 1,000 limitations (and special cases).

6.3. To understand where to put multiple exits by understanding the diagonal separation requirements.

6.4. To understand travel distance and egress by knowing that travel distance varies with building type and occupancy.

6.5. To understand exiting through intervening spaces by knowing that certain spaces are prohibited and that intervening spaces are not allowed once an exitway is entered.

6.6. To understand egress width and height by knowing that minimum height is constant (more or less) and that width is entirely dependent on occupant load.

6.7. To understand dead-end corridors by knowing the limitations under various conditions.

6.8. To understand doors in egress by knowing the limitations on door types, sizes, and operating methods.

6.9. To understand stairs in exiting by understanding the necessity of using stairs to exit under emergency conditions.

6.10. To understand elevators in exiting by understanding the limitations of emergency power backup and smoke control.

6.11. To understand egress marking by understanding the requirements for high-rise buildings and other special situations.

6.12. To understand special assembly requirements by understanding aisles, aisle access ways, and row spacing in various assembly situations.

6.13. To understand egress illumination and emergency egress illumination by seeing the minimum requirements and the extent of application for both egress and emergency egress illumination.

notes

1. International Building Code 2009, pages 217–18.

2. Ibid., page 239.

3. Ibid., page 240.

4. Ibid., page 237.

5. Ibid., page 238.

6. Ibid., page 218.

7. Ibid., page 221.

8. Ibid.

9. Ibid., page 242.

10. Ibid.

11. Ibid., page 224.

12. Ibid.

13. Ibid., pages 224–25.

14. Ibid., page 225.

15. Ibid., page 226.

16. Ibid., page 227.

17. Ibid.

18. Ibid., pages 227–28.

19. Ibid., page 228.

20. Ibid.

21. Ibid., page 229.

22. Ibid.

23. Ibid., page 230.

24. Ibid., pages 231–32.

25. Ibid., page 232.

26. Ibid.

27. Ibid., page 233.

28. Ibid., page 234.

29. Ibid., page 235.

30. Ibid., page 236.

31. Ibid., page 237.

32. Ibid., page 222.

33. Ibid., pages 234–35.

34. Ibid., page 235.

35. Ibid., pages 246–47.

36. Ibid., page 250.

37. Ibid., page 252.

38. Ibid.

39. Ibid., pages 252–53.

40. Ibid.

41. Ibid., page 253.

42. Ibid., pages 253–54.

43. Ibid., page 221.

44. Ibid.

45. Ibid.

46. Ibid., page 217.

47. NFPA 101 Life Safety Code, 7.9.1.2, page 101–76.

What Is Accessibility?

objectives

7.1. To understand the meaning of "accessibility."

7.2. To understand the meaning of "universal design."

7.3. To understand the meaning of Chapter 11 of the International Building Code.

7.4. To understand the meaning of ICC/ANSI A117.1.2003.

7.5. To understand the meaning of ADA.

7.6. To understand the meaning of ABA.

7.7. To understand the concept of UFAS.

7.1 What Is Accessibility?

Broadly speaking, "accessibility" means that facilities, including buildings, are usable by persons with disabilities, usually physical disabilities. Physical disabilities include blindness, deafness, difficulty walking, difficulty bending over, being wheelchair-bound, missing a limb or limbs, being quadriplegic, being paraplegic, and so on. The challenges come about due to the varying provisions that need to be made to accommodate varying disabilities.

Until the past several decades or so, there has been little attention paid to such issues. Prior to the enactment of the Americans with Disabilities Act (ADA) in 1990 by the federal government, each state had some form of regulations requiring access for the disabled. But such rules were inconsistent, sometimes incomplete, sometimes poorly enforced, and usually applicable only to new projects and some major renovation projects. So the progress toward making facilities accessible to everyone was very slow; in fact, it hardly moved at all.

In 1990, the federal government enacted ADA and everything changed for four major reasons:

1. The ADA is neither a code nor a regulation; instead, it is a civil rights law, which means that it is applicable to all citizens under all circumstances. This also means that it has a direct effect on employment practices as well as on facilities. There are regulations that are associated with the law, namely the 1991 and 2010 Americans with Disabilities Act Accessibility Guidelines (ADAAG) as related to buildings, but the broad nature of the underlying law is paramount.

2. The enactment of such a law strongly encouraged each state to adopt similar laws.

3. The ADA includes provisions requiring accessibility improvements across a much broader range of circumstances than simply new facilities and major renovations. In fact, ADA requires every owner to make needed accessibility improvements whenever possible—but always when renovating—up to a reasonable level of expense (\leq 20% of the overall project cost). The latter is called the "proportionality provision."

4. The ADA includes protection of persons with mental disabilities.

The ADA was amended by Congress in late 2008, and the new version went into effect in July 2010. Determining which version of federal accessibility guidelines is applicable to a given project is not quite as simple as one might hope. For projects built from July 26, 1992, up to September 14, 2010, either UFAS or the 1991 ADAAG may be used. For projects built from September 15, 2010, until March 14, 2012, UFAS, 1991 ADAAG, or 2010 ADAAG may be used. For projects built from March 15, 2012, onward, either UFAS or 2010 ADAAG may be used.[1]

The 2010 law is essentially the same as the original law in regard to facilities, but Congress made several changes to clarify the intended scope of applicability. In particular, in several lawsuits since 1992 (when ADA went into effect), the Supreme Court has tightened the applicability of the law by interpreting the requirements narrowly. In the 2009 amendments, Congress makes it very clear that it disagrees with this narrowing. Here is some of the language from the new law itself—

"Sec 12101 note: Finding and Purposes of ADA Amendments Act of 2008, Pub. L. 110-325, § 2, Sept. 25, 2008, 122 Stat. 3553, provided that:

(a) Findings. Congress finds that

 (1) in enacting the Americans with Disabilities Act of 1990 (ADA), Congress intended that the Act 'provide a clear and comprehensive national mandate for the elimination of discrimination against individuals with disabilities' and provide broad coverage;

 (2) in enacting the ADA, Congress recognized that physical and mental disabilities in no way diminish a person's right to fully participate in all aspects of society, but that people with physical and mental disabilities are frequently precluded from doing so because of prejudice, antiquated attitudes, or the failure to remove societal and institutional barriers;

 (3) while Congress expected that the definition of disability under the ADA would be interpreted consistently with how courts had applied the definition of a handicapped individual under the Rehabilitation Act of 1973, that expectation has not been fulfilled;

 (4) the holdings of the Supreme Court in Sutton v. United Air Lines, Inc. 517 U.S. 471 (1999) and its companion cases have narrowed the broad scope of protection intended to be afforded by ADA, thus eliminating protection for many individuals whom Congress intended to protect;

 (5) the holding of the Supreme Court in Toyota Motor Manufacturing, Kentucky, Inc. v. Williams, 534 U.S. 184 (2002) further narrowed the broad scope of protection intended to be afforded by the ADA;

(6) as a result of these Supreme Court cases, lower courts have incorrectly found in individual cases that people with a range of substantially limiting impairments are not people with disabilities;

(7) in particular, the Supreme Court, in the case of Toyota Motor Manufacturing, Kentucky, Inc. v. Williams, 534 U.S. 184 (2002), interpreted the term 'substantially limits' to require a greater degree of limitation than was intended by Congress; and

(8) Congress finds that the current Equal Employment Opportunity Commission ADA regulations defining the term 'substantially limits' as 'significantly restricted' are inconsistent with congressional intent, by expressing too high a standard"[2]

Some specific language should be noted here: "physical *and mental* disabilities" (emphasis added). This means that persons with mental disorders are also protected under this law. That seems to be simple enough until one considers that persons with mental disabilities can be more or less sensitive to environmental stimuli, including, but not limited to, sound, light, and heat. In other words, it is conceivable that the ADA could require special sound isolation, lighting, and/or HVAC—none of which is addressed clearly in the law itself, in the ADAAG, or any other guideline. This is the greatest risk to ADA compliance. Because it is a very broad civil rights law, it is possible for an individual to step forward with a claim that special provisions are required—for that single individual's case but that are not identified anywhere in any accessible design guidelines—and win such a claim.

Enforcement of the ADA is entirely different from code enforcement—because it is a civil rights law and not a regulation. All enforcement of the ADA is done by the U.S. attorney general within the federal civil court system—not by any of the states and not by any locality. The mechanism is straightforward: anyone (yes, anyone) who thinks that he or she sees a violation of the ADA anywhere at any time simply reports the purported violation to the local U.S. attorney, who will in turn investigate and determine whether or not to sue. If there is a suit, the property owner would be sued, but that property owner would in turn probably attempt to draw in anyone else who may have contributed to the problem, including contractors, engineers, architects, and—yes—interior designers.

Congress has gone on in the new law to make the intended broad scope very, very clear:

"(b) Purposes. The purposes of this Act are:

(1) to carry out the ADA's objectives of providing 'a clear and comprehensive national mandate for the elimination of discrimination' and 'clear, strong, consistent, enforceable standards addressing discrimination' by reinstating a broad scope of protection to be available under the ADA;

(2) to reject the requirement enunciated by the Supreme Court in Sutton v. United Air Lines, Inc. 527 U.S. 471 (1999) and its companion cases that whether an impairment substantially limits a major life activity is to be determined with reference to the ameliorative effects of mitigating measures;

(3) to reject the Supreme Court's reasoning in Sutton v. United Air Lines, Inc. 527 U.S. 471 (1999) with regard to coverage under the third prong of the definition of disability and to reinstate the reasoning of the Supreme Court in School Board of Nassau County v. Arline, 480 U.S. 273 (1987) which set forth a broad view of the third prong of the definition of handicap under the Rehabilitation Act of 1973;

(4) to reject the standards enunciated by the Supreme Court in Toyota Motor Manufacturing, Kentucky, Inc. v. Williams, 534 U.S. 184 (2002), that the terms 'substantially' and 'major' in the definition of disability under the ADA 'need to be interpreted strictly to create a demanding standard for qualifying as disabled,' and that to be substantially limited in performing a major life activity under the ADA 'an individual must have an impairment that prevents or severely restricts the individual from doing activities that are of central importance to most people's daily lives'

(5) to convey congressional intent that the standard created by the Supreme Court in the case of Toyota Motor Manufacturing, Kentucky, Inc. v. Williams, 534 U.S. 184 (2002) for 'substantially limits,' and applied by lower courts in numerous decisions, has created an inappropriately high level of limitation necessary to obtain coverage

under the ADA, to convey that it is the intent of Congress that the primary object of attention in cases brought under the ADA should be whether entities covered under the ADA have complied with their obligations, and to convey that the question of whether an individual's impairment is a disability under the ADA should not demand extensive analysis; and

(6) to express Congress' expectation that the Equal Employment Opportunity Commission will revise that portion of its current regulations that defines the term 'substantially limits' as 'significantly restricted' to be consistent with this Act, including the amendments made by this Act."[3]

ADAAG is closely based on the American National Standards Institute's (ANSI) document A117.1, which provided the most up-to-date standards when ADA was enacted. Today, A117.1 is co-published by ANSI and ICC (the International Code Council) and it remains the most authoritative document available.

7.2 What Is Universal Design?

Universal design simply takes accessible design a step—a big step—further, to say that all facilities, including buildings, should be accessible to everyone and usable by everyone, all the time. So this includes physically disabled, mentally disabled, physically able, and mentally able persons—simultaneously—across the full range of human ergonomics; from people who are less than 3′ tall to those who are nearly 8′ tall and from 2-pound infants to 1,200-pound adults. Although there is nothing wrong with this as a goal, it can be challenging to designers.

First, there are no "universal" standards for most specific situations that actually work for everyone. For example, standard water closet seats in the United States are usually about 15″ above the finish floor and "accessible" water closet seats are required to be 17″ above the finish floor. But there is no reason to believe that ALL people can use, comfortably, either a 15″- or a 17″-high seat. Virtually everything is going to be wrong for someone at some time.

Second, it is simply impossible to meet all possible requirements: why not 9″-high seats for very short people or 24″-high seats for very tall people or for people who can't bend over? What about smaller seats for children or very small adults? What about larger seats for very large people? ICC/ANSI A117.1-2003 addresses these challenges by providing standards that meet most requirements. But keep in mind that the ADA is not about "most."

Since the enactment of the ADA, virtually all of the states (or localities, as the case may be) have adopted accessible design provisions for their codes that are similar to those of the ADA. The 2009 International Building Code devotes Chapter 11 to accessibility, and it says:

"1101.2 Design. Buildings and facilities shall be designed and constructed to be *accessible* in accordance with this code and ICC A117.1"[4]

and

"1103.1 Where required. *Sites*, buildings, *structures, facilities*, elements and spaces, temporary or permanent, shall be *accessible* to persons with physical disabilities."[5]

Accessible

—"A site, building, facility or portion thereof that complies with this chapter [Chapter 11]."

Note the specific mention of "physical" disabilities. This is the greatest difference between most state and local rules and the ADA. The ADA is a civil rights law that protects both physical and mental disabilities, but most state and local rules (and ICC/ANSI A117.1-2003) are about physical disabilities only.

7.3 What Does Chapter 11 of the 2009 International Building Code Require?

Given that the interior designer's first (but not only) responsibility is to locally applicable rules and regulations, it is best to start with compliance with the specific local (or state) accessibility regulations. In many instances, this will begin with Chapter 11 of the 2009 IBC.

As noted above, the basic requirement is compliance with ICC/ANSI A117.1-2003, and those requirements will be reviewed in detail shortly. But first, a few special provisions need to be discussed. Note the thread that runs through these citations; the thread will be summarized at the end.

"1103.2.2 Existing Buildings. Existing buildings shall comply with Section 3411."[6]

Chapter 34 covers Existing Structures and Section 3411 covers Accessibility for Existing Structures, and it says:

Historic buildings

—"Buildings that are listed in or eligible for listing in the National Register of Historic Places, or designated as historic under an appropriate state or local law (see Sections 3409 and 3411.9)."

"3411.1 Scope. The provisions of Sections 3411.1 through 3411.9 apply to maintenance, change of occupancy, additions and alterations to existing buildings, including those identified as *historic buildings*. . . .

3411.3 Extent of Application. An *alteration* of an existing element, space or area of a building or facility shall not impose a requirement for greater accessibility than that which would be required for new construction.

Alterations shall not reduce or have the effect of reducing accessibility of a building, portion of a building or facility. . . .

Accessible Additions

Simply put, all additions to buildings must be fully accessible—period.

3411.5 Additions. Provisions for new construction shall apply to additions. . . .

3411.6 Alterations. A building, facility or element that is altered shall comply with the applicable provisions of Chapter 11 of this code and ICC A117.1, unless *technically infeasible*.

Accessible Alterations

Simply put, all altered areas inside existing buildings must be fully accessible—period.

Where compliance with this section is *technically infeasible*, the *alteration* shall provide access to the maximum extent technically feasible. . . .

3411.8.11 Toilet Rooms. Where it is *technically infeasible* to alter existing toilet and bathing facilities to be *accessible*, an *accessible* family or assisted-use toilet or bathing facility constructed in accordance with Section 1109.2.1 is permitted. The family or assisted-use facility shall be located on the same floor and in the same area as the existing facilities. . . .

3411.9 Historic Buildings. These provisions shall apply to buildings and facilities designated as historic structures that undergo alterations or a change of occupancy, unless *technically infeasible*. Where compliance with the requirements for *accessible* routes, entrances or toilet facilities would threaten or destroy the historic significance of the building or facility, as determined by the applicable governing authority, the alternative requirements of Sections 3411.9.1 through 3411.9.4 for that element shall be permitted.

3411.9.1 Site arrival points. At least one *accessible* route from a site arrival point to an *accessible* entrance shall be provided.

3411.9.2 Multilevel buildings and facilities. An *accessible* route from an *accessible* entrance to public spaces on the level of the *accessible* entrance shall be provided.

3411.9.3 Entrances. At least one main entrance shall be *accessible*.

Exceptions:

1. If a main entrance cannot be made *accessible*, an *accessible* nonpublic entrance that is unlocked while the building is occupied shall be provided; or
2. If a main entrance cannot be made *accessible*, a locked *accessible* entrance with a notification system or remote monitoring shall be provided.

Signs complying with Section 1110 shall be provided at the primary entrance and the *accessible* entrance.

3411.9.4 Toilet and bathing facilities. Where toilet rooms are provided, at least one *accessible* family or assisted-use toilet room complying with Section 1109.2.1 shall be provided."[7]

That thread was as follows: 1103.2.2 to 3411; 3411.1 through 3411.8 to 3411.8.11 to 1109.2.1, to 3411.9, then to 3411.9.3, Exception 2 to 1110, then to 3411.9.4, then back to 1109.2.1 again. This is why it is important to learn to read carefully and to follow all of these twists, turns, and loops wherever they may go.

So what does all of this mean? Do existing buildings need to be accessible? Do historic buildings need to be accessible? Yes, all buildings need to be accessible—to the greatest extent technically feasible. Particularly for historic buildings, wide latitude is granted to prevent damaging historic fabric (the physical materials) and destroying historic significance (which can include physical, cultural, historic, social, and even political significance). At a minimum, this should include at least one accessible entrance.

7.4 ICC/ANSI A117.1-2003
Accessible and Usable Buildings and Facilities

This document covers all aspects of accessible design. The chapter titles are

7.4.1 Building Blocks

7.4.2 Accessible Routes

7.4.3 General Site and Building Elements

7.4.4 Plumbing Elements and Facilities

7.4.5 Communications Elements and Facilities

7.4.6 Special Rooms and Spaces

7.4.7 Built-in Furnishings and Equipment

7.4.8 Dwelling Units and Sleeping Units

Each of these will be covered in that order.

In Chapter 1, Application and Administration, the following language is used:

"101 Purpose The technical criteria in Chapters 3 through 9, and Sections 1002, 1003 and 1005 of this standard make sites, facilities, buildings and elements accessible to and usable by people with such physical disabilities as the inability to walk, difficulty walking, reliance on walking aids, blindness and visual impairment, deafness and hearing impairment,

incoordination, reaching and manipulation disabilities, lack of stamina, difficulty interpreting and reacting to sensory information, and extremes of physical size. The intent of these sections is to allow a person with a physical disability to independently get to, enter, and use a site, facility, building, or element."[8]

and

"102 Anthropometric Provisions The technical criteria in this standard are based on adult dimensions and anthropometrics. This standard also contains technical criteria based on children's dimensions and anthropometrics for drinking fountains, water closets, toilet compartments, lavatories and sinks, dining surfaces and work surfaces."[9]

Some key definitions follow:

> **"Detectable warning:** A standardized surface feature built in or applied to floor surfaces to warn of hazards on a circulation path. . . .
>
> **Operable part:** A component of an element used to insert or withdraw objects, or to activate, deactivate, or adjust the element. . . .
>
> **Ramp:** A walking surface that has a running slope steeper than 1:20. . . .
>
> **TTY:** An abbreviation for teletypewriter. Equipment that employs interactive, text-based communications through the transmission of coded signals across the standard telephone network. The term TTY also refers to devices known as text telephones and TDDs."[10]

Detectable warnings are used most frequently outdoors (usually noted at sidewalk ramps and some store entrances), but they can apply indoors under some circumstances. Operable parts are encountered frequently, on devices from door handles to paper towel dispensers to thermostats, and on and on. Ramps are used frequently outdoors and indoors. And TTY telephones are used by the deaf and are required under certain circumstances.

7.4.1 BUILDING BLOCKS

Here are the basic items—

Floor Surfaces ALL finish floor materials must comply with the following—

- Materials: stable, firm, and slip resistant.
- Carpet with or without pad; level loop, textured loop, level cut pile, or level cut/uncut pile; maximum 1/2 inch (13 mm) pile height; fastened along the edges with trim (if edges are exposed); edge trim not to exceed 1/4 inch (6.4 mm) in height.
- Floor openings not to allow passage of a 1/2 inch (13 mm) diameter (with some exceptions); elongated openings placed with the long axis perpendicular to traffic flow.
- For edges between 1/4 inch (6.4 mm) and 1/2 inch (13 mm), a bevel—not to exceed a slop of 1:2—may be used. Edges greater than 1/2 inch (13 mm) are to be ramped.

Turning Space Turning spaces are for wheelchair maneuvering, and the following requirements apply—

- Slope across turning space not to exceed 1:48.
- Size: circle with minimum 60 inch (1525 mm) diameter or T-shaped per Figure 7.1.[11]
- Doors are permitted to swing into turning spaces.

Clear Floor Spaces Clear floor spaces are required for facilities such as lavatories, drinking fountains, and water coolers, cooking appliances, service counters, and anywhere else a wheelchair might need to stay for the occupant to undertake some activity. The following requirements apply—

- Slope not to exceed 1:48.
- Size: minimum 48 inches (1220 mm) long and 30 inches (760 mm) wide.

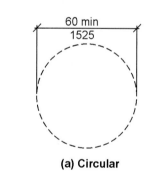

(a) Circular

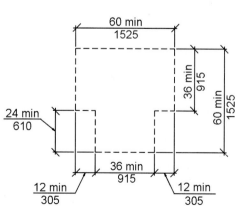

(b) T-shaped

FIGURE 7.1 ICC/ANSI A117.1-2003 Figure 304.3 Size of Turning Space

- Knee and toe clearance may extend under an element.
- Position for forward or parallel approach, meaning that wheelchair can approach the element from the front or alongside.
- The approach to the clear floor space must have one unobstructed side open to an accessible route or another clear floor space.
- If a clear floor space is in an alcove, the minimum dimensions increase to 36 inches (915 mm) wide for forward approach and 60 inches (1525 mm) long for parallel approach.

Knee and Toe Clearance Knee and toe clearances apply when the toes and/or knees are required to extend under an element, such as a hand-washing lavatory. The following requirements apply—

- The toe clearance extends from floor surface up to +9 inches (230 mm) above the floor surface.
- The knee and toe clearances can extend up to 25 inches (635 mm) under an element.
- The minimum toe clearance must extend at least 17 inches (430 mm) under an element.
- Minimum width of the knee and toe clearances is 30 inches (760 mm).
- The knee clearance extends from +9 inches (230 mm) above the floor surface to +27 inches (685 mm) above the floor surface.
- The minimum knee clearance must extend at least 11 inches (280 mm) at +9 inches (230 mm) above the floor and at least 8 inches (205 mm) at +27 inches (685 mm) above the floor.
- Between +9 inches (230 mm) and +27 inches (685 mm) above the floor the front edge of the knee space may be reduced in depth by 1 inch (25 mm) for each 6 inches (150 mm) in height.

See Figure 7.2 below for graphic clarification.

Protruding Objects Along accessible routes, wall-mounted objects are strictly controlled, mostly to enhance safety for the blind. The following requirements apply—

- Protrusion limits: the maximum protrusion between +27 inches (685 mm) and +80 inches (2030 mm) above the floor is 4 inches (100 mm), horizontally. This rule is most commonly applied to wall-mounted light fixtures (sconces), but it applies to everything that is wall-mounted between 27 inches (685 mm) and 80 inches

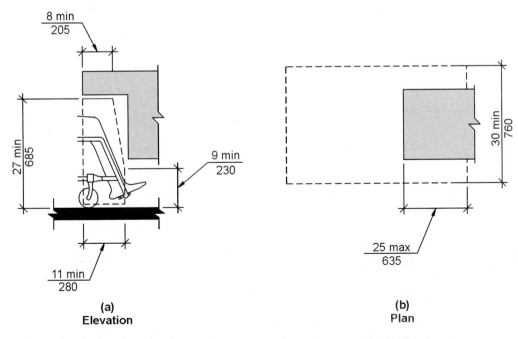

(a)
Elevation

(b)
Plan

FIGURE 7.2 ICC/ANSI A117.1-2003 Figure 306.3 Knee Clearance

(2030 mm) above the floor along an accessible route. The challenge here is to determine exactly where an accessible route might be, which is virtually anywhere due to the "universal access" intention of these regulations. Exceptions include handrails projecting up to 4 1/2 inches (115 mm) and automatic door closers mount as low as 78 inches (1980 mm) above the floor.

- For post-mounted protruding objects (like free-standing directory signs or other similar objects), the 4-inch (100-mm) maximum projection and 27-inch (685-mm) and 80-inch (2030-mm) heights apply, just as for wall-mounted objects.

- If the ceiling (or underside of an exposed stair, for example) can be lower than 80 inches (2030 mm) above the floor, guards are to be installed to maintain a minimum of 80 inches (2030 mm) of headroom.

- Protruding objects may not reduce required widths. This creates a gray area of interpretation. It is perfectly OK to install a wall with a door in it across a corridor (as long as door approaches are met—more on that later), so what would happen if a "portal" were built in a corridor that reduces the 44-inch- (1117-mm-) wide corridor to 36 inches (914 mm)? Nothing, because that portal would be no different from the door. But the protruding object rules noted above would still have to be met.

Reach Ranges Reach ranges are all about how far someone sitting in a wheelchair can reach to operate something, grab something, or do some other activity. The following requirements apply—

- For unobstructed conditions, the maximum height for forward and side reach is 48 inches (1220 mm), and the minimum height is 15 inches (380 mm).

- For obstructed conditions (like reaching over a lavatory or a countertop), the maximum height for forward reach is 48 inches (1220 mm) if the obstruction is 20 inches (510 mm) or less and 44 inches (1120 mm) if the obstruction is between 20 inches (510 mm) and 25 inches (635 mm). For side reach, the maximum height is 48 inches (1220 mm) with an obstruction up to 10 inches (255 mm) deep by 34 inches (865 mm) high and 46 inches (1170 mm) for an obstruction that is between 10 inches (255 mm) and 24 inches (610 mm) wide by 34 inches (865 mm) high.

Operable Parts

All operable parts must have clear floor space complying with all other requirements noted above. Given that it is oftentimes impossible to confirm whether a situation is forward or side reach (due to potentially changing conditions—such as movable furnishings), it is only prudent to use the most conservative conditions at all times. In other words, never install any operable part higher than +48″ aff.

Operable parts are also required to be operable using one hand and may not require tight grasping, pinching, or twisting of the wrist. This is why lever handles are used on doors now; old-fashioned door knobs require tight grasping and twisting of the wrist.

7.4.2 ACCESSIBLE ROUTES

Accessible routes are some of the most critical aspects of accessible design. Accessible routes include "walking surfaces with a slope not steeper than 1:20, doors and doorways, ramps, curb ramps excluding the flared sides, elevators, and platform lifts."[12] Revolving doors, revolving gates, and turnstiles are not allowed to be part of an accessible route. Typically, the accessible route includes the pathway from any accessible location to an exit discharge, up to and including the public way in most cases.

7.4.2.1 Width

The minimum clear width of an accessible route is 36 inches (915 mm) if longer than 24 inches (610 mm); for routes that are less than or equal to 24 inches (610 mm), the width can be

Segment Length	Minimum Segment Width
≤ 24 inches (610 mm)	32 inches (815 mm)[1]
> 24 inches (610 mm)	36 inches (915 mm)

[1]Consecutive segments of 32 inches (815 mm) in width must be separated by a route segment 48 inches (1220 mm) minimum in length and 36 inches (915 mm) minimum in width.

FIGURE 7.3 ICC/ANSI A117.1-2003, Table 403.5 Clear Width of an Accessible Route

decreased to 32 inches (815 mm). See Figure 7.3. At turns, the 36-inch (915-mm) width applies if, and only if, the turning space length is at least 60 inches (1525 mm); if the turning space is 48 inches (1220 mm) long, the accessible route width must be increased to 42 inches (1065 mm) at both sides. See Figure 7.4.

7.4.2.2 Doors and Doorways

The minimum clear width of doorways is 32 inches (815 mm), measured from the strike jamb perpendicular to the door face when the door is open 90 degrees. If the depth of the opening—the thickness of the walls, so to speak—is greater than 24 inches (610 mm), the clear width must be increased to 36 inches (915 mm). See Figure 7.5.

One of the most significant areas of accessible design for interior designers is maneuvering clearances at doors, or the spaces required around doors for wheelchair users to maneuver to open or close a door. See Figures 7.6 through 7.12.

No matter how awkward it may be, it is simply necessary to comply with these various requirements for ALL doors in the accessible route; there are no exceptions.

Door hardware, handles, pulls, latches, locks, and other operable parts must be easy to grasp and tight grasping, pinching, and twisting are not permitted. For sliding doors, the hardware must be fully exposed and usable from both sides when the door is in its fully open position.

For doors with automatic closers (devices that close the door from any open position—usually mounted at the head of the door), the closing speed may not exceed 12 degrees in 5 seconds. For doors with spring hinges, the door must take at least 1.5 seconds to move from 70 degrees open to fully closed.

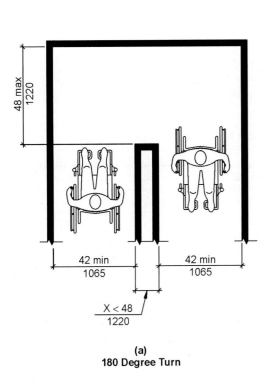

(a)
180 Degree Turn

(b)
180 Degree Turn
(Exception)

FIGURE 7.4 ICC/ANSI A17.1-2003, Figure 403.5.1 Clear Width at Turn

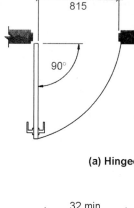

(a) Hinged Door

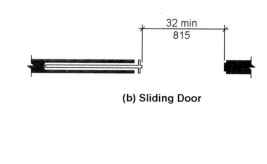

(b) Sliding Door

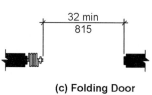

(c) Folding Door

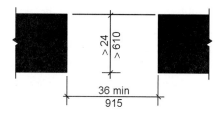

(d) Doorways without Doors

FIGURE 7.5 ICC/ANSI A117.1-2003, Figure 404.2.2 Clear Width of Doorways

Door surfaces (faces) within 10 inches (255 mm) of the floor must be smooth on the push side across the full width of the door; there can be no more than 1/16 inch (1.6 mm) of flatness variation in this zone. See Figure 7.13.

If vision lights are provided in doors or if side lights are provided next to the door, the sill of at least one panel must be no more than 43 inches (1090 mm) above the floor (unless the entire light is above 66 inches [1675 mm] above the floor). In the latter case, the expectation is that the purpose is not for vision for able bodied or disabled persons.

For two doors in series, if the doors swing away from each other, the minimum space between them must be at least 60 inches (1525 mm) square; if the doors swing toward each other, the minimum space between the ends of the doors in the open position is 48 inches (1220 mm) and the minimum width is 60 inches (1525 mm); and if the doors swing in the same direction, the minimum space between the doors in the open position is 48 inches (1220 mm) and the minimum width is 60 inches (1525 mm). See Figure 7.14.

7.4.2.3 Ramps

In general, ramp slope may not exceed 1:12. But in existing buildings where adequate space is not available, ramp slope may be no greater than 1:10 for a 6-inch (150-mm) rise and 1:8 for

TYPE OF USE		MINIMUM MANEUVERING CLEARANCES	
Approach Direction	Door Side	Perpendicular	Parallel to Doorway (beyond latch unless noted)
From front	Pull	60 inches (1525 mm)	18 inches (455 mm)
From front	Push	48 inches (1220 mm)	0 inches (0 mm)[3]
From hinge side	Pull	60 inches (1525 mm)	36 inches (915 mm)
From hinge side	Pull	54 inches (1370 mm)	42 inches (1065 mm)
From hinge side	Push	42 inches (1065 mm)[1]	22 inches (560 mm)[3 & 4]
From latch side	Pull	48 inches (1220 mm)[2]	24 inches (610 mm)
From latch side	Push	42 inches (1065 mm)[2]	24 inches (610 mm)

[1]Add 6 inches (150 mm) if closer and latch provided.
[2]Add 6 inches (150 mm) if closer provided.
[3]Add 12 inches (305 mm) beyond latch if closer and latch provided.
[4]Beyond hinge side.

FIGURE 7.6 ICC/ANSI A117.1-2003, Table 404.2.3.1 Maneuvering Clearances at Manual Swinging Doors

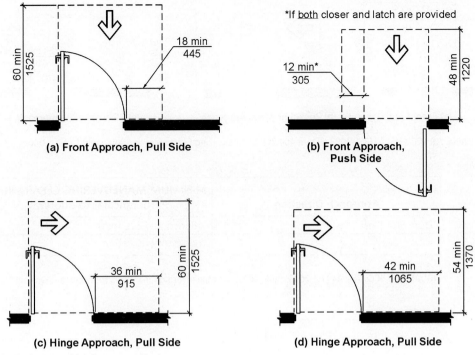

*If both closer and latch are provided

18 min
445

60 min
1525

(a) Front Approach, Pull Side

12 min*
305

48 min
1220

(b) Front Approach, Push Side

36 min
915

60 min
1525

(c) Hinge Approach, Pull Side

42 min
1065

54 min
1370

(d) Hinge Approach, Pull Side

* If both closer and latch are provided
** 48 min (1220) if both closer and latch provided

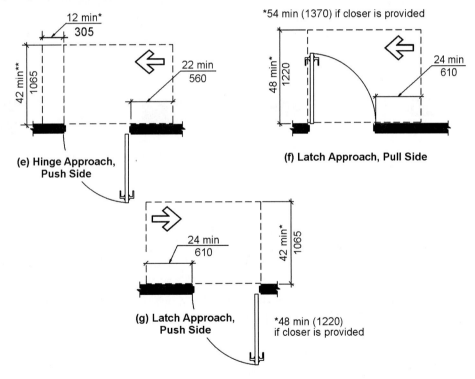

12 min*
305

42 min**
1065

22 min
560

(e) Hinge Approach, Push Side

*54 min (1370) if closer is provided

48 min*
1220

24 min
610

(f) Latch Approach, Pull Side

24 min
610

42 min*
1065

(g) Latch Approach, Push Side

*48 min (1220) if closer is provided

FIGURE 7.7 ICC/ANSI A117.1-2003, Figure 404.2.3.1 Maneuvering Clearances at Manual Swinging Doors

	MINIMUM MANEUVERING CLEARANCES	
Approach Direction	**Perpendicular to Doorway**	**Parallel to Doorway (beyond stop or latch side unless noted)**
From front	48 inches (1220 mm)	0 inches (0 mm)
From nonlatch side	42 inches (1065 mm)	22 inches (560 mm)[1]
From latch side	42 inches (1065 mm)	24 inches (610 mm)

[1]Beyond pocket or hinge side.

FIGURE 7.8 ICC/ANSI A117.1-2003, Table 404.2.3.2 Maneuvering Clearances at Sliding and Folding Doors

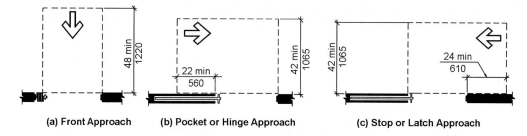

(a) Front Approach (b) Pocket or Hinge Approach (c) Stop or Latch Approach

FIGURE 7.9 ICC/ANSI A117.1-2003, Figure 404.2.3.2 Maneuvering Clearances at Sliding and Folding Doors

Approach Direction	MINIMUM MANEUVERING CLEARANCES Perpendicular to doorway
From Front	48 inches (1220 mm)
From side	42 inches (1065 mm)

FIGURE 7.10 ICC/ANSI A117.1-2003, Table 404.2.3.3 Maneuvering Clearances for Doorways without Doors

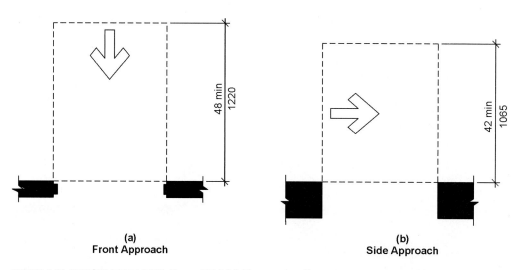

(a)
Front Approach

(b)
Side Approach

FIGURE 7.11 ICC/ANSI A117.1-2003, Figure 404.2.3.3 Maneuvering Clearances at Doorways without Doors

a 3-inch (75-mm) rise. Landings are required at the top and bottom of all ramps, and all landings must be at least 60 inches (1525 mm) long in the direction of travel. Corner landings must be at least 60 inches (1525 mm) square. All landings must be at least as wide as their ramps. Handrails are required for all ramps with a rise greater than 6 inches (150 mm). The ramp must extend, in width, 12 inches (305 mm) beyond the handrails unless a curb or barrier is provided. A curb or barrier is required to prevent the passage of a sphere 4 inches (100 mm) in diameter. See Figure 7.15.

There are extensive requirements for curb ramps in sidewalks for city streets and for parking lots, but these requirements are of limited value to interior design and will not be covered. This applies to detectable warnings too.

7.4.2.4 Elevators

Elevators call buttons (for new elevators but not for existing elevators) are required to be raised or flush as compared with the wall surface, and anything on the wall below the call button can project no more than 1 inch (25 mm). Call buttons must be located according to the normal reach ranges, although existing call buttons can be located up to 54 inches (1370 mm) above the floor, and a clear floor space is required at the call button(s). Additional detailed requirements apply for call signals, floor designations, call signal sizes, control buttons, keypads, position indicators, leveling, and so on. Various car sizes are acceptable, as shown in Figure 7.16. Minimum illumination at the controls, platform, threshold, and landing is 5 foot-candles (54 lux).

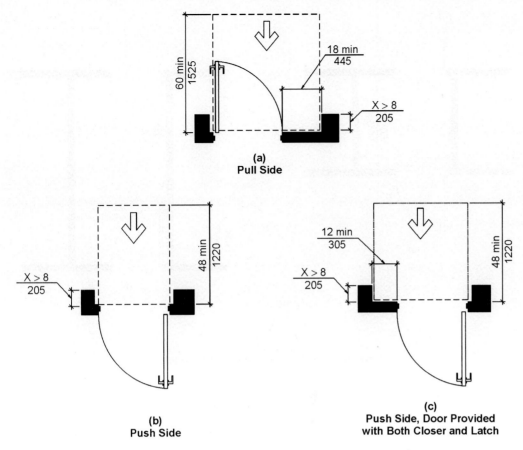

(a)
Pull Side

(b)
Push Side

(c)
**Push Side, Door Provided
with Both Closer and Latch**

FIGURE 7.12 ICC/ANSI A117.1-2003, Figure 404.2.3.4 Maneuvering Clearances at Recessed Doors

7.4.3 GENERAL SITE AND BUILDING ELEMENTS

The first part of general site requirements covers parking and loading zones, neither of which is critical to interior design and will not be discussed further.

7.4.3.1 Stairways

The minimum tread depth for an accessible stair is 11 inches (280 mm), the maximum riser height is 7 inches (180 mm), and the minimum riser height is 4 inches (100 mm). Open risers are not permitted, which is unfortunate from a design point of view because they eliminate the use of certain types of stair designs. But open stairs are no longer allowed—if the stair is part of an accessible route. The nosing at the leading edge of a tread is to have a radius of not more than 1/2 inch (13 mm) and the nosing may project over the tread below up to 1 1/2 inches (38 mm). See Figure 7.17. The leading 2 inches (51 mm) of the tread is to be dark-on-light or light-on-dark to provide a clear contrast. Handrails are required for all stairs.

Stair lighting is required to be at least 10 foot-candles (108 lux) at the centers of the treads and on the landings within 24 inches (610 mm) of the step nosings. Occupancy controls may be used for stair lighting, as long as the controls turn on the lights at the entrance landing and at least one landing above and one landing below the entrance landing.

Stair level identification signage (including tactile signage) is required at all levels, and a tactile "exit" sign is required at the exit level.

Handrail requirements are nearly the same as the requirements in the IBC (as covered in Chapter 5), with one exception: for noncircular cross sections, the maximum dimension is 6 1/4 inches (160 mm) as opposed to 6 inches (150 mm) in the IBC. Because the IBC requires a

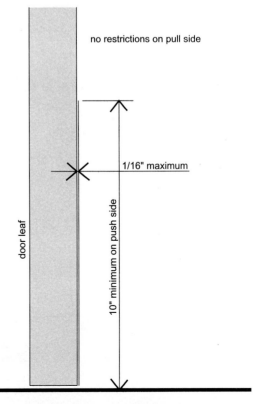

FIGURE 7.13 Door Flatness *(drawing by the author)*

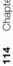
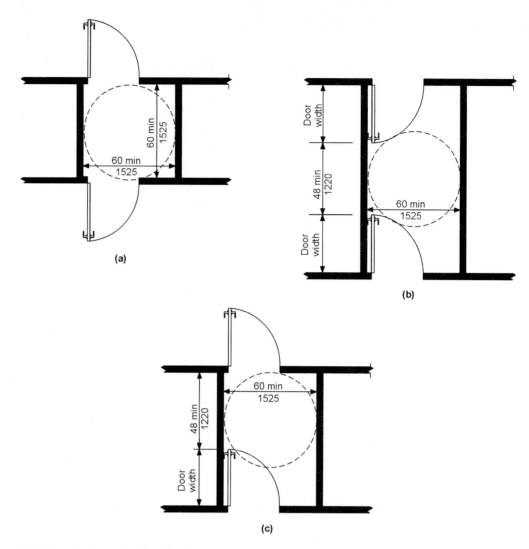

FIGURE 7.14 ICC/ANSI A117.1-2003, Figure 404.2.5 Two Doors in a Series

maximum of 6 inches (150 mm), the ICC/ANSI A117.1-2003 allowance for 6 1/4" (160 mm) doesn't matter and the maximum is 6 inches (150 mm). Handrails are required to extend beyond the top and bottom of ramps and stairs, as shown in Figure 7.18. In Figure 505.10.3, note that dimension "X" is equal to a tread width.

7.4.4 PLUMBING ELEMENTS AND FACILITIES

This section covers the following specific topics—

- Drinking Fountains (and electric water coolers)
- Toilet and Bathing Rooms

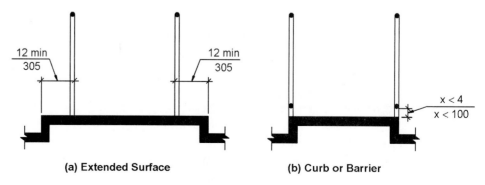

(a) Extended Surface (b) Curb or Barrier

FIGURE 7.15 ICC/ANSI A117.1-2003, Figure 405.9 Ramp Edge Protection

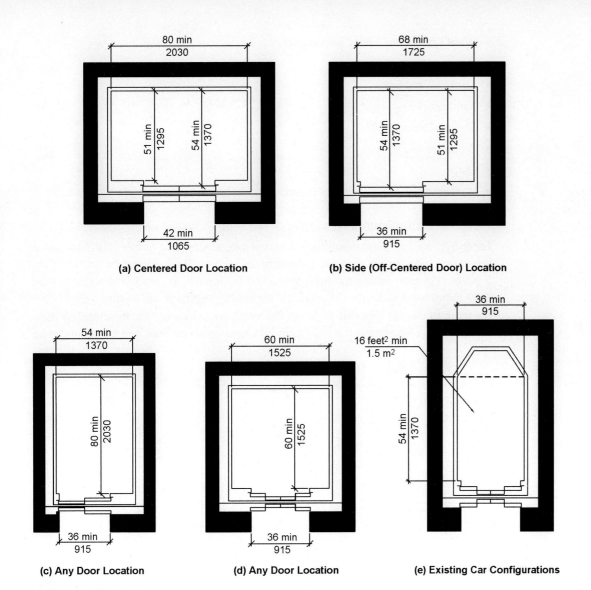

(a) Centered Door Location

(b) Side (Off-Centered Door) Location

(c) Any Door Location

(d) Any Door Location

(e) Existing Car Configurations

FIGURE 7.16 ICC/ANSI A117.1-2003, Figure 407.4.1 Inside Dimensions of Elevators Cars

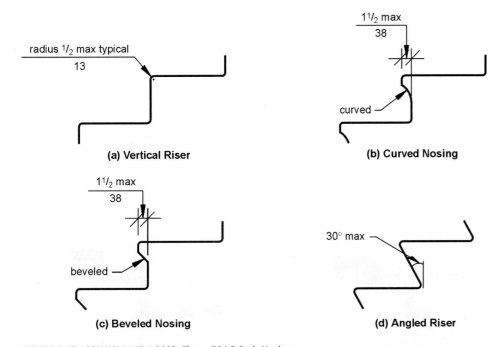

(a) Vertical Riser

(b) Curved Nosing

(c) Beveled Nosing

(d) Angled Riser

FIGURE 7.17 ICC/ANSI A117.1-2003, Figure 504.5 Stair Nosings

- Water Closets and Toilet Compartments
- Urinals
- Lavatories and Sinks
- Bathtubs
- Shower Compartments
- Grab Bars
- Seats
- Washing Machines and Clothes Dryers

7.4.4.1 Drinking Fountains

Either a forward or parallel approach is acceptable, as long as a proper clear floor space is provided and standard knee and toe clearances are met. The spout can be no more than 5 inches (125 mm) behind the front of the unit for forward approach and no more than 3 1/2 inches (89 mm) for parallel approach. For forward approach, the minimum depth from the spout to the wall behind is 15 inches (380 mm). For units accessible to wheelchair uses, the spout can be no higher than 36 inches (915 mm) above the floor, and the spout can be

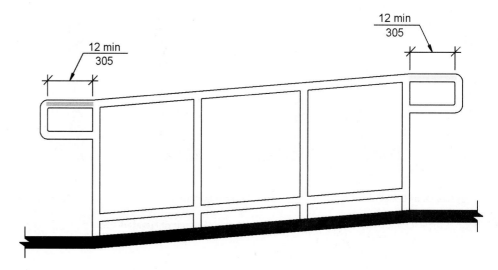

FIGURE 7.18 ICC/ANSI A117.1-2003, Figures 505.10.1 Top and Bottom Handrail Extensions at Ramps, 505.10.2 Top Handrail Extensions at Stairs, and 505.10.3 Bottom Handrail Extensions at Stairs

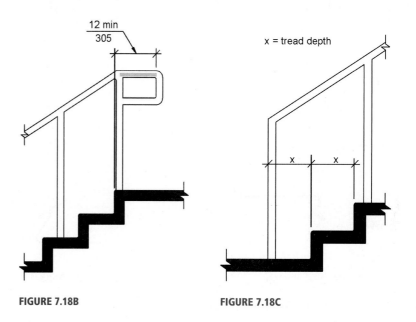

FIGURE 7.18B **FIGURE 7.18C**

between 38 inches (965 mm) and 43 inches (1090 mm) for standing users. The flowing water spout is to be at least 4 inches (102 mm) high with a maximum angle of 30 degrees if it's located with 3 inches (76 mm) of the front edge of the unit. The maximum angle is 15 degrees for spouts that are located between 3 inches (76 mm) and 5 inches (125 mm) of the front edge of the unit.[13]

7.4.4.2 Toilet and Bathing Rooms

A wheelchair turning space is to be provided within each room, and it is acceptable for the turning space to overlap with clear floor spaces and clearances at fixtures.

Doors may not swing into the clear floor space or clearance at any fixture.

Mirrors above lavatories must be mounted with the bottom edge at least 40 inches (1015 mm) above the floor and other mirrors must be mounted with the bottom edge at least 35 inches (890 mm) above the floor.

Coat hooks are to be mounted within the standard forward and parallel reach ranges, and shelves are to be mounted between 40 inches (1015 mm) and 48 inches (1220 mm) above the floor.[14]

7.4.4.3 Water Closets and Toilet Compartments

The requirements for water closets and toilet compartments are extensive and include a number of critical dimensions.

The centerline of the water closet itself must be within 16 inches (405 mm) to 18 inches (465 mm) of the wall (or toilet partition) for an accessible fixture; for ambulatory users, this range changes to 17 inches (430 mm) to 19 inches (495 mm).

Other fixtures are not allowed with a 60-inch (1525-mm) wide by 56-inch (1420-mm) deep area around a water closet.

The height of water closet seats must be between 17 inches (430 mm) and 19 inches (485 mm). See Figure 7.20. Water closet grab bars are required at the side:

> 42 inches (1065 mm) long minimum, 12 inches (305 mm) from the rear wall, and extending at least to 54 inches (1370 mm) from the rear wall.

With a vertical bar:

> 18 inches (455 mm) long minimum above the horizontal bar, with the bottom of the bar between 39 inches (990 mm) and 41 inches (1040 mm) above the floor.

And with a rear bar:

> 36 inches (915 mm) long minimum, extending 12 inches (305 mm) minimum from the water closet centerline

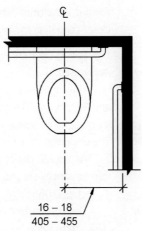

(a) Accessible Water Closets

16 – 18
405 – 455

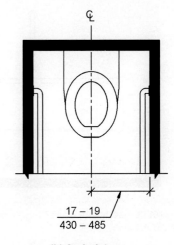

(b) Ambulatory Accessible Water Closets

17 – 19
430 – 485

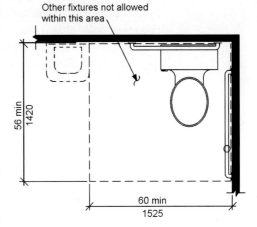

Other fixtures not allowed within this area

56 min / 1420

60 min / 1525

FIGURE 7.19 ICC/ANSI A117.1-2003, Figure 604.2 Water Closet Location and 604.3 Size of Clearance for Water Closet

Water Closet to Wall Distance

A major change from previous codes is that there is now a range of 16″ to 18″ for the dimension from the centerline of an accessible water closet to the wall. Under previous rules, this simply said 18″, which provided no room for error at all. When new water closets are added in existing buildings, it is quite common to encounter structural obstacles that cause moving the fixture a few inches. If a fixture moves too far from a wall, the wall can be thickened to meet the new range. If the fixture moves too close to the wall, the wall simply must be moved. These wall movements can also affect the overall size of the room.

No Lavatory Overlap at Water Closet

This new requirement that prohibits having a lavatory within the 59″ wide by 60″ deep clear space at an accessible water closet is the single biggest change in accessibility design for decades. It may seem like a small issue, but it forces single-fixture toilet rooms to be 7′-6″ wide, when they have been 60″ wide for many, many years. This must be incorporated into all space plans to avoid major problems.

Grab Bars

These long side grab bars can be a problem in small toilet rooms, especially in hospitals where over-sized doors are commonly used. The grab bars must be included when working out the dimensions of accessible toilet rooms.

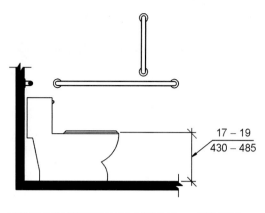

FIGURE 7.20 ICC/ANSI A117.1-2003, Figure 604.4 Water Closet Height

toward the closed side, and extending at least 24 inches (610 mm) from the water closet centerline toward the open side.15 See Figure 7.21.

Swing-up bars are allowable on the open side of water closets, but they are rarely used.

The centerline of the toilet paper dispenser must be between 7 inches (180 mm) and 9 inches (230 mm) in front of the leading edge of the water closet, and the outlet must be between 15 inches (380 mm) and 48 inches (1220 mm) above the floor. The dispenser may not be located behind the grab bar.[16] See Figure 7.22.

Accessible doors are to be located on the front of the compartment (although side entrances are allowed too), and the approach width to the door must be at least 42 inches (1065 mm). See Figure 7.23.

The compartment must be at least 56 inches (1420 mm) deep and 60 inches (1525 mm) wide for wall-mounted water closets and at least 59 inches (1500 mm) and 60 inches (1525 mm) wide for floor-mounted water closets.[17] Usually, such compartments are 60 inches (1525 mm) square to accommodate either type of fixture. Flush controls can be manual (tank or flush valve) or automatic (flush valve only), but the operating handle (if any) must be located on the open side of the fixture.

Special requirements apply for children: centerline between 12 inches (305 mm) and 18 inches (455 mm) from the wall and seat height between 11 inches (280 mm) and 17 inches (430 mm). Flush controls can be manual (tank or flush valve) or automatic (flush valve only), but the operating handle (if any) must be located on the open side of the fixture. Such controls must be mounted no more than 36 inches (915 mm) above the floor. Toilet paper dispensers must be located between 7 inches (180 mm) and 9 inches (230 mm) in front of the leading edge of the water closet, and the outlet must be between 14 inches (355 mm) and 19 inches (385 mm) above the floor. Coat hooks can be no higher than 48 inches (1220 mm) above the floor, and the shelf rules are the same as for adults.[18]

7.4.4.4 Urinals

The requirements for urinals include—

Stall-type and wall-hung fixtures with the rim no higher than 17 inches (430 mm) above the floor are allowed, with a clear floor space, and manual or automatic control.[19]

7.4.4.5 Lavatories and Sinks

The maximum height to the rim of lavatories and sinks is 34 inches (865 mm). If hand-operated metering faucets are used, they must remain on for at least 10 seconds. Exposed piping under a lavatory or sink must be insulated or configured to prevent contact, and sharp or abrasive surfaces are not allowed under lavatories or sinks. The reach ranges for operable

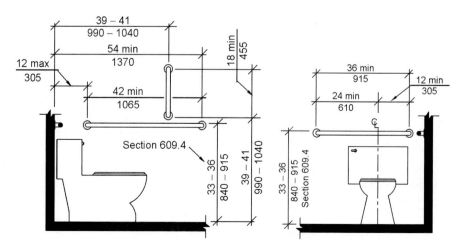

FIGURE 7.21 ICC/ANSI A117.1-2003, Figures 604.5.1 Side Wall Grab Bar for Water Closet and 604.5.2 Rear Wall Grab Bar for Water Closet.

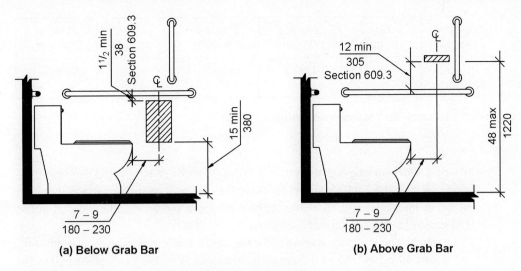

(a) Below Grab Bar (b) Above Grab Bar

FIGURE 7.22 ICC/ANSI A117.1-2003, Figure 604.7 Dispenser Location

parts of towel dispensers and hand dryers are shown.[20] See Figure 7.24.

7.4.4.6 Bathtubs

Clear spaces are required alongside bathtubs, at least 30 inches (760 mm) wide and the length of the tub. If a permanent seat is provided at the end of the tub, the clear has to extend 12 inches (305 mm) beyond the length of the tub, at the seat end.

Where there is a permanent seat, two grab bars are required at the control end and two along the side of the bathtub: at the control end, at least 24 inches (610 mm) long between 33 inches (840 mm) and 36 inches (915 mm) high and a vertical bar no more than 4 inches (100 mm) from the outer edge of the tub, 3 inches (75 mm) to 6 inches (150 mm) above the horizontal bar and at least 18 inches (455 mm) long; along the side, two bars, one 9 inches (230 mm) above the tub rim and the other between 33 inches (840 mm) and 36 inches (915 mm) above the floor, 12 inches (305 mm) maximum from the control end and 15 inches (380 mm) maximum from the seat end. See Figure 7.25.

Where there is no permanent seat, the control end bars are the same, but the side bars are only 24 inches (610 mm) long. See Figure 7.26.

Controls are to be located on an end wall; the shower head is to be on a 59-inch (1500-mm) long hose or mounted to a vertical rail (which is positioned so as not to conflict with the grab bars); an enclosure may not obstruct controls or transfer in to the bathtub, and the hot water may not be hotter than 120°F. (49°C).[21]

7.4.4.7 Shower Compartments

Accessible showers come in two forms: transfer and roll-in. In transfer showers, a person in a wheelchair is transferred from the wheelchair seat to the shower seat; in roll-in showers, a wheelchair (usually a special all-plastic shower chair) is rolled into the shower.

Transfer showers are required to be at least 36 inches (915 mm) wide and 36 inches (915 mm) deep, with a 36-inch (915-mm) wide by 48-inches (1220-mm) long transfer space that extends 12 inches (305 mm) past the back wall of the shower. A horizontal grab bar is required on the control end, continuing around the corner at least 18 inches (455 mm) toward the seat wall. A vertical grab bar is required within 4 inches (102 mm) of the entry side of the control wall, at least

> **Flush Handle on the Open Side**
>
> This seems like a small issue—getting the flush handle on the open side of the water closet—but this is one of the most common of all code violations. Anyone paying attention is sure to see one that is backwards within days.

> **Accessible and Non-Accessible Lavatories**
>
> Even though it is perfectly legal to put an accessible lavatory right next to a non-accessible lavatory (even in a single countertop), it is not at all clear how a disabled person is supposed to tell the difference between the two. In many cases, it would be just as well to make all lavatories in a single grouping accessible. Of course, it is vital for the interior designer to notify the plumbing engineer if that is the case.

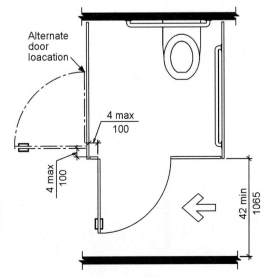

FIGURE 7.23 ICC/ANSI A117.1-2003, Figure 604.8.3 Wheelchair Accessible Compartment Doors

Maximum Reach Depth	0.5 inch (13 mm)	2 inches (50 mm)	5 inches (125 mm)	6 inches (150 mm)	9 inches (230 mm)	11 inches (280 mm)
Maximum Reach Height	48 inch (1220 mm)	46 inch (1170 mm)	42 inch (1065 mm)	40 inches (1015 mm)	36 inches (915 mm)	34 inches (865 mm)

FIGURE 7.24 ICC/ANSI A117.1-2003, Table 606.7 Maximum Reach Depth and Height

18 inches (455 mm) long with its bottom 3 inches (75 mm) to 6 inches (150 mm) above the horizontal bar. The controls are to be located on the wall opposite the seat, between 38 inches (965 mm) and 48 inches (1220 mm) above the floor and within 15 inches (380 mm) left or right of the seat's centerline.

A standard roll-in shower is at least 60 inches (1525 mm) long with an equal width entry, and at least 30 inches (760 mm) deep, with a clearance alongside that is at least 30 inches (760 mm) wide. An accessible lavatory is allowed to encroach into the clearance. Shower controls are allowed on either end and at the center of the back wall. Standard roll-in showers without seats require horizontal grab bars at both ends and along the back wall, and the ends of bars can be no more than 6 inches (150 mm) from the inside corners. Standard roll-in showers with seats require horizontal bars at the control end and along the back wall, but not overlapping the seat. The controls are to be located at the same height as for a transfer shower, but on the back wall within 27 inches (685 mm) of the seat end.

An alternate roll-in shower is at least 60 inches (1525 mm) long with a 36-inch (915-mm) wide entry at the opposite end from a seat wall. Shower controls are allowed on either end at the center of the back wall. Alternate roll-in showers require a horizontal bar at the control end, a vertical bar (like for a transfer shower) at the control end, and a horizontal bar along the back wall (within 6 inches [150 mm] of the corner but not overlapping the seat). The controls are to be located at the same height as for a transfer shower either on the end wall opposite the seat or on the back wall within 27 inches (685 mm) of the seat end. See Figure 7.27.

Accessible Showers

All accessible showers are a problem, because they all cannot contain water adequately. Therefore, it is necessary to add a floor drain just outside every accessible shower. The Interior Designer needs to tell the plumbing engineer if that is the case.

Shower heads are to be as for bathtubs (see 6.74.4.6 above); thresholds for transfer and roll-in showers must be 1/2 inch (13 mm) or less, and the thresholds must be beveled for transfer showers; shower enclosures are allowable but may not obstruct the controls or transfer; hot water may not exceed 120° F (49° C). [22]

7.4.4.8 Grab Bars

Circular grab bars may have diameters between 1 1/4 inches (32 mm) and 2 inches (51 mm) and noncircular grab bars may have perimeters between 4 inches (100 mm) and 4.8 inches (120 mm) with no dimensions exceeding 2 inches (51 mm). The space between the wall and the grab bar is to be 1 1/2 inches (38 mm). Projecting objects below a grab bar must be at least 1 1/2 inches (38 mm) below the grab bar and projecting objects above a grab bar must be at least 12 inches (305 mm) above the grab bar.

Standard placement for horizontal grab bars is between 33 inches (840 mm) and 36 inches (915 mm) above the floor; for children, horizontal grab bars are to be between 18 inches (455 mm) and 27 inches (685 mm) above the floor. If special dimensions are noted in any specific section, the special dimensions overrule the standard dimensions. Grab bars must be able to support a vertical or horizontal force of 250 pounds (1112 N). [23]

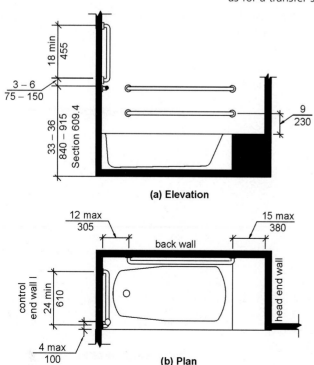

(a) Elevation

(b) Plan

FIGURE 7.25 ICC/ANSI A117.1-2003, Figure 607.4.1 Grab Bars for Bathtubs with Permanent Seats

7.4.4.9 Seats

Bathtub and shower seats are to be between 17 inches (430 mm) and 19 inches (485 mm) above the floor. Removable bathtub seats are to be between 15 inches (380 mm) and 16 inches (405 mm) in depth, and permanent seats are to be at least 15 inches (380 mm) in depth. Seats for standard roll-in showers are to be the folding type. L-shaped seats are allowed, and all seats must support a load of at least 250 pounds (1112 N).[24] See Figure 7.28.

7.4.4.10 Washing Machines and Clothes Dryers

A parallel approach clear floor space is required, centered on the appliance; the maximum height for top-loading appliances is 36 inches (915 mm), and the bottom of the opening in front-loading appliances is to be between 15 inches (380 mm) and 34 inches (865 mm) above the floor.[25]

7.4.5 COMMUNICATION ELEMENTS AND FEATURES

This section covers audible and visual alarms and signs.

Visual characters are governed by ICC/ANSI A117.1-2003, Table 703.24 – Visual Character Height. See Figure 7.29.

In general, this requires characters to be larger as they are read from increasing distances. The heights are based on the uppercase letter "I" and the widths are based on the uppercase letter "O." The width of the uppercase "O" has to be within 55% and 110% of the width of the uppercase "I." Stroke width is to be between 10% and 30% of the height of the uppercase "I." Spacing between characters is to be sbetween 10% and 30% of the character height. Uppercase and lowercase characters may be used. Spaces between lines are to be between 135% and 170% of character height.

Characters and their background—for both non-tactile and tactile characters—are to have non-glare finishes and the characters must contrast with the background, either dark on light or light on dark.[26]

Tactile characters may be uppercase only and are to be raised above their background by at least 1/32 inch (0.8 mm), using beveled sides. Character height is also based on the uppercase letter "I" and it is to be between 5/8 inch (16 mm) and 2 inches (51 mm). Character width, stroke width, and line spacing are the same as for non-tactile characters. Spaces between characters are to be a minimum of 1/8 inch (3.2 mm) at the tops of the beveled edges and 1/16 inch (1.6 mm) at the bottoms of the beveled edges, and a maximum of 4 times the stroke width. Spaces between characters and raised borders or decorative feature are to be at least 3/8 inch (9.5 mm).

Tactile signs at doors are to be located on the latch side, at a minimum height of 48 inches (1220 mm) to the bottom of the lower line of characters and a maximum height of 60 inches (1525 mm) to the bottom of the upper line of characters.[27]

Braille (Grade 2), using domed or rounded dots, is also required and is to be located below the corresponding text (below all lines if the text is multiline), separated by at least 3/8 inch (4.8 mm) from any other item. Braille is to be located between 48 inches (1220 mm) and 60 inches (1525 mm) above the floor. Specific requirements for Braille dimensions are provided in Figure 7.7 and Table 7.7.[28] See Figure 7.30.

Pictograms may be used as well and are to be at least 6 inches (150 mm) tall, with a non-glare finish and in a contrasting color. Text descriptors, with Braille, are to be located directly below the pictogram.[29]

International symbols are to be used for accessibility, TTY, hearing loss, and volume-controlled telephone, as follows.[30] See Figure 7.31.

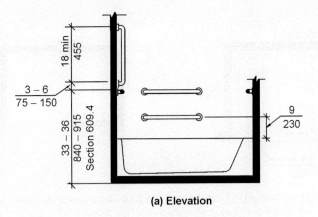

(a) Elevation

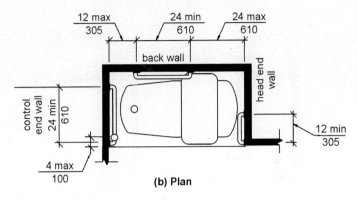

(b) Plan

FIGURE 7.26 ICC/ANSI A117.1-2003, Figure 607.4.2 Grab Bars for Bathtubs without Permanent Seats

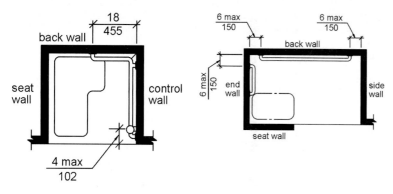

FIGURE 7.27 ICC/ANSI A117.1-2003, Figures 608.3.1 Grab Bars in Transfer-Type Showers and 608.3.3 Grab Bars in Alternate Roll-in Type Showers

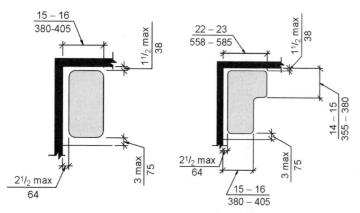

FIGURE 7.28 ICC/ANSI A117.1-2003, Figures 610.3.1 Rectangular Shower Compartment Seat and 610.3.2 L-Shaped Shower Compartment Seat

Public telephones, if provided, are to have clear floor spaces for either forward or parallel approach, push-button controls, and handset cords at least 29 inches (735 mm) long and are to be mounted with operable parts at the heights required by standard forward and side reaches. If volume controls are provided, they must provide at least 20 dB in gain adjustment, with a 12-dB incremental step with an automatic reset. If a TTY is required, it is to be permanently installed in or directly adjacent to the telephone enclosure (with a cord of sufficient length for connection to the telephone). The touch surface of TTY keypads is to be installed at least 34 inches (865 mm) above the floor.[31]

Detectable warnings are to be standardized for any given building, facility, site, or complex. Detectable warnings are to contrast in color with adjacent surfaces and are to be constructed using truncated domes sized in accordance with ICC/ANSI A117.1-2003 Figure 705.5.[32] See Figure 7.32.

Assistive listening systems, where provided, are to use 1/8 inch (3.2 mm) standard mono-jacks, be hearing-aid compatible, provide a sound pressure level between 110 dB and 118 dB with a dynamic range of at least 50 dB, and have a signal-to-noise ratio of at least 18 dB. Peak clipping may not exceed 18 dB relative to the peaks of speech.[32]

Automatic teller machines (ATM) are to have clear floor spaces for forward or parallel approach; operable parts are to be mounted at the heights required by standard forward and side reaches; numeric keys are to be in a 3-wide by 4-high pattern, either ascending or descending numerically; function keys are to be tactile with contrasting colors, the display screen is to be visible from a point 40 inches (1015 mm) above the center of the clear space on the floor (except for drive-up only machines); characters are to use only sans-serif fonts with heights of at least 3/16 inch (4.8 mm) based on the uppercase letter "I" and with contrasting colors; speech-enabled; and required to have Braille markings.[33]

Height above Floor to Baseline of Character	Horizontal viewing Distance	Minimum Character Height
40 inches (1015 mm) to less than or equal to 70 inches (1780 mm)	Less than 6 feet (1830 mm)	5/8 inch (16 mm)
	6 feet (1830 mm) and greater	5/8 inch (16 mm), plus 1/8 inch (3.2 mm) per foot (305 mm) of viewing distance above 6 feet (1830 mm)
Greater than 70 inches (1780 mm) to less than or equal to 120 inches (3050 mm)	Less than 15 feet (4570 mm)	2 inches (51 mm)
	15 feet (4570 mm) and greater	2 inches (51 mm), plus 1/8 inch (3.2 mm) per foot (305 mm) of viewing distance above 15 feet (4570 mm)
Greater than 120 inches (3050 mm)	Less than 21 feet (6400 mm)	3 inches (75 mm)
	21 feet (6400 mm) and greater	3 inches (76 mm), plus 1/8 inch (3.2 mm) per foot (305 mm) of viewing distance above 21 feet (6400 mm)

FIGURE 7.29 ICC/ANSI A117.1-2003, Table 703.2.4 Visual Character Height

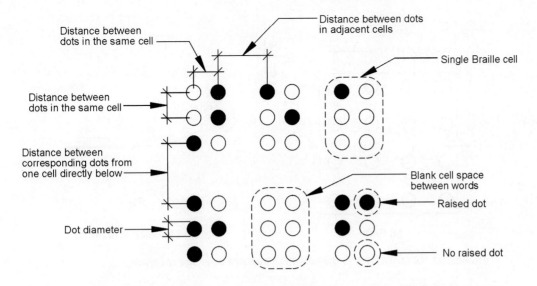

Distance between dots in the same cell

Distance between dots in adjacent cells

Single Braille cell

Distance between dots in the same cell

Distance between corresponding dots from one cell directly below

Blank cell space between words

Raised dot

Dot diameter

No raised dot

Measurement range	Minimum in inches Maximum in inches
Dot base diameter.	0.059 (1.5 mm) to 0.063 (1.6 mm)
Distance between two dots in the same cell	0.090 (2.3 mm) to 0.100 (2.5 mm)
Distance between corresponding dots in adjacent cells [1]	0.241 (6.1 mm) to 0.300 (7.6 mm)
Dot height	0.025 (0.6 mm) to 0.037 (0.9 mm)
Distance between corresponding dots from one cell directly below[1]	0.395 (10.0 mm) to 0.400 (10.2 mm)

[1]Measured center to center

FIGURE 7.30 ICC/ANSI A117.1-2003, Figure 703.4.3 Braille Measurement and Table 703.4.3 Braille Dimensions

7.4.6 SPECIAL ROOMS AND SPACES

Special rooms and spaces include wheelchair seating in assembly occupancies; dressing, fitting, and locker rooms; kitchens and kitchenettes; and transportation facilities. Requirements for transportation facilities involve mostly site planning and will be omitted from the discussion here.

Basically, single wheelchair parking spaces in assembly occupancies are required to be at least 36 inches (915 mm) wide by 48 inches (1220 mm) deep with front or rear access; if side access is required, the depth is to be increased to at least 60 inches (1525 mm). For multiple wheelchairs, the minimum width can be decreased to 33 inches (840 mm). A companion seat (standard seat or chair) is required for each wheelchair space. Wheelchair spaces are to be positioned so that a person in the wheelchair can see over the

FIGURE 7.31 ICC/ANSI A117.1-2003, Figures 703.6.3.1 International Symbol of Accessibility, 703.6.3.2 International TTY Symbol, 703.6.3.3 International Symbol of Access

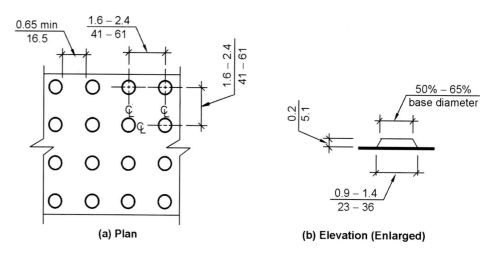

FIGURE 7.32 ICC/ANSI A117.1-2003, Figure 705.5 Truncated Dome Size and Spacing

heads of those seated in front of (and below) the wheelchair, or between the heads of those in front, and over or between standing

spectators in front according to Table 7.8 Required Wheelchair Space Location Elevation Over Standing Spectators.[34] See Figure 7.33.

The minimum number of wheelchair spaces is determined by Table 802.10.[35] See Figure 7.34. What this means is that a movie theater that seats 150 or less would have to have at least one wheelchair space, a theater seating 151 to 500 would have to have at least two wheelchair spaces, a theater seating 501 to 1,000 would have to have at least three wheelchair spaces, and a theater seating 2,000 would have to have at least three plus one or four total wheelchair spaces.

Riser height	Minimum height of the wheelchair space location based on row spacing[1]		
	Rows less than 33 inches (840 mm)[2]	Rows 33 inches (840 mm) to 44 inches (1120 mm)[2]	Rows over 44 inches (1120 mm)[2]
0 inch (0 mm)	16 inch (405 mm)	16 inch (405 mm)	16 inch (405 mm)
4 inch (102 mm)	22 inch (560 mm)	21 inch (535 mm)	21 inch (535 mm)
8 inch (205 mm)	31 inch (785 mm)	30 inch (760 mm)	28 inch (710 mm)
12 inch (305 mm)	40 inch (1015 mm)	37 inch (940 mm)	35 inch (890 mm)
16 inch (406 mm)	49 inch (1245 mm)	45 inch (1145 mm)	42 inch (1065 mm)
20 inch (510 mm)[3]	58 inch (1475 mm)	53 inch (1345 mm)	49 inch (1245 mm)
24 inch (610 mm)	N/A	61 inch (1550 mm)	56 inch (1420 mm)
28 inch (710 mm)[4]	N/A	69 inch (1750 mm)	63 inch (1600 mm)
32 inch (815 mm)	N/A	N/A	70 inch (1780 mm)
36 inch (915 mm) and higher	N/A	N/A	77 inch (1955 mm)

[1]The height of the wheelchair space location is the vertical distance from the tread of the row of seats directly in front of the wheelchair space location to the tread of the wheelchair space location.
[2]The row spacing is the back-to-back horizontal distance between the rows of seats in front of the wheelchair space location.
[3]Seating treads less than 33 inches (840 mm) in depth are not permitted with risers greater than 18 inches (455 mm) in height.
[4]Seating treads less than 44 inches (1120 mm) in depth are not permitted with risers greater than 27 inches (685 mm) in height.

NOTE: Table 802.8.9 is based on providing a spectator in a wheelchair a line of sight over the head of a spectator two rows in front of the wheelchair space location using average anthropometrical data. The table is based on the following calculation: $[(2X+34)(Y-2.25)/X] + (20.2-Y)$ where Y is the riser height of the rows is front of the wheelchair space location and X is the tread depth of the rows in front of the wheelchair space location. The calculation is based on the front of the wheelchair space location being located 12 inches (305 mm) from the back of the seating tread directly in front and the eye of the standing spectator being set back 8 inches (205 mm) from the riser.

FIGURE 7.33 ICC/ANSI A117.1-2003 Table 802.9.2.2 Required Wheelchair Space Location Elevation over Standing Spectators

Total seating in Assembly Areas	Minimum required number of dispersed locations
Up to 150	1
151 to 500	2
501 to 1,000	3
1,001 to 5,000	3, plus 1 additional space for each 1,000 seats or portions thereof above 1,000
5,001 and over	7, plus 1 additional space for each 2,000 seats or portions thereof above 5,000

FIGURE 7.34 ICC/ANSI A117.1-2003, Table 802.10 Wheelchair Space Dispersion

In dressing, fitting, and locker rooms, the requirements are essentially the same as the requirements for accessible toilet rooms, with the addition of a requirement for a bench.[36]

In pass-through kitchens and kitchenettes (either one- or two-sided), the path between the cabinets or appliances and the opposite wall or cabinets or appliances must be at least 40 inches (1015 mm) wide. In dead-end or U-shaped kitchens or kitchenettes, the space between the cabinets must be at least 60 inches (1525 mm) wide. All of the usual reach ranges apply, and at least 50% of the contents of a refrigerator must be no more than 54 inches (1370 mm) above the floor.[37]

7.4.7 BUILT-IN FURNISHINGS AND EQUIPMENT

The tops of dining tables are to be located between 28 inches (710 mm) and 34 inches (865 mm) above the floor, and sales and service counters in stores must provide an accessible check-out or service counter with a surface no higher than 36 inches (915 mm) above the floor. In check-out aisles, the surface cannot be higher than 38 inches (965 mm) above the floor with a maximum 2-inch (51-mm) side rail above that. In cafeterias or restaurants where trays are used, the tray slide rails must be located between 28 inches (710 mm) and 34 inches (865 mm) above the floor.[38] Where benches are provided, or required, they must comply with Figure 903. See Figure 7.35.

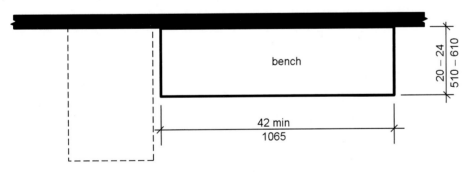

(a) Clear Floor Space and Size

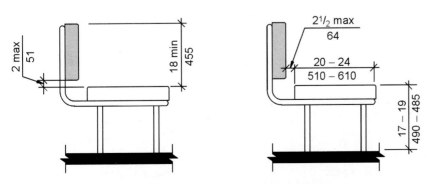

(b) Bench Back Support and Seat Height

FIGURE 7.35 ICC/ANSI A117.1-2003 Figure 903 Benches

7.4.8 DWELLING UNITS AND SLEEPING UNITS

Accessible dwelling units and sleeping units fall into four categories—

- Accessible (fully accessible under all rules of ICC/ANSI A117.1-2003);
- Type A (mostly subject to the rules of ICC/ANSI A117.1-2003, with some reductions in requirements for toilet and bathing facilities);
- Type B (less subject to the rules of ICC/ANSI A1171.-2003); and
- Accessible communications only.

For Type A units, the main difference is that lavatories are allowed more overlap with water closets, bathtubs, and showers than under the standard rules.

For Type B units, even tighter clearances are allowed for toilet and bathing facilities.

For accessible communications (also required for accessible, Type A, and Type B units), smoke detection, visible fire-alarm notification, and a door bell are required.[39]

7.5 What Do the Americans with Disabilities Act Accessibility Guidelines (ADAAG) Require?

The requirements of "new" ADAAG are nearly the same as the requirements noted above for ICC/ANSI A117.1-2003. Here are the most significant differences—

Under 213.2 Toilet Rooms and Bathing Rooms, it is explicitly stated that "Where toilet rooms are provided, each toilet room shall comply with 603."[40] Section 603 is where the detailed requirements are found for accessible toilet facilities. Even though this clear language is not included in ICC/ANSI A117.1-2003, the requirement is there anyway. Simply put, all toilet rooms must be adaptable, at a minimum. This is important because it means that adequate space must be allocated even if a facility is non-accessible in its current form.

Table 219.3 Receives for Assistive Listening Systems provides the number of receivers that are required as well as the number of receivers that are required to be hearing-aid compatible. If the seating capacity is 50 or less, two receivers are required, both of which have to be hearing-aid compatible; if the seating capacity is 51 to 200, two receivers are required plus one for each 25 seats (or portion thereof) above 50 seats and two of those must be hearing-aid compatible; if the seating capacity is 201 to 500, two receivers are required plus one for each 25 seats (or portion thereof) above 50 seats and one for each four must be hearing-aid compatible, and on and on for larger and larger facilities.[41]

221 Assembly Areas provides for much more stringent requirements for wheelchair locations in assembly spaces. Specifically, here are the requirements:

Capacity	Number of wheelchair spaces
4 to 25	1
26 to 50	2
51 to 150	4
151 to 300	5
301 to 500	6
500 to 5,000	6, plus 1 for each increase of 150, or fraction there of
5,001 and over	36, plus 1 for each increase of 200, or fraction there of.[42]

As noted under 7.4.6 above, ICC/ANSI A117.1-2003 would require 4 wheelchair spaces for a theater seating 2,000. Under this ADA requirement, that would increase to 6 plus 8 or a total of 14 spaces! This does mean that the ICC/ANSI requirements should be ignored and the ADAAG requirements should be used instead for such facilities.

When designing transient lodging facilities, accessible features are required in some rooms, as follows—

1 to 25 rooms, 1 room without roll-in shower

25 to 50 rooms, 2 rooms without roll-in shower

51 to 75 rooms, 3 rooms without roll-in shower plus 1 room with roll-in shower

76 to 100 rooms, 4 rooms without roll-in shower plus 1 room with roll-in shower

101 to 150 rooms, 5 rooms without roll-in shower plus 2 rooms with roll-in shower

151 to 200 rooms, 6 rooms without roll-in shower plus 2 rooms with roll-in shower

201 to 300 rooms, 7 rooms without roll-in shower plus 3 room with roll-in shower

301 to 400 rooms, 8 rooms without roll-in shower plus 4 rooms with roll-in shower

401 to 500 rooms, 9 rooms without roll-in shower plus 4 rooms with roll-in shower

501 to 1,000 rooms, 2 percent of total without roll-in shower plus 1 percent of total with roll-in shower

1,001 and over rooms, 20 plus 1 for each 100 (or fraction thereof) without roll-in shower plus 10 plus 1 for each 100 (or fraction thereof) with roll-in shower

In addition, if there are more than 25 guest rooms, at least 5% of beds are to have required clear space. And some rooms are required to have communication features (2 rooms for 2 to 25 rooms; 4 rooms for 26 to 50 rooms; 7 rooms for 51 to 75 rooms; 9 rooms for 76 to 100 rooms, and 12 for 101 to 150 rooms, etc.).[43]

705 Detectable Warnings requires the use of raised truncated domes.[44] Some disability advocates argue that this is incorrect (and troublesome for some wheelchairs and some ambulatory people with unusually small feet), and that inset grooves should be used instead. But neither ADAAG nor ICC/ANSI A117.1-2003 makes provision for an alternate, and raised truncated domes should be used.

7.6 What Do the ABA Accessibility Standards for Federal Facilities Require?

The requirements of the ABA standards are nearly the same as the requirements noted above for ICC/ANSI A117.1-2003. Here are the most significant differences—

F221.2.1.1 Number of Wheelchair Spaces in Assembly Areas has yet a third set of requirements, as follows:

Capacity	Number of wheelchair spaces
4 to 25	1
26 to 50	2
51 to 150	4
151 to 300	5
301 to 500	6
501 to 5,000	6 plus 1 for each increase of 150
More than 5,001	36 plus 1 for each increase of 200

In this case, a 2,000-seat theater would be required to have 6 plus 10 or a total of 16 spaces. Given that this is greater than the ICC/ANSI requirements but less than the ADAAG requirements, prudence would dictate using the ADAAG requirements.

F705 Detectable Warnings also requires the use of raised truncated domes.

7.7 What Do the Uniform Federal Accessibility Standards (UFAS) Require?

The updated 2006 ABA Accessibility Standards for Federal Facilities replaced the old UFAS standards, so the latter are no longer relevant.

summary

It is clear that accessibility is one of the most heavily—and specifically—regulated areas in the realm of buildings, facilities, and sites. The requirements of ICC/ANSI A1171.-2003 are extremely detailed, and they must be followed without exception in most circumstances.

From time to time, latitude may be granted for less-than-complete accessibility in historic buildings, but one should always plan for complete accessibility—even universal design where feasible—in all new projects and in all major renovation projects.

It is important to remember that accessibility is the one area in the vast sea of code requirements that transcends the boundaries of codes entirely, because the ADA is a federal civil rights law and not an industry-specific regulation. This cannot be overstated nor can it be under considered in the design of projects. Simply put, all new projects—new construction and renovation—must meet accessibility requirements all of time. There are a few exceptions, but they affect only a very small number of projects. The overall intent is as clear as anything can be: make facilities accessible to occupants with physical disabilities.

There are no laws that absolutely require universal design. But as facilities become more universal, they become more attractive to more potential occupants, which cannot be a bad thing. The extremes of ergonomics are becoming increasingly important, especially for unusually large people—those who are very tall and/or very heavy. In recent years, it has become common for employers to furnish oversized chairs, remove wall-hung water closets (which are usually limited to 500 pounds), and so on.

One of the most specialized projects to design is a bariatric unit for a hospital, where stomach-reducing surgeries of various types are done for morbidly obese people. Such a unit requires enlarged doors, elevators, beds, wheelchairs, chairs, other furnishings, and sometimes even special structural reinforcement. Special ambulances can be required too. This specialized segment of the medical industry will probably continue to grow well into the future despite extensive private and governmental efforts to encourage better nutrition and increased exercise. But even a bariatric unit would not be accessible to everyone; in fact, very small people could find such a facility to be harder to use than a conventional facility.

It is also true that the enactment of the ADA has resulted in extensive accessibility improvements to many different facilities all around the country, which has enabled a number of formerly home-bound (or virtually home-bound) individuals to get out and about, to have jobs, and to be more involved in society—all of which is much to the advantage of all of us.

Last, the tension between true code (state and local) requirements and the ADA is significant. Disability lawyers have been known to claim that state and local codes are "unenforceable" because no one can get sued over them. That is true, but design professionals are bound, first and foremost, by the state and local codes and not by the ADA. In truth, there is only one response: use the most conservative requirement in all cases, whether that is from ICC/ANSI A117.1-2003, ABA, or the ADA.

results

Having completed this chapter, the following objectives should have been met:

7.1. To understand the meaning of "accessibility" by understanding the basic requirements of design for physically and mentally disabled people.

7.2. To understand the meaning of "universal design" by understanding the implications of human ergonomics on facility design.

7.3. To understand the meaning of Chapter 11 of the International Building Code, by understanding its use of ICC/ANSI A117.1-2003.

7.4. To understand the meaning of ICC/ANSI A117.1.2003, by having read and understood many, if not most, of the detailed requirements therein.

7.5. To understand the meaning of ADA by knowing that it is a federal civil rights law and not a code per se, and that it has drastically changed everything about accessible design since it went into force in 1992.

7.6. To understand the meaning of ABA by knowing that it s a federal design standard that is applicable to all federal projects (except postal, housing, and military facilities).

7.7. To understand the concept of UFAS by knowing that it has been superceded by the ABA.

notes

1. 2010 ADA Standards for Accessible Design, page 3.
2. Americans with Disabilities Act of 1990, as Amended Title 42 — The Public Health and Welfare Chapter 126 — Equal Opportunity for Individuals with Disabilities Sec. 12101. Findings and Purpose (A) Findings, pages 5–6.
3. Ibid., page 6.
4. International Building Code 2009, page 257.
5. Ibid.
6. Ibid.
7. Ibid., pages 575–77.
8. ICC/ANSI A117.1-2003 *Accessible and Usable Buildings and Facilities*, page 1.
9. Ibid.
10. Ibid., page 3.
11. Ibid., page 8.
12. Ibid., page 15.
13. Ibid., page 45.
14. Ibid., page 46.
15. Ibid., pages 46–48.
16. Ibid., page 52.
17. Ibid., page 50.
18. Ibid., pages 51–52.
19. Ibid., pages 52–53.
20. Ibid.
21. Ibid., pages 54–56.
22. Ibid., pages 56–61.
23. Ibid., page 61.
24. Ibid., pages 62–63.
25. Ibid., page 63.
26. Ibid., pages 65–66
27. Ibid., pages 66–67.
28. Ibid., pages 67–69.
29. Ibid., pages 69–70.
30. Ibid., pages 70–71.
31. Ibid., pages 71–72.
32. Ibid., page 72.
33. Ibid., pages 72–74.
34. Ibid., pages 75–78.
35. Ibid., page 79.
36. Ibid., pages 79–80.
37. Ibid., pages 80–81.
38. Ibid., pages 85–87.
39. Ibid., pages 89–103.
40. 2010 ADA Standards for Accessibility, page 69.
41. Ibid., page 77.
42. Ibid., page 78.
43. Ibid., page 84.
44. Ibid., page 196.

Interior Materials

Requirements

objectives

8.1. To understand general interior materials requirements.

8.2. To understand wall and ceiling finish requirements.

8.3. To understand finish floor requirements.

8.4. To understand combustible materials in Types I and II construction.

8.5. To understand decorative materials and trim requirements.

8.6. To understand acoustical ceiling systems requirements.

8.7. To understand the impact of sustainable design initiatives.

8.8. To understand basic textile labeling systems.

8.1 What Are the General Requirements for Interior Materials?

Broadly speaking, Chapter 8 of the 2009 International Building Code has special requirements for

- Interior finishes (walls, ceilings, and floors)
- Interior trim
- Decorative materials

It also has requirement for materials located below the design flood elevation for buildings in flood hazard areas. The latter area will not be covered in detail in this book, but all of the information can be found in the 2009 IBC.

Combustible materials are allowed for use as finishes for walls, ceilings, floors, and other interior surfaces. Show windows in the first story above grade are allowed to be constructed of wood or unprotected metal framing. And foam plastics may be used only as finish materials under special circumstances (found in section 803.4).[1]

8.2 Wall and Ceiling Finishes

All interior wall and ceiling finish materials must be classified in one of two ways. First, all materials are classified as follows—

Class A: Flame spread index less than or equal to 25 and smoke-developed index of less than or equal to 450.

Class B: Flame spread index from 26 to less than or equal to 75, and smoke-developed index of less than or equal to 450.

Class C: Flame spread index from 76 to less than or equal to 200, and smoke-developed index of less than or equal to 450.2.[2]

ASTM E84, NFPA 255, and UL 723 tests are done using the Steiner Tunnel Test. In this test, a long narrow sample of the material to be tested (17.6 inches [448 mm] wide by 24 feet [7300 mm] long) is adhered to the ceiling of a chamber that is 12 inches (305 mm) high, and the sample is ignited near one end. Ventilation air enters the chamber near the ignition end and a photoelectric cell is located 40 feet (12 200 mm) beyond the sample at the opposite end. The photoelectric cell reads the smoke that exits the tunnel and a rating is determined on the basis of the quantity of that smoke. Unfortunately, this testing apparatus doesn't even resemble real-world conditions—how many rooms are 12 inches (305 mm) high? How many materials are adhered to the ceiling? So various other testing procedures have been developed in response.

Or, second, all materials are classified using the room corner test under NFPA 286. The criteria for NFPA 286 are as follows—

"803.2.1.1 Acceptance criteria for NFPA 286. During the 40 kW exposure, the *interior finish* shall comply with Item 1. During the 160 kW exposure, the *interior finish* shall comply with Item 2. During the entire test, the *interior finish* shall comply with Items 3 and 4.

1. During the 40 kW exposure, flames shall not spread to the ceiling.
2. During the 160 kW exposure, the *interior finish* shall comply with the following:
 2.1 Flame shall not spread to the outer extremity of the sample on any wall or ceiling.
 2.2 Flashover, as defined in NFPA 286, shall not occur.
3. The peak rate of heat release throughout the NFPA 286 test shall not exceed 800 kW.
4. The total smoke released throughout the NFPA 286 test shall not exceed 1,000 m^2."[3]

For textile wallcoverings and expanded vinyl wallcoverings, either NFPA 265 Method B protocol or ASTM E 84 (or UL723) may be used. The NFPA 265, Method B protocol requirements are—

"803.1.3.1 Acceptance criteria for NFPA 265. During the 40 kW exposure the *interior finish* shall comply with Item 1 during the 150 kW exposure, the *interior finish* shall comply with Item 2. During the entire test, the *interior finish* shall comply with Item 3.

1. During the 40 kW exposure, flames shall not spread to the ceiling.
2. During the 150 kW exposure, the *interior finish* shall comply with the following:
 2.1 Flame shall not spread to the outer extremities of the samples on the 8-foot by 12-foot (203 mm by 305 mm) walls.
 2.2 Flashover, as described in NFPA 265, shall not occur.
3. The total smoke released throughout the NFPA 265 test shall not exceed 1,000 m^2."[4]

NFPA 265, UL 1715, NFPA 286, and ASTM E2257 tests are done using the Room Corner Test. In the Room Corner Test, an actual room corner is constructed that is 8 feet (2440 mm) wide by 12 feet (3660 mm) long by 8 feet (2440 mm) high, and portions of two walls are covered by the material being tested (especially in the corner and within 24 inches [610 mm]

Flame spread index

—A comparative measure, expressed as a dimensionless number, derived from visual measurements of the spread of flame versus time for a material tested in accordance with ASTM E 84 or UL 723.

Smoke-developed index

—A comparative measure, expressed as dimensionless number, derived from measurements of smoke obscuration versus time for a material tested in accordance with ASTM D 84.

Interior finish

—"Interior finish includes interior wall and ceiling finish and interior floor finish."

Interior wall and ceiling finish

—"The exposed interior surfaces of buildings, including but not limited to: fixed or movable walls and partitions; toilet room privacy partitions; columns; ceilings; and interior wainscoting, paneling or other finish applied structurally or for decoration, acoustical correction, surface insulation, structural fire resistance or similar purposes, but not including trim."

Interior floor finish

—"The exposed floor surfaces of buildings including coverings applied over a finished floor or stair, including risers."

Interior Materials Requirements

of the ceiling). The ignition source is located in the corner at the test sample. This test does closely resemble actual conditions in real fires.

The ASTM E 84 requirements are—

"803.1.4 Acceptance criteria for textile and expanded vinyl wall or ceiling coverings tested to ASTM E 84 or UL 723. Textile wall and ceiling coverings and expanded vinyl wall and ceiling coverings shall have a Class A flame spread index in accordance with ASTM E 84 or UL 723 and be protected by an automatic sprinkler system installed in accordance with Section 903.3.1.1 or 903.3.1.2. Test specimen preparation and mounting shall be in accordance with ASTM E 2404."[5]

Materials having a thickness of less than 0.036 inch (0.9 mm) that are applied directly to the surface of walls or ceilings and exposed heavy timber in Type IV building are exempt from these testing requirements.[6]

The use of foam plastics is governed by Section 2603.9, which has extensive and detailed requirements; however, 2603.9 allows for the use of foam plastics whenever approved under a large-scale test (similar to NFPA 286, FM 4880, UL 1040, or UL 1715). Even if the materials are approved under one of these large-scale tests, the flame spread requirements of IBC Chapter 8 still apply.[7] Essentially, this means that foam plastics can be used only where large-scale testing has been done that resembles the proposed installation. Such materials have been used extensively in various building types, especially in retail stores.

So what determines where to use Class A, Class B, or Class C materials? Table 803.9 Interior Wall and Ceiling Finish Requirements by Occupancy. See Figure 8.1.

As can be seen in this table, finishes in rooms and enclosed spaces (not including corridors, exit enclosures, and exit passageways) can be Class C in all sprinklered buildings, except those housing I-2 and I-4 occupancies. Materials in sprinklered corridors, exit enclosures, and exit passageways are either Class B or Class C, except for Class A in I-3 occupancies.

For non-sprinklered buildings, the requirements are understandably a little tighter: Class B in most rooms and enclosed spaces and Class A, B, or C in corridors, exit enclosures and exit passageways. The explanatory notes at the bottom of the table are critical and must be checked for each particular situation.

Finishes for fire-rated assemblies are essentially the same, except that there are limitations on attachment methods. First, the finishes can be applied directly to the rated assembly. Second, the finishes can be applied using furring strips up to 1 3/4 inch (44 mm) thick, if (a) the spaces between the furring strips are filled with inorganic or noncombustible material, (b) the spaces are filled with Class A materials, or (c) the spaces are fire-blocked at 8 feet (2438 mm) or less in any direction.[8]

If offsets are greater than 1 3/4 inch (44 mm), Class A materials must be used unless lower classification materials are protected on both sides by an automatic sprinkler system or attached to noncombustible backing or furring. In Type III and V buildings, dropped ceilings may be constructed using combustible materials.[9]

Class A Finishes

It is best to use only Class A finishes in commercial projects. But if a Class B or Class C material is desirable, it is necessary for the interior designer to verify that it can be acceptable in the situation at hand.

Deep Furring

There really is no good reason to install finish materials with large furred-out spaces behind them. Such spaces create problems and they use up valuable space.

8.3 Interior Floor Finish

In general, floor finish materials must meet the requirements of Class I or Class II as defined by NFPA 253, but all "traditional" floor finishes and coverings are exempt, including wood, vinyl, linoleum, or terrazzo and resilient materials that are not composed of fibers.[10]

GROUP	SPRINKLERED[1]			NON-SPRINKLERED		
	Exit enclosures and exit passageways[a,b]	Corridors	Rooms and enclosed spaces[c]	Exit enclosures and exit passageways[a,b]	Corridors	Rooms and enclosed spaces[c]
A-1 & A-2	B	B	C	A	A[d]	B[e]
A-3[f], A-4, A-5	B	B	C	A	A[d]	C
B, E, M, R-1	B	C	C	A	B	C
R-4	B	C	C	A	B	B
F	C	C	C	B	C	C
H	B	B	C[g]	A	A	B
I-1	B	C	C	A	B	B
I-2	B	B	B[h,i]	A	A	B
I-3	A	A[j]	C	A	A	B
I-4	B	B	B[h,i]	A	A	B
R-2	C	C	C	B	B	C
R-3	C	C	C	C	C	C
S	C	C	C	B	B	C
U		No restrictions			No restrictions	

For SI: 1 inch = 25.4 mm, 1 square foot = 0.0929 m².

a. Class C interior finish materials shall be permitted for wainscoting or paneling of not more than 1,000 square feet of applied surface area in the grade lobby where applied directly to a noncombustible base or over furring strips applied to a noncombustible base and fireblocked as required by Section 803.11.1.

b. In exit enclosures of buildings less than three stories above grade plane of other than Group I-3, Class B interior finish for non-sprinklered buildings and Class C interior finish for sprinklered buildings shall be permitted.

c. Requirements for rooms and enclosed spaces shall be based upon spaces enclosed by partitions. Where a fire-resistance rating is required for structural elements, the enclosing partitions shall extend from the floor to the ceiling. Partitions that do not comply with this shall be considered enclosing spaces and the rooms or spaces on both sides shall be considered one. In determining the applicable requirements for rooms and enclosed spaces, the specific occupancy thereof shall be the governing factor regardless of the group classification of the building or structure.

d. Lobby areas in Group A-1, A-2, and A-3 occupancies shall not be less than Class B materials.

e. Class C interior finish materials shall be permitted in places of assembly with an occupant load of 300 persons or less.

f. For places of religious worship, wood used for ornamental purposes, trusses, paneling or chancel furnishing shall be permitted.

g. Class B materials is required where the building exceeds two stories.

h. Class C interior finish materials shall be permitted in administrative spaces.

i. Class C interior finish materials shall be permitted in rooms with a capacity of four persons or less.

j. Class B materials shall be permitted as wainscoting extending not more than 48 inches above the finished floor in corridors.

k. Finish materials as provided for in other section of this code.

l. Applies when the exit enclosures, exit passageway, corridors or rooms and enclosed spaces are protected by an automatic sprinkler system installed in accordance with Section 903.3.1.1 or 903.3.1.2.

FIGURE 8.1 IBC 2009, Table 803.9 Interior Wall and Ceiling Finish Requirements by Occupancy

Effectively, this huge exception eliminates most of the requirements in most situations except carpet and rugs. Both carpet and rugs must be tested (using the NFPA 253 procedures), including underlayment.

Floor finish materials in exit enclosures must withstand a critical radiant flux test (the DOCFF-1 "pill test," CPSC 16 CFR, Part 1630) for Class I in I-1, I-2, and I-3 occupancies and Class II in all other occupancies. Again, there is a very large exception here. If the building is equipped with a complete automatic sprinkler system, Class II materials may be used wherever Class I materials are required.[11]

The pill test apparatus consists of a small box that is 12 inches (305 mm) deep, 12 inches (305 mm) wide, and 12 inches (305 mm) high without a top. A 9-inch (230-mm) sample of the test material is placed in the bottom of the box with a 9-inch (230-mm) square steel plate on top of it. The steel plate has an 8-inch (205-mm) hole in it to expose the test sample. A methenamine tablet (or pill) is used as an ignition source that resembles a burning cigarette or an ember from

a fireplace. After the fire has gone out (on its own), a measurement is taken to see how far the burn extended from the pill. If the burn reached closer than 1 inch (25 mm) to the metal plate, the material fails the test.

8.4 Combustible Materials in Types I and II Construction

Combustible materials installed on or embedded in floors in Types I and II construction must meet the following requirements—

- Fire-blocked or noncombustible-filled spaces between sleepers; and
- No open spaces below permanent partitions or walls; or
- Attached directly to embedded or fire-blocked wood sleepers that are cemented directly to the top surface of the fire-resistance-rated assembly; and
- Combustible insulating boards up to 1/2 inch (12.7 mm) thick that are covered with finish flooring are allowed if attached directly to the noncombustible floor assembly or to properly fire-blocked wood sleepers.[12]

8.5 Decorative Materials and Trim

In Groups A, E, I, and R-1 occupancies and Group R-2 dormitories, curtains, draperies, hangings and other *decorative materials* suspended from walls or ceilings must (a) be noncombustible, (b) meet the flame propagation requirements of NFPA 701, or (c) meet the following—

- In Groups I-1 and I-2, decorative materials must meet the requirements of NFPA 701 unless the materials (including but not limited to paintings and photographs) are of such limited quantity as to present little fire risk.
- In Group I-3, combustible decorative materials are not allowed at all.
- If a material covers 10 percent or more of a surface, that material is an interior finish and not a decorative material.
- In Groups B and M, fabric partitions suspended from the ceiling (and not supported by the floor) must be noncombustible or must meet the flame propagation requirements of NFPA 701. The amount of such materials is not limited.
- Combustible decorative materials may not exceed 10 percent of a specific wall or ceiling area.
- In Group A auditoriums, the extent of combustible decorative materials may not exceed 75 percent where the building is fully sprinklered.
- If testing is required, test reports are to be made available to the building official upon request.
- Combustible trim may not exceed 10 percent of the wall or ceiling to which it is attached.
- Interior wall base 6 inches (152 mm) or less in height is to be no less than Class II and tested in accordance with NFPA 253. Wall base for Class I floors must be Class I also.[13]

Decorative materials

—All materials applied over the building interior finish for decorative, acoustical, or other effect (such as curtains, draperies, fabrics, streamers, and surface coverings), and all other materials utilized for decorative effect (such as batting, cloth, cotton, hay, stalks, straw, vines, leaves, trees, moss, and similar items), including foam plastics and materials containing foam plastics. Decorative materials do not include floor coverings, ordinary window shades, interior finish and materials 0.025 inch (0.64 mm) or less in thickness applied directly to and adhering tightly to a substrate.

8.6 Acoustical Ceiling Systems

Suspended acoustical ceiling systems—usually called "lay-in" or "grid" ceilings are to be installed according to ASTM C 635 and ASTM C 636, and fire-rated suspended acoustical ceiling systems are to be installed as required by the testing.[14]

Fire-rated suspended acoustical ceilings create many additional difficulties, mostly due to penetrations for lights and HVAC ductwork. HVAC penetrations are more easily resolved than lighting penetrations because standard "radiation dampers" are available to put into the ductwork at the point of penetration. For light fixtures, it is often necessary to build fire-resistance-rated boxes above and around the fixtures, to buy special fixtures, or to buy special protective enclosures for standard fixtures—all of which is costly and to be avoided where feasible.

Fire-Rated Ceilings II
Fire-rated ceiling assemblies are a problem that should be avoided, especially in lay-in ceiling systems.

8.7 Sustainable Design

Numerous new systems have appeared in recent years to encourage the development and use of more sustainable materials and systems in buildings. Here are a few of them—

- ACT (Association for Contract Textiles) and GreenBlue Institute are working toward sustainable standards for textiles.
- BIFMA (Business and Institutional Furniture Manufacturer's Association) is developing a sustainable business furniture standard.
- CRI (Carpet and Rug Institute) is developing sustainable carpet standards.
- Green Globes (The Green Building Initiative) provides an alternative to LEED®.
- LEED® (Leaders in Energy and Environmental Design), from the U.S. Green Building Council, has become the dominant system for sustainable building projects.
- RFCI (Resilient Floor Covering Institute) is developing a sustainable resilient floor covering standard.

8.8 Textile Labeling Systems

Manufacturers of commercial textiles use various labeling systems for their products, ranging from simple notations such as "Class A fire rated in accordance with ASTM E 84 tunnel test" to ACT's Voluntary Performance Guidelines system.

ACT's system includes symbols for Flammability (a flame), Wet & Dry Crocking (a palette), Colorfastness to Light (a sun), Physical Properties (a 5-pointed star), and Abrasion (a lowercase "a" for general upholstery and an uppercase "A" for heavy-duty upholstery).

ACT's flame symbol indicates the following:

Upholstery—passed the California Technical Bulletin #117 Section E—Class 1

Direct Glue Wallcovering—passed ASTM E 84-03, Class A or 1

Drapery—passed the NFPA 701-89 Small Scale test

Crocking is the transfer of dye by rubbing, and ACT's palette symbol indicates the following:

Upholstery—Grade 3 minimum for wet and Grade 4 minimum for dry

Direct Glue Wallcovering—Grade 3 minimum for wet and dry

Wrapped Panels and Upholstered Walls—Grade 3 minimum for wet and dry

Drapery, solids—Grade 3 minimum for wet and dry

Drapery, prints—Grade 3 minimum for wet and dry

ACT's sun symbol indicates the following:
Upholstery—AATCC 16 Option 1 or 3-2003, Grade 4 minimum at 40 hours

Direct Glue Wallcovering—AATCC 16 Option 1 or 3-2003, Grade 4 minimum at 40 hours

Wrapped Panels and Upholstered Walls—AATCC 16 Option 1 or 3-2003, Grade 4 minimum at 40 hours

Drapery—AATCC 16 Option 1 or 3-2003, Grade 4 minimum at 60 hours

ACT's star symbol rates resistance to pilling, breaking strength, and seam slippage, and it indicates the following:

Upholstery—

Brush pill ASTM D3511-02, Class 3 minimum

Breaking strength ASTM D5034-95 (2001) Grab Test, 50 pounds minimum in warp and weft

Seam slippage ASTM D4034, 25 pounds minimum in warp and weft

Wrapped Panels and Upholstered Walls—

Breaking strength ASTM D5034-95 (2001) Grab Test, 35 pounds minimum in warp and weft

Drapery—

Seam slippage ASTM D3597-02-D434-95 for fabrics over 6 oz/sy, 25 pounds minimum in warp and weft

ACT's abrasion symbols indicate the following:

General Contract Upholstery—ASTM D4157-02, 15,000 double rubs Wyzenbeek method or ASTM D4966-98 (12 KPa pressure), 20,000 cycles Martindale method

Heavy Duty Upholstery—ASTM D4157-02, 30,000 double rubs Wyzenbeek method or ASTM D4966-98 (12 KPa pressure), 40,000 cycles Martindale method.[15]

Basically, these designations simply say that a textile, whether used for upholstery, wall panels, wallcovering, or drapery, meets the essential requirements for commercial use.

Maharam (a major commercial textile manufacturer) uses different designations. Here are few examples:

Fabric A —"Class A fire rated in accordance with ASTM E 84 tunnel test" with the ACT flame symbol and "40+ hours" for lightfastness with the ACT sun symbol.

Fabric B —"23,000+ double rubs" with the ACT lowercase "a" symbol and "This textile meets all appropriate flammability requirements, including California Bulletin #117 and NFPA 260, and is compatible with California Bulletin #133" with the ACT flame symbol, and "40+ hours" for lightfastness with the ACT sun symbol.

Carnegie Fabrics uses another set of designations:

Fabric C —"Passes NFPA 701" for flame retardancy.

Fabric D —"Qualifies For Class A/Class 1 Areas Under ASTM E84 This Fabric Meets Requirements of UL Fabric Recognition Program Can Be Treated To Pass NFPA 701" for flame retardancy.

Fabric E —"Passes California Bulletin 117E. Passes NFPA 260. Can Be Treated To Pass NFPA 701" for flame retardancy and "Qualifies For Heavy Duty Contract Use No Wear After 50,000 Double Rubs Wyzenbeek Abrasion Test ASTM D4157" for durability.

Fabric F —"Inherently Fire Retardant" for finish and "Passes NFPA 701 Qualifies For Class A/Class 1 Areas Under ASTM E84" for flame retardancy.

Instyle Contract Textiles uses yet another set of designations:

Fabric G —ACT uppercase A, flame, palette, sun, and star, plus more detailed information about actual performance (which exceeds ACT's standards in most areas).

Fabric H —ACT uppercase A, flame, palette, sun, and star, plus more detailed information about actual performance (which exceeds ACT's standards in most areas).

And, last, HBF Textiles says the following about one of its fabrics "FR Rating: California Technical Bulletin 117" and "Abrasion: 99,000 (Wyzenbeek)," along with ACT's uppercase A, flame, palette, sun, and star symbols.

Ultimately, it is up to the designer to verify that any textile (upholstery, wallcovering, wrapped wall panel, or drapery) meets the requirements for commercial projects. Clearly, the manufacturers make information available, but the designer should not assume that a given product meets a specific requirement unless the manufacturer provides some kind of evidence.

summary

In addition to the specific requirements noted above, there are also a number of industry standards for various other products, from millwork, to furniture, to fabrics. Many of these standards are nationally recognized and few commercial products are available that do not comply with them.

The increasing prominence of sustainable products has put some strain on these systems, and a number of new systems have cropped up in response to new concerns about VOCs, off-gassing, recyclability, recycled content, and so on. But this remains a largely unregulated area.

Overall, each interior designer must take care to ensure that all products used in every project do not comprise unreasonable hazards and do not violate any applicable codes or regulations.

results

Having completed this chapter, the following objectives should have been met:

8.1. To understand general interior materials requirements by knowing that materials must meet minimum flame spread and smoke-developed standards (in general).

8.2. To understand wall and ceiling finish requirements by understanding Class A, Class B, and Class C and where each class applies.

8.3. To understand finish floor requirements by understanding Type I and Type II and where each type applies.

8.4. To understand combustible materials in Types I and II construction by knowing that the use of combustible material is heavily limited in Types I and II construction, except where carefully constructed and/or protected by a sprinkler system.

8.5. To understand decorative materials and trim requirements by knowing that the use of combustible decorative materials and trim is limited, except where carefully constructed and/or protected by a sprinkler system.

8.6. To understand acoustical ceiling systems requirements by knowing that all systems must meet minimum criteria and by knowing that fire-resistance-rated systems can be highly problematic.

8.7. To understand the impact of sustainable design initiatives, by recognizing the need for updated material and systems quality standards.

8.8. To understand basic fabric labeling systems used by various manufacturers by recognizing ACT's symbols and by understanding what various test results mean.

notes

1. International Building Code 2009, page 175.
2. Ibid., pages 175–76.
3. Ibid., page 176.
4. Ibid.
5. Ibid.
6. Ibid.
7. Ibid., page 177.
8. Ibid.
9. Ibid., pages 177–78.
10. Ibid., page 178.
11. Ibid.
12. Ibid.
13. Ibid., pages 178–79.
14. Ibid., page 179.
15. Association for Contract Textiles, ACT Voluntary Performance Guidelines, January 2005.

Mechanical, Electrical, and Plumbing

9.1 Mechanical Systems Code Documents

Four documents cover most code requirements for mechanical systems—

- 2009 International Building Code
- 2009 International Mechanical Code
- 2009 International Energy Conservation Code
- ASHRAE 90.1-2007 Energy Standard for Buildings Except Low-Rise Residential Buildings (Some advanced jurisdictions might be using the 2010 version of this document.)

9.1.1 2009 INTERNATIONAL BUILDING CODE

In the 2009 International Building Code, Chapter 12 governs interior environments and Chapter 28 governs mechanical systems.

Article 1203 includes requirements for—

- general natural ventilation (1203.1);
- general mechanical ventilation (1203.1, requiring conformance with the International Mechanical Code);

objectives

9.1. To understand code-related impacts of mechanical systems.

9.2. To understand code-related impacts of electrical systems.

9.3. To understand code-related impacts of plumbing systems.

- attic space cross-ventilation (1203.2);

- under-floor ventilation, that is, crawl-spaces (1203.3);

- detailed natural ventilation (1203.4); and

- hazardous ventilation (1203.5).

Similarly, article 1204.1 requires minimum heating indoor temperate of $68°F$ ($20°C$) at a point 3 feet (914 mm) above the floor.[1] (Note that there is no requirement for cooling.) These requirements are critical for architects and engineers, but they are rarely applicable to interior design, so they will not be discussed is greater detail.

Nevertheless, some discussion of ventilation is in order. As we breathe, we inhale air, which is composed of mostly nitrogen with a substantial percentage of oxygen, and we exhale a gas that is mostly carbon dioxide (CO_2). As the concentration of CO_2 increases, we begin to get a sensation of "stuffiness," and very high levels of CO_2 can be dangerous.

Also, when we burn fuel inside a building for cooking or for space heating, the appliance uses air (the same air that we breathe for atmospheric burners but outdoor air for sealed combustion burners) to burn the fuel. Part of the byproduct of combustion of fossil fuels is carbon monoxide (CO), which is quite deadly in high concentrations. CO is odorless and colorless, so we can't sense its presence. Increasing levels of CO make us drowsy, eventually causing us to pass out and then to die.

The answer to excessive concentration of both CO_2 and CO is ventilation, which can be accomplished in two ways—

a. Naturally, by opening windows and/or doors or by using louvers (openings)

b. Mechanically, by using fans to force bad air out and bring fresh air in.

In most commercial buildings, mechanical ventilation is provided according to the requirements of the 2009 International Mechanical Code (see 9.1.2 below).

In many, if not most, residential buildings—especially one- and two-family dwellings and apartment buildings—natural ventilation is used. Using natural ventilation does mean that there is no ventilation if all of the windows, doors, and louvers are closed (or even partially closed), which is often the case. When windows, doors, and louvers are closed, the only opportunity for air to enter the building occurs when the exterior doors are opened and closed; this is why buildings that have been closed for an extended period of time smell "stuffy" (and are oftentimes moldy too).

If there are exhaust fans running in a building (any building), there will be some mechanical ventilation. An exhaust fan can only push air out of the building if there is air coming in to the building to balance the air going out; this will occur whether or not there are specific "ventilation openings." If there are no specific openings, air will simply leak into the building through every available crack and crevice.

Moving air into and out of a building for ventilation purposes is very costly, especially in very cold climates in the winter and in warm and damp climates in the summer, so there is some incentive to reduce these expenses. This can be done by (a) reducing the amount of air (which can be done in some cases and not in others), (b) using special filtration equipment to reduce the need for "clean" air, and (c) using equipment to recover heat (and/or cool) from the exhaust air stream. The later is called a "heat exchanger" or energy recovery ventilation (ERV). The latter term is used more often. Today, we often see ERVs in both residential and commercial buildings.

The highly hazardous nature of carbon monoxide makes it desirable to know if it's rising to dangerous levels. Although there are no code requirements for such monitoring in commercial buildings (there are requirements for one- and two-family dwellings—see Chapter 10), inexpensive devices are readily available and can be used in homes and commercial buildings with or without other monitoring systems.

There is another undetectable gas that comes into play in residences too: radon. Radon is found in the soil, and where there is a substantial risk, vent systems are built

Ventilation

For every project, ventilation should be discussed among the whole design team with the owner at the outset of the project to make sure that everyone is operating from the same starting point. The resolution of ventilation can affect spacing planning, window sizing and placement, space for ductwork, and so on, and it simply can't be ignored.

under buildings to collect the gas and expel it to the sky at the top of the building with or without fans. Again, there are no code requirements for radon monitoring or evacuation, but it is commonly done in multifamily projects and in some one- and two-family dwellings.

9.1.2 2009 INTERNATIONAL MECHANICAL CODE

The 2009 IMC directly affects the practice of interior design only in the requirements for "plenums" and for commercial exhaust systems in kitchens. The former is more critical for most interior designers.

9.1.2.1 The Plenum

The return-air plenum has come to dominate certain building types in recent years, primarily office buildings. This has occurred mostly to reduce costs. What this means is that the space above the ceiling is used to return air to the fans in the HVAC system (wherever they are and however many there are). This has two major impacts on the practice of interior design.

First, IMC 602.2.1 says—

"602.2.1 Materials exposed with plenums. Except as required by Sections 602.2.1.1 through 602.2.1.5, materials within plenums shall be noncombustible or shall have a flame spread index of not more than 25 and a smoke-developed index of not more than 50 when tested in accordance with ASTM E 84."[2]

The most significant exception (and the only one that affects interior design practice) is that these requirements do not apply to one- and two-family dwellings—unless the applicable residential code says so (the 2009 International Building Code usually does NOT apply to one- and two-family dwellings). But they do apply to anything that might be in a plenum anywhere else: line voltage wiring, low voltage wiring (including fire alarm, security, voice, video, audio, data, etc.), plumbing piping (including waste, vent, domestic water, and natural gas), HVAC piping (including steam, water, glycol, and refrigeration), fire protection piping, specialty piping (including medical gas), ductwork, and materials used to construct the plenum itself (i.e., no combustible products—no wood, ever).

Oddly, it has been learned recently that it is possible to construct a plenum in a Type III-B or a Type V-B (unprotected combustible) structure by using combustible materials. This seems to be completely inconsistent with everything about the idea of an air plenum, but it has been confirmed in ICC commentary. But even if the plenum is defined by combustible materials, the requirements for materials and systems within the plenum are the same.

Second, when a return-air plenum is used, there is a strong need to leave the plenum as open as possible, which means that walls extending through the ceiling to the deck above are strongly discouraged. (This alone makes fire-rated corridors and return-air plenums mostly incompatible.) This is the case because such full-height walls cut off access to return air, which requires special consideration by the mechanical engineer and increased cost in the mechanical system (and increased risk of noise problems). If walls extend a few inches above the ceiling, that usually has only a minor effect on the plenum. Walls that stop at the underside of the ceiling (which is quite common in the commercial office market) have no effect on the plenum at all.

If a particular building has fully ducted return-air system, then the space above the ceiling is NOT a return-air plenum and these requirements do not apply. But it can be difficult to know that a system is fully ducted return-air, so it is best to assume that the space is a plenum unless someone (with authority) confirms that it is not. Partially ducted systems (which is most of them, actually) still result in the space being a plenum.

This also applies to supply air and exhaust air plenums too, although those are both far less common.

Some projects are being built with supply air plenums under the floor, and the plenum restrictions would apply there too.

Plenum

—An enclosed portion of the building structure, other than an occupiable space being conditioned, that is designed to allow air movement, and thereby serves as part of an air distribution system.

In Chicago, special plenum rules are in effect as well, which affect recessed light fixtures more than anything else.

9.1.2.2 Commercial exhaust systems

The challenge related to commercial kitchen exhaust systems is the gray area between full commercial kitchens in restaurants and institutions (schools, hospitals, prisons, etc.) and smaller kitchens that may or may not use residential cooking equipment. For full residential kitchens (one- and two-family dwelling units, residential-style motels and hotels, apartments, and condominiums), there are no specific exhaust requirements. But commercial kitchens require two different types of exhaust hoods: Type I and Type II.

> **Plenums**
>
> The issue of air plenums must also be addressed at the beginning of the project with the whole design team and the owner. This issue affects low-voltage cabling, wall design and placement, ductwork sizing and extent, and so on, and it simply can't be ignored.

Type I hoods are hoods that include grease-removal devices (special filters used to reduce the concentration of grease in the exhaust air stream) and fully automatic fire-suppression systems (dry chemical systems that automatically put out substantial fires—small fires are OK if they are not out of control, as when doing flambé while cooking). Type I hoods are required "where cooking appliances produce grease or smoke. Type I hoods shall be installed over medium-duty, heavy-duty and extra-heavy duty cooking appliances. Type I hoods shall be installed over light-duty cooking appliances that produce grease or smoke."[3] These requirements are sensible because cooking can be highly hazardous. Many different cooking appliances—fryers, griddles, cooktops, and even some ovens—do release substantial amounts of grease into the air. Grease is a highly flammable substance and it is quite possible to have fires in the ducts that lead from hoods to the exhaust fans (which are usually, but not always, outside the building). For that reason, such ducts are required to be constructed using heavy steel and fully welded joints to prevent fires from escaping into the surrounding structure.

These grease ducts, as they are called, also require substantial separation (up to 18″) from combustible materials, which can make it very difficult to install them in wood-framed buildings. Special, and very costly, fire-resistive duct insulation is available for use in such situations.

Type II hoods do not require grease-removal or fire suppression, but they are required above "dishwashers and light-duty appliances that produce heat or moisture and do not produce grease or smoke, except where the heat and moisture loads from such appliances are incorporated into the HVAC system design or into the design of a separate removal system. Type II hoods shall be installed above all light-duty appliances that produce products of combustion and do not produce grease or smoke."[4]

Both of these lists of applications are based on the assumption of commercial equipment. What happens if the equipment is residential but it is used in a commercial environment (restaurant, institutional kitchen, church, day care center, fire station, etc.)?

"507.2.3 Domestic cooking appliances used for commercial purposes. Domestic cooking appliances utilized for commercial purposes shall be provided with Type I or Type II hoods as required for the type of appliances and processes in accordance with Sections 507.2, 507.2.1, and 507.2.2."[5]

Section 507.2.1 is the source for the Type I hood requirements noted above and Section 507.2.2 is the source for the Type II hood requirements noted above, which means that the requirements for domestic (or residential) appliances used in commercial environments are the same as the requirements for commercial appliances.

This is a highly unpopular rule for fire station, day care, and church projects (among others) because Type I hoods are very costly to purchase and install. For a typical single 30″-wide range, a Type I hood (with its required make-up air system) could cost more than $20,000 installed, and that's a cost that many owners don't want to incur. Type I hoods for large kitchens often cost well over $60,000, installed. Some large kitchens have two or more Type I hoods. Some grocery stores have up to four or more Type I hoods in various departments (prepared foods, service fish, deli, bakery, etc.).

The main objection from firefighters is that they are really doing "family"-style cooking, and that makes sense for small fire stations where they cook for 4 to 6 people. But many fire stations are much larger than that, and these requirements do make sense if the kitchen is being used to cook for 10, 12, or more people three times every day.

Churches object to this primarily because they don't cook every day, sometimes not even every week.

Day care centers object because many of them don't actually cook at all—they "warm" or "reheat" instead. But if they install a commercial or residential range (with or without an oven) for their warming, they are still subject to these requirements.

This whole commercial hood issue matters for interior designers not because an interior designer would ever design one (even mechanical engineers rarely design such systems—they are usually designed by their manufacturers, largely due to UL-listing issues) but because they affect the budget and the space plan. Commercial hoods (Type I or Type II) are usually 6″ wider than the equipment under them at each end and at least 6″ deeper (front to back) than the equipment; typical hoods are 48″ deep, or more. If the equipment is 8′-0″ wide, the hood would be 9′-0″ long. For a Type I hood, there is usually an additional 12″-deep cabinet on one end of the hood, which contains the fire-suppression equipment. The fire-suppression cabinet can be remote from the hood too.

> **Residential Cooking Appliances**
> Anytime that an owner is interested in using residential appliances in a commercial cooking environment, the interior designer (or architect or mechanical engineer) must explain all of the ramifications of that decision to the owner because of the budget impacts more than anything else.

The Type II hood requirements for commercial dishwashers (usually called dishmachines) are also challenging. As noted above, a Type II hood is required for a commercial dishwasher that produces heat or moisture, and, most assuredly, all commercial dishwashers produce heat and/or moisture. This can be controversial because some commercial dishwashers do not use 180°F water to sanitize the dishes; instead, they use chemical sanitizing. Machines that sanitize chemically produce far less heat and moisture than conventional machines, but they still produce some of both, so they are still subject to the requirement for a Type II hood. This is also unpopular due to the cost, but the cost of Type II hood is much lower, although still substantial.

9.1.2.3 Space Requirements

Mechanical systems also have effects on interior design practice due to headroom restrictions and floor space requirements, depending on the type of system that's in place, or that's planned. The basic system types most commonly seen in commercial projects are—

- All-Air Constant Volume (CV or CAV) single-zone or multi-zone split-system with indoor furnaces or fan coils and outdoor air-cooled condensing units (ACCU) or heat pumps.

This is the type of system that is used for most single-family homes, some small commercial buildings, some churches, and so on. Its forms include indoor coal-fired, oil-fired, wood-fired, propane-fired, and natural gas–fired furnaces without cooling; all of those furnace types with added indoor coils and outdoor ACCUs for cooling; natural gas–fired furnaces with heat pumps for cooling (in this system the heat pump is the primary heating source and the furnace takes over when the heat pump becomes less efficient); and indoor fan coils with outdoor heat pumps. An electric heat pump is simply an ACCU that can run backward to provide heating. Heat pumps do lose efficiency as the outdoor temperature drops, and most systems switch over to electric resistance heat (usually called "auxiliary heat") at some predetermined outdoor temperature (usually in the low to mid-30°F range). The newest systems are hybrid gas/electric systems as noted above. These are all single-zone systems, meaning that there is a single thermostat. Zone dampers can be added to provide limited multi point control by closing off a room, or group of rooms, to prevent overcooling or overheating, but zone dampers can't produce heat in one room and cooling in another room at the same time.

- All-Air Constant Volume (CV or CAV) single-zone packaged gas/electric or all-electric rooftop unit (RTU).

This is the most common system used in light commercial, some major commercial, some educational, and even some institutional buildings. It is similar to the first system mentioned above, except that both the heating and cooling equipment are located within a single cabinet (hence "packaged") that sits on a special curb on the roof. Only the supply and return ducts, the wiring, and sometimes the gas piping penetrate the roof. These units can be heat pumps, and they can also be used with zone dampers.

- All-Air Variable Air Volume (VAV) split-system with indoor air handlers and outdoor air-cooled condensing units.

This system is used in some light commercial, some major commercial, and some institutional buildings. The difference is that the equipment for this system is variable, meaning that the fans can run at part speed and the heating (if any) and the cooling can run at "partial load." The central unit(s) usually runs in cooling only (except for morning warm-up sometimes), and heating is provided at local terminals via hot water or electric heat in the "VAV terminals." These VAV terminals are air valves that open and close according to whether or not the specific zone needs cooling (or heating). VAV terminals are also available with internal fans to keep air recirculating even when there is no need for cooling. Fan-powered terminals are usually but not always used in perimeter zones with sun exposure. These systems are considerably more complicated and more difficult to operate. On the heating side, they do operate by reheating air that has already been cooled, which greatly limits their energy efficiency. Hot water reheat can be much more efficient than electric reheat, but it is also more costly to build and more difficult to operate.

- All-Air Variable Air Volume (VAV) packaged gas/electric (heating and cooling) or cooling-only rooftop unit (RTU).

This system is just like the split-system VAV mentioned above, but it is done by using packaged rooftop equipment. All of the same operational parameters apply.

- Air-water closed-loop water-source heat pumps (with or without earth coupling—also called "geothermal").

Until very recently, this has been the system of choice for high-energy efficiency because it is the first system that can do full "heat recovery." In any system, when the air-conditioning is on, some machine somewhere is producing excess heat, and when the heating is on, some machine somewhere is using heat. In the first four systems mentioned above, if there are two systems and one is running in heating while the other is running in cooling, the excess heat generated by the unit in cooling is dumped and the heating is provided by using some kind of fuel. By contrast, a heat recovery system can capture the heat from the cooling unit and make it available to the heating unit, thereby drastically increasing energy efficiency. In a water-source heat-pump system, this is done by using a single water loop that connects a series of local heat pumps. The loop water is maintained within a range that can both provide heat for the units that need heat and accept heat from the units that need cooling, using water as the heat transfer medium (which is inherently far more efficient than using air). Under some conditions, these systems can operate in a "steady state," where heat added = heat rejected, but at very low outdoor conditions supplemental heat is needed. Supplemental heat can be provided by an electric or natural gas-fired boiler. At very high outdoor temperatures, the system generates too much heat, which must be rejected to the atmosphere (as with an ACCU or heat pump), and that is done by using either an evaporative cooler (preferred) or a dry cooler. If even higher operating efficiency is desired, the boiler and cooler can be omitted if a very long loop of piping is installed in the ground (earth-coupled, often erroneously called geothermal) or in a pond or lake. This loop stores heat in the ground or water via contact with the long runs of piping. (For earth coupling, the rule-of-thumb is to use about 400 linear feet of piping for each ton of air-conditioning. That's about 1,200 linear feet for a moderately sized house; commercial buildings can easily require miles and miles of piping.)

- Air-water four-pipe, heating hot water and cooling chilled water, fan coils.

This system has been used commonly in institutional (hospitals, schools, government buildings, etc.) and some commercial buildings. In this system, there is a boiler (electric or fueled by coal, oil, wood, propane, or natural gas) to provide heat, which is circulated around the building through piping and distributed to the space using radiators or fan coils. There is also a centralized system to produce chilled water for cooling, which is circulated around the building through piping and distributed to the space using fan coils. If systems provide both heating and cooling, radiators are not usually used (except in heating-only areas). This system can provide heating and cooling simultaneously whenever the boiler and chiller are operating. Although this system can provide for excellent comfort conditions with lots of control (i.e., many thermostats), it is costly to build and generally inefficient, unless an energy-recovery chiller is used. An energy-recovery chiller uses the excess heat from producing chilled water to provide heating.

- Air-water two-pipe, heating hot water or cooling chilled water, fan coils

This is a simplified (therefore lower cost) version of the four-pipe system. Here, the whole system runs in heating or in cooling and has to be switched back and forth when loads change. It is less costly to build (half as much piping), but it has the same efficiency challenges as the four-pipe system. Heat recovery is not an option here because there is no simultaneous heating and cooling to take advantage of it.

- Steam heating

Even though steam heating systems used to be quite common, they have become quite rare in recent years. Steam heating systems are inherently far more dangerous than hot water (and other) systems, and they should be replaced whenever feasible.

- Variable refrigerant flow (VRF) and variable refrigerant volume (VRV) systems that are fan-coil based.

These systems are very similar to closed-loop water source heat pump systems, except that the heat exchange medium is refrigerant instead of water. Even though refrigerant is a chemical and there are some potential health effects to be concerned about in the case of a large scale leak, these systems are actually simpler than water-source heat pump systems. These systems are also as efficient as earth-coupled water-source heat pump systems, largely because everything element of these systems is variable—variable speed fan coils, variable speed compressors, and variable speed condenser fans. This allows the system to tailor itself to the load on a minute-by-minute basis, thereby reducing the operating costs—nothing is wasted. (By contrast, in a water-source heat pump system, the compressors are all still like the compressors in a basic home system—on or off. The cycling on and off and lack of exact load-matching are what allow the VRF systems to catch up, so to speak.) The disadvantage to these systems is that they are designed to operate with exposed fan coils, using equipment that is designed to be seen. But in the American market, everyone is used to having concealed equipment and it can be a challenge to incorporate these systems into projects from an aesthetic point-of-view. This is changing rapidly and it may not be an issue for much longer in most projects.

The water-source heat pump, 4-pipe, 2-pipe, and VRF systems can be built with integral or separated ventilation. Systems having integral ventilation bring outside air directly in through the primary equipment, whether that is a large central air handler or rooftop unit or a series of smaller distributed units. In general, the larger a system is, the easier it is to design it to accommodate outside air intake; conversely, the smaller systems get, the more they struggle with direct outside air intake. In the very demanding midwestern climate (cold winters and hot and damp summers), the rule of thumb is to limit outside air intake on small or low-end systems to 10% of the total air flow; that's simple to do but it doesn't always meet the ventilation requirements for the building. In meeting rooms and other assembly spaces, it is not at all uncommon to see ventilation loads that exceed 30% of the total. In such cases, it is necessary to design a larger system or to use separate ventilation.

Separate ventilation systems are exactly that: separate. By putting the ventilation into a completely different system, the remaining equipment can operate under far better conditions. And the separate ventilation system is designed—upfront—specifically to handle ventilation,

and ventilation only, at levels up to and including 100%. These systems can drive installation costs slightly higher (depending on many complicated details of equipment, performance, and installation) but they nearly always result in improved comfort. Although some people think that they reduce operating efficiency, that does not have to be the case, especially if Energy Recovery is incorporated into the design of the system.

What is the affect of these systems on the interior designer?

All-air VAV systems use very large ductwork (up to 24" high) that can fill up a ceiling plenum and cause low ceilings; these large ducts can also use up large amounts of floor space in multistory buildings (100 sf is not uncommon on the third floor of a three-story building). VAV systems also have terminals located above the ceilings in numerous locations, and those terminals require occasional servicing (and therefore access through the ceiling).

All-air single-zone systems are similar to VAV systems.

Closed-loop water-source heat-pump systems are commonly built with horizontal heat pumps located above ceilings, creating headroom constraints and potential noise problems. These systems can also be built with vertical units in closets and mechanical rooms, which take up a substantial amount of floor space, or with a combination of horizontal and vertical units. These systems don't have centralized large ductwork, although they could have centralized small ventilation ductwork.

Fan-coil-based systems also have no centralized large ductwork, although they could have centralized small ventilation ductwork. The fan coils themselves can be horizontal above ceilings, vertical in closets, vertical exposed on walls, horizontal under windows, and so on.

VRF systems are most like fan-coil systems.

> **Mechanical System Type**
>
> Interior designers should be aware of the mechanical system type so that they can understand how much ductwork there will be and roughly how large it will be. Ceiling elevations cannot be determined without this information.

9.1.2.4 Changing Existing Systems

Is it legal to move an existing duct, pipe, or even a piece of mechanical equipment to make it possible to raise a ceiling? Yes, although it may be difficult and costly.

Is it legal to move equipment from one place to another in a space plan? Yes, although it may be difficult and costly.

Is it legal to make existing mechanical rooms smaller? Yes, as long as valid egress paths are maintained (remember from Chapter 5 that an egress path is required to be only 24" wide in a mechanical room) and as long as the equipment can be serviced with the new arrangements.

9.1.3 2009 INTERNATIONAL ENERGY CONSERVATION CODE

The 2009 IECC contains complete requirements for the design of building envelopes, HVAC systems, domestic hot water heating systems, and lighting systems, using two basic compliance paths—

a. following prescriptive requirements in the IECC itself and
b. following the requirements of ASHRAE 90.1-2007 (which itself has multiple compliance paths)

The building envelope requirements are of interest primarily to architects and engineers and the HVAC and hot water requirements are of interest primarily to engineers, so there is no need to discuss them in further detail here. The lighting requirements will be covered under Section 9.2.

9.1.4 2007 ASHRAE 90.1-2007

ASHRAE 90.1-2007 also contains complete requirements for the building envelope, HVAC systems, domestic hot water heating systems, and lighting systems. Building envelope, HVAC design, and domestic hot water heating design are rarely relevant for interior designers and will not be covered in more detail. Lighting design will be covered in Section 9.2.

9.2 Electrical Systems Code Documents

Four documents cover most code requirements for electrical systems—

- 2009 International Building Code (and 2009 NFPA 101 Life Safety Code and 2009 NFPA 5000 Building Construction and Safety Code)
- 2008 NFPA 70 National Electrical Code
- 2009 International Energy Conservation Code
- ASHRAE 90.1-2007 Energy Standard for Buildings Except Low-Rise Residential Buildings

9.2.1 2009 INTERNATIONAL BUILDING CODE

In the 2009 International Building Code, Chapter 12 governs interior environments and Chapter 27 governs electrical systems.

9.2.1.1 Natural Light

Article 1205 requires natural light by means of exterior glazed openings (usually called windows) or artificial lighting. If exterior glazed openings are used, they are to open directly onto a public way, a yard, or a court. For natural lighting, the minimum area of such exterior openings is 8% of the floor area of the room served, but an adjacent room may be considered "open" too where at least 50% of the common wall is open and unobstructed and where the opening to the interior room is at least 10% of the floor area of the interior room or 25 sf (2.32 m^2), whichever is greater. Exterior openings may open onto a porch, as long as the porch ceiling is at least 7 feet (2134 mm) high and the long side of the porch is at least 65% open.[6]

> **Excessive Day-Lighting**
>
> Buildings that are designed for extensive day-lighting often experience excessive day-lighting, and it is not all that uncommon for interior designers to have to add internal shading devices after the fact. This should be considered at the beginning of the project and not as a fix after a problem develops.

9.2.1.2 Artificial Light

Artificial light (1205.3) is required to provide at least 10 foot-candles (107 lux) average at 30 inches (762 mm) above the floor.[7] This rule is unfortunate and needs to be changed. The Illuminating Engineering Society, which is the most authoritative source for lighting information in the United States (not a source for laws, but a source for standards and recommendations) defines (in *The Lighting Handbook*, 9th ed., 2000) seven illuminance categories—

A	Public spaces:	3 fc (30 lux)
B	Simple orientation for short visits:	5 fc (50 lux)
C	Working spaces where simple visual tasks are performed	10 fc (100 lux)
D	Performance of visual tasks of high-contrast and large size	30 fc (300 lux)
E	Performance of visual tasks of high-contrast and small size, or visual tasks of low-contrast and large size	50 fc (500 lux)
F	Performance of visual tasks of low-contrast and small size	100 fc (1000 lux)
G	Performance of visual tasks near threshold	300–1,000 fc (1000–10 000 lux)[8]

Two comments are in order about these recommendations.

First, they were published in 2000, and the current general trend is to push these values downward to lower levels, especially in categories D and E.

Second, categories A and B are both below the 10 fc threshold identified in the 2009 IBC.

The simple truth is that there is no reason to light lobbies, circulation spaces, stairways, closets, storage rooms, even dining rooms in restaurants to an average of 10 fc today, and there will be even less reason to do so in the future. The extensive use of LEDs for light sources

will change all of this yet again because LEDs—unlike all other artificial light sources—emit substantial lumens of blue light (even at low color temperatures), which changes the perceived brightness level, sometimes dramatically. Also, as optical systems improve (which they do for nearly all types of lamps over time), generalized average levels become less and less important because better optics make for better control and distribution.

Here's a specific example—recently the author designed a new lighting scheme for the "fresh aisle" in a grocery store owned by a regional chain. (The fresh aisle is the area where produce, cheese, bread, and other fresh products are sold.) The design calls for ambient lighting of roughly 8 fc average, with accent lighting on the product between 100 fc and 150 fc. The spill light from the accent lighting brings the average up to well over 10 fc, thereby making this compliant with the IBC, but no one would suggest that this is a dark area. Darkness is much more related to perception than measurements, and it is unfortunate that this rule exists in the IBC. Nevertheless, the rule does exist (until it is removed by amendment by the adopting authority), so compliance can be an issue.

9.2.1.2.1 Egress and Emergency Egress Light

2009 IBC 1205.4 requires a minimum of 1 fc (11 lux) on tread runs of stairways in dwelling units and exterior stairs serving dwelling units and notes that Chapter 10 governs lighting for stairways in other occupancies.[9]

2009 IBC 1006.2 requires a minimum of 1 fc (11 lux) at the walking surface within the means of egress, including corridors, horizontal exits, exit enclosures, and stairways, up to the public way. In addition, if the power fails, emergency egress illumination must be provided for at least 90 minutes duration (via batteries or a generator system) at an average of 1 fc (11 lux) and a minimum of 0.1 fc (1 lux), but only to the landing at the exit discharge. (At the end of the 90-minute period, the average may drop to 0.6 fc [6 lux] and the minimum may drop to 0.06 fc [0.6 lux].)[10] The distinction between egress illumination and emergency egress illumination is important but widely misunderstood.

Egress lighting must be available during all occupied hours for all occupied areas, and it must extend from every point of egress in a given situation to the public way. Recall the definition of public way: "A street, alley or other parcel of land open to the outside air leading to a street, that has been deeded, dedicated or otherwise permanently appropriated to the public for public use and which has a clear width and height of not less than 10 feet (3048 mm)."[11] Take the example of a private college campus: the public way may not exist anywhere on campus, so the egress lighting might have to extend from each point of egress in every building on campus to some location off campus that complies with the definition of public way. Clearly, this is not a problem during the daytime, when the sunlight (under any conditions) would be adequate to fulfill this requirement. But at night, the case is entirely different, and this rule might make is necessary for the owner to provide egress lighting along the full path from each and every building to the public way.

Emergency egress lighting has different requirements under the 2009 IBC.

"1006.3 Illumination emergency power. The power supply for *means of egress* illumination shall normally be provided by the premises' electrical supply.

In the event of power supply failure, an emergency electrical system shall automatically illuminate all of the following areas:

1. Aisles and unenclosed egress *stairways* in rooms any spaces that require two or more *means of egress*.
2. *Corridors, exit enclosures,* and *exit passageways* in buildings required to have two or more *exits*.
3. Exterior egress components at other than their *levels of exit discharge* until *exit discharge* is accomplished for buildings required to have two or more *exits*.
4. Interior *exit discharge* elements, as permitted in Section 1027.1, in buildings required to have two or more *exits*.
5. Exterior landings as required by Section 1008.6.1 for *exit discharge* doorways in buildings required to have two or more *exits*."[12]

Section 1008.6.1 lists the normal landing size requirements.

It should be noted that egress illumination is required for ALL areas in all facilities, no matter how many exits are required, whereas emergency egress illumination is required only for the specific areas already listed and only for areas, buildings, or facilities that require two or more exits. The same requirement applies to exit signs as well.

The 2009 NFPA 101 Life Safety Code requires emergency egress lighting to have the same coverage as egress lighting, so emergency egress lighting would need to be provided everywhere and to the public way in areas, buildings, or facilities that are subject to the requirements of NFPA 101 (including federally funded projects, most licensed health care facilities, anywhere else where a jurisdiction has adopted NFPA 101, or on any project where the owner has adopted NFPA 101 as a requirement). NFPA 101 also increases the egress lighting requirement to a minimum of 10 fc (108 lux) for the walking surface of new stairs.[13]

The 2009 NFPA 5000 Building Construction and Safety Code has requirements that are essentially the same as the requirements in 2009 NFPA 101 Life Safety Code,[14] so these more stringent requirements would apply in any jurisdiction that has adopted the 2009 NFPA 5000.

Chapter 27 of the 2009 IBC essentially says to use NFPA 70, the National Electrical Code.

9.2.1.2.2 Exit Signs Exit signs are required in areas, buildings, and facilities that are required to have two or more exits to direct occupants to and through egress paths until a safe location is reached. In most cases, that safe location will be the exterior of the public building in the public way or a safe private area, but it could also be a courtyard or some other location. As soon as an occupant leaves the common path of egress and enters the exit way, two or more options must be available and two or more exit signs must be visible. Directional arrows are used to let occupants know which direction to go once a given exit sign has been reached. Exit signs may be omitted at main entrances, if acceptable to the authority having jurisdiction (AHJ).[15]

9.2.1.3 Fire Protection Systems

Fire protection systems are governed by the 2009 IBC in Chapter 9, and they include fire sprinkler systems, standpipe systems, fire pump systems, and fire alarm and detection systems. Fire sprinkler, standpipe, and fire pump systems will be covered in Section 9.3.

9.2.1.3.1 Fire Alarm and Detection Systems Fire alarm and detection systems fall into the three broad categories:

- Manual
- Standard automatic
- Voice-evacuation automatic

A manual system is one that does not automatically detect fires but is available to occupants to notify other occupants to evacuate in the event of fire via standard visual and audible notification devices. All of these systems also fall into two technical categories—

1. Zoned (or hard-wired)
2. Addressable (or networked)

Zoned systems are antiquated today, but many of them still exist in the field. A zoned system can be recognized at its annunciator (or at the fire alarm control panel itself) because there will be indications only for "zones." (A graphic annunciator—a physical panel that is a drawing of the building with lights for various areas—would also indicate a zoned system.) By contrast, an addressable system has a text display that shows the address of each individual device in the system when needed. Addressable systems can use graphic annunciation too, but that would probably consist of color-coded drawings on computer displays and not on physical panels. The key difference between these systems is that zoned systems require manual maintenance; in other words, someone has to go to each device and test it individually to confirm that everything is working (according to NFPA guidelines, this testing should be done monthly). Few zoned systems are ever tested thoroughly and consistently. Again, by

contrast, an addressable system is computerized and it conducts self-testing every month and sends out reports.

A standard automatic system is one that does detect fires (via smoke and/or heat detectors) at various locations and can notify occupants of a fire either automatically or by manual action via standard visual and audible notification devices.

A voice-evacuation system is like a standard automatic system except that the notification is done by visual signals and by voice over a system of speakers (for the audible portion) rather than by standard audible notification devices.

The requirements are based on occupancy, and they are—

Group A having an occupant load of more than 300: manual system

Group A having an occupant load of 1,000 or more: voice/evacuation automatic

Group B having an occupant load of 500 or more on all floors: manual system

Group B having an occupant load of 100 or more above or below the level of exit discharge: manual system

Group B occupancy containing an ambulatory health facility: manual system

Group B ambulatory health facility: manual system with automatic detection in public use areas

Group E occupancy: manual system (if smoke detection or sprinklers are used, such devices must be connected to the fire alarm system)

Group F occupancy 2 or more stories in height and having an occupant load of 500 or more above or below the level of exit discharge: manual system

Group H: manual system with smoke detection for area using highly toxic gases

Group I: manual system with limited smoke detection

Group M occupancy having an occupant load of 500 or more on all floors or with an occupant load of 100 or more on a level above or below the level of exit discharge: manual system

Group R-1: manual system with smoke detection in sleeping areas and corridors

Group R-2: manual system

Group R-4: manual system with smoke detection in corridors, waiting areas, and habitable spaces (other than sleeping rooms and kitchens)

Groups R-2, R-3, R-4, and I-1: smoke alarms outside sleeping areas, in each sleeping room, and in each story in a dwelling unit

Special amusement buildings: automatic system

High-rise building: voice-evacuation automatic system

Atriums connecting more than 2 stories: smoke detection in the atrium connected to a voice-evacuation automatic system in A, E, or M occupancies

High-piled storage: automatic smoke detection

Aerosol storage: manual

Lumber, wood structural panel, and veneer mills: manual system

Underground buildings with smoke control: automatic system

Covered mall buildings: voice-evacuation automatic system[16]

When detection is available, smoke detectors are provided in public areas (mostly lobbies and corridors) and smoke or heat detectors are provided in mechanical rooms, electrical rooms, storage rooms, labs, shops, and other spaces with risk profiles higher than typical occupied spaces. Smoke detection is required in sleeping rooms and immediately outside sleeping rooms in all residential occupancy classifications.

Notification devices fall into the subcategories of visual and audible.

Visual devices (usually called "strobes") are wall-mounted (sometimes ceiling-mounted) at 6'-8" above the floor and they have to be visible from all areas. This doesn't mean directly

visible from all areas, but an occupant should be able to see the effects of the flashing from all areas. Certainly, such devices should be directly visible in all areas of the egress path. As a result of an interpretation of the Americans with Disabilities Act that was issued some years ago, visual devices are also required in all common-use areas, which include hallways; lobbies; meeting and conference rooms, classrooms; cafeterias; filing and photocopy rooms; employee break rooms; dressing, examination, and treatment rooms; and similar spaces—in short anywhere that is not a workspace for a single individual, and even those can be subject to this requirement if the space is used for meetings.

Audible devices (usually called "horns" or speakers for voice-evacuation systems) have to be placed so that the signal is 15 db (decibels) louder than the background noise, which can be difficult to do. This means that there must be enough devices to be heard everywhere, even in interior closets and sub-rooms, at all times. Enforcement officials often carry around decibel (sound) meters and require the addition of audible devices before allowing the facility to be occupied; unfortunately, their meters are sometimes uncalibrated and inaccurate.

The detailed requirements for fire alarm systems are found in the 2007 NFPA 72 National Fire Alarm Code, which is adopted by reference in the 2009 IBC.

9.2.2 2008 NFPA 70 NATIONAL ELECTRICAL CODE

The NEC's "working space" requirements can have a major impact on interior design and the requirements for large equipment and indoor transformers can have a significant impact. In lighting, the rules for track lighting are critical. Wiring methods are significant, but critical only if an interior designer is designing and specifying the wiring.

9.2.2.1 Working Space

The working space requirements are there to protect electricians while they install and service electrical equipment, so they are important.

There are three categories of requirements—

1. 0 to 150 volts
2. 151 to 600 volts
3. 601 volts or higher

Higher than 600 volts is called medium voltage; even though medium voltage is used inside large buildings from time to time, such instances are few and far between and are not of significant importance to interior design. Suffice is to say that medium voltage equipment has to be located in a room having a 4-hour fire-resistance-rating, which would be designed into the shell of the building by the architects and engineers.

The other requirements are simple in concept but complicated in execution. For both 0 to 150 volts and 151 to 600 volts, there are three "conditions"—

"**Condition 1:** Exposed live parts on one side of the working space and no live or grounded parts on the other side of the working space or exposed live parts on both sides of the working space that are effectively guarded by insulating materials.

Condition 2: Exposed live parts on one side of the working space and grounded parts on the other side of the working space. Concrete, brick, or tile walls shall be considered as grounded.

Condition 3: Exposed live parts on both sides of the working space."[17]

"Exposed live parts" means exactly what it says: exposed electrical parts—wires and/or buses—that are electrically live. In any day-to-day situation, there are no exposed live parts inside a building because having exposed live parts is dangerous and illegal. However, when an electrician is working on the system, cabinet fronts may be open, which could expose parts that could be live under some circumstances. Generally speaking, electricians don't work on live parts because it is so dangerous, but there are exceptions where they do something "hot" or live.

Condition 1 is the one-sided non-grounded condition, which would be the case if you had a load center, panel board, distribution board, switchboard, circuit breaker, switch, or some

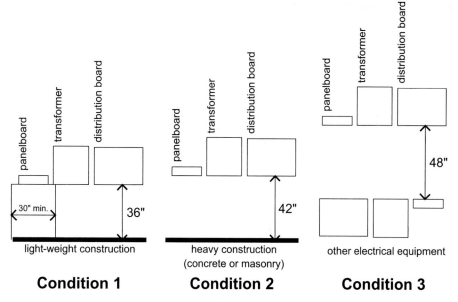

FIGURE 9.1 Working Space *(drawing by the author)*

Condition 1 — light-weight construction — 30" min. — 36"

Condition 2 — heavy construction (concrete or masonry) — 42"

Condition 3 — other electrical equipment — 48"

panelboard / transformer / distribution board

other electrical equipment facing a wall that is not concrete, masonry, or tile. In this case, for both 0 to 150 volts and 151 to 600 volts, the minimum clearance is 36 inches (914 mm).

Condition 2 is the one-side grounded condition, which would be the case if you had electrical equipment facing a wall that is concrete, masonry, or tile. In this case, the minimum clearance for 0 to 150 volts is 36 inches (914 mm), but the clearance for 151 to 600 volts is increased to 42 inches (1.07 m).

Condition 3 is the "electrical equipment on both sides" condition, which would be the case for any two pieces of electrical equipment facing each other. In this case, the minimum clearance is 36 inches (914 mm) for 0 to 150 volts and 48 inches (1.22 m) for 151 to 600 volts.[18]

All of the clearances apply from the live parts to the opposite element (whether that's a wall or other live parts). The live parts inside a typical panel board are actually at least 2″ behind the face of the cabinet front, but it is good practice just to use the face of the cabinet when calculating these clearances. See Figure 9.1.

The width and height of the working space vary somewhat according to the specifics of the installation. The minimum width is 30 inches (762 mm) or the width of the equipment, whichever is greater. The minimum height is 6 ½ feet (2.0 m) or the height of the equipment, whichever is greater.[19]

The biggest challenge here is that these working spaces apply to "all electrical equipment,"[20] which is defined as "A general term, including material, fittings, devices, appliances, luminaires, apparatus, machinery, and the like used as part of, or in conjunction with, an electrical installation."[21] A literal interpretation of this would make it nearly impossible to provide a power system in any building. How many receptacles have furniture less than 36″ in front of them? How many light switches?

In reality, this is interpreted to mean that it's OK to have movable furniture encroaching in the working space for devices (switches, receptacles, etc.) but not for permanent equipment (including load centers, panel boards, disconnect switches, etc.) and to locate some equipment above ceilings (including junction boxes, disconnect switches, switches, etc.—as long as it's feasible to gain access to the equipment through the ceiling). The latter can be a major issue with "hard" ceilings, such a gypsum board, wood, or plaster, because it is necessary to have access panels to get to any and all electrical equipment that might be above the ceiling. For new installations, the engineers try (or should try) to keep such equipment out of the area to the greatest extent feasible, but it may be difficult to move equipment in an existing building.

Working space requirements are important because they affect how much space electrical equipment takes up in a given situation, and it is necessary for the interior designer to work closely with the electrical engineer to work out the requirements. Interior designers commonly want to know if it's OK to conceal existing equipment. The answer is usually yes, but it all depends on the details. In older buildings, branch circuit panel boards that were installed in concealed locations (usually electrical rooms) sometimes end up in occupied space when walls are moved around. Such panel boards usually have plain flush fronts, but they are not thought to be decorative elements to most designers, so they want to hide them. A door can be placed right in front of a panel board (within just a few inches) as long as the door opening provides a space at least 30″ wide centered on the panel board that's also at least 6′-6″ high (or the height of the equipment, whichever is greater); when the door is closed, the panel board cannot be seen,

New Electrical Equipment

Whenever new electrical equipment is added in a project, but especially panel boards or transformers, the interior designer should be aware of it and should make the necessary provisions for working space.

but legal working space is provided when the door is open. This door must extend all the way to the floor, so a cabinet door that is as large as the panel board front is not acceptable.

9.2.2.2 Large Equipment

If there is equipment in an electrical room that exceeds 1,200 amps (at any voltage) and is more than 6 feet (1.8 mm) wide, special exiting requirements come into play. Even though such requirements should be found in the 2009 International Building Code or the 2009 NFPA 5000 Building Construction and Safety Code, only portions of these requirements are found in the IBC; all of the requirements are found only in NFPA 70, the National Electrical Code.

These requirements include two exits at opposite ends of the space, at least 24 inches (610 mm) wide and 6 1/2 feet (2.0 m) high with out-swinging doors and panic bars for emergency exiting. Unless—

a. More than 25 feet (7.6 m) separates the door from the equipment, where the door may swing in and is not required to have a panic bar; or

b. Double working space is provided, where a single entrance will suffice. The swing of the door and the use of the panic bar depends on the distance between the door and the equipment as noted under (a) above; or

c. A "continuous and unobstructed way of egress travel" is available, where a single entrance will suffice.[22]

Unfortunately, it is not at all clear what "continuous and unobstructed way of egress travel" means, so that exception is difficult to use.

This is important simply because such rooms can get to be large and because they have to be positioned to allow for both exits (and for the technical requirements of the wiring). It is necessary for the interior designer to work closely with the electrical engineer to address these requirements. A room like this for equipment that is 6′ wide would need to be about 8′ wide and about 10′ deep to avoid having to have the second exit.

9.2.2.3 Transfomers

Power systems, in concept, are simple: power is generated at the generating station (coal-fired, natural gas–fired, oil-fired, nuclear, solar, wind, hydroelectric, etc.) and sent out over wires to customers. In order to avoid huge losses in long wiring runs, the power leaves the generating station at very high voltage, probably more than 100,000 volts. From that point, it is sent (via transmission lines) to transformer stations to reduce the voltage for distribution systems that are run by utility companies to provide power to individual customers. Transmission lines run at various voltages, from more than 100,000 volts, 69,000 volts, and even 26,400 volts. Transmission lines end at substations, which are the groupings of large transformers and other devices that are located all around. At the substation, the voltage is lowered again, usually to either 4,160 volts (the oldest system), 12,470 volts (the most common system), or 13,200 volts. The wiring from the substation runs out to buildings mostly overhead (on poles) or sometimes underground.

At the building, or group of buildings, the utility will install more transformers to reduce the power to voltage needed in the building. These transformers might be single tub-style transformers on poles (as at most older houses), multiple tub-style transformers at some commercial buildings, small ground-mounted transformers (at newer houses), and large ground-mounted transformers (at most commercial buildings). The wiring from this last transformer, or group of transformers, to the building belongs either to the utility or the customer, depending upon the location of the meter. Utilities own the facilities up to and including the meter in most cases, so if the meter is on the building (in a small meter cabinet or in a large CT (current transformer) cabinet, the utility will own the wire all the way to the building. If the meter is located at the transformer (on a pole, a post, or the transformer itself), the customer will own the wire from there to the building. Generally speaking, it is to the customer's advantage for the utility to own as much as possible, simply to put more responsibility on the utility. But giving the utility responsibility also means following the utility's rules for locating transformers, meters, and so on, and such rules can make for unattractive installations near the building. Each case has to be worked

out in detail in conjunction with the utility, the engineers, the architects, and maybe even with the interior designers. Wiring that is owned by the customer is called premises wiring, or wiring that is on the premises.

In the vast majority of cases, the utility's last transformer will delivery one of the following four voltages to the building—

1. 120/240 volts, single phase: this is the system that most people have at home
2. 120/208 volts, three phase: this is most common commercial system
3. 120/240 volts, three phase, open delta: this is an antiquated type of commercial service that is still seen extensively in some service areas
4. 277/480 volts, three phase: this is most common commercial system for large buildings

All buildings must have 120 volts, single phase available for convenience receptacles (if for no other reason), and such voltage can be provided directly from systems 1, 2, and 3 above. But if the system is a 277/480 volts, three-phase system, it is necessary to use transformers inside the building for the receptacle load (and any other 120-volt loads that might happen to be in the facility). Even though utility companies use liquid-filled transformers (mostly due to low cost), such transformers are very dangerous inside buildings (because they can explode and spray burning oil all around when they fail), and they are not used in most situations (medium voltage excepted). Instead, dry-type transformers are used inside buildings to reduce the hazards.

The requirements for installing dry-type transformers inside buildings are relatively simple.

First, they must be readily accessible for inspection and maintenance (meaning on or very close to the floor) unless they are mounted on columns or walls in high spaces without ceilings.

Second, they must be located at least 12 inches (300 mm) from combustible materials unless protected by a fire-resistant heat-insulated barrier (not usually done).

Third, they must be installed so that ventilating openings are not blocked or obstructed.

Fourth, they must be located in a 1-hour fire-resistance-rated room unless 112 1/2 kVA or smaller. Believe it or not, 112 1/2 kVA is a standard size.[23]

These requirements are important mostly because of the size of dry-type transformers. These units are used in various sizes for various reasons in many different types of facilities, but it is not at all uncommon to see 112 1/2 kVA units. Such a unit is roughly 37 inches (940 mm) high by 30 inches (762 mm) wide by 24 inches (610 mm) deep, weighing approximately 800 pounds. By way of comparison, a 300 kVA unit (a rather large one but not one of the biggest) is roughly 49.5 inches (1257 mm) high by 41 inches (1041 mm) wide by 36 inches (914 mm) deep, weighing approximately 1,600 pounds.

The interior designer has to be sure to work closely with the electrical engineer to cover requirements for transformers, as for working space and special requirements for large equipment.

9.2.2.4 Wiring Methods

There are two basic methods for wiring buildings:

a. Wire and conduit
b. Cables

plus the older system of "knob and tube," which still exists in some old buildings. Knob and tube is a system that was used extensively from the early 1900s until the 1940s or so when new systems took over. There is no need to discuss knob and tube in any more detail.

The wire and conduit method uses individual insulated conductors (wires) run inside a metallic or plastic tube. Metallic conduits come in several different grades—

RMC (Rigid Metal Conduit, sometimes also called GRC, or galvanized rigid conduit), with screwed fittings. This is by far the toughest, and most costly, system, and it is rarely used these days.

IMC (Intermediate Metallic Conduit), with screwed fittings. This is a lighter weight version of RMC and it is also infrequently used.

EMT (Electrical Metallic Tubing) with compression or set-screw fittings. This is a light-weight system that is used in most situations where metallic conduit is used.

There are also flexible metallic conduits that are used to minimize vibration transfer (mostly), including both indoor (dry—FMC, flexible metal conduit) and outdoor (wet—LFMC or liquid-tight flexible metal conduit) versions.

Under the NEC, it is legal to use metallic conduit in place of having a separate ground wire. But most designers have long since abandoned this practice, and most projects are designed with separate ground wires even when using metallic conduits. (As it turns out, the conduit grounding simply isn't reliable enough over the long term.)

Plastic conduits also come in several grades—

ENT (Electrical Non-metallic Tubing)

PVC (Rigid Polyvinyl Chloride Conduit, often called RNC) This conduit is available in Schedule 40 and Schedule 80, which are wall thickness measurements. Schedule 80 is thicker and is not often used.

HDPE (High Density Polyethelene Conduit), usually used for underground installations.

LFNC, which is liquid-tight flexible non-metallic tubing.

The choice between using metallic and nonmetallic conduits is made on the basis of a combination of cost and exposure. All metallic conduits will eventually rust and fail when buried, so it is strongly preferred to use HDPE or PVC conduits underground. If there is a substantial risk of damage due to digging, underground conduits are sometimes encased in concrete for protection. Oftentimes, it makes more sense to use nonmetallic conduits outdoors as well, and for the same reasons. In indoor environments that are exceptionally wet (swimming pools and spas, swimming pool equipment rooms, car washes, laundries, etc.), it sometimes makes sense to use nonmetallic conduit indoors. Nonmetallic conduits should be avoided indoors where extreme temperature fluctuations may exist—cold attics, unheated or winterized buildings, and so on.

But all conduit installations are labor intensive and costly, so much (if not most) indoor wiring is done using cables instead. Cables are premanufactured pre-wired products that include multiple conductors, with or without separate ground conductors, inside some kind of sheath. These also come in various forms—

NM (Nonmetallic cable), usually known by the tradename "Romex." (There are also subcategories of NMC and NMS.)

This is plastic-wrapped cabling that is used in most one- and two-family dwellings and in some small (up to three-story) commercial buildings.

AC (Armored cable), which uses the cable sheath as the ground. This is an unreliable (though inexpensive) product that should be avoided.

MC (Metal-Clad cable). This is similar to AC cable, but it should have a separate ground conductor. Some manufacturers are selling versions of this that they call "MC-A" or something similar, but that really means that it is AC cable. Such products should be avoided.

FCC (Flat Conductor cable). This cable is so flat that it can be installed directly under carpet. It is also very costly and rarely used.

And there are other types for direct-burial service entrances, underground feeders, medium voltage, and control wiring.

Why does this grounding issue matter? Why avoid AC cable?

Electrical grounding is widely misunderstood. Simply put, grounding is needed for two main reasons—

1. To minimize risk under failure conditions. Occasionally, something goes wrong and a "short" or "dead short" occurs in wiring. When that happens, the excess power is shunted to the "ground" (literally the ground, or soil, under or around the building) to avoid harming occupants.
2. To dump excess power. Whenever anything that uses power is turned off, a small amount of power remains in the wires between the power source (the switch) and the device itself. This power is shunted away on the "neutral" wiring, which then redirects to the ground when it gets to a panel board, load center, and so on.

As a result of the safety issues involved, it is necessary to have effective and reliable grounding throughout the power system. At the service entrance, this is done by driving a "ground rod" (usually a steel rod 8′ to 10′ long, sometimes coated in copper) into the ground and connecting a ground conductor to that rod; the other end of the ground conductor is connected to the ground bus in the panel board. Everything in the system has to be tied into this ground bus by using ground conductors (or conduits).

Soil is not inherently conductive to electricity; after all, it's mostly sand and stone, with some organic materials mixed in. But the water in the soil is highly conductive to electricity, and that's why grounding works. If for some reason, the soil under (or around) a particular building won't hold moisture, there is a possibility of having an inadequate ground. In such cases, chemical grounding can be used to ensure safety in the system.

Grounding is measured in ohms of resistance, and the amount of resistance that's allowed varies according to the size of the power system. Small systems are allowed to have higher grounding resistance, but never more than 10 ohms. (Large systems are required to be at 5 ohms, 3 ohms, or even less, depending on the specifics.) Chemical grounding is necessary if there is reason to believe that this 10-ohm maximum cannot be met. (The author has observed grounding resistances of 90 ohms in the presence of large amounts of sand. Stony soils could have this problem too.)

Oftentimes, data and communications (and sometimes audio and video) people ask for "isolated grounds" to protect their systems, but using isolated grounds is actually a bad idea. Electronic systems are sensitive to high ground resistance (up to a point), but the critical factor is really "difference of potential" in the grounding. In other words, what a computer does not want to see is 10 ohms here in the system and 5 ohms there; all of the grounds really need to be the same, so isolated grounding actually goes in the wrong direction entirely. Instead, an effort should be made by the power system designer (whoever that may be) to ensure low and consistent grounding throughout the system.

Other general wiring methods include requirements for "back boxes" for receptacles and luminaires. Under the NEC, these boxes are required even when using cables for wiring, and there are no exceptions. There are specific requirements for the sizes and depths of these boxes, but there is no reason to go into great detail about that here.

Over-current protection (i.e., circuit breakers and fuses) is not there for personal safety, much to the surprise of many people. Instead, over-current protection is used to prevent overheating of wires and the fires that tend to result from overheated wires. That's all that it's for. Special devices are required for circuits for which personal safety is paramount (see information on ground fault circuit interrupter and arc fault circuit breaker to follow). Circuit breakers trip under two conditions: overload and ground fault, although they usually react too slowly to suffice for ground fault protection. In general, for load purposes, the vast majority of loads are taken at 125% of their actual value, which really means that over-current devices cannot be loaded beyond 80% (25% more is the same as 20% less—1.25/1.0 = 0.80). So a 20-ampere circuit breaker cannot be loaded to more than 16 amps. A 100 amp, 3-pole circuit breaker cannot be loaded to more than 80 amps—unless it is specifically designed to do so. The latter case would be what we call a "100% rated" device; these things exist, but they are rare and costly and should be avoided whenever possible. Fuses tolerate 100% ratings, but one should be careful whenever talking about 100% loads.

Personal safety is provided in wiring by three methods:

Grounding, as previously discussed.

Ground fault circuit interrupter (GFCI, sometimes called GFI) receptacles and/or circuit breakers. These are special receptacles that are used in wet environments (kitchens, bathrooms, outdoors, etc.) and include special circuitry to turn off if a fault is detected, as when water might be splashed on the device accidentally. All GFCI receptacles have "test" and "reset" buttons, and many have indicator lights to show that they are on. They are effective and they are required in all wet environments. The one exception to this is that a compressor (in a refrigerator or similar piece of equipment) won't work reliably with a GFCI, although the NEC does not really say that it's OK to omit GFCI protection on such circuits. The NEC does say that GFCI protection can be omitted for a

dedicated circuit (a circuit that serves only one load) for such an appliance, but small appliances are sometimes plugged into standard outlets, and this can be a problem.

Arc fault circuit breakers. When something is plugged into, or taken out of, a receptacle, there is a small electrical arc (or spark to most people). An electrical arc can be extremely dangerous, and it has been determined that arc fault protection is required in residential environments where people may be sleeping—and unaware of developing fires. More on that in Chapter 10.

9.2.2.5 Track and Busway Lighting

Track lighting comes in various forms for various different purposes. All of the systems are intended to provide for easily movable lighting for museums, galleries, stores, offices, homes, and so on. There are four basic families—

- Low-voltage decorative track, including cable-based systems
- 120 volt systems, in 1-, 2-, and 3-circuit configurations
- 277 volt systems, in 1- and 2-circuit configurations (these are rare)
- High capacity busway systems in both 120 volts and 277 volts

The low-voltage, 120-volt, and 277-volt track systems are subject to the same NEC load limitations.

Loads for all lighting, except track lighting, are simply the sum of the lamps, ballasts, and drivers connected to that particular circuit. In other words, if 20 old-style 60-watt light bulbs in recessed downlights are connected to a single circuit, the load on the circuit would be 20×60 watts = 1,200 watts. If 40 32-watt linear T8 fluorescent lamps with standard electronic ballasts were connected to a similar circuit, the load would be 40×32 watts $\times 1.14$ (ballast factor) = 1,459 watts. All lighting must be connected to 20-amp, single-pole circuits, either 120 volts or 277 volts (the latter can be used directly for all lamp types except incandescent), and the general 125% load rule applies as well.

For track lighting, this is different. The 20 amp-circuit rule still applies; 16 amps (80% of 20 amps) \times 120 volts = 1,920 watts and 16 amps \times 277 volts = 4,432 watts. These are maximum circuit capacities. The NEC (under 220.43 [B]) requires using a load of 75 vA (or 75 watts in most cases)[24] for each foot (305 mm) of light track, which can be split between multiple circuits. This means that a 12-foot (3.66-m) section of light track is counted as 12×75 vA = 900 watts, no matter how many lights are actually installed on that 12-foot (3.66-m) section of track. In reality, it would be quite rare to have 900 watts worth of track heads installed in 12 feet (3.66 m). This also means that the maximum distance a single 120-volt circuit can feed is 1,920 watts / 75 w/lf = 25.6 feet (7.8 m). A single 277-volt circuit could feed 4,432 watts / 75 w/lf = 59.1 feet (18 m).

> **Track Lighting Circuiting**
> While it is very common to see illegal track lighting installations (usually more than 24' on a single circuit), new work must be done in compliance with all applicable rules. The interior designer should bring the issue to the owner's attention if illegal practices are observed.

This is important because one of the most costly aspects of installed track lighting is running the circuiting from the panel board to the tracks. In nominal terms, for a 120-volt track, a new circuit is required for every 24 feet (7.3 m) of track, which can be costly.

Small busway systems were invented to avoid this problem. (Large busway systems are used to move around large amounts of power long distances in large facilities and to serve high equipment loads in shops, factories, and even kitchens.) As a result of a technicality in the NEC, a "busway" is not classified as a "light track," so some manufacturers offer 60-amp and even 100-amp busway systems that can have light fixtures directly attached, just like in light track. These systems are considerably more costly to buy, but they can be less costly to install due to the savings in running the wiring. And they can be used to power equipment, which is not the case for light track.

For comparison purposes, it would take three 20-amp circuits to run 72 feet (21.9 m), but only one 60-amp, 120-volt circuit could feed 72 feet (21.9 m) of busway. The 60-amp circuit is more costly than a single 20-amp circuit, but there is just one circuit, so the overall installation cost is lower.

This is also important from an energy point of view because energy codes require counting track lighting loads just as the NEC does, which can eliminate the possibility of using track lighting for a project that is subject to IECC 2009, ASHRAE 901.-2007, or Title 24 (in California) Lighting Power Density limitations. (See Section 9.2.3.) The answer to this is the "current limiter" that most track lighting manufacturers now offer. This device is a legal (under the NEC) way to limit the capacity of the track so as to make it work within the Lighting Power Density limitations of the energy codes.

9.2.2.6 Low-Voltage Wiring

According to the 2008 NEC, all wiring from 150 volts to 0 volts is in the same category (see Section 9.2.2.1). In reality, the requirements are different for "low-voltage" wiring, which is usually defined as 24 volts or less. The main difference is that it is not required to use conduit and individual conductors or special cables (types NM, AC, and MC, for example) for low-voltage applications. Instead, special cables are made for various systems, the most common of which is "un-shielded twisted-pair" (Category 5 or Category 6). The latter is used for basic computer networks, networked fire alarm systems, networked video and audio systems, networked lighting control systems, and even networked HVAC control systems.

The biggest issue with this low-voltage wiring is whether or not it is running in a plenum (see Section 9.1.2.1). If it is located in a plenum, then "plenum-rated cable" is required; if it is not located in a plenum, then standard cable can be used.

Plenums II

It must be known at the start of the project if plenums are going to be used—and where they will be used.

Un-shielded twisted-pair wiring is copper (as is standard telephone wiring that the utility brings to a building for telephone or DSL service), but much of the cabling in these systems today is not metal at all. In fact, fiber optic cable is used extensively now.

Fiber optic cable is glass and does not transmit electricity; instead, it transmits light, which is converted to and from electricity at both ends of the cable.

The basic data system is structured like this (and it is usually called "structured' cabling)—

1. Incoming service to the premises, copper for conventional telephone and DSL (the low end of high-speed data lines), or fiber for high-speed systems. This cabling ends inside the building at the "telephone service board," which is sometimes called a "demarc" point. (Demarc is a shortened version of "demarcation.") Network equipment (switches, routers, etc.) will usually (not always) be located at the demarc point.
2. For a small system, un-shielded twisted-pair cabling will extend from the demarc point (with network equipment) to individual wall outlets, systems furniture whips, and so on.
3. For a large system, there will be distribution demarc points around the facility due to the 100-meter maximum length for un-shielded twisted-pair data lines. Those sub-demarcs will probably be linked together with fiber optic cabling—horizontally, vertically, or both, as the case may be. The wiring from each sub-demarc to individual points is the same as in the small system example. (Similarly, large fire alarm systems often use fiber optic loops to connect multiple fire alarm control panels.)

But having said all of that, there are few pertinent code requirements outside of plenum cabling. There are extensive technical standards for such wiring, but those are standards and not codes in most cases. It is important to find out at the beginning of every project if the owner has specific requirements for this type of wiring, because it may be necessary to add costly cable trays at some locations in a project.

Wireless systems are also used, but they tend to remain somewhat unreliable and they are usually backed up by parallel fully wired systems. If wireless systems are used, there will be "repeater" antennas at numerous locations; these are sometimes visible and need to be known to the interior designer as early as possible.

9.2.3 THE 2009 INTERNATIONAL ENERGY CONSERVATION CODE

The 2009 IECC includes limitations for lighting power sensities (LPDs), which are critical for anyone designing lighting in a jurisdiction that has these requirements. (California also has Title 24 requirements for lighting, but those are applicable only within the state.) The allowed LPDs are shown in Table 505.5.2 Interior Lighting power. See Figure 9.2. The basic

LIGHTING POWER DENSITY

Building Area Type[a]	(W/ft^2)
Automotive Facility	0.9
Convention Center	1.2
Court House	1.2
Dining: Bar Lounge/Leisure	1.3
Dining: Cafeteria/Fast Food	1.4
Dining: Family	1.6
Dormitory	1.0
Exercise Center	1.0
Gymnasium	1.1
Healthcare—clinic	1.0
Hospital	1.2
Hotel	1.0
Library	1.3
Manufacturing Facility	1.3
Motel	1.0
Motion Picture Theater	1.2
Multifamily	0.7
Museum	1.1
Office	1.0
Parking Garage	0.3
Penitentiary	1.0
Performing Arts Theater	1.6
Police/Fire Station	1.0
Post Office	1.1
Religious Building	1.3
Retail[b]	1.5
School/University	1.2
Sports Arena	1.1
Town Hall	1.1
Transportation	1.0
Warehouse	0.8
Workshop	1.4

For SI: 1 foot = 304.8 mm, 1 watt per square foot = W/0.0929 m^2.

a. In cases where both a general building area type and a more specific building area type are listed, the more specific building area type shall apply.

b. Where lighting equipment is specified to be installed to highlight specific merchandise in addition to lighting equipment specified for general lighting and is switched or dimmed on circuits different from the circuits for general lighting, the smaller of the actual wattage of the lighting equipment installed specifically for merchandise, or additional lighting power as determined below shall be added to the interior lighting power determined in accordance with this line item.

Calculate the additional lighting power as follows:

Additional Interior Lighting Power Allowance = 1000 watts + (Retail Area 1 × 0.6 W/ft^2) + (Retail Area 2 × 0.6W/ft^2) + (Retail Area 3 × 1.4 W/ft^2) + (Retail Area 4 × 2.5 W/ft^2).

where:
Retail Area 1 = The floor area for all products not listed in Retail Area 2, 3, or 4.
Retail Area 2 = The floor area used for the sale of vehicles, sporting goods, and small electronics.
Retail Area 3 = The floor area used for the sale of furniture, clothing, cosmetics, and artwork.
Retail Area 4 = The floor area used for the sale of jewelry, crystal, and china.

Exception: Other merchandise categories are permitted to be included in Retail Areas 2 through 4 above, provided that justification documenting the need for additional lighting power based on visual inspection, contrast, or other critical display is *approved* by the authority having jurisdiction.

FIGURE 9.2 IECC 2009, Table 505.5.2 Interior Lighting Power

compliance method is to use this table to determine how many watts are allowable in each space, and then design accordingly.

In theory, these LPDs have been developed by ASHRAE and the IES, jointly, to correspond to the minimum illuminance recommendations in the ninth edition of *The Lighting Handbook*, which was published by the IES in 2000. In reality, it can be extremely difficult to achieve these LPDs while simultaneously meeting the IES illuminance requirements, depending upon exactly which categories have been targeted for various areas.

The IECC also has some requirements for exterior lighting, but they require only automatic control (for lights not to be left on 24/7) and minimal lamp efficacy of 45 lumens/watt. See Figures 9.3 and 9.4.

Most critically, the IECC has special requirements for lighting controls (i.e., switches). The most basic requirement is that each area must have a local manual control within the area served, except in security or emergency areas or in stairways or corridors that are elements of the means of egress (2009 IECC 505.2.1).[25] Also, each occupied area is also required to have a manual control so that the occupant can reduce the illumination pattern by at least 50% (except in areas with only one luminaire; in areas with automatic controls; in corridors, restrooms, or public lobbies; in sleeping units; and in spaces using less than 0.6 w/sf (2009 IECC 505.2.2.1).[26] In buildings that are larger than 5,000 sf (465 m^2), an automatic system is to be provided to turn off the lights on a schedule, by occupant sensors within 30 minutes of leaving, or upon a signal from another system to indicate that the area is unoccupied, except in sleeping units, patient care areas, and where automatic shut-off would endanger occupant safety (2009 IECC 505.2.2.2).[27] Manual override is to be allowed for periods up to 2 hours in areas no larger than 5,000 sf (465 m2) (2009 IECC 505.2.2.2.1).[28]

Separate controls are required for daylight zones (as compared to general lighting controls). If the daylight zone faces a single direction (e.g., east, west, north, or south), a single control device can be used for the luminaires in that contiguous zone. Zones under skylights that are located more than 15 feet (4572 mm) from the perimeter also require separate controls. The only exception to these requirements is enclosed spaces containing two or fewer luminaires (2009 IECC 505.2.2.3).[29]

In hotels, motels, boarding houses, and other similar buildings, each sleeping unit is to have a master control at the main entry door to turn off all permanently wired luminaires and switched receptacles, except those in the bathroom (2009 IECC 505.2.3).[30]

Exit sign lamps may not exceed 5 watts per side (2009 IECC 505.4).[31]

9.2.4 ASHRAE 90.1-2007

Similar to the 2009 IECC, ASHRAE 90.1-2007 includes limitations for LPDs, for both exterior and interior lighting and requirements for lighting controls. Given that one means of complying with the 2009 IECC is to comply with ASHRAE 90.1-2007, the latter document is commonly used.

The lighting control requirements are somewhat more restrictive than in 2006 IECC.

Lighting Zone	Description
1	Developed areas of national parks, state parks, forest land, and rural areas
2	Areas predominantly consisting of residential zoning, neighborhood business districts, light industrial with limited nighttime use and residential mixed use areas
3	All other areas
4	High-activity commercial districts in major metropolitan areas as designated by the local land use planning authority

FIGURE 9.3 IECC 2009, Table 505.6.2(1)

INDIVIDUAL LIGHTING POWER ALLOWANCES FOR BUILDING EXTERIORS

		Zone 1	Zone 2	Zone 3	Zone 4
Base Site Allowance (Base allowance may be used in tradable or non-tradable surfaces.)		500 W	600 W	750 W	1300 W
Tradable Surfaces (Lighting power densities for uncovered parking areas, building grounds, building entrances and exits, canopies and overhangs and outdoor sales areas may be traded.)	**Uncovered Parking Areas**				
	Parking areas and drives	0.04 W/ft²	0.06 W/ft²	0.10 W/ft²	0.13 W/ft²
	Building Grounds				
	Walkways less than 10 feet wide	0.7 W/linear foot	0.7 W/linear foot	0.8 W/linear foot	1.0 W/linear foot
	Walkways 10 feet wide or greater, plaza areas special feature areas	0.14 W/ft²	0.14 W/ft²	0.16 W/ft²	0.2 W/ft²
	Stairways	0.75 W/ft²	1.0 W/ft²	1.0 W/ft²	1.0 W/ft²
	Pedestrian tunnels	0.15 W/ft²	0.15 W/ft²	0.2 W/ft²	0.3 W/ft²
	Building Entrances and Exits				
	Main entries	20 W/linear foot of door width	20 W/linear foot of door width	30 W/linear foot of door width	30 W/linear foot of door width
	Other doors	20 W/linear foot of door width	20 W/linear foot of door width	20 W/linear foot of door width	20 W/linear foot of door width
	Entry canopies	0.25 W/ft²	0.25 W/ft²	0.4 W/ft²	0.4 W/ft²
	Sales Canopies				
	Free-standing and attached	0.6 W/ft²	0.6 W/ft²	0.8 W/ft²	1.0 W/ft²
	Outdoor Sales				
	Open areas (including vehicle sales lots)	0.25 W/ft²	0.25 W/ft²	0.5 W/ft²	0.7 W/ft²
	Street frontage for vehicle sales lots in addition to "open area" allowance	No allowance	10 W/linear foot	10 W/linear foot	30 W/linear foot
Non-tradable Surfaces (Lighting power density calculations for the following applications can be used only for the specific application and cannot be traded between surfaces or with other exterior lighting. The following allowances are in addition to any allowance otherwise permitted in the "Tradable Surfaces" section of this table.)	Building facades	No allowance	0.1 W/ft² for each illuminated wall or surface or 2.5 W/linear foot for each illuminated wall or surface length	0.15 W/ft² for each illuminated wall or surface or 3.75 W/linear foot for each illuminated wall or surface length	0.2 W/ft² for each illuminated wall or surface or 5.0 W/linear foot for each illuminated wall or surface length
	Automated teller machines and night depositories	270 W per location plus 90 W per additional ATM per location	270 W per location plus 90 W per additional ATM per location	270 W per location plus 90 W per additional ATM per location	270 W per location plus 90 W per additional ATM per location
	Entrances and gatehouse inspection stations at guarded facilities	0.75 W/ft² of covered and uncovered area	0.75 W/ft² of covered and uncovered area	0.75 W/ft² of covered and uncovered area	0.75 W/ft² of covered and uncovered area
	Loading areas for law enforcement, fire, ambulance and other emergency service vehicles	0.5 W/ft² of covered and uncovered area	0.5 W/ft² of covered and uncovered area	0.5 W/ft² of covered and uncovered area	0.5 W/ft² of covered and uncovered area
	Drive-up windows/doors	400 W per drive-through	400 W per drive-through	400 W per drive-through	400 W per drive-through
	Parking near 24-hour retail entrances	800 W per main entry	800 W per main entry	800 W per main entry	800 W per main entry

For SI: 1 foot = 304.8 mm, 1 watt per square foot = W/0.0929 m².

FIGURE 9.4 IECC 2009, Table 505.6.2(2)

Each individual classroom, conference/meeting room, and employee lunch/break room must have an automatic system, no matter how small (ASHRAE 90.1-2007 9.4.1.2a).[32] For other areas, control devices are limited to no more than 2,500 sf for a space up to 10,000 sf or 10,000 sf for a space larger than 10,000 sf (ASHRAE 90.1-2007 9.4.1.2b).[33]

The calculating procedures for exterior lighting are complicated, but Table 9.4.5 Lighting Power Densities for Building Exteriors provides most of the needed information. See Figure 9.5.

Table 9.5.1 Lighting Power Densities Using the Building Area Method provides most of the needed information for that method. See Figure 9.6.

Table 9.6.1 Lighting Power Densities Using the Space-by-Space Method provides most of the needed information for that method. See Figure 9.7.

These tables are used to determine the budget that is allowed for lighting power in a given project. That budget is then compared to the lighting power used by the design, and the design is changed, if necessary, to meet the requirements (or to exceed them as the case may be in LEED® certified project).

Lighting Power Densities for Building Exteriors

Tradable Surfaces (*LPDs* for uncovered parking areas, building grounds, building entrances and exits, canopies and overhangs, and outdoor sales areas may be traded.)	**Uncovered Parking Areas**	
	Parking lots and drives	**0.15** W/ft^2
	Building Grounds	
	Walkways less than 10-ft wide	**1.0** W/linear foot
	Walkways 10-ft wide or greater / Plaza areas / Special feature areas	**0.2** W/ft^2
	Stairways	**1.0** W/ft^2
	Building Entrances and Exits	
	Main entries	**30** W/linear foot of door width
	Other doors	**20** W/linear foot of door width
	Canopies and Overhangs	
	Canopies (free standing and attached and overhangs)	**1.25** W/ft^2
	Outdoor Sales	
	Open areas (including vehicle sales lots)	**0.5** W/ft^2
	Street frontage for vehicle sales lots in addition to "open area" allowance	**20** W/linear foot
Non-tradable Surfaces (*LPD* calculations for the following applications can be used only for the specific application and cannot be traded between surfaces or with other exterior lighting. The following allowances are in addition to any allowance otherwise permitted in the "Tradable Surfaces" section of this table.)	**Building facades**	**0.2** W/ft^2 for each illuminated wall or surface or **5.0** W/linear foot for each illuminated wall or surface length
	Automated teller machines and night depositories	**270** W per location plus **90** W per additional ATM per location
	Entrances and gatehouse inspection stations at guarded facilities	**1.25** W/ft^2 of uncovered area (covered areas are included in the "Canopies and Overhangs" section of "Tradable Surfaces"
	Loading areas for law enforcement, fire, ambulance, and other emergency service vehicles	**0.5** W/ft^2 of uncovered area (covered areas are included in the "Canopies and Overhangs" section of "Tradable Surfaces")
	Drive-through windows at fast food restaurants	**400** W per drive-through
	Parking near 24-hour retail entrances	**800** W per main entry

FIGURE 9.5 ASHRAE 90.1-2007, Table 9.4.5 Lighting Power Densities for Building Exteriors *(used by permission of ASHRAE)*

Lighting Power Densities Using the Building Area Method

Building Area Type[a]	Lighting Power Density (W/ft²)
Automotive Facility	0.9
Convention Center	1.2
Court House	1.2
Dining: Bar Lounge/Leisure	1.3
Dining: Cafeteria/Fast Food	1.4
Dining: Family	1.6
Dormitory	1.0
Exercise Center	1.0
Gymnasium	1.1
Health Care-Clinic	1.0
Hospital	1.2
Hotel	1.0
Library	1.3
Manufacturing Facility	1.3
Motel	1.0
Motion Picture Theater	1.2
Multi-Family	0.7
Museum	1.1
Office	1.0
Parking Garage	0.3
Penitentiary	1.0
Performing Arts Theater	1.6
Police/Fire Station	1.0
Post Office	1.1
Religious Building	1.3
Retail	1.5
School University	1.2
Sports Arena	1.1
Town Hall	1.1
Transportation	1.0
Warehouse	0.8
Workshop	1.4

[a]In cases where both general building area type and a specific building area type are listed, the specific building area type shall apply.

FIGURE 9.6 ASHRAE 90.1-2007, Table 9.5.1 Lighting Power Density *(used by permission of ASHRAE)*

9.3 Plumbing Systems Code Documents

Eight documents cover most code requirements for electrical systems—

- 2009 International Building Code (and 2009 NFPA 101 Life Safety Code and 2009 NFPA 5000 Building Construction and Safety Code)
- 2009 International Plumbing Code
- ASHRAE 90.1-2007 Energy Standard for Buildings Except Low-Rise Residential Buildings

Lighting Power Densities Using the Space-by-Space Method

Common Space Types[a]	LPD, W/ft²	Building-Specific Space Types	LPD, W/ft²
Office—Enclosed	1.1	Gymnasium/Exercise Center	
Office—Open Plan	1.1	Playing Area	1.4
Conference/Meeting/Multipurpose	1.3	Exercise Area	0.9
Classroom/Lecture/Training	1.4	Courthouse/Police Station/Penitentiary	
For Penitentiary	1.3	Courtroom	1.9
Lobby	1.3	Confinement Cells	0.9
For Hotel	1.1	Judges' Chambers	1.3
For Performing Arts Theater	3.3	Fire Stations	
For Motion Picture Theater	1.1	Engine Room	0.8
Audience/Seating Area	0.9	Sleeping Quarters	0.3
For Gymnasium	0.4	Post Office—SortingArea	1.2
For Exercise Center	0.3	Convention Center—Exhibit Space	1.3
For Convention Center	0.7	Library	
For Penitentiary	0.7	Card File and Cataloging	1.1
For Religious Buildings	1.7	Stacks	1.7
For Sports Area	0.4	Reading Area	1.2
For Performing Arts Theater	2.6	Hospital	
For Motion Picture Theater	1.2	Emergency	2.7
For Transportation	0.5	Recovery	0.8
Atrium—First Three Floors	0.6	Nurses' Station	1.0
Atrium—Each Additional Floor	0.2	Exam/Treatment	1.5
Lounge/Recreation	1.2	Pharmacy	1.2
For Hospital	0.8	Patient Room	0.7
Dining Area	0.9	Operating Room	2.2
For Penitentiary	1.3	Nursery	0.6
For Hotel	1.3	Medical Supply	1.4
For Motel	1.2	Physical Therapy	0.9
For Bar Lounge/Leisure Dining	1.4	Radiology	0.4
For Family Dining	2.1	Laundry—Washing	0.6
Food Preparation	1.2	Automotive—Service/Repair	0.7
Laboratory	1.4	Manufacturing	
Restrooms	0.9	Low Bay (<25 ft Floor to Ceiling Height)	1.2
Dressing/Locker/Fitting Room	0.6	High Bay(>25 ft Floor to Ceiling Height)	1.7
Corridor/Transition	0.5	Detailed Manufacturing	2.1
For Hospital	1.0	Equipment Room	1.2
For Manufacturing Facility	0.5	Control Room	0.5
Stairs—Active	0.6	Hotel/Motel Guest Rooms	1.1
Active Storage	0.8	Dormitory—Living Quarters	1.1
For Hospital	0.9	Museum	
Inactive Storage	0.3	General Exhibition	1.0
For Museum	0.8	Restoration	1.7
Electrical/Mechanical	1.5	Bank/Office—Banking Activity Area	1.5
Workshop	1.9	Religious Buildings	
Sales Area [for accent lighting, see Section 9.6.2 (b)]	1.7	Worship Pulpit, Choir	2.4
		Fellowship Hall	0.9
		Retail	
		Sales Area [for accent lighting, see Section 9.6.3 (c)]	1.7
		Mall Concourse	1.7
		Sports Arena	
		Ring Sports Area	2.7
		Court Sports Area	2.3
		Indoor Playing Field Area	1.4

FIGURE 9.7 ASHRAE 90.1-2007, Table 9.6.1 Lighting Power Densities Using the Space-by-Space Method *(used by permission of ASHRAE)*

Warehouse	
Fine Material Storage	1.4
Medium/Bulky Material Storage	0.9
Parking Garage—Garage Area	0.2
Transportation	
Airport—Concourse	0.6
Air/Train/Bus—Baggage Area	1.0
Terminal—Ticket Counter	1.5

[a] In cases where both a common space type and a building-specific type are listed, the building specific space type shall apply.

FIGURE 9.7 (*Continued*)

- 2009 International Fuel Gas Code
- 2007 NFPA 13 Installation of Sprinkler Systems
- 2010 NFPA 13R Standard for the Installation of Sprinkler Systems in Residential Occupancies Up to and Including Four Stories in Height
- 2010 NFPA 13D Standard for the Installation of Sprinkler Systems in One- and Two-Family Dwellings and Manufactured Homes
- 2006 NFPA 99 Healthcare Facilities

In addition, some fixtures are affected by federal regulations. When the first Energy Policy Act was enacted by the federal government in the 1990s, one of its primary goals was to reduce domestic water usage. So that law imposed limits on the amount of water that could be used in faucets and showers and to flush toilets and urinals. Prior to this time, water closets were designed to use no more than 3.2 gallons per flush (gpf; an earlier federal regulation set that standard; older fixtures often use 5.0 gallons or even 6.0 gallons per flush). The new limit is 1.6 gallons per flush, which is still in force today. Similarly, urinals were reduced to 1.0 gallon per flush and showers were reduced to 2.5 gallons per minute.

Today, water closets are available at 1.3 gpf and even less, and "dual flush" fixtures are available. Dual-flush fixtures usually use 1.6 gpf (or less) for "high" and 1.3 gpf (or less) for "low," and they have a dual-action button or separate buttons for high and low flushing.

Urinals are available at 1.0 gpf, 0.25 gpf, and 0.0 gpf. The latter fixtures are "water-less" urinals that use no domestic water for flushing at all. Water less fixtures are technically illegal in some jurisdictions, so that should be verified before they are specified for any particular project. There are several different types of water less urinals, but the key issue to using them is to make sure that they are piped into the sanitary waste piping downstream of another type of fixture that will put water into the piping (sinks, lavatories, showers, or water closets would all be acceptable). The reason for this is that human urine does contain solid materials, and water less urinals that are piped without any water flow at all can result in serious pipe-clogging issues.

9.3.1 2009 INTERNATIONAL BUILDING CODE

In the 2009 International Building Code, Chapter 29 governs plumbing systems, and there is only one significant issue, which is a large one: minimum number of plumbing fixtures. This is determined by Table 2902.1. See Figure 9.8.

All of the numbers on this table relate to the overall occupant count for the facility in question, and that overall occupant count is to be split 50/50 between men and women, unless approved statistics can be provided to prove a distribution other than 50/50.[34]

Separate facilities are required for each sex, except within dwelling and sleeping units, for occupant loads of 15 or less, and for mercantile occupant loads of 50 of less.[35]

Facilities must be provided for customers, patrons, and visitors to structures and tenant spaces intended for public utilization, although such facilities can be shared and accessed via

No.	Classification	Occupancy	Description	Water Closets (Urinals See Section 419.2 of the International Plumbing Code)		Lavatories		Bathtubs/ Showers	Drinking Fountains[e,f] (See Section 410.1 of the International Plumbing Code)	Other
				Male	Female	Male	Female			
1	Assembly	A-1[d]	Theaters and other buildings for the performing arts and motion pictures	1 per 125	1 per 65	1 per 200		—	1 per 500	1 service sink
		A-2[d]	Nightclubs, bars, taverns, dance halls, and buildings for similar purposes	1 per 40	1 per 40	1 per 75		—	1 per 500	1 service sink
			Restaurants, banquet halls, and food courts	1 per 75	1 per 75	1 per 200		—	1 per 500	1 service sink
		A-3[d]	Auditoriums without permanent seating, art galleries, exhibition halls, museums, lecture halls, libraries, arcades, and gymnasiums	1 per 125	1 per 65	1 per 200		—	1 per 500	1 service sink
			Passenger terminals and transportation facilities	1 per 500	1 per 500	1 per 750		—	1 per 1,000	1 service sink
			Places of worship and other religious services	1 per 150	1 per 75	1 per 200		—	1 per 1,000	1 service sink
		A-4	Coliseums, arenas, skating rinks, pools, and tennis courts for indoor sporting events and activities	1 per 75 for the first 1,500 and 1 per 120 for the remainder exceeding 1,500	1 per 40 for the first 1,520 and 1 per 60 for the remainder exceeding 1,520	1 per 200	1 per 150	—	1 per 1,000	1 service sink
		A-5	Stadiums, amusement parks, bleachers, and grandstands for outdoor sporting events and activities	1 per 75 for the first 1,500 and 1 per 120 for the remainder exceeding 1,500	1 per 40 for the first 1,520 and 1 per 60 for the remainder exceeding 1,520	1 per 200	1 per 150	—	1 per 1,000	1 service sink

FIGURE 9.8 IBC 2009, Table 2902.1 Minimum Number of Required Plumbing Fixtures

No.	Classification	Description						
2	Business	B	Buildings for the transaction of business, professional services, other services involving merchandise, office buildings, banks, light industrial and similar uses	1 per 25 for the first 50 and 1 per 50 for the remainder exceeding 50	1 per 40 for the first 80 and 1 per 80 for the remainder exceeding 80	—	1 per 100	1 service sink
3	Educational	E	Educational facilities	1 per 50	1 per 50	—	1 per 100	1 service sink
4	Factory and industrial	F-1 and F-2	Structures in which occupants are engaged in work fabricating, assembly or processing of products or materials	1 per 100	1 per 100	See Section 411 of the *International Plumbing Code*	1 per 400	1 service sink
5	Institutional	I-1	Residential care	1 per 10	1 per 10	1 per 8	1 per 100	1 service sink
		I-2	Hospitals, ambulatory nursing home patients[b]	1 per per room[c]	1 per per room[c]	1 per 15	1 per 100	1 service sink
			Employees, other than residential care[b]	1 per 25	1 per 35	—	1 per 100	—
			Visitors, other than residential care	1 per 75	1 per 100	—	1 per 500	—
		I-3	Prisons[b]	1 per cell	1 per cell	1 per 15	1 per 100	1 service sink
		I-3	Reformatories, detention centers, and correctional centers[b]	1 per 15	1 per 15	1 per 15	1 per 100	1 service sink
			Employees[b]	1 per 25	1 per 35	—	1 per 100	—
		I-4	Adult day care and child care	1 per 15	1 per 15	1	1 per 100	1 service sink
6	Mercantile	M	Retail stores, service stations, shops, salesrooms, markets, and shopping centers	1 per 500	1 per 750	—	1 per 1,000	1 service sink
	Residential	R-1	Hotels, motels, boarding houses (transient)	1 per sleeping unit	1 per sleeping unit	1 per sleeping unit	—	1 service sink
		R-2	Dormitories, fraternities, sororities, and boarding houses (not transient)	1 per 10	1 per 10	1 per 8	1 per 8	1 service sink

FIGURE 9.8 (*Continued*)

No.	Classification	Occupancy	Description	Water Closets (Urinals See Section 419.2 of the International Plumbing Code) Male	Water Closets Female	Lavatories Male	Lavatories Female	Bathtubs/ Showers	Drinking Fountains[e, f] (See Section 410.1 of the International Plumbing Code)	Other
7	Residential	R-2	Apartment house	1 per dwelling unit	1 per dwelling unit	1 per dwelling unit	1 per dwelling unit	1 per dwelling unit	—	1 kitchen sink per dwelling unit; 1 automatic clothes washer connection per 20 dwelling units
7	Residential	R-3	Congregate living facilities with 16 or fewer persons	1 per 10	1 per 10	1 per 10	1 per 10	1 per 8	1 per 100	1 service sink
		R-4	Residential care/ assisted living facilities	1 per 10	1 per 10	1 per 10	1 per 10	1 per 8	1 per 100	1 service sink
8	Storage	S-1 S-2	Structures for the storage of goods, warehouses, storehouses, and freight depots, low and moderate hazard	1 per 100	1 per 100	1 per 100	1 per 100	See Section 411 of the International Plumbing Code	1 per 1,000	1 service sink

a. The fixtures shown are based on one fixture being the minimum required for the number of persons indicated or any fraction of the number of persons indicated. The number of occupants shall be determined by this code.

b. Toilet facilities for employees shall be separate from facilities for inmates or patients.

c. A single-occupant toilet room with one water closet and one lavatory serving not more than two adjacent patient sleeping units shall be permitted where such room is provided with direct access from each patient sleeping unit and with provisions for privacy.

d. The occupant load for seasonal outdoor seating and entertainment areas shall be included when determining the minimum number of facilities required.

e. The minimum number of required drinking fountains shall comply with Table 2902.1 and Chapter 11.

f. Drinking fountains are not required for an occupant load of 15 or fewer.

FIGURE 9.8 (*Continued*)

public lobbies and corridors. The maximum travel distance is 500 feet (152 400 mm) and the facilities must be located within one story vertically except that the maximum travel distance is 300 feet (91 440 mm) in covered mall buildings. In rooms having more than one water closet or urinal, partitions are required to create separate compartments for the former and to provide screening for each fixture for the latter.[36]

As with HVAC, questions can be asked: Is it legal to move piping to raise a ceiling height? Yes, as long as the systems remain functional, although such changes can be costly. Unpressurized sanitary waste lines are different from other pressurized piping (such as HVAC hot and chilled water and domestic water) because they flow by gravity. This means that the waste pipes slope downward (usually between 1% and 2%), which can be altered only in a limited range, if at all. Vent piping slopes upward at 1%, but there is somewhat more flexibility there.

Is it legal to raise plumbing equipment (say a remote chiller for a water cooler or a water heater expansion tank, or the water heater itself for that matter)? Yes, as long as it remains viable to get to the equipment for servicing; changes like this can be costly too. And the ceiling access panel issue could complicate the matter if hard ceilings are involved.

9.3.2 2009 INTERNATIONAL PLUMBING CODE

The 2009 International Plumbing Code provides technical requirements for all plumbing systems, which have no direct relevance to interior design and will not be covered in greater detail.

Nonetheless, it is worthwhile to point out some general practices.

Sanitary waste and vent piping may be constructed using cast iron, copper, PVC, ABS, CPVC, and HFDP piping. Of these, PVC and ABS cannot meet the required flame spread and smoke developed requirements to be used in a plenum, so they must be covered to provide that protection. Wrapping these pipes in elastomeric insulation ("Armaflex," to use one trade name) works reasonably well for the wrapping, but contractors are fond of wrapping the piping using aluminum foil tape. It is not at all clear that the tape method is acceptable, and it should be resisted.

Domestic water piping may be constructed using galvanized steel (a bad idea, because of the likelihood of serious corrosion and relatively short lifetime), copper, PVC, CPVC, and Pex piping. Of these PVC and Pex cannot meet the flame spread and smoke developed requirements to be used in a plenum, so the same issues apply as noted above for waste and vent piping.

Storm water piping (usually from roof drains) may be constructed using cast iron, PVC, ABS, or CPVC, and the same flame spread and smoked developed issues apply to PVC and ABS in this situation too.

Natural gas piping may be constructed using steel (welded or threaded), copper (rarely done), and flexible plastic-coated (yellow) stainless steel tubing. The issue with the latter is that it is exceeding ugly and should be avoided wherever it might be seen in a finished environment.

9.3.3 ASHRAE 90.1-2007

ASHRAE 90.1-2007 also provides technical requirements for energy-saving aspects of plumbing systems (especially domestic hot water heating), which have no direct relevance to interior design and which will not be covered in detail.

9.3.4 2009 INTERNATIONAL FUEL GAS CODE

This code provides all the technical requirements for the use of natural gas and propane in buildings. As such, it will not be covered in detail.

9.3.5 2007 NFPA 13 INSTALLATION OF SPRINKLER SYSTEMS

This standard (adopted by reference as code in most jurisdictions) provides the technical requirements for wet-pipe and dry-pipe fire protection sprinkler systems for most types of buildings. Wet-pipe systems are used everywhere except areas that are subject to freezing

(e.g., cold attics, unheated parking garages); areas that are subject to freezing use dry-pipe systems or small systems can use wet-pipe systems filled with antifreeze.

The technical requirements are beyond the scope of this book, but some aspects of sprinkler system design have a major impact on interior design. The most significant of these is sprinkler selection (sprinklers are often called "sprinkler heads" but that term is technically incorrect). Sprinklers are available in the following types—

1. Upright (usually used in areas without ceilings)
2. Pendant (this is the type that extends several inches below the ceiling with a large trim piece)
3. Recessed (this type has only a deflector below the ceiling)
4. Flush (this type has a visible deflector above the bottom of the ceiling)
5. Concealed (this is the type that is completely concealed where only a cover plate is visible). See Figure 9.9.

Concealed sprinklers are the most appealing to designers, but there are some challenges to using them. It is illegal (due to NFPA14 requirements) to paint or refinish a cover plate in the field, so the plates must be ordered with the proper finish. That is often overlooked during design, and this is why white cover plates are seen in colored ceilings on a regular basis. Cover plates can be ordered in any color (or other special finish), but that adds even more to the high cost of concealed sprinklers and could slow down the installation process. Concealed sprinklers are the most costly option.

Recessed sprinklers are more costly than pendant sprinklers, but only by a small amount so such sprinklers are used extensively these days, especially with a white finish. White recessed sprinklers don't entirely disappear in the ceiling, but their visual presence is subtle.

Pendant and flush sprinklers are not often used these days, but many specifiers still call out polished chrome finishes for sprinklers. If the interior designer feels strongly about the look of the sprinkler system, he or she should work with whoever is writing the fire protection specifications to make sure that the correct sprinklers are specified.

Sprinkler Types

The interior designer should identify preferred types of sprinklers to the plumbing designer (or fire protection contractor) at the beginning of the project.

The next most significant impact of a sprinkler system is the compressor for a dry-type system. Dry-type systems operate by keeping air pressure in the empty pipes that is higher than the water pressure, which "holds back" the water. If the fusible link in a sprinkler melts (which is how water starts to flow from a sprinkler), the drop in air pressure allows the water to flow. These compressors are usually small, but they can be noisy and their locations should be planned carefully to avoid noise problems.

The next effect is exposed piping. If there are no ceilings, or if there are partial ceilings, in a space, there is a good chance that at least some of the sprinkler piping will be visible. This piping must be installed to drain, and it is usually installed in steel pipe with clunky couplings at the fittings—not all that beautiful. Where exposed piping is a concern, the interior designer should work carefully with whoever is writing the sprinkler specifications to ask for special consideration.

In many jurisdictions, only licensed fire protection engineers are allowed to design sprinkler systems, and most of them work for the installing contractors. Plumbing engineers routinely write specifications for sprinkler systems, and special language (and even drawings) can be added to let bidding contractors know about special situations. This is especially critical in many historic buildings.

Essentially, the way that conventional sprinkler systems work in commercial buildings is that the water supply is designed to serve the "most remote 1,500 sf." If that 1,500 sf is office space, there will be roughly 7 sprinklers in that area; if the space is storage space, there will be roughly 12 sprinklers in the area. A single sprinkler flows about 6 gallons per minute (gpm), so the MAXIMUM flow for this area (as storage) would be about 72 gpm. In addition, there are hose requirements that add another 250 gpm or so to that figure. So the water supply and piping have to be able to deliver about 320 gpm to this area, usually for up to 90 minutes.

TY-FRB

Horizontal, Recessed Horizontal Sidewall & Vertical Sidewall

- Light hazard/Ordinary hazard
- 3 mm bulb
- Designed for use in applications where aesthetics must be considered or where building construction makes the installation of standard pendent or upright sprinklers impractical
- Vertical sidewall sprinkler can be installed in either the pendent or upright position along a wall or the side of a beam and just below a smooth ceiling

K FACTOR	K=5.6 (80,6)
THREAD SIZE	1/2" NPT
ESCUTCHEON	Style 10 • Style 20
ESCUTCHEON FINISH	White Coated, Chrome Plated, Brass Plated
SPRINKLER FINISH	Natural Brass, Chrome Plated, White Polyester, Lead Coated
SIN	TY3331, TY3431
TECH DATA	TFP176

RFII "ROYAL FLUSH II"

Pendent Concealed

- Light hazard/Ordinary hazard
- 5 mm bulb (standard)
 3 mm bulb (quick)
- Concealed in an enclosed escutcheon plate with flat cover for use in those applications where aesthetics is a primary consideration
- Separable, two-piece design of the mounting cup and cover plate allows installation of the sprinklers and pressure testing of the fire protection system prior to installation of a suspended ceiling or application of the finish coating to a fixed ceiling

K FACTOR	K=5.6 (80,6)
THREAD SIZE	1/2"
SPRINKLER FINISH	Cover Plate: Chrome Plated, Natural Brass Plated, White Polyester Painted, Custom
SIN	TY3551, TY3531
TECH DATA	TFP181

- Internally threaded closure with 1/2" (12,7 mm) of adjustment
- Available with optional dust and air seal

TY-L

Upright, Pendent & Recessed Pendent

- All hazards
- Solder type
- Discharges a hemispherical water spray pattern in the area beneath the sprinkler

K FACTOR	K=5.6 (80,6) • K=8.0 (115,2)
THREAD SIZE	1/2" NPT • 3/4" NPT
ESCUTCHEON	Style 20 • Style 30
ESCUTCHEON FINISH	White Coated, Chrome Plated, Brass Plated
SPRINKLER FINISH	Natural Brass, Chrome Plated, Lead Coated, Wax Coated, Wax over Lead Coated
SIN	TY3111, TY3211, TY4111 TY4211, TY4811, TY4911
TECH DATA	TFP110

Always refer to the product's Technical Data Sheet for a complete description of all Listing and Approval criteria, design parameters, installation instructions, care and maintenance guidelines, and our limited warranty.

Mechanical, Electrical, and Plumbing **171**

STANDARD SPRAY SPRINKLERS

FIGURE 9.9 Tyco Fire Protection General Purpose Catalog pages 9–12. *(used by permission of Tyco Fire Products)*

AUTOMATIC SPRINKLERS
STANDARD SPRAY SPRINKLERS

TY-L

Horizontal Sidewall

- Light hazard / Ordinary hazard
- Solder type
- Suited for hotels, nursing homes and hospitals
- Design allows piping to be confined to corridors, closets or service areas

K FACTOR	K=5.6 (80,6)
THREAD SIZE	1/2" NPT
SPRINKLER FINISH	Natural Brass, Chrome Plated, Lead Coated, Wax Coated, Wax over Lead Coated
SIN	TY3311
TECH DATA	TFP120

TY-FRL

Upright, Pendent & Recessed Pendent

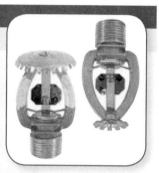

- Light hazard/Ordinary hazard *light hazard K=2.8 (40,3)*
- Solder type
- Typically used in hotels, motels, office buildings and other commercial and industrial applications

K FACTOR	K=2.8 (40,3) • K=5.6 (80,6) K=8.0 (115,2)
THREAD SIZE	1/2" NPT • 3/4" NPT
ESCUTCHEON	Style 20
ESCUTCHEON FINISH	White Coated, Chrome Plated, Brass Plated
SPRINKLER FINISH	Natural Brass, Chrome Plated
SIN	TY1121, TY1221, TY3121 TY3221, TY4121, TY4221
TECH DATA	TFP130

Horizontal Sidewall

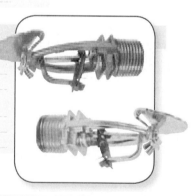

- Solder type
- Light hazard/Ordinary hazard
- Designed for compact installation along a wall or on the side of a beam just beneath a smooth ceiling
- Generally used in lieu of pendent or upright sprinklers because of aesthetics, building construction or economic considerations

K FACTOR	K=5.6 (80,6)
THREAD SIZE	1/2" NPT
SPRINKLER FINISH	Natural Brass, Chrome Plated
SIN	TY3321
TECH DATA	TFP140

TY-QRF

Flush Pendent

- Solder type
- Light hazard/Ordinary hazard
- Features separable escutcheon with 3/8" vertical adjustment

K FACTOR	K=5.6 (80,6)
THREAD SIZE	1/2" NPT
ESCUTCHEON FINISH	Chrome Plated, White Polyester, Black
SPRINKLER FINISH	Chrome Plated, White Polyester, Black
SIN	TY3261
TECH DATA	TFP190

Always refer to the product's Technical Data Sheet for a complete description of all Listing and Approval criteria, design parameters, installation instructions, care and maintenance guidelines, and our limited warranty.

AUTOMATIC SPRINKLERS
EXTENDED COVERAGE SPRINKLERS

EC-25

Upright

- All hazard
- Solder type
- Extended coverage area/density
- Deflector design allows maximum coverage area of 14' X 14' (4,3m X 4,3m)
- For use in high density applications such as "big box" retailing, extra hazard, and high-piled storage occupancies
- Minimum operating pressure of 7 psi (0,48 bar)

K FACTOR	K=25.2 (362,9)
THREAD SIZE	1" NPT or ISO 7-R1
SPRINKLER FINISH	Natural Brass
SIN	TY9128
TECH DATA	TFP213

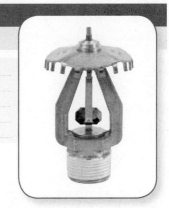

EC-17

Pendent & Recessed Pendent

- Solder type
- Extended coverage for higher density applications
- Recessed configuration is ideal for retail applications
- Maximum 196 sq. ft./sprinkler spacing (14 ft. x 14 ft. spacing)
- Can reduce the number of installed sprinklers by nearly 50%
- Hydraulic calculations based on actual spacing (sxl rule)
- Intended for area/density applications of 0.25 gpm/sq. ft. and higher

K FACTOR	K=16.8 (241,9)
THREAD SIZE	3/4" NPT
SPRINKLER FINISH	Natural Brass, White Polyester, Chrome Plated
SIN	TY7228
TECH DATA	TFP215

EC-11 & EC-14

Upright, Pendent & Recessed Pendent

- Light hazard/Ordinary hazard
- 3 mm bulb
- Nominal K=11.2 designed for coverage applications of 14' x 14' (4,3 m x 4,3 m) up to 20' x 20' (6,1 m x 6,1 m)
- Nominal K=14.0 designed for coverage applications of 16' x 16' (4,9 m x 4,9 m) up to 20' x 20' (6,1 m x 6,1 m)
- Low profile glass bulb spray sprinklers

K FACTOR	K=11.2 (161,3), K=14.0 (201,6)
THREAD SIZE	3/4" NPT
ESCUTCHEON	Style 30 • Style 40 • Style 60
ESCUTCHEON FINISH	White Coated, Chrome Plated, Brass Plated
SPRINKLER FINISH	Natural Brass, Chrome Plated, White Polyester, Lead Coated
SIN	TY5137, TY5237, TY6137, TY6237
TECH DATA	TFP220

Always refer to the product's Technical Data Sheet for a complete description of all Listing and Approval criteria, design parameters, installation instructions, care and maintenance guidelines, and our limited warranty.

EXTENDED COVERAGE SPRINKLERS

Mechanical, Electrical, and Plumbing **173**

FIGURE 9.9C

It takes a large (usually 4″ and sometimes 6″) pipe to deliver that quantity of water. Among other things, this means that it is impossible (yes, impossible) to have more than 12 (roughly speaking) sprinklers running simultaneously for any significant length of time. If the firefighters are not on site and are not using their hoses, this would increase to 50 odd sprinklers in an office area. But what is seen in the movies all the time—large areas with sprinklers all going off at once—simply doesn't happen in the real world. The sprinklers go off one at a time, as the fusible links melt; it is not possible to turn a valve to make a sprinkler go off. This also means that standard sprinkler systems are not designed to put out fires. Instead, they are designed to slow down fires until the fire department puts them out. There are special sprinkler systems (called ESFR—early suppression/fast response) that are designed to put out fires, but they require much higher flow rates (about double), which means that fire pumps are required and there are more sprinklers per given area. ESFR systems are only used where they are required—high pile storage, in particular—due to their much higher cost.

9.3.6 2010 NFPA 13R STANDARD FOR THE INSTALLATION OF SPRINKLER SYSTEMS IN RESIDENTIAL OCCUPANCIES UP TO AND INCLUDING FOUR STORIES IN HEIGHT

This standard sets out less demanding provisions for sprinklers in residential environments: apartments, hotels, and so on. The basic requirements are similar to NFPA 13 systems except that sprinklers can be omitted from bathrooms, closets, attics, concealed combustible spaces, and crawl spaces—all of which would have to be covered in conventional NFPA13 systems. Also, under 13R, the flow duration is reduced to 30 minutes and the simultaneous coverage is reduced to 4 sprinklers.

9.3.7 2010 NFPA 13D STANDARD FOR THE INSTALLATION OF SPRINKLER SYSTEMS IN ONE- AND TWO-FAMILY DWELLINGS AND MANUFACTURED HOMES

This standard sets out the much less demanding provisions for sprinklers in small residential environments. In this case, the simultaneous coverage is reduced to one sprinkler.

9.3.8 2006 NFPA 99 HEALTHCARE FACILITIES

This standard sets out requirements for medical gases (oxygen, nitrous oxide, nitrogen, medical air, and medical vacuum) and other highly technical systems (including emergency power, nurse call systems, etc.), and as such it is well beyond the scope of this book.

summary

Although mechanical, electrical, and plumbing systems in buildings are complex and have their own long and detailed requirements in the various documents noted in this chapter, only a few of these requirements are of substantial interest to interior designers. These include

- plenum requirements
- commercial hood requirements
- working spaces for electrical equipment

EPAct 1995

All plumbing fixture's water usage rates are subject to the requirements of 1995 EPAct, which reduced the amount of water to flush a water closet from 3.2 gallons per flush to 1.6 gallons per flush. This is not a code issue, strictly speaking, but the federal government has regulated the manufactures of the fixtures.

- exit requirements for rooms housing large electrical equipment
- 1-hour fire-resistance-rated rooms for large dry-type transformers

- accessibility issues for plumbing fixtures
- fixture counts for plumbing fixtures
- energy limitations for lighting
- control requirements for lighting
- track lighting wiring limitations
- difficulties involved in moving around these systems if it is desirable, or necessary, to raise a ceiling
- selecting sprinkler types and finishes
- making special provisions for exposed sprinkler piping

- making special provisions for exposed plumbing piping, ductwork, and wiring

The last item is of some significance. In any situation where there is a chance of seeing an ugly pipe, conduit, or duct in the wrong place, it is always reasonable for the interior designer to work with the engineers to avoid such problems. This is all part of normal everyday teamwork, and it is well within reason for an interior designer to raise such issues.

results

Having completed this chapter, the following objectives should have been met:

9.1. To understand code-related impacts of mechanical systems, by understanding the complications associated with air plenums and by understanding the requirements for commercial hoods in kitchens.

9.2. To understand code-related impacts of electrical systems, by understanding working space, special exit requirements for rooms housing large equipment, the need for 1-hour fire-resistance-rated rooms for large dry-type transformers, energy limitations on lighting loads, and challenging track lighting wiring requirements.

9.3. To understand code-related impacts of plumbing systems, by understanding fixture count requirements and accessibility requirements.

notes

1. International Building Code 2009, pages 271–72.
2. Ibid., page 272.
3. International Mechanical Code 2009, page 50.
4. Ibid.
5. Ibid.
6. International Building Code 2009, page 272.
7. Ibid.
8. The IESNA Lighting Handbook, Ninth Edition, pages 10–13.
9. Ibid.
10. Ibid., page 218.
11. Ibid., page 221.
12. Ibid., pages 234–35.
13. 2009 NFPA 101, pages 101–76.
14. International Building Code 2009, page 234.
15. 2009 NFPA 5000, pages 5000-145.
16. International Building Code 2009, pages 195–200.
17. 2008 NFPA 70, pages 70-36.
18. Ibid.
19. Ibid.
20. Ibid., pages 70–36 to 70–37.
21. Ibid., pages 70–26.
22. Ibid., pages 70–37.
23. Ibid., pages 70–339.
24. Ibid., pages 70–60.
25. International Energy Conservation Code 2009, page 47.
26. Ibid., page 49.
27. Ibid.
28. Ibid.
29. Ibid., page 58.
30. Ibid.
31. Ibid
32. ASHRAE 90.1-2007, page 60.
33. Ibid.
34. International Building Code 2009, page 551.
35. Ibid.
36. Ibid., pages 551–52.

10

Residential
Requirements

objectives

10.1 Residential Documents

Two documents cover most code requirements for residential occupancies—

- 2009 International Residential Code
- 2009 International Building Code

The International Residential Code is applicable to one- and two-family dwellings in most jurisdictions, and the International Building Code is applicable to all other residential occupancies in most jurisdictions. As usual, it is necessary to verify exactly which model code is applicable for each project and to confirm the applicable state or local amendments.

10.2 The 2009 International Residential Code

In most jurisdictions, some edition of the International Residential Code is used for one- and two-family dwellings, which include—

- single-family houses (including site-built, factory-built, and modular);

- two-family houses (often called "doubles" or "duplexes");
- two-family condominium buildings; and
- two-family apartments (rare, but theoretically possible).

If there are more than two units in a building, the International Residential Code does not apply and the International Building Code does apply—in most cases.

The International Residential Code is very different from the International Building Code in two important respects.

First, most jurisdictions don't require the direct involvement of licensed professionals (registered architects, professional engineers, or licensed interior designers) in one- and two-family dwelling projects.

Second, because of the lack of a requirement for licensed professionals, the International Residential Code is highly prescriptive—much more so than the International Building Code.

In order to illustrate these prescriptive requirements, consider structural design. The International Building Code provides minimum load criteria (for dead loads, live loads, wind loads, snow loads, and seismic loads) and some limitations on structural methodology for structural engineers and architects, who then use their professional judgment and standard mathematical techniques to perform the necessary structural calculations. In the International Residential Code, tables (and other information) are provided that show the required sizes of individual rafters, joists, footings, and so on, and structural calculations are mostly unnecessary.

Also, the International Residential Code is an all-in-one document, with all areas of construction covered, from foundations to planning; from floors to walls, ceilings, and roofs; and from plumbing to mechanical and electrical—in a single large volume. By contrast, even though the International Building Code technically includes the International Plumbing Code, the International Mechanical Code, the International Energy Conservation Code, the International Fuel Gas Code, and the International Electric Code, all of these are published in six individual volumes.

Under these typical requirements, virtually anyone can design a one- or two-family dwelling, with no need to bring in registered architects, professional engineers, or licensed interior designers. This includes unlicensed interior designers and even laypeople.

10.2.1 HOW IS THE 2009 INTERNATIONAL RESIDENTIAL CODE ORGANIZED?

The parts and chapters are as follows—

Part I Administration
- Chapter 1 Administration

Part II Definitions
- Chapter 2 Definitions

Part III Building Planning and Construction
- Chapter 3 Building Planning
- Chapter 4 Foundations
- Chapter 5 Floors
- Chapter 6 Wall Construction
- Chapter 7 Wall Covering
- Chapter 8 Roof-Ceiling Construction
- Chapter 9 Roof Assemblies
- Chapter 10 Chimneys and Fireplaces

Part IV Energy Conservation

- Chapter 11 Energy Efficiency

Part V Mechanical

- Chapter 12 Mechanical Administration
- Chapter 13 General Mechanical System Requirements
- Chapter 14 Heating and Cooling Equipment
- Chapter 15 Exhaust Systems
- Chapter 16 Duct Systems
- Chapter 17 Combustion Air
- Chapter 18 Chimneys and Vents
- Chapter 19 Special Fuel-Burning Equipment
- Chapter 20 Boilers and Water Heaters
- Chapter 21 Hydronic Piping
- Chapter 22 Special Piping and Storage Systems
- Chapter 23 Solar Systems

Part VI Fuel Gas

- Chapter 24 Fuel Gas

Part VII Plumbing

- Chapter 25 Plumbing Administration
- Chapter 26 General Plumbing Requirements
- Chapter 27 Plumbing Fixtures
- Chapter 28 Water Heaters
- Chapter 29 Water Supply and Distribution
- Chapter 30 Sanitary Drainage
- Chapter 31 Vents
- Chapter 32 Traps
- Chapter 33 Storm Drainage

Part VIII Electrical

- Chapter 34 General Requirements
- Chapter 35 Electrical Definitions
- Chapter 36 Services
- Chapter 37 Branch Circuit and Feeder Requirements
- Chapter 38 Wiring Methods
- Chapter 39 Power and Lighting Distribution
- Chapter 40 Devices and Luminaires
- Chapter 41 Appliance Installation
- Chapter 42 Swimming Pools
- Chapter 43 Class 2 Remote-Control, Signaling and Power-Limited Circuits

Part IX Referenced Standards

- Chapter 44 Referenced Standards
- Appendix A Sizing and Capacities of Gas Piping
- Appendix B Sizing of Venting Systems Serving Appliances Equipped with Draft Hoods, Category I Appliances, and Appliances Listed for Use and Type B Vents.
- Appendix C Exit Terminals of Mechanical Draft and Direct-Vent Venting Systems
- Appendix D Recommended Procedure for Safety Inspection of an Existing Appliance Installation

- Appendix E Manufactured Housing Used as Dwellings
- Appendix F Radon Control Methods
- Appendix G Swimming Pools, Spas, and Hot Tubs
- Appendix H Patio Covers
- Appendix I Private Sewage Disposal
- Appendix J Existing Buildings and Structures
- Appendix K Sound Transmission
- Appendix L Permit Fees
- Appendix M Home Day Care—R-3 Occupancy
- Appendix N Venting Methods
- Appendix O Gray Water Recycling Systems
- Appendix P Sizing of Water Piping System
- Appendix Q ICC International Residential Code Electrical Provisions/National Electrical Code Cross Reference

Each of these will be discussed in the level of detail that's appropriate for interior designers interested in one- and two-family dwellings.

10.2.1.1 Part I, Chapter 1 Administration

The administration chapters in the model codes, including the 2009 IRC, are frequently modified, or entirely removed, by state or local amendments because of specific legal requirements in each jurisdiction. The topics that are covered in this chapter include

- Creation of a local building department and the building official.
- Duties and power of the building official—"The building official shall have the authority to render interpretations of this code and to adopt policies and procedures in order to clarify the application of its provisions. Such interpretations, policies and procedures shall be in conformance with the intent and purpose of this code. Such policies and procedures shall not have the effect of waiving requirements specifically provided for in this code."[1] Clearly, this shows that building officials, broadly speaking, do not have the authority to add or remove requirements from the code, as adopted. But that's just according to the ICC. It's always possible that a state or local ordinance could expand or restrict this definition of a building official, so it is always necessary to know which specific requirements are directly applicable to the project at hand.

> **Residential Officials**
> In general, great deference should be used when dealing with officials in the residential realm. Such officials tend to believe that they are highly knowledgeable, and it is best to minimize disagreements to the greatest extent feasible. Also, it should be noted that professional credentials typically carry no weight at all in this area.

- Permitting requirements, which are rarely left as is by local authorities.
- Construction document requirements—"Construction documents shall be of sufficient clarity to indicate the location, nature and extent of the work proposed and show in detail that it will conform to the provisions of this code and relevant laws, ordinances, rules and regulations, as determined by the building official."[2] The exact meaning of this somewhat general language varies from location to location, so it is necessary to check with the local building department to determine the applicable requirements for each project.
- Requirements for temporary structures and uses—these requirements are highly variable from location to location.
- Fees—vary widely from location to location and must be determined for each project.
- Inspections—these requirements also vary widely, although it is common to see foundation, underground plumbing, framing, plumbing rough-in, and electrical rough-in inspections of one- and two-family dwellings. Each inspection is usually required before the project can move on to the next phase. The most common requirements is that wall

finishes (usually gypsum board) cannot be installed until the inspections of the plumbing and electrical rough-ins have been completed. This makes sense because much of the plumbing and electrical work will be covered up by the gypsum board.

- Certificate of occupancy—again, highly variable requirements here from location to location. The general purpose is for the building official to inspect the facility and agree that it is code compliant.
- Service utilities—in this section, the IRC allows for the building official to turn off one or more utility connections to a structure in the case of "immediate hazard to life or property."[3]
- Board of appeals—again, highly variable from location to location.
- Violations—again, highly variable from location to location, but it is reasonably safe to assume that most jurisdictions will have financial penalties in place for permitting violations.
- Stop work order—this is usually called the "red tag" process, whereby a building official cites a project for a violation (often noted on a red tag or sheet of paper, but often not). Such a notice usually includes an order to stop work by a certain future date (spelled out in the notice) if the problem in question is not resolved.

10.2.1.2 Part II, Chapter 2 Definitions

Dozens of definitions are provided in this chapter, and a number of them will be included as various chapters are discussed. Here are a few critical definitions—

"Approved. Acceptable to the building official."[4]

"Basement. That portion of a building that is partly or completely below grade (see 'Story above grade')."[5]

"Conditioned Area. That area within a building provided with heating and/or cooling systems or appliances capable of maintaining, through design or heat loss/gain, 68°F (20°C) during the heating season and/or 80°F (27°C) during the cooling season, or has a fixed opening directly adjacent to a conditioned area."

"Conditioned Space. For energy purposes, space within a building that is provided with heating and/or cooling equipment or systems capable of maintaining, through design or heat loss/gain, 50°F (10°C) during the heating season and 85°F (29°C) during the cooling season, or communicates directly with a conditioned space. For mechanical purposes, an area, room or space being heated or cooled by any equipment or appliance."[6]

"Emergency Escape and Rescue Opening. An operable window, door or similar device that provides for a means of escape and access for rescue in the event of an emergency."[7]

"Grade Floor Opening. A window or other opening located such that the sill height of the opening is not more than 44 inches (1118 mm) above or below the finished ground level adjacent to the opening."[8]

"Manufactured Home. Manufactured home means a structure, transportable in one or more sections, which in the traveling mode is 8 body feet (2438 body mm) or more in width or 40 body feet (12 192 body mm) or more in length, or, when erected on site, is 320 square feet (30 m²) or more, and which is built on a permanent chassi and designed to be used as a dwelling with or without a permanent foundation when connected to the required utilities, and includes the plumbing, heating, air-conditioning and electrical systems contained therein; except that such term shall include any structure that meets all the requirements of this paragraph except the size requirements and with respect to which the manufacturer voluntarily files a certification required by the secretary (HUD) and complies with the standards established under this title. For mobile homes built prior to June 15, 1976, a label certifying compliance to the Standard for Mobile Homes, NFPA 501, in effect at the time of manufacture is required. For the purpose of these provisions, a mobile home shall be considered a manufactured home."[9] This definition is

crucial because it clarifies that the IRC applies to modular manufactured homes with permanent foundations, modular manufactured homes without permanent foundations, and mobile homes.

"Townhouse. A single-family dwelling unit constructed in a group of three or more attached units in which each unit extends from foundation to roof and with open space on at least two sides."[10] Note here that this IRC definition is such that the IRC itself is not applicable; the grouping of "three or more attached units" means that only the IBC would be applicable to townhouse projects.

10.2.1.3 Part III, Chapter 3 Building Planning

This chapter includes the following general requirements—

A. Structural design—"safe," meeting stated requirements, and done using accepted engineering practice where outside the scope of the IRC
B. Climate and geographic design criteria—wind maps, seismic maps, weathering probability for concrete map, snow load maps, decay probability map, and component and cladding pressure zones
C. Seismic design requirements
D. Location on lot requirements—1-hour fire-resistance-rated exterior walls are required at separation distance of less than 5 feet (1523 mm) without openings. Openings are not allowed at separation distance of less than 3 feet (914 mm); openings cannot exceed 25% at separation distance of 3 feet (914 mm), and openings can be unlimited at separation distance of 5 feet (1523 mm) or more.[11]
E. A garage has to be separated from the residence and attic by at least 1/2 inch (13 mm) thick gypsum board or equivalent and from all habitable rooms above the garage by at least 5/8 inch (16 mm) Type X gypsum board or equivalent.[12]
F. Light, ventilation, and heating requirements include (but are not limited to)—
 - Glazed area of at last 8% of the floor area of each habitable room (with at least 4% openable), unless the room is provided with artificial lighting that is capable of producing average illumination of 6 foot-candles (65 lux), 30 inches (762 mm) above the floor and mechanical ventilation is provided to produce at least 0.35 air changes per hour in the room or a whole-house ventilation system to supply at least 15 cubic-feet-per-minute (cfm) (7.08 liters-per-second [L/s]) per occupant (on the basis of two occupants for the first bedroom and one occupant for each additional bedroom).
 - Glazed area of at least 3 square feet (1.86 m^2), at least 50% of which must be openable, in bathrooms, or artificial lighting and a mechanical ventilation system of at least 50 cfm (23.6 L/s) for intermittent operation or 20 cfm (9.4 L/s) for continuous ventilation, with all air exhausted directly to the exterior.
 - Stairway illumination (including landings and treads) of at least 1 fc (11 lux) at the center of treads and landings, with switches at the top and bottom.
 - Heating capable of maintaining 68°F (20°C) 3 feet (914 mm) above the floor and 2 feet (610 mm) from exterior walls in all habitable rooms at design temperature. Portable space heaters may not be used.[13]
G. Minimum room areas—every dwelling unit is required to have at least one habitable room that is at least 120 gross square feet (11.2 m^2); other rooms are to be at least 70 gross square feet (6.5 m^2) (except kitchens); and the minimum room dimension is 7 feet (2134 mm), except in kitchens. If the ceiling is below 7 feet (2134 mm), or if a sloping ceiling is below 5 feet (1524 mm),[14] the areas under such ceilings don't count as habitable area.
H. Ceiling height—minimum ceiling height is 7 feet (2134 mm), except for beams less than 6 inches (152 mm) high and more than 4 feet (1219 mm) apart; basements, where 6 feet 8 inches (2032 mm) is acceptable with obstructions down to 6 feet 4 inches (1931 mm); up to 50% of the area sloping between 5 feet (1524 mm) and 7 feet (2134 mm); bathroom ceilings may be as low as 6 feet 8 inches (2032 mm) over fixtures, fixture clearances, and over showers.[15]

I. Sanitation—every dwelling unit is required to have at least one water closet, one lavatory, and a bathtub or shower. Every dwelling unit is required to have a kitchen or kitchen area and every kitchen or kitchen area is required to have a sink. All fixture drains are to be connected to a sanitary sewer or an approved private sewage disposal system. All fixtures are to have water supply, and all fixtures except water closets are required to have hot and cold water connections.

J. Toilet, bath, and shower spaces—non absorbent wall surfaces are required for bathtubs and showers to at least 6 feet (1829 mm) above the floor.[16]

Tile Backer Board

Although it is legal to use "green-board" water-resistant gypsum board as a tile backer in bathrooms, kitchens, or other damp areas, such usage should be avoided. Green-board simply has a moisture-resistant paper facing (but it's still paper), and the gypsum is just fragile as the gypsum in conventional gypsum board. Cementitious backer board (i.e., cement board) should be used instead in all cases. This is not a code issue at all.

K. Glazing—includes standards for safety glazing, as related to impact loads (i.e., bodies hitting glass), hazardous locations, and skylights and sloped glazing.

L. Garages and carports—garage floors must be noncombustible, and the parking area floor must be sloped to a drain or the doorway.[17]

M. Emergency escape and rescue openings—this is a key area in the IRC. Each basement, habitable attic, and sleeping room must have at least one emergency escape and rescue opening, meeting the following requirements:

Maximum sill height: 44 inches (1118 mm)

Minimum opening area: 5.7 sf (0.530 m²) for above and below grade opening or 5 sf (0.465 m²) for openings at grade

Minimum opening height: 24 inches (610 mm)

Minimum opening width: 20 inches (508 mm)

Operational from the inside without keys or special knowledge

Window wells are required for openings with a finished sill height below grade, as follows:

Minimum area: 9 sf (0.84 m²)

Minimum width (from wall of building): 36 inches (914 mm)

If more than 44 inches (1118 mm) deep, a permanent ladder or steps is required.

Bars, grills, covers, and screens are acceptable as long as they are operable from the inside without keys, tools, or special knowledge.[18]

Deep Window Wells

As a result of this requirement for permanent steps or a ladder into wells that are more than 44" deep, it is highly recommended to find a way to avoid having to build wells that are more than 44" deep.

N. Means of egress include a number of requirements—

enclosed accessible space under stairs must have walls, under stairs, soffits, etc. covered in 1/2 inch (13 mm) minimum gypsum board.

Minimum hallway width is 36 inches (914 mm).

At least one (1) 36 inches (914 mm) wide by 6 feet 8 inch (2032 mm) high exterior exit door is required from each dwelling unit.

There must be a landing on both sides of all exterior doors, at least as wide at the door and at least 36 inches (914 mm) in length.

Exterior door locks must be operable from the inside without a key or special knowledge.

Minimum stairway width is 36 inches (914 mm), with handrails projecting no more than 4.5 inches (114 mm) on either side.

Minimum stair headroom is 6 feet 8 inches (2032 mm), measured from the sloping plane along the tread nosings to the structure above.

Maximum riser height is 7 3/4 inches (196 mm), and the greatest difference between two risers in a single flight is 3/8 inch (9.5 mm).

Minimum tread depth is 10 inches (254 mm), and the greatest difference between two treads in a single flight is 3/8 inch (9.5 mm).

The curve (fillet) at the leading edge of the tread may not exceed 9/16 inch (14.3 mm), and nosings between 3/4 inch (19 mm) and 1 1/4 inch (32 mm) are allowed.

Risers may be vertical or sloped up to 30 degrees (0.51 rad) from vertical.

Open risers are permitted, as long as a 4-inch (102-mm) diameter sphere cannot pass through.

Landings are required at the top and bottom of all stairways, and anywhere the vertical rise exceeds 12 feet (3658 mm).

Minimum landing width is the width of the stairs, and minimum depth is 36 inches (914 mm) in the direction of travel.

Handrails are required on at least one side of all stairways with four or more risers, mounted between 34 inches (864 mm) and 38 inches (965 mm) above the treads.

Handrails are required to be continuous along a flight, and at least 1 1/2 inches (38 mm) away from the wall.

Circular section handrails may be 1 1/4 inches (32 mm) to 2 inches (50 mm) in diameter; noncircular handrails are to have a perimeter dimension of at least 4 inches (102 mm) but not more than 6 1/4 inches (160 mm) with a maximum cross sectional dimension of 2 1/4 inches (57 mm). These are Type I handrails.

Type II handrails may be larger than Type I handrails, but additional requirements come into play for finger grips.

Spiral stairs are permitted as long as they are at least 26 inches (660 mm) wide, having a minimum tread depth of 7 1/2 inches (190 mm) at 12 inches from the narrow edge. Maximum riser height is 9 1/2 inches (241 mm) and minimum headroom is 6 feet 6 inches (1982 mm).

Ramps—the maximum slope is one unit vertical to eight units horizontal (12.5 %), and 3 foot (914 mm) by 3 foot (914 mm) landings are required at the top, bottom, changes of direction, and where doors open onto ramps. Ramps exceeding a slope of one unit vertical to 12 units horizontal (8.33 %) require a handrail on one side, mounted between 34 inches (864 mm) and 38 inches (965 mm) above the ramp. Handrail continuity and sizes are as for stairways.[19]

O. Guards, meaning what most people would call guardrails, are required around any edge that is more than 30 inches (762 mm) above the floor or grade below. Such guards must be at least 36 inches (914 mm) high. Stairs with a total rise of more than 30 inches (762 mm) are required to have guards at least 34 inches (864 mm) high. These requirements apply to screened-in porches also. Openings in guards may not allow a 4-inch (102-mm) diameter sphere to pass through, except for the triangular spaces between stair riser, stair tread, and bottom rail of the guard, where the sphere diameter may increase to 6 inches (152 mm).

P. Smoke alarms are required in each sleeping room, outside each separate sleeping area in the immediate vicinity, at each additional story of the dwelling (including the basement but not crawl space or uninhabitable attic). Multiple smoke alarms are required to be wired together so that the actuation of one device will activate all devices, and the sound is to be audible above background noise with all intervening doors closed. All such alarms are to be hardwired to the 120-volt normal power source in the dwelling unit, with battery backup for emergency operation.

Q. New to the 2009 IRC, carbon monoxide alarms are also now required outside of each sleeping area in the immediate vicinity of the bedrooms where fuel-fired appliances are used and where there is an attached garage.[20]

R. Foam plastic may be used for insulation and for interior trim, as follows—

Maximum flame-spread rating: 75.

Maximum smoke developed rating: 450.

Minimum protection of 1/2-inch (12.7-mm) gypsum board.

Acceptable on the outside of concrete or masonry construction.

Acceptable in the roof assembly if separated by at least 15/32-inch (11.9-mm) structural panel sheathing.

Acceptable in attics and crawl spaces if protected by 1 1/2-inch (38-mm) mineral fiber insulation, 1/4-inch (6.4-mm) wood structural panels, 3/8-inch (9.5-mm) particleboard, 1/4-inch (6.4-mm) hardboard, 3/8-inch (9.5-mm) gypsum board or corrosion-resistant steel at least 0.016 inch (0.406 mm) thick.

Foam-filled doors are exempt from these requirements.

Up to 1/2-inch (12.7-mm) thick foam plastic may be used under exterior siding as long as it is protected from the interior by at least 2 inches (51 mm) of mineral fiber insulation or 1/2-inch (12.7-mm) gypsum board or if installed over an existing exterior finish.

Foam plastic interior trim may be used as long as its minimum density is 20 pounds per cubic foot (pcf) (3.14 kg/m^3); the maximum thickness is 0.5 inch (12.7 mm); the maximum width is 4 inches (102 mm); it constitutes no more than 10 % of the area of any wall or ceilings, and the flame spread rating is 75 or less.

Spray-applied foam plastic may be used on sill plates and headers up to 3 1/4 inches (82.6 mm) thick; if the density is between 1.5 and 2.0 pcf (24 to 32 kg/m^3); and if the flame-spread index is 25 or less and the smoke developed index is 450 of less.

Foam plastic may be used for other applications if special testing is done in accordance with ASTM E 84, FM 4880, UL 1040, NFPA 286, ASTM E 152, or UL 1715.[21]

S. Moisture vapor retarders are required on the warm-in-winter side of the insulation. Some counties, primarily in the southeastern part of the country (as identified by footnote to table N1101.2 in Chapter 11 of the IRC), are exempt from this requirement, mostly because of the unusually high humidity conditions in those counties.

Unfortunately, the use of vapor barriers in buildings in temperate climates is really far more complicated than the IRC implies in this simple requirement. In any temperate climate, where both heating and cooling are required, the vapor barrier is on the wrong side of the insulation at least part of the time. The warm-in-winter side requirement is based on the assumption that less damage will be done to the building by having the barrier on the warm-in-winter side, but it is far from clear that that is actually true. This varies from building to building, site to site, and location to location, and it is quite possible that some buildings in temperate climates would be better off with the vapor barrier on the warm-in-summer side—the outside, in other words. But this is a moot discussion because the code requirement is simple and clear.

T. Protection against decay—these requirements are intended to reduce the long-term likelihood of moisture damage, and they consist primarily of using treated lumber, minimum spaces between wood and the ground, and protection of wood on concrete from direct moisture (via the use of a vapor barrier).

U. Protection against termites—these requirements are intended to reduce the long-term risk of termite damage, and they consist primarily of chemical soil treatment, use of treated lumber, and the use of foam plastics.[22]

V. Site address requires "plainly visible and legible from the street" numbers or addresses for all new buildings.

W. Accessibility requires compliance with Chapter 11 of the IBC for all buildings that contain four or more dwelling or sleeping units. As a result, such buildings are not subject to the requirements of the IRC.

X. Elevators and platform lifts are required to comply with ANSI A17.1, which means—more or less—that residential elevators must be built in a similar fashion to commercial elevators.

Y. Flood-resistant construction includes a number of specialized requirements for buildings in floor zones. The best answer to this is not to build in a flood zone.[23]

The pattern of many of these requirements follows the pattern established in the 2009 International Building Code—fire-resistance-ratings, flame-spread and smoke developed indices per ASTM E 84, handrails, ramps, and so on. Some of the requirements vary due to the differing nature of one- and two-family dwelling units—narrower corridors and stairs, steeper stairs, and so on. But the general intention remains the same: protect life safety, especially with emergency egress, while also minimizing property damage to the greatest extent feasible.

10.2.1.4 Part III, Chapter 4 Foundations

This chapter covers the technical requirements for both concrete and wood foundations for one- and two-family dwellings. Bearing pressures (i.e., how much weight the on-site soil can support) are assumed for various types of soils per Table R401.4.1. See Figure 10.1.

The only difficulty with this is that the IRC doesn't say how to tell which soil is applicable for a given project. Obviously, one can always assume the lowest category and use 1,500 psf bearing pressure, but that will result in the largest possible footings and it may not be acceptable to the owner. The building official might be able to assist with this determination for laypeople. In the worst case, a soils engineer (a professional engineer who specializes in geotechnical engineering) can be brought in to make a final determination.

In some sections of the country, expansive soils can be encountered. These are soils that expand when wet, which creates special requirements for anchoring buildings.

All-wood foundations are allowable, but only when using stainless steel fasteners and wood treated in accordance with AWPA C22. Minimum concrete compressive strength is determined by Table R402.2; in brief, this table requires 2,500 psi (this is low strength) for concrete not exposed to weather; 3,000 psi for basement wall, foundation wall, exterior wall and other vertical concrete exposed to moderate to severe weathering potential and for horizontal concrete exposed to moderate weather potential, and 3,500 psi (this is moderate strength) for horizontal concrete exposed to severe weathering potential. Weathering potential is determined by the weathering potential maps in Chapter 3.

Minimum spread footing widths are provided by Table R403.1 and they vary from 12 inches (one-story building at 1,500 psf soil to three-story building at 4,000 psf soil) to 42 inches (three-story building at 1,500 psf soil). Minimum spread footing thickness is 6 inches (152 mm), and a spread footing must project at least 2 inches (51 mm) on both sides of the wall above.

One- and two-family dwellings with basements nearly always use spread footings under concrete or masonry walls (or all-wood systems); such buildings with crawl spaces are similar,

CLASS OF MATERIAL	LOAD-BEARING PRESSURE (pounds per square foot)
Crystalline bedrock	12,000
Sedimentary and foliated rock	4,000
Sandy gravel and/or gravel (GW and GP)	3,000
Sand, silty sand, clayey sand, silty gravel, and clayey gravel (SW, SP, SM, SC, GM, and GC)	2,000
Clay, sandy clay, silty clay, clayey silt, silt, and sandy silt (CL, ML, MH, and CH)	1,500[b]

For SI: 1 pound per square foot = 0.0479 kPa.

a. When soil tests are required by Section R401.4, the allowable bearing capacities of the soil shall be part of the recommendations.

b. Where the building official determines that in-place soils with an allowable bearing capacity of less than 1,500 psf are likely to be present at the site, the allowable bearing capacity shall be determined by a soils investigation.

FIGURE 10.1 IRC 2009, Table R401.4.1 Presumptive Load-Bearing Values of Foundation Materials

and such buildings with slab-on-grade can be done with both spread footings and with monolithic slabs with integral footings.

If the building is in an area that requires special seismic reinforcement (for earthquakes), those requirements are spelled out in R403.1.2 and R403.1.3.

The bottoms of all footings must be at least 12 inches (305 mm) below the undisturbed ground surface or below the local frost line, whichever is deeper. The frost depth is determined by Table R301.2(1) unless there is a different state or local requirement.

Special requirements for expansive soils are found in R403.1.8.

For heated buildings in cold climates (areas with frost lines), foundation insulation is required as noted on Table R403.3. See Figure 10.2.

The vertical thermal resistance value requirement varies from R = 4.5 for 1,500°F-days (degree days) or less to R = 10.1 for 4,000°F-days, and the horizontal thermal resistance value requirement varies from R = 1.7 for 2,500°F-days (none required for warmer climates) to R = 13.1 at corners for 4,000°F-days. The thicknesses of the required insulation vary according to climate severity too, with more required as the climate gets colder.

The thickness of vertical foundation walls varies with overall height and backfill height (the height of soil against the outside of the wall). Low concrete walls with low backfill—say 5 feet high with 4 feet of backfill—can be only 6 inches thick, whereas concrete walls that are 9 feet high with 9 feet of backfill have to be 10 inches or even 12 inches thick, depending on the soil classification. Hollow masonry walls must be filled solid in many instances, mostly due to backfill. These requirements are spelled out in detail on Table R404.1.1(1).

Many concrete and masonry foundation walls require reinforcement, which is spelled out in Tables R404.1.1(2), R404.1.1(3), and R404.1.1(4). And special seismic requirement are detailed in R404.1.4.

Requirements for wood foundation walls are detailed in R404.2 and R404.3.

Insulating concrete form (ICF) foundation walls are allowed too. This is a system whereby insulation is built on both sides of a void, which is filled with concrete, leaving a double-insulated wall. Such walls are highly energy efficient, and the technical requirements are found in Tables R404.4, R404.4(1), R404.4(2), R404.4(3), R404.4(4), and R404.4(5).

Foundations must be drained to prevent leaks into occupied spaces and deterioration from water damage, unless the foundation is located in well-drained (granular—sand and gravel) soil.

Where there is habitable space below grade, the foundation must be damp-proofed as stated in R406.1. If there is habitable space below grade and a high water table, the

AIR FREEZING INDEX (°F-days)[b]	MINIMUM FOOTING DEPTH, D (inches)	VERTICAL INSULATION R-VALUE[c,d]	HORIZONTAL INSULATION R-VALUE[c,e]		HORIZONTAL INSULATION DIMENSIONS PER FIGURE R403.3(1) (inches)		
			Along walls	At corners	A	B	C
1,500 or less	12	4.5	Not required	Not required	Not required	Not required	Not required
2,000	14	5.6	Not required	Not required	Not required	Not required	Not required
2,500	16	6.7	1.7	4.9	12	24	40
3,000	16	7.8	6.5	8.6	12	24	40
3,500	16	9.0	8.0	11.2	24	30	60
4,000	16	10.1	10.5	13.1	24	36	60

a. Insulation requirements are for protection against frost damage in heated buildings. Greater values may be required to meet energy conservation standards.

b. See Figure R403.3(2) or Table R403.3(2) for Air Freezing Index values.

c. Insulation materials shall provide the stated minimum R-values under long-term exposure to moist, below-ground conditions in freezing climates. The following R-values shall be used to determine insulation thicknesses required for this application: Type II expanded polystyrene—2.4R per inch; Type IV extruded polystyrene—4.5R per inch; Type VI extruded polystyrene—4.5R per inch; Type IX expanded polystyrene—3.2R per inch; Type X extruded polystyrene—4.5R per inch.

d. Vertical insulation shall be expanded polystyrene insulation or extruded polystyrene insulation.

e. Horizontal insulation shall be extruded polystyrene insulation.

FIGURE 10.2 IRC 2009, Table R403.3(1) Minimum Footing Depth and Insulation Requirements for Frost-Protected Footings in Heated Buildings

foundation must be water-proofed as stated in R406.2. All wood foundations must be damp-proofed.

Wood columns must be at least 4 inches (102 mm) by 4 inches (102 mm) in cross section and protected against decay, and steel columns must be at least 3 inches (76 mm) in diameter and coated with a rust-inhibitive primer inside and out.

Under-floor space (crawl space usually) must be ventilated at a rate of at least 1 square foot (0.0929 m^2) for each 150 square feet (14 m^2) of under-floor space area. There must be a ventilation space in the foundation within 3 feet (914 mm) of each corner of the building. The openings must be covered with a material having openings smaller than 1/4 inch (6.4 mm), including perforated sheet metal not less than 0.070 inch (1.8 mm) thick, or expanded sheet metal plates, or cast-iron grills or grating, or extruded load-bearing brick vents, or hardware cloth, or corrosion-resistant wire mesh. At least one access is required to the under-floor space, which has to be at least 18 inches (457 mm) by 24 inches (610 mm) if in the floor and at least 16 inches (407 mm) by 24 inches (610 mm) if in a perimeter wall. If the opening is in a wall and its sill is below grade, an areaway is required.[24]

10.2.1.5 Part III, Chapter 5 Floors

This chapter covers the structural requirements for wood and light-gauge (cold-formed) steel floor framing and sheathing and slabs-on-grade. A number of tables are included for selecting wood girder, rafter and joist sizes, based on loads, spans, spacing, and quality of wood. Details are provided for how and where to make cuts for piping and wiring to pass through wood joists, and draft-stopping and fire-blocking requirements are spelled out. Tables are provided for selecting floor sheathing and steel joists, and requirements are provided for steel fastening and bracing. Concrete slabs-on-grade are required to be at least 3.5 inches (89 mm) thick (except for expansive soils), and the concrete strength requirements are as noted above under foundations. A minimum of 4 inches (102 mm) of clean sand, gravel, crushed stone, or crushed blast furnace slag is required under the slab, and a 6 mil (thousandths of an inch), 0.006 inch, or 152 μm (micrometer) polyethylene vapor retarder is required between the granular base and the slab.[25]

10.2.1.6 Part III, Chapter 6 Wall Construction

This very long chapter covers all of the technical requirements for wood and light-gauge (cold-formed) steel wall framing, including nailing sizes and spacing, sizes of studs, detailed sheathing requirements, header sizes, and so on; for unit masonry (brick, concrete masonry units, and glass block) walls; and for ICF walls.[26]

10.2.1.7 Part III, Chapter 7 Wall Covering

This chapter covers technical requirements for portland cement plaster, gypsum plaster, gypsum board, ceramic tile, wood veneer paneling on interior walls, wood and hardboard siding, exterior portland cement plaster (usually called stucco), stone and masonry veneer, exterior insulation finish systems (EIFS), and fiber cement siding for exterior walls. For interior design purposes, the most critical issues covered relate to interior gypsum board usage, which is governed by Table R702.3.5.[27] See Figure 10.3. Generally speaking, even though this table allows for the use of 3/8-inch gypsum board for some applications, such usage should be avoided for performance reasons; 3/8-inch thick gypsum board is weak and should be used only where necessary—in curves, in multilayer applications, or in multilayer applications on curves.

10.2.1.8 Part III, Chapter 8 Roof-Ceiling Construction

This chapter covers technical requirements for roof framing in wood and light-gauge (cold-formed) steel, including tables for sizing rafters and ceiling joists; requirements for ceiling finishes (simply noted to be in compliance with Section R702); roof ventilation, which is required to consist of protected (using wire mesh having 1/8-inch (3.2-mm) to

THICKNESS OF GYPSUM BOARD (inches)	APPLICATION	ORIENTATION OF GYPSUM BOARD TO FRAMING	MAXIMUM SPACING OF FRAMING MEMBERS (inches o.c.)	MAXIMUM SPACING OF FASTENERS (inches)		SIZE OF NAILS FOR APPLICATION TO WOOD FRAMING[c]
				Nails[a]	Screws[b]	
Application without adhesive						
3/8	Ceiling[d]	Perpendicular	16	7	12	13 gage, 1 1/4" long, 19/64" head; 0.098" diameter, 1 1/4" long, annular-ringed; or 4d cooler nail, 0.080" diameter, 1 3/8" long, 7/32" head.
	Wall	Either direction	16	8	16	
1/2	Ceiling	Either direction	16	7	12	13 gage, 1 3/8" long, 19/64" head; 0.098" diameter, 1 1/4" long, annular-ringed; 5d cooler nail, 0.086" diameter, 5/8" long, 15/64" head; or gypsum board nail, 0.086" diameter, 5/8" long, 9/32" head.
	Ceiling[d]	Perpendicular	24	7	12	
	Wall	Either direction	24	8	12	
	Wall	Either direction	16	8	16	
5/8	Ceiling	Either direction	16	7	12	13 gage, 1 5/8" long, 19/64" head; 0.098" diameter, 1 3/8" long, annular-ringed; 6d cooler nail, 0.092" diameter, 1 7/8" long, 1/4" head; or gypsum board nail, 0.0915" diameter, 1 7/8" long, 19/64" head.
	Ceiling[e]	Perpendicular	24	7	12	
	Wall	Either direction	24	8	12	
	Wall	Either direction	16	8	16	
Application with adhesive						
3/8	Ceiling[d]	Perpendicular	16	16	16	Same as above for 3/8" gypsum board.
	Wall	Either direction	16	16	24	
1/2 or 5/8	Ceiling	Either direction	16	16	16	Same as above for 1/2" and 5/8" gypsum board, respectively.
	Ceiling[d]	Perpendicular	24	12	16	
	Wall	Either direction	24	16	24	
Two 3/8 layers	Ceiling	Perpendicular	16	16	16	Base ply nailed as above for 1/2" gypsum board; face ply installed with adhesive.
	Wall	Either direction	24	24	24	

For SI: 1 inch = 25.4 mm.

a. For application without adhesive, a pair of nails spaced not less than 2 inches apart or more than 2 1/2 inches apart may be used with the pair of nails spaced 12 inches on center.

b. Screws shall be in accordance with Section R702.3.6. Screws for attaching gypsum board to structural insulated panels shall penetrate the wood structural panel facing not less than 7/16 inch.

c. Where cold-formed steel framing is used with a clinching design to receive nails by two edges of metal, the nails shall be not less than 5/8 inch longer than the gypsumboard thickness and shall have ringed shanks. Where the cold-formed steel framing has a nailing groove formed to receive the nails, the nails shall have barbed shanks or be 5d, 13/12; gage, 15/64 inches long, 15/64-inch head for 1/2-inch gypsum board; and 6d, 13 1/2 gage, 15/8 inches long, 15/64-inch head for 5/8-inch gypsum board.

d. Three-eighths-inch-thick single-ply gypsum board shall not be used on a ceiling where a water-based textured finish is to be applied, or where it will be required to support insulation above a ceiling. On ceiling applications to receive a water-based texture material, either hand or spray applied, the gypsum board shall be applied perpendicular to framing. When applying a water-based texture material, the minimum gypsum board thickness shall be increased from 3/8 inch to 1/2 inch for 16-inch on center framing, and from 1/2 inch to 5/8 inch for 24-inch on center framing or 1/2-inch sag-resistant gypsum ceiling board shall be used.

e. Type X gypsum board for garage ceilings beneath habitable rooms shall be installed perpendicular to the ceiling framing and shall be fastened at maximum 6 inches o.c. by minimum 1 7/8 inches 6d coated nails or equivalent drywall screws.

FIGURE 10.3 IRC 2009, Table R702.3.5 Minimum Thickness and Application of Gypsum Board

1/4-inch (6.4-mm) openings) openings for cross ventilation in every attic or enclosed rafter space (where gypsum board is applied directly to the bottom of the rafters) to provide a free area of at least 1/150 of the area ventilated. If 50% to 80% of the openings are at least 3 feet (914 mm) above the eave or cornice vents, the ratio can be reduced to 1/300. The ratio can be 1/300 if a vapor barrier is applied to the warm side of the ceiling also; attic access, which is required to all attics greater than 30 square feet (2.8 m^2) or more than 30 inches (762 mm) high, consists of an opening at least 22 inches (559 mm) by 30 inches (762 mm) located in a hallway or other accessible location with minimum headroom at the opening of 30 inches (762 mm).[28]

10.2.1.9 Part III, Chapter 9 Roof Assemblies

This chapter covers technical requirements for roof sheathing and roof materials.[29]

10.2.1.10 Part III, Chapter 10 Chimneys and Fireplaces

This chapter covers detailed technical requirements for traditional masonry fireplaces and chimneys, factory-built chimneys, and factory-built fireplaces. Gas logs are included as well. The most significant aspects to interior design are the hearth extension requirements. For masonry fireplaces, the hearth in the firebox must be constructed of masonry or concrete at least 4 inches (102 mm) thick, and there must be a 2-inch (51-mm) thick masonry or concrete heath extension at least 16 inches deep for openings less than 6 square feet and 20 inches deep for openings 6 square feet or larger; the heath extension must also be at least 8 inches wider than openings less than 6 square feet and 12 inches wider for openings that are 6 square feet and larger. If the hearth is at least 8 inches (203 mm) above the floor, the hearth extension can be constructed using brick, concrete, stone, tile, or other approved noncombustible material at least 3/8-inch (9.5-mm) thick. For factory-built fireplaces, the heath extension is to be as required by the fireplace listing.[30]

10.2.1.11 Part IV, Chapter 11 Energy Efficiency

This chapter covers detailed technical requirements for all elements of the building envelope (windows, doors, walls, roofs, etc.), mechanical systems, and domestic water heating, including climate zones on Table N1101.2.[31]

10.2.1.12 Part V, Chapter 12 Mechanical Administration

This chapter simply refers to the more detailed requirements of Chapters 13 to 24, but it also refers to existing buildings and notes that "this code shall not require the removal, alteration or abandonment of, nor prevent the continued utilization and maintenance of, an existing mechanical system lawfully in existence at the time of the adoption of this code."[32] This is important because it means that there is no automatic requirement to update systems during renovations—if the adopting authority leaves such language intact.

10.2.1.13 Part V, Mechanical

Chapter 13 General Mechanical System Requirements

Chapter 14 Heating and Cooling Equipment

Chapter 15 Exhaust Systems

Chapter 16 Duct Systems

Chapter 17 Combustion Air

Chapter 18 Chimneys and Vents

Chapter 19 Special Fuel-Burning Equipment

Chapter 20 Boilers and Water Heaters

Chapter 21 Hydronic Piping

Chapter 22 Special Piping and Storage Systems

Chapter 23 Solar Systems

These chapters provide the detailed technical requirements for mechanical systems. As such, these requirements are beyond the scope of this book.

10.2.1.14 Part VI, Chapter 24 Fuel Gas

These chapters provides detailed technical requirements for fuel gas.

10.2.1.15 Part VII, Chapter 25 Plumbing Administration

This chapter simply refers to the more detailed requirements of Chapters 26 to 32, but it also refers to existing buildings and notes that "Additions, alterations, renovations or repairs to any plumbing system shall conform to that required for a new plumbing system without requiring the existing plumbing system to comply with all the requirements of this code. Additions, alterations or repairs shall not cause an existing system to become unsafe, insanitary or overloaded."[33] Clearly, this is a little different from the requirements under Chapter 12 for mechanical systems. In this case, all new work and modifications must be done in conformance to current rules. What that means in practice is that a new bathroom in an existing house would have to be plumbed in full accordance with all current rules, but existing plumbing can be left intact without alteration.

This chapter also lays out requirements for inspection and testing for both domestic water and waste and vent systems.

10.2.1.16 Part VII

Chapter 26 General Plumbing Requirements

Chapter 27 Plumbing Fixtures

Chapter 28 Water Heaters

Chapter 29 Water Supply and Distribution

Chapter 30 Sanitary Drainage

Chapter 31 Vents

Chapter 32 Traps

These chapters provide the detailed technical requirements for plumbing systems. As such, these requirements are beyond the scope of this book. Nevertheless, a few comments are in order.

Water heating can be done legally using oil-fired, natural gas–fired, propane-fired, electric, and solar water heaters with or without storage tanks. Oil, natural gas, or propane burners are available in two basic types: atmospheric and sealed-combustion, with a sub-category of atmospheric called "power burner." Atmospheric burners draw air for combustion from the space around them, which is why Chapter 17 exists in Part V of the IRC (see above), but sealed-combustion burners draw air directly from outside the building via a piped vent. Given the technologies available today, there is no reason not to use sealed combustion, which results in better efficiency and better conditions inside the building.

Continuous-flow water heaters (sometimes erroneously called "instantaneous") are available in both electric and burner (both natural gas and propane) versions. Electric continuous flow units are usually used at the "point of use," in other words at an individual fixture (usually a lavatory or a sink). Natural gas and propane-fired units are intended to serve multiple fixtures and can be used in groups in central locations. Only sealed combustion models of natural gas and propane continuous flow water heaters should be used.

Historically, domestic water has been distributed using metal pipes: first lead, then steel, and then copper (for the past 60 years or so). All metallic piping systems have a large number of joints and therefore many opportunities to leak. Lead pipes are unsafe; steel pipes are prone to

Water Heaters

Water heaters are widely misunderstood, especially among plumbers. When a homeowner asks a plumber what to do about inadequate hot water, the answer is usually "put in a larger water heater." Unfortunately, that is likely to be the right answer on occasion only by coincidence. The real issue is heat input to the water heater. If the larger water heater has higher heat input, it might be the right answer, but if it doesn't, it will probably fail as well.

severe corrosion problems, and copper pipes can erode from the inside simply because of minerals in the water. Today, steel and copper are still legal, although virtually no steel pipe is used for domestic water distribution. In addition, plastic piping is now available: poly vinyl chloride (PVC), chlorinated poly vinyl chloride (CPVC), and polyethylene (PEX). PVC is most often used for waste and vent piping, although it can be used for pressure piping with the proper fittings and joints; CPVC is often used for pressure piping, and PEX is used most commonly for domestic water distribution and for in-floor radiant heating and exterior snow-and-ice melt systems. PVC and CPVC systems have joints that are similar to metal systems, but PEX runs from each fixture, without joints, to a centralized manifold. PVC, CPVC, and PEX are usually used without insulation, which is not appropriate for metallic piping. In the one- and two-family dwelling world, PEX dominates to a high degree in many areas around the country.

Sanitary drainage, vents, and traps are all used to remove waste water from a building. Vent pipes are supposed to be dry, and sanitary waste pipes are designed to run only partially full. This means that there can be large quantities of sewer gases in the open spaces in the waste pipes. Traps are used to prevent this sewer gas from entering the building. There are only two materials that are commonly used for waste and vent piping: cast iron and PVC (sometimes ABS, which is a different plastic material). PVC has come to dominate the industry in recent years (especially in residential settings), but cast iron is actually only slightly more costly. Burning PVC produces highly toxic smoke and it is petro-chemical product, so cast iron is preferred for "green" or "sustainable" projects.

Science labs in industrial, commercial, and educational settings often require acid-resistant waste piping. In the past, this was usually done with glass piping, which was costly, difficult to install, and prone to joint problems. Today, a special plastic material called "polyvinyldine fluoride" (PVDF) is used for acid-waste piping. This material looks like PVC or CPVC but it is blue in color.

10.2.1.17 Part VII, Chapter 33 Storm Drainage

This chapter lays out technical requirements for subsoil drains and sump pumps.

10.2.1.18 Part VIII, Chapter 34 General Requirements

This chapter lays out basic electrical requirements including the limitation of the IRC to services at 120/240 volts up to and including 400 amps. Larger services and services at different voltages are required to follow all of the provisions of the 2008 NFPA 70 National Electrical Code, as is the case for all commercial buildings. It has become common to see larger services for many of the large single-family homes that have been constructed in recent years.

Similar to plumbing, additions and alternations must meet all current requirements, but existing unaltered systems are not required to be modified. Limitations are placed on cutting and notching structural members, and the need for inspection is stated.

Working spaces are defined: 36 inches (914 mm) deep by 30 inches (762 mm) wide (or the width of the equipment, whichever is greater) and 6.5 feet (1981 mm) high. These requirements are similar to, but not the same as, the commercial requirements.

Copper and aluminum conductors (wires) are acceptable, but aluminum wiring should not be used for branch circuits even if it is allowed by code. Aluminum has much lower mechanical strength than copper, so there is a tendency for aluminum connections to work loose over time. Loose connections can easily cause overheating, fires, and other failures and should be avoided. If aluminum is used at all, it should be limited to the service entrance conductors (called the "secondary") and possibly to panel board and load center buses. ("Buses" are the means that are used inside a panel board or load center to distribute power to individual circuit breakers or fuses.)

Additional highly technical requirements are provided for wire sizing, wire insulation, and wire connections, all of which are beyond the scope of this book.[34]

10.2.1.18 Part VIII

Chapter 35 Electrical Definitions

Chapter 36 Services

Chapter 37 Branch Circuit and Feeder Requirements

Chapter 38 Wiring Methods

Chapter 39 Power and Lighting Distribution

Chapter 40 Devices and Luminaires

Chapter 41 Appliance Installation

Chapter 42 Swimming Pools

Chapter 43 Class 2 Remote-Control, Signaling and Power-Limited Circuits

These chapters lay out the detailed technical requirements for electrical systems, and, as such, most of this is beyond the scope of this book. However, there are some requirements that are worth noting.

For a service, which is the wiring from the utility to the building, both overhead (suspended) and underground methods are acceptable. Underground wiring is hidden—therefore more attractive—and most services are built using underground wiring today despite higher costs. Grounding requirements are clearly spelled out.[35]

For interior wiring, various methods are allowed, including type NM (nonmetallic) cable, which is usually called "Romex," and individual wires in various types of metallic and plastic conduit. Cable means that the hot and neutral (and sometimes ground) conductors are encased in an outer sheath, which is plastic for Type NM cable. Metallic-sheathed cables come in two types: AC (armored cable) and MC (metallic cable). Type AC cable uses a strand in the sheath as the ground, and type MC cable uses a separate copper ground wire inside the sheath; type MC cable is strongly preferred over type AC cable. Most wiring in one- and two-family dwellings is done using NM cable.[36]

There are detailed requirements for convenience receptacle placement, as follows:

- In general, receptacles must be located so that no point along a wall in any habitable space is more than 6 feet (1829 mm) from a receptacle. See Figure 10.4. For purposes of receptacle placement, "wall space" means any wall that is 2 feet (610 mm) or more in width, fixed and sliding panels, and fixed railings and counters.

- Receptacles in the floor can be used (and must be used in some situations) to meet the spacing requirements, but they count only if they are within 18 inches (457 mm) of the wall.

- In kitchens with counters, receptacles must be installed at each wall that is at least 12 inches (305 mm) wide and so that no point is more than 24 inches (610 mm) from a receptacle. A receptacle is required at an island that is 24 inches (610 mm) or more long and 12 inches (305 mm) or more wide. A receptacle is required for a peninsula that is 24 inches (610 mm) or more long and 12 inches (305 mm) or more wide. See Figure 10.5.

- Receptacles above counters must be no more than 20 inches (508 mm) above the counter.

- Receptacles installed face-up in counters are not allowed.

- In bathrooms, there has to be at least one receptacle within 36 inches (914 mm) of the lavatory basin.

- On the exterior, there must be at least one receptacle not more than 6 feet 6 inches (1981 mm) above grade on the front and back sides of each dwelling unit.

- At least one receptacle (not including those for laundry equipment) is to be installed in a basement.

- At least one receptacle (not including those for laundry equipment) is to be installed in a garage.

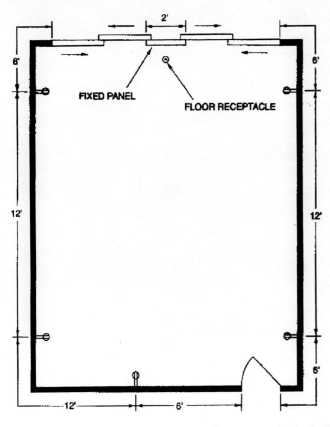

FIGURE 10.4 IRC 2009, Figure E3901.2 General Use Receptacle Distribution

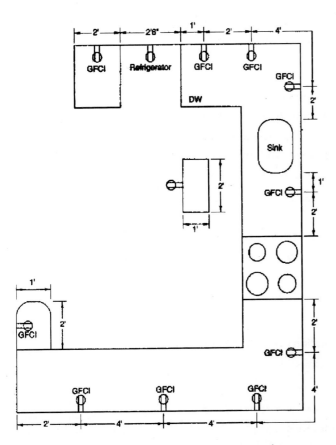

FIGURE 10.5 IRC 2009, Figure 3901.4 Countertop Receptacles

- Hallways 10 feet (3048 mm) or more in length are required to have at least one receptacle.
- A receptacle is required within 25 feet of each piece of HVAC equipment located in an attic or crawl space.

In addition to these location and quantity requirements, all receptacles in the following locations are required to have ground fault circuit interrupter (GFCI) protection—

Bathrooms

Garages and accessory buildings

Outdoors

Crawl spaces

Unfinished basements

Kitchens

Bar sinks

Boathouses

Electrically heated floors

Ground fault protection can be provided in two ways—

a. by using integral GFCI receptacles or
b. by using GFCI circuit breakers

GFCI receptacles are preferred in most cases so that it is not necessary to go to the panel board or load center to reset a tripped device.

All receptacles located in family rooms, dining rooms, living rooms, parlors, libraries, dens, bedrooms, sunrooms, recreation rooms, closets, hallways, and similar rooms are required to have arc-fault protection. (Note that this list includes everything except those areas listed for ground-fault.) Arc-fault protection can be done only at the panel board or load center by using special circuit breakers.[37]

Track lighting is prohibited in bathrooms within 3 feet (914 mm) horizontally and 8 feet (2438 mm) vertically from the top of a bathtub rim.[38]

10.2.1.19 Part IX

Chapter 44 Referenced Standards

Appendix A Sizing and Capacity of Gas Piping

Appendix B Sizing of Venting Systems Serving Appliances Equipped with Draft Hoods, Category I Appliances, and Appliances Listed for Use with Type B Vents

Appendix C Exit Terminals of Mechanical Draft and Direct-Vent Venting Systems

Appendix D Recommended Procedure for Safety Inspection of an Existing Appliance Installation

Appendix E Manufactured Housing Used as Dwellings

Appendix F Radon Control Methods

Appendix G Swimming Pools, Spas, and Hot Tubs

Appendix H Patio Covers

Appendix I Private Sewage Disposal

Appendix J Existing Buildings and Structures

Appendix K Sound Transmission

Appendix L Permit Fees

Appendix M Home Day Care—R-3 Occupancy

Appendix N Venting Methods

Appendix O Gray Water Recycling Systems

Appendix P Sizing of Water Piping System

Appendix Q ICC International Residential Code Electrical Provisions/National Electrical Code Cross Reference

The referenced standards and the numerous appendices provide detailed supplemental information, all of which is beyond the scope of this book.

10.3 The 2009 International Building Code

As noted previously, the International Residential Code will be applicable to one- and two-family dwellings in most jurisdictions (except for the electrical chapters for large services) and the International Building Code will be applicable to all other residential occupancies: three or more unit apartment and/or condominium buildings, hotels, motels, hostels, shelters, dormitories, jails, prisons, and so on.

Many of the requirements of the IBC have been covered in previous chapters, but it is worth noting that the some of the extensive receptacle location requirements of the IRC are found in the NEC for these other occupancies. In fact, as compared with older editions, the 2008 NEC has increased the requirements for arc fault receptacles, saying "outlets installed in dwelling units family rooms, dining rooms, living rooms, parlors, libraries, dens, bedrooms, sunrooms, recreation rooms, closets, hallways, or similar rooms or areas shall be protected by a listed arc-fault circuit interrupter, combination-type, installed to provide protection of the branch circuit."[39] Clearly, this requires arc-fault protection essentially everywhere (except those areas have ground-fault protection), which is the same as the requirements in the 2009 IRC.

summary

Despite the fact that the IRC is shorter than the combination of the IBC and its various subcodes, the IRC's detailed prescriptive requirements allow for much less flexibility than what is usually the case under the IBC. Although this is somewhat reasonable for those working on residential projects under the IRC who are not licensed professionals, this can be frustrating for licensed professionals, who have the knowledge, the experience, and the expertise to be more nuanced about the design of many different aspect of a one- or two-family dwelling. Unfortunately, exceptions are not made for licensed professionals (in most cases), and the same requirements are enforced no matter who is designing the building.

Enforcement tends to be more extensive for projects that fall under the scope of the IRC, which also makes sense because there are usually no licensed professionals involved.

The detailed prescriptive requirements in the IRC are usually clearer than the more performance-oriented requirements of the IBC, which is again due to having nonlicensed professionals designing most one- and two-family dwellings.

results

Having completed this chapter, the following objectives should have been met:

10.1. To understand the applicable documents for one- and two-family dwellings, by knowing that the 2009 IRC (or an earlier version) is applicable to most projects but that the 2009 IBC (or an earlier version) is applicable to three- (or more) family dwelling units, hotels, hostels, and so on.

10.2. To understand the applicable requirements of the 2009 International Residential Code, by knowing that this highly prescriptive code covers everything from structural to walls, door, and windows; to egress; to mechanical, electrical, and plumbing systems.

10.3. To understand the applicable requirements of the 2009 International Building Code, by knowing that the IBC has special requirements for residential occupancies.

notes



1. International Residential Code 2009, page 2.
2. Ibid., page 5.
3. Ibid., page 7.
4. Ibid., page 9.
5. Ibid., page 10.
6. Ibid., page 11.
7. Ibid., page 13.
8. Ibid., page 15.
9. Ibid., page 16.
10. Ibid., page 20.
11. Ibid., page 19.
12. Ibid., page 51.
13. Ibid., pages 53–54.
14. Ibid., page 54.
15. Ibid.
16. Ibid., page 55.
17. Ibid., page 58.
18. Ibid., pages 58–59.
19. Ibid., pages 59–61.
20. Ibid., page 62.
21. Ibid., pages 63–64.
22. Ibid., pages 65–66.
23. Ibid., pages 67–70.
24. Ibid., pages 71–109.
25. Ibid., pages 111–44.
26. Ibid., pages 145–356.
27. Ibid., page 358.
28. Ibid., pages 373–432.
29. Ibid., pages 433–44.
30. Ibid., pages 445–54.
31. Ibid., pages 455–74.
32. Ibid., page 475.
33. Ibid., page 589.
34. Ibid., pages 645–52.
35. Ibid., pages 657–65.
36. Ibid., pages 675–80.
37. Ibid., pages 681–84.
38. Ibid., page 709.
39. 2008 NFPA-70, National Electrical Code, pages 70–49.

Building Renovation Requirements

11.1 General

Chapter 34 of the 2009 International Building Code covers existing and historic buildings. In general, buildings (and their systems) are required to be maintained throughout the life of the building (3401.2), and all new work is required to comply with all current rules and regulations (3401.3). The extent to which existing problems have to be corrected varies considerably from jurisdiction to jurisdiction. In Indiana, the General Administrative Rules (which are higher level regulations than the codes themselves) clearly state that there is no obligation to correct existing problems unless there is a change of use. But in Chicago, it is quite common for existing problems to be corrected no matter where or what they may be.

Part of the challenge in correcting existing problems is that it can be next to impossible to do so. The clearest and simplest example is stairways.

Today, in commercial buildings, the minimum tread width is 11″ and the maximum riser height is 7″, which makes for a stair angle of about 40 degrees. But only 25 years ago, stairs were commonly (and legally) built using 10″-wide treads and 7.5″-high risers, which equates to a stair angle of about 49 degrees. Before that, stairs were sometimes flatter and sometimes steeper. But if the stair is steeper than 40 degrees, it would be necessary to enlarge the stair enclosure to lower the angle (lower angles mean longer stairways). If the stair is enclosed in solid concrete walls or 16″ solid masonry walls, enlarging such stair enclosures would be extremely disruptive and so costly as to kill many potential projects. See Section 11.2 for more information.

"Technically Infeasible. An *alteration* of a building or a facility that has little likelihood of being accomplished because the existing structural conditions required the removal or

objectives

11.1. To understand the requirements for the renovation of buildings in general.

11.2. To understand the requirements for additions and alterations.

11.3. To understand "change of occupancy" (also called "change of use").

11.4. To understand the requirements for historic buildings.

11.5. To understand accessibility requirements in existing buildings.

11.6. To understand compliance alternatives for existing buildings.

alteration of a load-bearing member that is an essential part of the structural frame, or because other existing physical or site constraints prohibit modification or addition of elements, spaces or features which are in full and strict compliance with the minimum requirements for new construction and which are necessary to provide accessibility."[1]

This definition is used extensively in the renovation of historic buildings in particular to avoid causing major damage to the building simply in order to reuse it for a new purpose or to restore it to a past condition.

11.2 Additions and Alterations

Additions and alterations are covered separately. The requirements for additions (Section 3403) include mostly special requirements for flood zones, existing structural elements, and seismic requirements. The requirements for alterations are of direct importance to interior designers.

Exception 1 to 3404.1 specifically exempts stairways from compliance with current rules "where the existing space and construction does not allow a reduction in pitch or slope."[2] The handrail extension requirements are waived too "where such extensions would be hazardous due to plan configuration."[3]

Special requirements are placed on buildings in flood zones, on loading of existing structural elements, and seismic requirements just as for additions. Egress widths are allowed on the basis of the code requirements that were in place at the time of construction, as long as the building official does not believe that there is any "distinct hazard to life."[4]

Section 3406 treats fire escapes, which are not allowed for new buildings under any circumstances. Existing fire escapes can continue to be used, although their structural capacity must be verified—sometimes by load testing in the field. New fire escapes can be added to existing buildings with existing fire escapes only if exterior stairs cannot be used.[5]

11.3 Change of Occupancy (Use)

When a change of occupancy (use) occurs—old school into new apartment building, old warehouse into new community center, old supermarket into conference center, old house into hair salon (which would also involve a change from the International Residential Code to the International Building Code), and so on—the building is required to be brought up to full compliance with all current rules, with the specific exception of stairways (as noted above). This could include widening the egress path, adding a sprinkler system, adding a fire alarm system, replacing doors and/or door hardware, and even replacing portions or all of the mechanical, electrical, and plumbing systems.

11.4 Historic Buildings

The requirements noted above for additions and alterations are not mandatory for "historic" buildings. Historic buildings are

"**1.** *Listed* or preliminarily determined to be eligible for listing in the National Register of Historic Places.

2. Determined by the Secretary of the U.S. Department of Interior as contributing to the historical significance of a registered historic district of a district preliminarily determined to qualify as an historic district; or

3. Designated as historic under a state or local historic preservation program that is *approved* by the Department of the Interior."[6]

Are there historic buildings in a historic district that do not contribute historically to that district? Actually, yes, when put into a district by state or local action.

Historic buildings (for IBC purposes) are defined nationally by listing (or planning to list) them on the National Register of Historic Places. Once a building is placed on that list, it will always be historic with or without a historic district around it. States and/or localities often decide to create historic districts around historic buildings (or groupings of historic buildings), where those buildings may or may not be listed on the National Register. When a district is formed, contributing buildings are individually listed (to provide justification for the district), but all other buildings in the district become subject to the same rules as the historic buildings once the district is formed, even if those buildings are brand new.

A thorough discussion of historic district regulations is beyond the scope of this book, but suffice it to say, for now, that all historic districts have detailed requirements, especially for enforcement of alterations and additions. Typically, all external changes to buildings in historic districts (including entirely new buildings) can be made only with the approval of some local board, often called the Historic Preservation Commission. This can be frustrating for building owners because they can literally not even paint the exterior of their building or replace a single window without getting approval, under whatever system was put in place when the district was formed.

11.5 Accessibility

Accessibility requirements for existing buildings are essentially the same as the general requirements: they can't be made to be less accessible, new work (additions and alterations) must be fully accessible, and some limitations are accepted for historic buildings.

11.6 Compliance Alternatives

Even though the general requirements don't directly apply to historic buildings (see Section 11.4), a special procedure is found in Section 3412 for buildings of a certain age. Each jurisdiction adopting the IBC is required to fill in the date that defines "historic" for these purposes. Most commonly, historic buildings are defined, broadly, as those buildings that are more than 40 years old, but this "age" is highly variable and should be determined in each jurisdiction for each project.

This section uses a points system to determine compliance. The items include

- allowable height
- allowable area
- fire compartmentation
- tenant separation
- corridor wall construction
- vertical opening protection (completely unprotected openings are commonly found in historic buildings having several floors)
- fire detection
- smoke control
- means of egress

- egress capacity
- egress width
- dead ends
- elevator controls
- means of egress emergency lighting
- mixed occupancy values
- sprinkler system
- standpipe system
- incidental and accessory uses

The mandatory minimum scores are found in Table 3412.8 in the three subcategories of "Fire Safety," "Means of Egress," and "General Safety."[7] As one simple illustration, if the building type and occupancy require fire standpipes and they are not provided, that would score −12 points; similarly, if standpipes are not required but they are provided, that would score +12 points. Those are some of the highest points available, but totals for each subcategory range from 15 to 36 depending on the subcategory and the occupancy classification.

This is a pass/fail system, so if the points add up to meet the mandatory minimum requirements, the project will pass. If the points are short, the project will fail and it cannot go forward.

summary

The requirements for renovations are basically pretty simple—

- Never make anything more dangerous or less code compliant.
- Meet all current rules for all additions and alterations (with some exceptions for historic buildings and for stairways).

- For historic buildings, use the Section 3412 points system to determine if the project is viable or not.

results

Having completed this chapter, the following objectives should have been met:

11.1. To understand not only the requirements for the renovation of buildings in general but also the jurisdiction's requirements for addressing existing code violations.

11.2. To understand the requirements for additions and alterations by understanding the jurisdiction's specific requirements for additions and alterations.

11.3. To understand "change of use" by knowing that any change in occupancy type for any reason constitutes change of use.

11.4. To understand the requirements for historic buildings by knowing that the 2009 IBC allows for certain compromises for historic buildings.

11.5. To understand accessibility requirements in existing buildings, especially historic buildings, by understanding the limitations of accessibility alterations.

11.6. To understand compliance alternatives for existing buildings by understanding the basic "point system" approach.

notes

1. International Building Code 2009, page 571.
2. Ibid., page 572.
3. Ibid.
4. Ibid., page 573.
5. Ibid., page 574.
6. Ibid., page 575.
7. Ibid., pages 577–86.

Design Tips

CHAPTER 1

Starting Code Research When first using code documents, it is helpful to write down the references as they come along, noting which ones are dead ends, which ones continue to others, and which ones really matter. This is a good way to begin the code research report.

Completing and Tracking Code Research When writing the code research report, include check-off boxes for (a) just before the end of space planning, (b) before reaching 50% of construction documents, and (c) just before reaching 100% of construction documents. This will provide for a simple way to do the progress checking.

Scheduling for Plan Review and Permitting When preparing a project schedule, make sure to include estimated periods for both plan review and permitting, explaining to the owner why these have been included and why the estimated times are what they are. Don't hesitate to modify these projections if new information should come along to clarify the timing of either plan review or permitting.

CHAPTER 2

Verifying Codes When contacting local officials to verify their current codes, simply explain that you are working on a project in their jurisdiction and that you want to be sure to respond to the correct codes. They will probably be happy to help.

Verifying Appeal Procedures If a conflict should arise, make sure to verify appeal procedures before jumping into a discussion with the AHJ. It may be difficult to find out exactly what the appeals processes are, but it is important to know before taking on an argument with an official. After all, there is no point in arguing at all if there is no practical appeal mechanism.

Exceeding Code Requirements It is nearly always a good thing to exceed code requirements, but sophisticated owners (or their contractors) often know the requirements and will challenge the need for work that exceeds the basic requirements. This doesn't mean that such work won't be included in the project, but it is important to discuss these issues with the owner early in the process to make sure that everyone agrees upon the basic goals for the project.

Using the Right Codes and Amendments A project cannot be designed without knowing the version of the basic model code and having the appropriate amendments for the jurisdiction of the project. It does no good to try to correlate the 2008 amendments with a 2003 model code, if the amendments are based on the 2006 version of the same model code.

Is NFPA 101 Life Safety Code Applicable? The Life Safety Code can cause significant complications (in emergency egress lighting, if nothing else—see Section 9.2.1 in this text) so it is important to confirm if it does, or does not, apply to the project in question. It could be required by the AHJ, by another government agency (especially for health care projects), or simply by the owner.

Special Health Care Requirements When working on a health care project, it is vital to determine state and/or local requirements prior to starting design, which may or may not include the common AIA Guidelines for Healthcare Facilities. It is also important to understand the reviewing agency's typical schedule because a long plan review time or a long field inspection time could extend a schedule by many weeks.

Special Food Service Requirements When working on a food service project, it is vital to determine state and/or local requirements prior to starting design. It is also important to understand the reviewing agency's typical schedule because a long plan review time (plan review would be unusual in this area but it can't be ruled out) or a long field inspection time could extend a schedule by many weeks.

Special School Requirements When working on a school (kindergarten through 12th grade) project, it is vital to determine state and/or local requirements prior to starting design. It is also important to understand the reviewing agency's typical schedule because a long plan review time or a long field inspection time could extend a schedule by many weeks.

Special Day Care Requirements When working on a day care project, it is vital to determine state and/or local requirements prior to starting design. It is also important to understand the reviewing agency's typical schedule because a long plan review time or a long field inspection time could extend a schedule by many weeks.

Verifying Code Adoption Procedures Each interior designer should become familiar with the code adoption and enforcement practices in his or her home area at the outset of his or her career. This should be updated periodically, and new research should be done in new jurisdictions whenever needed.

CHAPTER 3

Finding the AHJ As noted under the previous design tip, it is important to have a reasonably clear understanding of who the AHJ is in each jurisdiction, keeping in mind that it may be difficult to come to a clear conclusion. Over time, typical practices will become familiar, but young designers should look to their more experienced peers for this information early on.

How Are Codes Adopted? Again, it is important to understand how the rules came about in a jurisdiction, especially one's home jurisdiction.

Understanding Appeals Again, as in the design tip about verifying appeal procedures, it is vital to understand the appeal procedures if a conflict should arise. It does no one any good to get into a losing argument with the AHJ.

An Informed Owner The need to keep the owner fully informed cannot be overstated. Few designers have the equivalent resources (financial and/or legal) to many of their clients, so it is worth the effort to avoid major arguments with owners—especially legal arguments.

Code Variances Variances should be pursued when appropriate, but it must be kept in mind that they don't happen by themselves. They often require the involvement of a code consultant (who could charge hundreds or thousands of dollars in fees), and there is always a fee to be paid to the agency in question. Owners are not fond of paying for losing variance applications.

General Code Knowledge The need for interior designers to have knowledge about code requirements cannot be overstated. Each individual simply must make the effort to learn the basic rules, to stay up-to-date with changes, and apply those rules on a day-to-day basis.

Risk Factors Keeping in mind these risk factors can only make day-to-day work easier. Code problems on projects are not fun and should be avoided whenever possible. This includes noise, excessive glare from daylight (a typical problem in projects that use extensive daylighting), and so on.

Existing Building Limitations Understanding the limitations of an existing building is a key challenge to an interior designer, and young interior designers may need assistance from more senior interior designers, or even architects, to develop a good understanding of these issues. Each project will provide more and more examples to draw from for future work.

Understanding and Documenting Existing Conditions For each project, the existing conditions must be documented and shared with the owner. If the building is believed to be a Type II-A building, it is vital to put that into writing as part of the project assumptions to the entire project team, including the owner. If it should later be found that the building is really a Type II-B building, at least everyone will understand that the design was based on incorrect information—wherever it came from.

Existing Violations It is common to find violations of code in existing corridors. One often sees nonrated doors and frames, or rated frames and unrated doors, or unrated frames and rated doors, or nonrated walls, or all kinds of other problems. If such discoveries are made, an analysis must be done to determine if it is necessary to correct the problems—which will be based on the scope of work and requirements of the project jurisdiction. If it is found that the problems must be corrected, the owner must be fully informed of the extent of the problems and the potential impact on the budget and the schedule.

Rated Ceiling Complications The complications of rated ceilings in general, and rated lay-in (grid) ceilings in particular, really cannot be overstated. Even if everything is built correctly during the initial construction, over time some of the provisions tend to change—hold-down clips on the ceiling panels are left out, light fixture enclosures are disturbed, and so on. It is best to avoid rated ceilings whenever possible.

Fire and Smoke Dampers The importance of fire dampers and smoke dampers to mechanical engineers cannot be overstated. It is vital for the interior designer to notify all other team members whenever any rated assembly is used in a project.

Fire-Rated Glass Even though fire-rated glass is readily available on the market, its use should be carefully considered due to its high cost. It's easy to get in trouble over just a few thousand dollars if it causes the project to go over budget or if the owner simply didn't know about the high-cost item.

CHAPTER 5

Assembly Occupancies It is important for interior designers to be careful about assembly occupancies, largely due to the tendency of many officials to look toward concentrated occupant load factors in too many cases. This is an area that is probably worth discussing with the officials, if that's practical, early in the design process.

Covered Mall or Not? Many existing covered mall buildings are not covered mall buildings per IBC requirements. Instead, they are unlimited area type B or type M buildings. The differences are significant because the latter has no smoke control and no voice-evacuation fire alarm system, both of which are significant cost factors. If an interior designer is working on a tenant space in one of these "non-malls," there should be no need to worry about the voice-evacuation fire alarm system.

Atriums Although it is highly desirable to design atriums in buildings, the owner must be directly involved in the decision to do so, mostly due to the high cost of smoke control with emergency power backup and some other requirements.

Stages In many cases, owners who think that they want stages in their facilities really cannot afford to build them, so it is vital for the interior designer (and the architect) to explain the full ramifications of such decisions to the owner.

Smoke Compartmentation One of the most critical issues to mechanical engineers in an ambulatory surgery center, a hospital, or some other facilities is the requirement for smoke compartmentation, so it is vital for the interior designer to make sure that the entire team is well aware of such requirements.

Mezzanines Mezzanines are great devices for tall spaces, but the rules must be considered carefully. Many of these rules have been implemented over the past 25 years or so because the old, less restrictive rules were abused by enterprising designers, who were looking for ways to add "free space." As long as the rules are followed, there should be no problems.

Occupant Loads It is always important for the interior designer to follow the occupant load requirements as rigorously as possible in each given situation. There is nothing to be gained from trying to argue that the occupant load of a space is 150 when the official thinks that it's 300 and there is no practical difference.

Concentrated or Unconcentrated? As noted under the design tip about assembly occupancies, this is critical issue. And, as noted in the previous design tip, there is nothing to be gained from arguing with an official if the official can be accommodated with little damage to the project or the owner's budget.

CHAPTER 6

Clear Egress The importance of egress cannot be overstated. As long as the interior designer keeps this in mind and provides for clear and effective egress, there should be no problems with officials. Also, there is nothing to be gained from arguing with the official if the official can be accommodated with little damage to the project or the owner's budget.

Common Path One would think that "common path" would be related to the path where occupants from multiple suites or areas join together, but such is not the case. "Common path" simply means common because there is only one option.

Exit Separations There is nothing to be gained from tying to stretch the required distances for exit separations. In fact, it is best to separate exits more than the requirement to make sure that there is no problem with the officials or with egress in an emergency.

Travel Distances Just as in exit separation, there is nothing to be gained from playing games with travel distances. Again, it is best to provide shorter than required travel distance so as to avoid arguments and future problems.

Corridor Width Even though most corridors are built to a net dimension of 44″, it is best to enlarge this slightly to make sure that an inadvertent construction error doesn't create an illegal corridor. After all, 43.875″ is illegal.

Sliding Doors These days, sliding egress doors are very popular in interior design, but it is necessary for the interior designer to make sure that sliding doors are allowed for the application in question and that all provisions are met.

Door Landings Door landings also cannot be overemphasized. Interior designers simply must design every door with a full landing on both sides to avoid problems.

Elevator Car Sizes Elevator car sizes are critical in many instances due to accessibility requirements; see Chapter 7 in this text.

Exit Sign Costs The cost difference between typical edge-lit exit signs and standard thermoplastic back-lit exit signs is quite significant—say a factor of 3, or 300%, or 3 times as much (sometimes even more for really cool signs). Given the number of exit signs in most facilities, the total cost is more than one might think, so it is necessary to make sure that extra costs really are justified.

Emergency Egress Lighting It is actually difficult to meet the emergency lighting requirements when using dedicated emergency-only fixtures (such as the wall-mounted two-headed fixtures that are all over the place). Calculations should be done for emergency egress lighting to confirm that all requirements are met.

CHAPTER 7

Special Plumbing Fixtures There is one situation in which special small water closets (i.e., toilets) are required, which is in licensed day care facilities in jurisdictions that have such requirements. But such requirements have to be verified on a case-by-case basis.

Accessible Additions Simply put, all additions to buildings must be fully accessible—period.

Accessible Alterations Simply put, all altered areas inside existing buildings must be fully accessible—period.

Water Closet to Wall Distance A major change from previous codes is that there is now a range of 16″ to 18″ for the dimension from the centerline of an accessible water closet to the wall. Under previous rules, this simply said 18″, which provided no room for error at all. When new water closets are added in existing buildings, it is quite common to encounter structural obstacles that cause moving the fixture a few inches. If a fixture moves too far from a wall, the wall can be thickened to meet the new range. If the fixture moves too close to the wall, the wall simply must be moved. These wall movements can also affect the overall size of the room.

No Lavatory Overlap at Water Closet This new requirement that prohibits having a lavatory within the 59″ wide by 60″ deep clear space at an accessible water closet is the single biggest change in accessibility design for decades. It may seem like a small issue, but it forces single-fixture toilet rooms to be 7′-6″wide, when they have been 60″ wide for many, many years. This must be incorporated into all space plans to avoid major problems.

Grab Bars These long side grab bars can be a problem in small toilet rooms, especially in hospitals where oversized doors are commonly used. The grab bars must be included when working out the dimensions of accessible toilet rooms.

Flush Handle on the Open Side This seems like a small issue—getting the flush handle on the open side of the water closet—but this is one of the most common of all code violations. Anyone paying attention is sure to see one that is backwards within days.

Accessible and Non-accessible Lavatories Even though it is perfectly legal to put an accessible lavatory right next to a non-accessible lavatory (even in a single countertop), it is not at all clear how a disabled person is supposed to tell the difference between the two. In many cases, it would be just as well to make all lavatories in a single grouping accessible. Of course, it is vital for the interior designer to notify the plumbing engineer if that is the case.

Accessible Showers Accessible showers are a problem, because they all cannot contain water adequately. Therefore, it is necessary to add a floor drain just outside every accessible shower. The interior designer needs to tell the plumbing engineer if that is the case.

CHAPTER 8

Class A Finishes It is best to use only Class A finishes in commercial projects. But if a Class B or Class C material is desirable, it is necessary for the interior designer to verify that it can be acceptable in the situation at hand.

Deep Furring There really is no good reason to install finish materials with large furred-out spaces behind them. Such spaces create problems and they use up valuable space.

Fire-Rated Ceilings II As noted under the design tip of rated ceiling complications, fire-rated ceiling assemblies are a problem that should be avoided, especially in lay-in ceiling systems.

CHAPTER 9

Ventilation For every project, ventilation should be discussed among the whole design team with the owner at the outset of the project to make sure that everyone is operating from the same starting point. The resolution of ventilation can affect spacing planning, window sizing and placement, space for ductwork, and so on, and it simply can't be ignored.

Plenums The issue of air plenums must also be addressed at the beginning of the project with the whole design team and the owner. This issue affects low-voltage cabling, wall design and placement, ductwork sizing and extent, and so on, and it simply can't be ignored.

Residential Cooking Appliances Anytime that an owner is interested in using residential appliances in a commercial cooking environment, the interior designer (or architect or mechanical engineer) must explain all of the ramifications of that decision to the owner because of the budget impacts more than anything else.

Mechanical System Type Interior designers should be aware of the mechanical system type so that they can understand how much ductwork there will be and roughly how large it will be. Ceiling elevations cannot be determined without this information.

Excessive Daylighting Buildings that are designed for extensive daylighting often experience excessive daylighting, and it is not all that uncommon for interior designers to have to add internal shading devices after the fact. This should be considered at the beginning of the project and not as a fix after a problem develops.

New Electrical Equipment Whenever new electrical equipment is added in a project, but especially panel boards or transformers, the interior designer should be aware of it and should make the necessary provisions for working space.

Track Lighting Circuiting Although it is common to see illegal track lighting installations (usually more than 24′ on a single circuit), new work must be done in compliance with all applicable rules. The interior designer should bring the issue to the owner's attention if illegal practices are observed.

Plenums II As noted under the design tip about plenums, it must be known at the start of the project if plenums are going to be used—and where they will be used.

Sprinkler Types The interior designer should identify preferred types of sprinklers to the plumbing designer (or fire protection contractor) at the beginning of the project.

EPAct 1995 All plumbing fixture's water usage rates are subject to the requirements of 1995 EPAct, which reduced the amount of water to flush a water closet from 3.2 gallons per flush to 1.6 gallons per flush. This is not a code issue, strictly speaking, but the federal government has regulated the manufactures of the fixtures.

CHAPTER 10

Residential Officials In general, great deference should be used when dealing with officials in the residential realm. Such officials tend to believe that they are highly knowledgeable, and it is best to minimize disagreements to the greatest extent feasible. Also, it should be noted that professional credentials typically carry no weight at all in this area.

Tile Backer Board Although it is legal to use "green-board" water-resistant gypsum board as a tile backer in bathrooms, kitchens, or other damp areas, such usage should be avoided. Green-board simply has a moisture-resistant paper facing (but it's still paper), and the gypsum is just fragile as the gypsum in conventional gypsum board. Cementitious backer board (i.e., cement board) should be used instead in all cases. This is not a code issue at all.

Deep Window Wells As a result of this requirement for permanent steps or a ladder into wells that are more than 44″ deep, it is highly recommended to find a way to avoid having to build wells that are more than 44″ deep.

Water Heaters Water heaters are widely misunderstood, especially among plumbers. When a homeowner asks a plumber what to do about inadequate hot water, the answer is usually "put in a larger water heater." Unfortunately, that is likely to be the right answer on occasion only by coincidence. The real issue is heat input to the water heater. If the larger water heater has higher heat input, it might be the right answer, but if it doesn't, it will probably fail as well.

CHAPTER 11

Safe Facilities As noted in various other Design Tips and in numerous sections throughout the text, the overarching goal is to make facilities no less safe at a minimum, and somewhat more safe if possible. This minimum standard cannot be compromised.

Change of Occupancy (Use) Even though the need to bring facilities up to current rules under a change of occupancy (use) is widely known, it is also commonly ignored, mostly because it can be costly and difficult to accomplish. But the code is clear, and change of occupancy (use) is the trigger to cause complete updating in many jurisdictions.

Definitions

Accessible. A *site,* building, *facility,* or portion thereof that complies with this chapter. (2009 IBC, Chapter 11)

Accessible Means of Egress. A continuous and unobstructed way of egress travel from any *accessible* point in a building or facility to a *public way.*

Accessible Route. A continuous, unobstructed path that complies with this chapter. (2009 IBC, Chapter 11)

Accessible Unit. A *dwelling unit* or *sleeping unit* that complies with this code and the provisions for *Accessible units* in ICC/A117.1.

Addition. An extension or increase in floor area or height of a building or structure.

Aisle. An unenclosed *exit access* component that defines and provides a path of egress travel.

Aisle Accessway. That portion of an *exit access* that leads to an *aisle.*

Alarm Notification Appliance. A fire alarm system component such as a bell, horn, speaker, light, or text display that provides audible, tactile, or visible outputs, or any combination thereof.

Alarm Signal. A signal indicating an emergency requiring immediate action, such as a signal indicative of fire.

Ambulatory Health Care Facility. Buildings or portions thereof used to provide medical, surgical, psychiatric, nursing, or similar care on a less than 24-hour basis to individuals who are rendered incapable of self-preservation.

Approved. Acceptable to the code official or the authority having jurisdiction. (2009 IBC)

Approved. Approved refers to approval by the building official as the result of investigation and tests conducted by him or her, or by reason of accepted principles or tests by nationally recognized organizations. (2009 IRC)

Area of Refuge. An area where persons unable to use *stairways* can remain temporarily to await instructions or assistance during emergency evacuation.

Assisted Living Facility (Residential Care Facility). A building or part thereof housing persons, on a 24-hour basis, who because of age, mental disability, or other reasons live in a supervised residential environment that provides *personal care services.* The occupants are capable of responding to an emergency situation without physical assistance from staff. This classification shall include, but not be limited to, the following: residential board and care facilities, assisted living facilities, halfway houses, group homes, congregate care facilities, social rehabilitation facilities, alcohol and drug abuse centers, and convalescent facilities.

Atrium. An opening connecting two or more *stories* other than enclosed *stairways,* elevators, hoistways, escalators, plumbing, electrical, air-conditioning, or other equipment, which is closed at the top and not defined as a mall. Stories, as used in this definition, do not include balconies within assembly groups or *mezzanines* that comply with Section 505.

Attic. The space between the ceiling beams of the top *story* and the roof rafters.

Audible Alarm Notification Appliance. A notification appliance that alerts by the sense of hearing.

Basement. A *story* that is not a *story above grade plane* (see *"Story above grade plane"* in Section 202).

Basement. That portion of a building that is partly or completely below grade (see "Story above grade"). (2009 IRC)

Bleachers. Tiered seating supported on a dedicated structural system and two or more rows high and is not a building element (see "Grandstands").

Boarding House. A building arranged or used for lodging for compensation, with or without meals, and not occupied as a single-family home.

Building Official. The officer or other designated authority charged with the administration and enforcement of this code, or a duly authorized representative.

Ceiling Radiation Damper. A listed device installed in a ceiling membrane of a fire-resistance-rated floor/ceiling or roof/ceiling assembly to limit automatically the radiative heat transfer through an air inlet/outlet opening.

Child Care Facilities. Facilities that provide care on a 24-hour basis to more than five children, 2 1/2 years of age or less.

Circulation Path. An exterior or interior way of passage from one place to another for pedestrians.

Clinic, Outpatient. Buildings or portions thereof used to provide medical care on less than a 24-hour basis to individuals who are not rendered incapable of self-preservation by the services provided.

Code. A building rules document written or edited by a regulatory body (state or local) that is then adopted by a legislative body (state or local) and enacted by executive signature. (This definition is by the author.)

Combination Fire/Smoke Damper. A listed device installed in ducts and air transfer openings designed to close automatically upon the detection of heat and resist the passage of flame and smoke. The device is installed to operate automatically, is controlled by a smoke detection system, and, where required, is capable of being positioned from a fire command center.

Common Path of Egress Travel. That portion of *exit access* that the occupants are required to traverse before two separate and distinct paths of egress travel to two *exits* are available. Paths that merge are common paths of travel. Common paths of egress travel shall be included within the permitted travel distance.

Common Use. Interior or exterior *circulation paths,* rooms, spaces, or elements that are not for public use and are made available for the shared use of two or more people.

Conditioned Area. That area within a building provided with heating and/or cooling systems or appliances capable of maintaining, through design or heat loss/gain, 68°F (20°C) during the heating season and/or 80°F (27°C) during the cooling season, or has a fixed opening directly adjacent to a conditioned area. (2009 IRC)

Conditioned Space. For energy purposes, space within a building that is provided with heating and/or cooling equipment or systems capable of maintaining, through design or heat loss/gain, 50°F (10°C) during the heating season and 85°F (29°C) during the cooling season, or communicates directly with a conditioned space. For mechanical purposes, an area, room, or space being heated or cooled by any equipment or appliance. (2009 IRC)

Congregate Living Facilities. A building or part thereof that contains sleeping units where residents share bathroom and/or kitchen facilities.

Control Area. Spaces within a building where quantities of hazardous materials not exceeding the maximum allowable quantities per *control area* are stored, dispensed,

used, or handled. See also the definition of "Outdoor control area" in the *International Fire Code*.

Corridor. An enclosed *exit access* component that defines and provides a path of egress travel to an *exit*.

Decorative Materials. All materials applied over the building *interior finish* for decorative, acoustical, or other effect (such as curtains, draperies, fabrics, streamers, and surface coverings), and all other materials utilized for decorative effect (such as batting, cloth, cotton, hay, stalks, straw, vines, leaves, trees, moss, and similar items), including foam plastics and materials containing foam plastics. *Decorative materials* do not include floor coverings, ordinary window shades, *interior finish,* and materials 0.025 inch (0.64 mm) or less in thickness applied directly to and adhering tightly to a substrate.

Detectable Warning. A standardized surface feature built in or applied to floor surfaces to warn of hazards on a circulation path.

Detoxification Facilities. Facilities that serve patients who are provided treatment for substance abuse on a 24-hour care basis and who are incapable of self-preservation or who are harmful to themselves or others.

Dormitory. A space in a building where group sleeping accommodations are provided in one room, or in a series of closely associated rooms, for persons not members of the same family group, under joint occupancy and single management, as in college dormitories or fraternity house.

Dwelling. A building that contains one or two *dwelling units* used, intended, or designed to be used, rented, leased, let, or hired out to be occupied for living purposes.

Dwelling Unit. A single unit providing complete, independent living facilities for one or more persons, including permanent provisions for living, sleeping, eating, cooking, and sanitation.

Emergency Escape and Rescue Opening. An operable window, door, or similar device that provides for a means of escape and access for rescue in the event of an emergency.

Employee Work Area. All or any portion of a space used only by employees and only for work. *Corridors,* toilet rooms, kitchenettes, and break rooms are not *employee work areas.*

Exit. That portion of a means of egress system that is separated from other interior spaces of a building or structure by fire-resistance-rated construction and opening protectives as required to provide a protected path of egress travel between the *exit access* and the *exit discharge*. Exits include exterior exit doors at the *level of exit discharge,* vertical *exit enclosures, exit passageways, exterior exit stairways,* exterior *exit ramps,* and *horizontal exits.*

Exit Access. That portion of a *means of egress* system that leads from any occupied portion of a building or structure to an *exit*.

Exit Access Doorway. A door or access point along the path of egress travel from an occupied room, area, or space where the path of egress enters an intervening room, corridor, unenclosed *exit access stair,* or unenclosed *exit access ramp.*

Exit Discharge. That portion of a *means of egress* system between the termination of an *exit* and a *public way*.

Exit Enclosure. An *exit* component that is separated from other interior spaces of a building or structure by fire-resistance-rated construction and opening protectives, and that provides for a protected path of egress travel in a vertical or horizontal direction to the *exit discharge* or the *public way*.

Exit Horizontal. A path of egress travel from one building to an area in another building on approximately the same level, or a path of egress travel through or around a wall or partition to an area on approximately the same level in the same building, which

affords safety from fire and smoke from the area of incidence and areas communicating therewith.

Exit Passageway. An *exit* component that is separated from other interior spaces of a building or structure by fire-resistance-rated construction and opening protectives, and that provides for a protected path of egress travel in a horizontal direction to the *exit discharge* or the *public way*."

Exterior Wall. A wall, bearing or nonbearing, that is used as an enclosing wall for a building, other than a fire wall, and that has a slope of 60 degrees (1.05 rad) or greater with the horizontal plane.

Fire Alarm Signal. A signal initiated by a fire alarm initiating device such as a manual fire alarm box, automatic fire detector, water-flow switch, or other device whose activation is indicative of the presence of a fire or fire signature.

Fire Alarm System. A system or portion of a combination system consisting of components and circuits arranged to monitor and annunciate the status of fire alarm or supervisory signal-initiating devices and to initiate the appropriate response to those signals.

Fire Barrier. A fire-resistance-rated wall assembly of materials designed to restrict the spread of fire in which continuity is maintained

Fire Damper. A listed device installed in ducts and air transfer openings designed to close automatically upon detection of heat and resist the passage of flame. Fire dampers are classified for use either in static systems that will automatically shut down in the event of a fire or in dynamic systems that continue to operate during a fire. A dynamic fire damper is tested and rated for closure under elevated temperature airflow.

Fire Door. The door component of a fire door assembly.

Fire Door Assembly. Any combination of a fire door, frame, hardware, and other accessories that together provide a specific degree of fire protection to the opening.

Fire Partition. A vertical assembly of materials designed to restrict the spread of fire in which openings are protected.

Fire Protection Rating. The period of time that an opening protective will maintain the ability to confine a fire as determined by tests prescribed in Section 715. Ratings are stated in hours or minutes.

Fire Resistance. That property of materials or their assemblies that prevents or retards the passage of excessive heat, hot gases, or flames under conditions of use.

Fire-Resistance Rating. The period of time a building element, component, or assembly maintains the ability to confine a fire, continues to perform a given structural function, or both, as determined by the tests, or the methods based on tests, prescribed in Section 703.

Fire-Resistant Joint System. An assemblage of specific materials or products that are designed, tested, and fire-resistance-rated in accordance with either ASTM E 1966 or UL 2079 to resist for a prescribed period of time the passage of fire through joints made in or between fire-resistance-rated assemblies.

Fire-Retardant-Treated Wood. Even though this term is in italics in the IBC, the IBC offers no definition for it.

Fire Wall. A fire-resistance-rated wall having protected openings, which restricts the spread of fire and extends continuously from the foundation to or through the roof, with sufficient structural stability under fire conditions to allow collapse of construction on either side without collapse of the wall.

Fireblocking. Building materials or materials for use as fireblocking, installed to resist the free passage of flame to other areas of the building through concealed spaces.

Flame Spread. The propagation of flame over a surface.

Flame Spread Index. A comparative measure, expressed as a dimensionless number, derived from visual measurements of the spread of flame versus time for a material tested in accordance with ASTM E 84 or UL 723.

Floor Area, Gross. The floor area within the inside perimeter of the *exterior walls* of the building under consideration, exclusive of vent shafts and court, without deduction for corridors, stairways, closets, the thickness of interior walls, columns, or other features. The floor area of a building, or portion thereof, not provided with surrounding *exterior walls* shall be the usable area under the horizontal projection of the roof or floor above. The gross floor area shall not include shafts with no openings or interior courts.

Floor Area, Net. The actual occupied area not including unoccupied accessory areas such as corridors, stairways, toilet rooms, mechanical rooms, and closets.

Fly Gallery. A raised floor area above a stage from which the movement of scenery and operation of other stage effects are controlled.

Grade Floor Opening. A window or other opening located such that the sill height of the opening is not more than 44 inches (1118 mm) above or below the finished ground level adjacent to the opening. (2009 IRC)

Grade Plane. A reference plane representing the average of finished ground level adjoining the building at *exterior walls*. Where the finished ground level slopes away from the *exterior walls*, the reference lane shall be established by the lowest points within the area between the building and the lot line or, where the lot line is more than 6 feet (1829 mm) from the building, between the building and a point 6 feet (1829 mm) from the building.

Grandstand. Tiered seating supported on a dedicated structural system and two or more rows high and is not a building element (see "Bleachers").

Gridiron. The structural framing over a stage supporting equipment from hanging or flying scenery and other stage effects.

Handrail. A horizontal or sloping rail intended for grasping by the hand for guidance or support.

Guard. A building component or a system of building components located at or near the open sides of elevated walking surfaces that minimizes the possibility of a fall from the walking surface to a lower level.

High-Rise Building. A building with an occupied floor located more than 75 feet (22 860 mm) above the lowest level of fire department vehicle access.

Historic Buildings. Buildings that are listed in or eligible for listing in the National Register of Historic Places, or designated as historic under an appropriate state or local law (see Sections 3409 and 3411.9).

Horizontal Assembly. A fire-resistance-rated floor or roof assembly of materials designed to restrict the spread of fire in which continuity is maintained.

Hospitals and Mental Hospitals. Buildings or portions thereof used on a 24-hour basis for the medical, psychiatric, obstetrical, or surgical treatment of inpatients who are incapable of self-preservation.

Inspection Certificate. An identification applied on a product by an *approved agency* containing the name of the manufacturer, the function and performance characteristics, and the name and identification of an *approved agency* and that indicates that the product or material has been inspected and evaluated by an *approved agency* (see Section 1703.5 and "*Label,*" "Manufacturer's designation," and "*Mark*").

Interior Finish. *Interior finish* includes *interior wall and ceiling finish* and *interior floor finish*.

Interior Floor Finish. The exposed floor surfaces of buildings including coverings applied over a finished floor or *stair*, including risers.

Interior Wall and Ceiling Finish. The exposed interior surfaces of buildings, including but not limited to fixed or movable walls and partitions; toilet room privacy

partitions; columns; ceilings; and interior wainscoting, paneling, or other finish applied structurally or for decoration, acoustical correction, surface insulation, structural fire resistance, or similar purposes, but not including trim.

Label. An identification applied on a product by the manufacturer that contains the name of the manufacturer, the function and performance characteristics of the product or material, and the name and identification of an *approved agency* and that indicates that the representative sample of the product or material has been tested and evaluated by an *approved agency* (see Section 1703.5 and "Inspection certificate," "Manufacturer's designation," and "*Mark*").

Labeled. Equipment, materials, or products to which has been affixed a *label,* seal, symbol, or other identifying *mark* of a nationally recognized testing laboratory, inspection agency, or other organization concerned with product evaluation that maintains periodic inspection of the production of the above-labeled items and whose labeling indicates either that the equipment, material, or product meets identified standards or has been tested and found suitable for a specified purpose.

Law. An act written and adopted by a legislative body (federal, state, or local) and enacted by executive signature. Laws fall into broad categories of criminal and civil, and they are enforced by a number of different means, from the local police and prosecuting attorney to the FBI and the U.S. attorney general. All citizens are equally bound by the provisions of a *law*. (This definition is by the author.)

Listed. Equipment, materials, products, or services included in a list published by an organization acceptable to the code official and concerned with evaluation of products or services that maintains periodic inspection of production of listed equipment or materials or periodic evaluation of services and whose listing states either that the equipment, material, product, or service meets identified standards or has been tested and found suitable for a specified purpose.

Manufactured Home. A structure, transportable in one or more sections, which in the traveling mode is 8 body feet (2438 body mm) or more in width or 40 body feet (12 192 body mm) or more in length, or, when erected on site, is 320 square feet (30 m^2) or more, and which is built on a permanent chassi and designed to be used as a dwelling with or without a permanent foundation when connected to the required utilities, and includes the plumbing, heating, air-conditioning, and electrical systems contained therein; except that such term shall include any structure that meets all the requirements of this paragraph except the size requirements and with respect to which the manufacturer voluntarily files a certification required by the secretary (HUD) and complies with the standards established under this title. For mobile homes built prior to June 15, 1976, a label certifying compliance to the Standard for Mobile Homes, NFPA 501, in effect at the time of manufacture is required. For the purpose of these provisions, a mobile home shall be considered a manufactured home. (2009 IRC)

Manufacturer's Designation. An identification applied on a product by the manufacturer indicating that a product or material complies with a specific standard or set of rules (see also "Inspection certificate," "*Label,*" and "*Mark*").

Mark. An identification applied on a product by the manufacturer indicating the name of the manufacturer and the function of a product or material (see also "Inspection certificate," "*Label,*" and "Manufacturer's designation").

Means of Egress. A continuous and unobstructed path of vertical and horizontal egress travel from any occupied portion of a building or structure to a *public way*. A means of egress consists of three separate and distinct parts: the *exit access,* the *exit,* and the *exit discharge*.

Mezzanine. An intermediate level or levels between the floor and ceiling of any *story* and in accordance with Section 505.

Nursing Homes. Nursing homes are long-term-care facilities on a 24-hour basis, including both intermediate care facilities and skilled nursing facilities, serving more than five persons and any of the persons are incapable of self-preservation.

Occupant Load. The number of persons for which the *means of egress* of a building or portion thereof is designed.

Operable Part. A component of an element used to insert or withdraw objects, or to activate, deactivate, or adjust the element.

Panic Hardware. A door-latching assembly incorporating a device that releases the latch upon the application of a force in the direction of travel.

Personal Care Service. The care of residents who do not require chronic or convalescent medical or nursing care. Personal care involves responsibility for the safety of the resident while inside the building.

Photoluminescent. Having the property of emitting light that continues for a length of time after excitation by visible or invisible light has been removed.

Pinrail. A rail on or above a stage through which belaying pins are inserted and to which lines are fastened.

Platform. A raised area with a building used for worship; the presentation of music, plays, or other entertainments; the head table for special guests; the raised area for lecturers and speakers; boxing and wrestling rings; theater-in-the-round stage; and similar purposes wherein there are no overhead hanging curtains, drops, scenery, or stage effects other than lighting and sound. A temporary platform is one installed for not more than 30 days.

Plenum. An enclosed portion of the building structure, other than an occupiable space being conditioned, that is designed to allow air movement, and thereby serves as part of an air distribution system.

Proscenium Wall. The wall that separates the stage from the auditorium or assembly seating area.

Public Entrance. An entrance that is not a *service entrance* or a *restricted entrance.*

Public Way. A street, alley, or other parcel of land open to the outside air leading to a street that has been deeded, dedicated, or otherwise permanently appropriated to the public for public use and which has a clear width and height of not less than 10 feet (3048 mm).

Ramp. A walking surface that has a running slope steeper than 1:20.

Registered Design Professional. An individual who is registered or licensed to practice his or her respective design profession as defined by the statutory requirements of the professional registration laws of the state or jurisdiction in which the project is to be constructed.

Regulation. A document written or edited by a regulatory body (federal, state, or local), which is then adopted by a legislative body (federal, state, or local) and enacted by executive signature. (SLH)

Religious Worship, Place of. A building or portion thereof intended for the performance of religious services.

Residential Building Type. The type of residential building for determining building thermal envelope criteria. Detached one- and two-family dwellings are Type A-1. Townhouses are Type A-2. (2009 IRC)

Restricted Entrance. An entrance that is made available for *common use* on a controlled basis, but not public use, and that is not a *service entrance.*

Self-Luminous. Illuminated by a self-contained power source, other than batteries, and operated independently of external power sources.

Service Entrance. An entrance intended primarily for delivery of goods or services.

Sleeping Unit. A room or space in which people sleep, which can also include permanent provisions for living, eating, and either sanitation or kitchen facilities but not both. Such rooms and spaces that are also part of a *dwelling unit* are not sleeping units.

Smoke Barrier. A continuous membrane, either vertical or horizontal, such as a wall, floor, or ceiling assembly, that is designed and constructed to restrict the movement of smoke.

Smoke Compartment. A space within a building enclosed by *smoke barriers* on all sides, including the top and bottom.

Smoke Damper. A listed device installed in ducts and air transfer openings designed to resist the passage of smoke. The device is installed to operate automatically, is controlled by a smoke detection system, and, where required, is capable of being positioned from a fire command center.

Smoke Detector. A listed device that senses visible or invisible particles of combustion.

Smoke-Developed Index. A comparative measure, expressed as a dimensionless number, derived from measurements of smoke obscuration versus time for a material tested in accordance with ASTM D 84.

Smoke-Proof Enclosure. An exit stairway designed and constructed so that the movement of the products of combustion produced by a fire occurring in any part of the building into the enclosure is limited.

Special Amusement Building. Any temporary or permanent building or portion thereof that is occupied for amusement, entertainment, or educational purposes and that contains a device or system that conveys passengers or provides a walkway along, around, or over a course in any direction so arranged that the *means of egress path* is not readily apparent due to visual or audio distractions or is intentionally confounded or is not readily available because of the nature of the attraction or mode of conveyance through the building or structure.

Stage. A space within a building utilized for entertainment or presentations, which includes overhead hanging curtains, drops, scenery, or stage effects other than lighting and sound.

Stair. A change in elevation, consisting or one or more risers.

Stairway. One or more *flights* of *stairs*, either exterior or interior, with the necessary landings and platforms connecting them, to form a continuous and uninterrupted passage from one level to another.

Stairway, Exterior. A *stairway* that is open on at least one side, except for required structural columns, beams, *handrails,* and *guards*. The adjoining open areas shall be either *yards, courts,* or *public ways*. The other sides of the exterior stairway need not be open.

Stairway, Interior. A *stairway* not meeting the definition of an *exterior stairway*.

Standard. A document written, edited, and adopted by a body of experts. (SLH)

Storm Shelter. A building, structure, or portion(s) thereof, constructed in accordance with ICC 500 and designated for use during a severe windstorm event, such as a hurricane or tornado.

Story. That portion of a building included between the upper surface of a floor and the upper surface of the floor or roof next above (also see "Basement," "Mezzanine," and Section 502.1). It is measured as the vertical distance from top to top of two successive tiers of beams or finished floor surfaces and, for the topmost story, from the top of the floor finish to the top of the ceilings joists or, where there is not a ceiling, to the top of the roof rafters.

Story Above Grade Plane. Any *story* having its finished floor surface entirely above *grade plane,* or in which the finished surface of the floor next above is (1) more than

6 feet (1829 mm) above *grade plane*, or (2) more than 12 feet (3658 mm) above the finished ground level at any point.

Technically Infeasible. An *alteration* of a building or a facility that has little likelihood of being accomplished because the existing structural conditions required the removal or *alteration* of a load-bearing member that is an essential part of the structural frame, or because other existing physical or site constraints prohibit modification or addition of elements, spaces, or features that are in full and strict compliance with the minimum requirements for new construction and are necessary to provide accessibility.

Townhouse. A single-family dwelling unit constructed in a group of three or more attached units in which each unit extends from foundation to roof and with open space on at least two sides. (2009 IRC)

Transient. Occupancy of a *dwelling unit* or *sleeping unit* for not more than 30 days.

Trim. Picture molds, chair rails, baseboards, handrails, door and window frames, and similar decorative or protective materials used in fixed applications.

TTY. An abbreviation for teletypewriter. Equipment that employs interactive, text-based communications through the transmission of coded signals across the standard telephone network. The term TTY also refers to devices known as text telephones and TDDs.

Ventilation. The natural or mechanical process of supplying conditioned or unconditioned air to, or removing such air from, any space.

Visible Alarm Notification Appliance. A notification appliance that alerts by the sense of sight.

Resources

ANSI	American National Standards Institute 25 West 43rd Street, Fourth Floor New York, NY 10036 www.ansi.org
ASHRAE	American Society of Heating, Refrigeration, and Air Conditioning Engineers 1791 Tullie Circle NE Atlanta, GA 30329 (800) 527-4723 www.ashrae.org
ASTM	ASTM International 100 Barr Harbor Drive West Conshohocken, PA 19428-2959 (610) 832-9500 www.astm.org
ATBCB	Architectural and Transportation Barriers Compliance Board (also known as the U.S. Access Board) 1331 F Street NW Suite 1000 Washington, DC 20004-1111 (800) 872-2253 (800) 993-2822 TTY www.access-board.gov
BHMA	Building Hardware Manufacturers' Association 355 Lexington Avenue, 17th Floor New York, NY 10017-6603 www.bhma.org
CPSC	Consumer Product Safety Commission 4330 East West Highway Bethesda, MD 20814-4408 www.cpsc.gov
DOE	U.S. Department of Energy 1000 Independence Avenue SW Washington, DC 20585 (800) dial-DOE (342-5363) www.doc.gov

1819 L Street NW, 6th Floor
Washington, DC 20036
(202) 293-8020

DOI U.S. Department of Interior
 1849 C Street NW
 Washington, DC 20240
 (202) 208-3100
 www.doi.gov

DOJ U.S. Department of Justice
 950 Pennsylvania Avenue, NW
 Washington, DC 20530-0001
 (202) 514-2000
 www.usdoj.gov

DOL U.S. Department of Labor
 Frances Perkins Building
 200 Constitution Avenue NW
 Washington, DC 20210
 (866) 4-USA-DOI (487-2365)
 (877) 889-5627 TTY
 www.dol.gov

DOT U.S. Department of Transportation
 c/o Superintendent of Documents
 1200 New Jersey Avenue, SE
 Washington, DC 20402-9325
 (202) 366-4000
 www.dot.gov

EPA U.S. Environmental Protection Agency
 Ariel Rios Building
 1200 Pennsylvania Avenue NW
 Washington, DC 20460
 (202) 272-0167
 www.epa.gov

FCC U.S. Federal Communications Commission
 445 12th Street SW
 Washington, DC 20554
 (888) CALL-FCC (225-5322)
 (888) TELL-FCC (835-5322) TTY
 www.fcc.gov

FEMA Federal Emergency Management Agency
 Federal Center Plaza
 500 C Street S.W.
 Washington, DC 20472
 (800) 621-FEMA (3362)
 (800) 462-7595 TTY
 www.fema.gov

FM Factory Mutual Global Research
 Standards Laboratories Department
 1301 Atwood Avenue, P.O. Box 7500
 Johnson, RI 02919
 www.fm.org

GA Gypsum Association
 810 First Street N.E. #510
 Washington, DC 20002-4268
 www.ga.org

GBI	Green Globes
	The Green Building Initiative
	222 SW Columbia Street
	Suite 1800
	Portland, OR 97201
	(877) GBI-GBI 1
	www.thegbi.org
HUD	U.S. Department of Housing and Urban Development
	451 7th Street, SW
	Washington, DC 20410
	(202) 708-1112
	(202) 708-1455 TTY
	www.hud.gov
ICC	International Code Council, Inc.
	500 New Jersey Ave, NW
	6th Floor
	Washington, DC 20001
	(800) ICC-SAFE (422-7233)
	www.iccsafe.org
LEED	Leadership in Energy and Environmental Design
	U.S. Green Building Council
	1800 Massachusetts Avenue NW
	Suite 300
	Washington, DC 20036
	(202) 289-7800
	www.usgbc.org
NCSBCS	National Conference of States on Building Codes and Standards
	505 Huntmar Park Drive
	Suite 210
	Herndon, VA 20170
	(703) 437-0100
	www.ncsbcs.org
NIBS	National Institute of Building Sciences
	1090 Vermont Avenue NW
	Washington, DC 20005-4905
	(202) 289-7800
	www.nibs.org
NIST	National Institute of Standards and Technology
	100 Bureau Drive
	Stop 1070
	Gaithersburg, MD 20899-8600
	(301) 975-NIST (6478)
	(800) 975-8295 TTY
	www.nist.gov
NFPA	National Fire Protection Association
	1 Batterymarch Park
	Quincy, MA 02169-7471
	(617) 770-3000
	www.nfpa.org

NPS	National Park Service
	1849 C Street NW
	Washington, DC 20240
	(202) 208-6843
	www.nps.gov

NPS
National Park Service
1849 C Street NW
Washington, DC 20240
(202) 208-6843
www.nps.gov

NSF
NSF International
789 N Dixboro Road
Ann Arbor, MI 48015
(800) NSF-MARK (673-6275)
www.nsf.org

OSHA
Occupational Safety and Health Administration
200 Constitution Avenue NW
Washington, DC 20210
(202) 523-8148
www.osha.gov

SLH
Samuel L. Hurt, R.I.D., P.E., R.A.
c/o
Pearson Education, Inc.

UL
Underwriters Laboratories, Inc.
333 Pfingsten Road
Northbrook, IL 60062-2096
(877) UL-HELPS (854-3577)
www.ul.com

USC
United States Code
c/o Superintendent of Documents
U.S. Government Printing Office
Washington, DC 20402-9325
www.usc.gov

WDMA
Window and Door Manufacturers Association
1400 East Touhy Avenue #470
Des Plaines, IL 60018
www.wdma.org

Note: Page numbers followed by f indicate figures; those followed by t indicate tables.